From Aryana-Khorasan to Afghanistan

From Aryana-Khorasan to Afghanistan

Afghanistan History in 25 Volumes

HAMID WAHED ALIKUZAI

Order this book online at www.trafford.com
or email orders@trafford.com

Most Trafford titles are also available at major online book retailers.

Printed in the United States of America.

ISBN: 978-1-4269-6113-7 (sc)
ISBN: 978-1-4269-6114-4 (e)

Trafford rev. 03/10/2011

www.trafford.com

North America & International
toll-free: 1 888 232 4444 (USA & Canada)
phone: 250 383 6864 ◆ fax: 812 355 4082

Hamid Wahed Alikuzia

Afghanistan History in 25 Volumes encyclopaedia
Faß ohne Boden Afghanistan today
Solomon the ideal ruler

Global unification one God, one Religion, one Language one
Currencies and one Government
World unification is Peace for all time "now era in 2012"

Afghanistan is completely free and independent in the administration
of its domestic and foreign affairs. U.S.A is the founder of the now
Afghanistan after 72 years, October 1929 until October 2001,
Democratic-Afghanistan like Germany after 1945

**Aryana Empire B.C 200 until 200 A. D included twenty nine
Provinces or "satrapies" embracing Macedonia, Egypt, Syria,
Palestine, Phoenicia, Phrygia, Cappadocia, Caucasus, Iraq, Iran,
and India "new Afghanistan-Central Asia"**

A.D 1338 Afghan—Turkmen "Ottoman Empire & A.D 1361 Tajik
Empire
Turkmen Emperor allover Islamic Nations & Tajik Central
Asia—India
Turkmen until 1922 & Tajik until 1871

Volume 25 consists of an outline of the 25 volume encyclopaedia included is the American dream of tapping into markets in Afghanistan-Central Asia

Contents

The History of Afghanistan and Philosophic Thought -
In 25 volumes encyclopaedia
Volume
Introduction

1. from Aryana-Khorasan to Afghanistan Cultural History & Art from Aryana 35,000 years ago "A.D 747 Khorasan, middle of the nineteen century Afghanistan"

2. the History of Art, Architectural, Painting, Poems, Embroidered, Woven textiles, and Carpet Making, Jewellers part first and second

3. map from 35,000 years ago Aryana, A.D 747 Khorasan, meddle of nineteen century Afghanistan-central Asia

4. precious element collection of 400 photographs historical images from B.C 500 until 1991

5. khorasan 747 " meddle of nineteen century Afghanistan" with Islamic history until Oct 2001

6. Art during united empire of Afghanistan in Herat with Dari Kabuli

7. Aryan religions Art in 747 Khorasan meddle of the nineteen century Afghanistan-central Asia

8. Aryana Personalities Noble first part

9. Tajik Empire in Dari Kabuli Miniatures, Calligraphic, Architectural, painting, and poems two Shah nama "two book, the book of the king one in province of Ghazni in 989 A.D and the anther one in Herat 1480 A.D Afghanistan Literature Master Piece in Dari Kabuli, in Art Museum in UK London

Author's Note

Research and studying on this manuscript from 1976s until 2001, sixty percents family document and forty my research

The book is still designed to set the fist early history of Aryan and Aryana-Khorasan (new Afghanistan) civilization as a unit, and its attempts to tell story of an integrated, or at least interconnected, World. This is an attempt to tell story of Aryana-Khorasan-Afghanistan this work has been subjected in manuscript. I began the manuscript when I was living in Germany in the 1976s at the urging of friends I worked to complete it and get it ready for publishing. It has been a massive undertaking the manuscript involved painstaking years of research. Sixty percent of the book is from my document like my grand Mother and great grand Mother's and forty percent my research and studying history and political education and knowledge. Philosophy of the history of the human race worthy of its name, must begin with the heavens and descend to the earth must be charged with the conviction that all existence is one a single conception sustained from beginning to end upon one identical law. The universal history is at once something more and something less than the aggregate of the international histories to which we are accustomed that it must be approached in a different spirit and dealt with in a different manner, this manuscript seeks to justify that answer.

I natural a full-blown expert on all the subjects and periods covered in the book. Have tried to use best sources and the best interpreters of the martial that myself could find, and to make my work as

free as possible egregious. I therefore have thought it best not to mention who have contributed to the writing and production of My work, but merely to express my general gratitude for my grand mother and to draw attention once to the excellent history of My family which have contributed so much to the success of earlier Heritages.

Hamid Wahed. Alikuzai

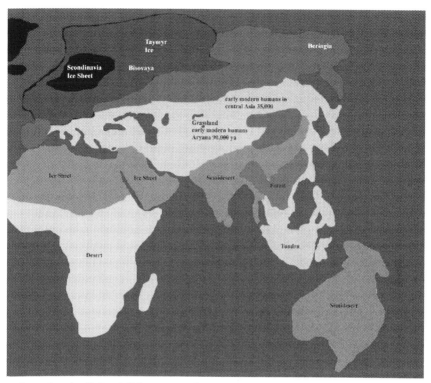

Grassland of the Afghan people 90, 000 years ago Aryan in Aryana

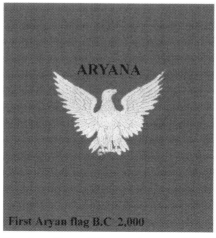

The first flag of Aryan (new Afghan)

Outline

These Books are designed to set in perspective the first early years of history of Aryan in Aryana or (Afghan in Afghanistan) civilization as a unit, and in its attempts to tell the story and the Progress of earliest humans lived in Aryansa-Khorasan or Afghanistan 90, 000 years until 2001, as an integrated this is the subject of this work in manuscript.

From Aryana to Afghanistan, Cultural, history & Art, 35, 000 years Aryana (the light of God) , 747 A.D khorasan (Sunrise middle of nineteenth century Afghanistan this is Volume 1 with 585 pages covering that topic. The history of 35, 000 years ago the of the Grassland of Aryana, 1262 years ago of Khorasan to the middle of the nineteenth Century Afghanistan, central Asia was changed by the most powerful three German cousins in Europe, the German Kaiser, the Saxon King, and the Russian Tsarist. The Greatest civilities of the world can be found in Afghanistan history; excavations of prehistoric sites suggests that early humans lived in Oxus river, north of Afghanistan at least 90,000 years ago, and the farming communities in Afghanistan were among the earliest in the World.

In the middle Palaeolithic period, from 90,000 years ago people in Afghanistan were isolated there and elsewhere by ice and swamps. The remains of the Homo sapiens Neanderthal found at Amman kitten cave near Samarqand (Samarqand in 1360 was capital of Afghanistan) date roughly to 100,000 to 40, 000 years ago, and are the earliest known human remains in the World. in 4, 000 B.C the city of Lot in Aria (new Heart was capital of Aria until the Great Games in the middle of nineteenth century A.D and 6000 years ago Aria was Capital of Aryana or Afghanistan) with 6, 000 years of civilization around I, Lot city and desert is among the most attractive in the region to be seen in Aryana

Province of Aria (New Heart) its' ancient castles with 7, 000 years of oldness, the natural relics such as Barchans (crescent like sand hills). Also are worth mentioning here is the 6,000 years old king Das, town, which is built the town in one of the first places in history (the Ancient Provinces of Afghanistan, Paropamisada (new Kabul) Aria (new Heart) Drangiana (new Seistan) Arochosia (new Kandahar) Gandaritis (new Peshawar) Gedrosia) (new Baluchitan) Lampaqaqar (new Laqhman) Bactria (new Balkh-Bukhara) and more. Those names are displaced by European Saxon Empire in when has called the Great Games in the middle of nineteen Century A.D

The Vedas, Zoroastrian, and Buddhist, oldest known religion of Aryana (New Afghanistan) in the capital Bactria (New Balkh) Sanskrit at is the original History of Aryana-Khorasan new Afghanistan

30, 000 – 2, 300 B.C Kabul valley, Hindu Kush Mountains and Oxus River and mountains, the Afghan, landmass has presented the larges and perhaps one of the best places for human beings to live in this landmass. There is Oxus Mountains, plains pastures, Hindu Kush, mountains and rivers; the geographic diversity produced different life styles and cultures, but cultural exchange between the different groups of people has never stopped through history. Aryan (Afghan) Noble and the early Bronze Art Aryana metallurgy came into being sometime before 3, 000 B.C the kneeling man bull, an excellent silver, gold sculpture Jam at Bactria can be dated from 3, 000 B.C the Kabul valley at the end of the second millennium B.C holds archaeological finds from the ancient cities in the Kabul valley, where Kabul valley civilization was born, including some bronze and gold objects and a copper sculpture, Dancing Girl. Aryana (Afghanistan) Noble culture in Buddhist Art in Central Asia before the arrival of the Mauryans Buddhism, which was founded by shakyamuni in the sixth century B. C and had already known in most parts of Aryana where Buddhist Art exists the first patron of Buddhism was Ashoka's King of Bactria northern Afghanistan, the grandson who found the Mauryan Dynasty. The first Buddhist Art appeared after King Ashoka firmly settled down. Mauryan sculptures were modeled on the Aryan archaic style, but they kept an even closer relationship with Bactria, which has a stronger geometric and blocky

quality. The famous Kanisshka excavated from a stupor at shah-Ji-ki near Province of Peshawar in Afghanistan, bears a great deal of Bactria influence for example. Bactia life and culture during the kushan Empire Period in Afghanistan-central Asia, the kushan Empire, already established in Afghanistan, merely its boundaries further inside with the breakdown of the imperial authority of Pataliputra. Vasudeva'a, a Kushan king, and his conversion to orthodox Hinduism eliminated whatever foreign character the kushan monarchy had originally, there is no wonder; therefore, the Afghanistan life and culture, except one branch of Art, did not undergo substantial changes during the kushan age. However the empire of the Afghan-kushans proved a Great factor. It opened the way for Aryan (Afghan) civilization to flow to central and eastern Asia, where trade and commerce flowed between Mesopotamia and Aryana (Afghanistan) Empire. The Afghans' kushans were patrons of Literature and Art. Large quantities of Sanskrit literature of high standard, both religions and secular, were produced in the congenial atmosphere of royal patronage, while the name of the kushan empire, kanishka, is associated with several eminent Buddhist writers-among them Asvaghosha, Vasomotor and charka Asvaghosha all of whom were versatile genius, well versed in Music, Literature, Religion, Philosophy and debate. Kandahar School of Sculpture, Kandahar Art became very important as it turned to be the parent of the Buddhist Art of the Afghanistan, Korea, and Japan. The Kandahar sculptures have been in Axial and in various ancient sites in Afghanistan and consist mostly of images of the Buddha relief sculptures representing scenes from Buddhist texts executed in stone, stucco-cotta and clay, and appear to have been invariably embellished with gold leaf or paint, specimens preserved in Province of Peshawar. But at txila the archaeologists have discovered, in addition to stone images, a large number of stucco ones and smaller number of terra-cotta and clay figures. The discoveries have greatly added to our knowledge of sculpture and technical skill employed by the artists of the Great Kandahar school of Art, in sixth century B.C the great ancient history of the Vedas, the oldest known religion of Aryana

The sixth century B.C size of the city of Kandahar was 1.2 million Sq k meter. Called the Great Arachosia, (new Kandara) as learned from

the Great Arachosia, was ruled by king and councils of Prominent men in varying degrees of Monarchy and influence, metathesis, stating that monarchies were dissolved and democratic governments were set up in the Great Afghan cities, Jainism and Buddhism flourished particularly in the independent clans, in the sixth century B.C there were sixteen major states of which Magadha (new India) Kosala, Vast were the most powerful. After the Buddha's death Arachosia was a major city also was major or less the same in importance as kasha,

The Literature, Physics, Mathematics, Science, Medical science, Geometry, Arts, Miniature, Calligraphy, Poems all those were invented by Afghanis ancestors the Aryans in the Aryana territory from 640 B.C until A. D 1928

In 1,000 B.C in Bactria north of Afghanistan the Original manuscript of the Afghan Bible was written, by the Prophet in his own hand-Zoroastrian. Born in Bactria c 3, 000 years ago Genghis burned the ancient Afghan Bible, the original in Bactria although a copy dating back to the twelfth century A.D remains safe on display in a New Delhi Museum. The ancient Afghanistan (Aryana) which Zoroastrian (in translation Zoroastrian means the Gold Desert) is said to have written himself is still used by the Aryan as their Bible and prays books. The Afghan Bible Zoroastrian was not only for prayer, but the Afghan Bible was also to teach Song, Agriculture, Philosophy, astronomy, Mathematic, Medical, and basic science in 960 B.C

Buddhism 650-321 B.C in the Mauryan Age with the advent of the seventh century B.C Afghan history become precise and clear before this century everything is obscure and chronology is indefinite. The Buddhist Books of Aryana History, at this time was divided into twelve small and big monarchies and a number of small tribal republics, the most important among theses were the Kingdoms of Bactria with the king of Kandahar, and as its capital Heart. At this time as its capital size of Herat was 1, 6 million Sq km. Despite thee twelve tribes of Buddhism in the United kingdom in Bactria (new Balkh)when the rules of Magadha (new India) were extending their dominion, the kings of Kandahar were also building up their power in the whole of the Indus valley and

probably stretching as far as the salt range in the Jhelum district the founder of the Aryan empire, and the sequence of kings extended their coquets right up to the Hindu Kush, formed the Kush as a part of this empire, then one of the kings sent his admiral to explore the mouth of the Indus river. This was followed by an expedition to Magadha (new India) in 517 B.C resulting in the annexation of portion of the Afghan-eastern Province Punjab. This formed the twentieth Province of the Aryana (new Afghanistan) empire comprising the Buddhist civilization of Kandara and Herat 322 B.C the Hellenistic influence was nowhere more dramatic than in Kandahar, a term now used to describe the School of semi classical sculptures of Aryana (Afghanistan) in the early centuries of Christian era. Arochosia (new Kandahra) is the name of the ancient Province and Kingdom, which in classical times, Afghanistan, the Province Kandahra included roughly Gedrsia (new Pashtunistan) between the Khyber Pass and the Indus River and region of the Kabul valley. However, Art and Architecture from Kandahra School of Art had been found as far the Oxus river in the sixth to fourth centuries B.C and Kandara was dominated under the Aryana Dynasty the Great maintained themselves in Bactria from 322B.C to 50 B.C in the Afghan Bible Zoroastrian was not only prayer, bath the Afghan Bible was also to-teach Song, Agriculture, Philosophy, astronomy, mathematic, medical, and basic science in 960 B.C

The Progress of earliest Aryan (newly termed Afghan), and the rise of the civilization, the earlier par of this story form what we call ancient history. The first steps and the earliest Ages of human Progress if we go back far enough in the story of Aryan (Afghan) where we reach a time when Aryan possessed, was the find of a stone with a well worn ragged edge to assist in Aryan (Afghan) life more than iffy thousand years ago. The one find of a ragged edged stone indicates the possibility of speaking and hunting nomadic peoples in Oxus Mountains and river in Aryana (Afghanistan). The life of early Stone Age Aryan Oxus river and mountains in Aryan savages entered they followed the life of hunters roaming about in the Great forests, which covered much of central Asia. In that distant age, 4,000 B.C Aryana (new Afghanistan) the men and women submit to his control domestic animals in Grassland of Aryana-Central Asia. This is also the home of horsemen with the Great civilization as for the first

time in human history. 6,500 years ago, and Afghan tamed domestic animals like cattle, sheep and Goats. Because of hours for hunting and shifting over into the land, the region at the Aria & Bactria Mountains and rivers the Afghan occupied a district some five hundred miles long. They were a rude mountaineer peasant folk leading a settled agricultural life. Aryana (new Afghanistan) has more than 300 rivers, 90 percent of those rivers going into the Ocean. These estuaries made 25 percent of the Ocean Water coming from Aryan (Afghan) Mountains-River. The language and social life of Aryan and the Aryan language, the region of the central Asia and later in Europe and spreading from that region, of Aryan (Afghanistan) originally the Aryan (Afghan) language of the Aryana race. Aryan began to differentiate into a number of subordinate languages. 8, 000 years ago during the bronze in Aryana (Afghanistan) before the metals, came, by that time Aryan (Afghan) social life had developed so that there were men of various occupations and women and men of different ranks in the community of Aryana. There men who worked wood and leather, potters and carvers, the women span and wove and embroidered. 5, 000 years ago all these spoken languages have a common resemblance; each have already explained geographic rings that mark the changes upon a number of common roots. The industries of the middle stone ago in Aryan and the progress of earliest Aryan and the rise of the civilization, with each invention growing out of earliest inventions, and each would have been impossible without the previous discoveries, it became possible to write for one hand invented, and so there were read books and knowledge of science circa 1000 B.C and such institutions as schools and churches even laws and government intended to tell the story. Around 2, 000 B, C for the first time Aryana emigrate from Aryana (Afghanistan) to Mediterranean and Egypt, and horses are used for hunting. After 1, 000 B.C the second emigration from Aryana (Afghanistan) occurred in 960 B.C the first Books of religion Zoroastrian (desert of Gold) and the second Books 640s of religion talk about the book of Solomon who lived in the Province of Bactira and Kabul-Afghanistan. In 498 B.C Buddhism in Kandara, and Hindus in Bactria and Eastern Turkistan, began to look out the life of women and men, which Aryans studied in an effort to find a new religion fitted to meds of women and men. Afghan watched the ceaseless struggle between Good and Evil.

Alexander the great 321 B.C after 200 years dreamed of Greek gold, Silver, oil, ruby, Diamond, Iron, wine, and Horses. Alexander was twenty years old his father was murdered by his friends. Alexander succeeds to a kingdom, best on all sides with great dangers and rancorous in Aryana (new Afghanistan). Alexander took ten of the noble Aryan (Afghan) Philosophers and sent them to Greece-or Macedonia- Art in Aryana-Khorasan (new Afghanistan) Art from 960 B.C and Art from 500 B.C Buddhism Art in Afghanistan one of the richest century in world, with earlier Buddhism Art, and Solomon Art from 640 B. C and Art of 200 A. D the tow statues of Province Bamiyon 175 feet, and the one thousand meter Lang Sleeping Buddha. Bactria Art from 5, 500 years ago, Art of Province Aria (Heart) Art of the Province Bukahra, Art of the Province Kandara, Art of the Province Samarkand, Art from 3, 500 B.C until 747 A.D is the art from the roof of the world. The architectural of Afghan-Central Asia is rich and varied; it consists of well preserved medieval structures and ruins of early feudal castles lost in the mountains and deserts which have engulfed the formerly fertile oases. As Afghanistan-Central Asia came under Islam's influence epigraphically Ornamentation began to play a prominent role. Dari Kabuli and Kufic (New Arabic) inscriptions were religious or moral-didactic in content. Painting decorated from 6th to 8th century painting decorated not only palaces and temples but town houses as well present whole galleries of such painting the monumental painting of Afghanistan-Central Asia, in the 6th to centuries. The period between the 3rd and early 5th centuries was a turning as the statues of Buddha; the main objects of worship were of enormous size. The Buddhist sculpture period was characterized by a heightened interest in frightful demonic creatures, mostly and formidable semi-deities, the carved wood show mythological characters. Decorative and applied Arts Artistic ceramics is one of most tradition branches of the decorative and applied Arts in Afghanistan-Central Asia. The 4th -2nd millennia B.C millennia B.C have painted wares, mostly semi spherical bowls with geometric pattern of crosses, rhombuses and triangles. Early 2nd millennia B.C for that time a virtual technological Revolution, Clay ware became more varied in form and ornamentation. Craftsmen worked in various metals, such gold, silver, bronze, copper and brass. In ancient times bronze pieces predominated, as metalwork of Antiquity

and the middle Ages is represented, primarily by artistic utensils made of gilt silver and, less often of gold, beginning in the 1st or 2nd century B.C Metalwork from 1, 500 B.C was influenced by the traditions of the ancient Aryana (Afghanistan) Art and Afghanistan-Central Asia Jeweller art from 1,500 B.C Miniatures second century B.C and 9th century A.D articles made of wool, linen, silk and leather have always played an important role in the everyday life of Afghanistan-Central Asia. 4, 000 ago Afghanistan-Central Asia carpet, both piled and flat, served various purposes, floor flat woven pales carpets and short-piled strips of carpet, and embroidery in gold thread was a special branch of Afghanistan-Central Asia, needlework, which reached its acme in Bukhara, Afghanistan with Islamic History from 747 A.D until Oct 2001. the history of role Afghan flag from 3, 000 B.C until 2004 A.D the history of role Aryan (new Afghan) flag flags recognizable as such were the invention, almost certainly of the ancient civilization of Aryana the first flags consisted of symbols attached to the tops of poles. Such flag-like objects appear in Aryana (New Afghanistan) of the mid 2000s B.C cloth flags were first used in Bactria (New Balkh) 3, 000 B.C these flags were made of silk. Flags had equal importance in ancient Aryana, being carried on chariots, with emblems of Eagle, Lion, and elephants. Flags took the for of cloth or similar displaying the insignia of a community, an armed force, an office or an individual. It marked the position of an important individual before a battle, during a siege, throughout a ceremony, or at a tournament.

Miniature, Calligraphic, Painting, and Poems of Alisher Navoi 1485 Art during United Empire of Herat from 15th century in Afghanistan took the form of Miniatures, painting and calligraphy. Afghanistan Art may well claim a place among the greatest achievements of man's artistic activity. Its supreme expression is in architecture, in which the followers of Afghan, the architects they employed worked out a scheme of building construction and of decoration in harmony with the austerity and dignity of their faith and adapted to its ritual and forms of worship among Afghan noble personalities, from 960 B.C until 660 A.D under Zoroastrians, Buddhism, Hinduism, and Muslim. The Tajik Empire in Dari Kabuli (the languages spoke in Kabul) Miniature, calligraphic, Architectural, painting and poems, (the European called Mughal

empire) the sourcebooks of the Afghan-Tajik era are a marvellous boon to the student of Tajik history. A particularly rich period was the reign of Empire Akbar in second half of the nineteenth century. Durand Line on Afghan territory was created by the Europeans, their most powerful Cousins Empire, The Saxon first cousin's empire, the Kaiser, the king and Tsars, Afghanistan's (Mignon) as a buffer state between the German-Saxon and the German Empire of Russia 147 years of war. Afghanistan was the key for India and China Saxon (new British) and Russia empire called the Great Games, in the case of Afghanistan the situation is further complicated by its geological and historical background though Afghanistan (Mignon) as a state existed since the middle of nineteen century, before there was an Empire of Khorasan the name Afghanistan first applied originally by Saxon empire for the great games country called Afghanistan (Mignon) its current political borders Owen country evolved only toward the end of the last century 1880-1901 as an outcome of rivalry, and Saxon-Tsars Activity on Afghan Teratology until 1929. the Aryan (new Afghan) national Sport Buzkashi from 3,500 years ago until today Buzkashi, is one of the ancient games played in Afghanistan, the name of this game is perhaps derived from hunting mountain goats by ancient Afghan champions in horseback on the basis of popular beliefs and legends, one could say this game was played for the first time in the Oxus river basin. Aryan people had earlier domesticated the horse and used to fight the enemy on horseback. The Bactria camel and the Buzkashi, it is said the Zoroastrians had his law inscribed on bull's hide in gold and hung it on the gates of Bactria, 3,000 years ago. Buzkashi Games on now year's day and local fairs, only champions, however participate in important matches on the basis of their horsemanship, played on the 22nd of March which is the Afghan New Year's day.

Given the History of the conceptions of the Afghan languages from 1,500 B.C and the science of life in Aryana from the primitive to the earliest civilization, the certainly could be hypothesized that life began upon the earth here. Biologists have made many guesses and suggestions, and there seems to be a general agreement that life began in warm sunlit shallow water, it began perhaps as slime, as a sort sub-life slowly and imperceptibly took on the distinctive qualities

of life. In the Aryan (new Afghan) holy Bible from 960 the coming of the Prophet-Aryan religion before Zoroastrian the bible of Afghan Ahura Mazda the good and the evil spear struggle for the possession of the World. Almost 600 years later the new civilization of Christians followed the life and death of Holy Prophet Jesus. The Brief history of all the these faiths and religions, the history of Afghan River and Mountain, the Afghan briefly linked with the European history as the Afghanistan Central Asia was in geo political transition in History before the advent of Christ was very different. In 178 B.C Bactria (new Blahk) a northern Province of Aryan (new Afghanistan) the united empire the great Buddhist monks of Arochosia (new kandahar) Bactria a northern Province of the Aryana empire conquered by Alexander in the late fourth century B.C the Bactria's seceded from the Seleucid Empire in the third century and was not conquered by the parathions when the Seleucied empire was overrun. In the 130 or 140s B.C Bactria was overrun by westward advance of the yu-chi, when the Aryana were best by internal troubles. The country remained in their hands until it was at the start of the third-century. Buddhist monks of Arochosia had been a common feature in India and Bactria for centuries before the arrival of the Kushan invaders from Aryana-Central Asia. The great king of Arochosia (new Kandahar) and the beginning of the history period, 500-150 B.C for this phase of Aryana history a variety of historical sources are available, such as the Buddhist canon, pertaining of the Buddha c 6^{th} – 5^{th} century B.C and later, is invaluable as a cross reference for the Brahmanism. This also is true, though to a more limited extent, of Jaina sources, in the 4^{th} century B.C there were secular writings on political and accounts of foreign travelers as the most important sources, however also important are inscriptions of the 3^{rd} century B.C and Greek sources attest to the unification of yu-chi under a single leader in the very early part of the first century A.D the fourth Buddhist council stated in the fourth century A.D the history of Buddhism includes four great councils on Buddhism, doctrine, the first and second councils happened shortly after the death of the Buddha. A third was held under the auspices of Ashoka king of Arochosia (new Kandahra) in the third century B.C Ashoka's council's is only reported some Buddhist traditions so it was probably a local matter concerned with the doctrine or a particular area or as was the case with the forth

Buddhist council, held under king kanishka in the second century A.D, the main source for the council Buddhist traditions on his journey one of the traditions he collected cancers king kanishka's council interested Arochosia (new Kandahar) Buddhist Art and its impact it is impossible to talk about Buddhism without mentioning its profound impact on the development of Aryana (new Afghanistan) Art it is through those artworks that a fusion of eastern and western cultures was demonstrated the Art of Buddhism left the World the most powerful and enduring monuments along the Silk road, and among them, some of the most precious Buddhist sculptures, Paintings and murals furthermore the contact with Hellenized Kandaharn culture resulted in the development of a new art from Buddha statue.

200 A.D the Great Christianity history of Aryana (new Khorasan-Afghanistan-Central Asia) the foundation tradition of the church of the Afghanistan, beginning in the last decades of the first century, was formed amongst Caucasus and Syrian speaking communities in Syria and Mesopotamia from these territories, from Media-Kufic (new Iraq) and Prathian then stretching as far as Afghanistan-India had been amongst the crowd at Pentecost, according to Luke's account, and many more, Christian as well as Aryan (Afghan) Women as well as men are said to have fled eastward after the destruction of Jerusalem in 70 b.c. e busbies. Writing before 324, declares that Thaddeus one of the seventy disciples, worked in Odessa and the agar, women's life 97 A.D in Afghanistan-central Asia in particular, it is notable that women played important roles in the early Church of the Afghanistan as prophets and martyrs, abbesses and spiritual leaders, ministers to the poor and ascetics. Bartizan details the ways in which in Parthian and Bactria (new Balhk) Paropamisada (New Kabul) Aria (new Herat) Drangiana (new Seitan) Arochosia (new Kandahra) Gedrosia (new Pashtunistan) Christian women showed a radically different style of life and morality Mosaics, relief's and tombs discovered at such locations as Edessa depict a liberal attitude to women's who were also honoured in family life. A written dowry contract was normal, but they did not enjoy legal equality and divorce law discriminated against them. The teaching of the apostles and the constitutions of the holy apostles refer to classes of ordained deaconesses and also to orders of virgin's widows.

In 720 A.D by force par of the Aryan (new Afghan) people were converted to Islam. The population of peasants was growing in numbers and they were forced to accept Islam as their way of life from amongst the people of Aryana (new Afghanistan). Nineteen years old man called Abdul Rahman as he was born changed his name to Abu-Muslim, born in Sar-I-pol Province of Samangan north of Afghanistan chorused as a major politician of the era by 747 while Afghanistan in a battle between Muslim and the elite leaders called Abu-Muslim dressed in a black robe and declared a holy War against the Kufic (new Arab). By 752 region was Islamic and by eliminating the Kufic leaders in the area, Abu-Muslim created a large Islamic Kingdom of Khorasan (New Afghanistan, Egypt, Palestine, Syria, Phoenicia, Lydia, Phryggia, Cappadocia, Cilicia Babylon, Iran, India, Turkey, East Turkistan, Caucasus, Turkmenistan, Uzbekistan, Krighizitan, Kazakhstan, Mongolia, from 642 until 822 A.D. from Spain to Africa to Khorasan, or central Asia. Kufic (new Arab) influence brought a bought the creation of Kufic language in Afghanistan and the establishment of the Islamic religion in Afghanistan made the Kufic language and interchanged the new language from the Afghan into the Kufic (new Arabic) the Afghani had at the time the language of Literature and Noble Psalms (the Book of Aryana in B.C 960 and the books B.C 640s and the Books of 498 B.C). In 747 Abul Rahman was the leader of a revolutionary movement in Aryana against the Kufic called the Muslim War, and the twenty years religion War. Aryana become Khorasan (Sunrise) a name applied original by Abdul Rahman who called himself Abu-Muslim Khorasani in the war which killed 10 million people in the name of religion in the new Khorasan (Afghanistan) the first War Muslim 747 until 989. the Muslim history displace Aryana to Khorasan in 747 A.D (at the time the size of Khorasan was from Spain, same Mediterranean central Asia to India part of China, known as Eat Turkistan.

Dr William Osler, author of the Evolution of Science writes; the Qanun has remained a medical bible

981 A.D One of thousand Afghan Noble Personalities was-Abu Ali Hussain ibn Adbullah ibn Sina Physician, Philosopher, mathematician, astronomer Ibn Sina, known in the World by name of Avivenna, was

the most famous Physician Philosopher, mathematician astronomer of his time, his major contribution to medical was his famous Book al-Qanun fi al-Tibb, known as the Canon' in the west, No deliberation on the science of medicine can be complete without a reference to Ibn Sina, Abu Ali al-Hussein Ibn Sina was born in 981 A. D at North of Province Kabul and by the age of ten he had become well versed in the study of Qur'an and basic sciences, he studied logic from Abu Abdullah Natili, a famous Philosopher of the time and his study of Philosophy included various Greek and Afghan Books. In his youth he showed remarkable expertise in medicine and was well known in the region, at the age of seventeen, he was successful in curing Noah Ibn Mansoor, the King of Bactria (new Balkh-Bukaras), of an illness in which all the well-known Physicians had given up hope, on his recovery King Mansoor wished to reward him the young Physician only desired permission to use his uniquely stocked Library. Ibn Sina traveled to Jordan after his father's death in Afghanistan, where he met his famous contemporary Abu Raihan Al-Biruni, he wrote his famous Books Al-Qanun fi al Tibb (medical science) where completed many of his monumental writings, nevertheless, he continued traveling, finally he returned to Afghanistan where he died in 1037. His major contribution to medical science was his Book the Canons of Medicine is an immense encyclopaedia of medicine extending over a million words, it reviewed the medical knowledge available from ancient and Afghan sources, Ibn Sina's Qanun contains many of his anatomical findings, which are accepted even today (2009) Ibn Sina was the first scientist to describe the minute and graphic description of different parts of the eye, such as conjunctive sclera, come choroids, iris, retina, layer lens, aqueous humour, optic nerve and optic chiasm, Sina condemned conjectures and presumptions in anatomy and called upon physicians and surgeons to base their knowledge on a close study of human body, he observed that Aorta at its origin contains three valves, which open when the blood rushes into it from the heart during contraction and closes during relaxation of the heart so the blood may not be poured back into the heart. In the twelfth Century it became the textbooks for medical education in the schools of Europe, Dr William Osler, author of the Evolution of Modern Science writes; "The Qanun has remained a medical bible for a longer period that any other work. Ibn

Sina also contributed to mathematics, Physics and other fields, he made several astronomical observations, and devised a device similar to the venire, to increase the precision of instrumental reading, in Physics, he contributed to the study of different forms of energy, heat, light and mechanical, and such concepts as force, vacuum and infinity, he made the important observation that if the perception of light is due to the emission of some sort of particles by the luminous source, the speed of light must be finite, he propounded on an interconnection between time and motion, and also made investigation on specific gravity and used an air thermometer. Ibn Sina's Portrait adorns the Great hall of the Faculty of Medicine in the University of Paris France.

Afghan Personalities Noble from 940 A.D Abdul Wafa M. iIbn Muhammad Ibn Ismail al-Buzjani was born in Buzjan Nishapur in 940 he flourished as a Great mathematician and astronomer at Province of Ghazin and died in 998 he learnt mathematics in Heart in 959 he migrated to Babylon Like many other Afghan and lived there till his death Abdul Wafa's main contribution lies in several branches of mathematics, especially geometry. In geometry his contribution comprises solution of geometrical problems with opening of the compass construction of a squire equivalent to other squares regular construction of regular hectagon taking for its side half the side of the equilateral triangle inscribed in the same circle construction of parabola by points and geometrical solution of the equations X4=a and x4+ax3=b he also developed relations for a+b and the formula. 2 sin 2 – a/2 coos – a/2 in addition he made a special study.

706-767 A. D Abu Hanifah's system of Law his full name was Abu Hanifah Al-Human ibn Thabit he is one of most influential and celebrated personalities in the Muslim World he was the founder of the first orthodox schools of Law, which became known after his name the Hanifist. His brilliant use of reason and systematic thought provided Muslim civilization with a coherent and applicable of Law. Abu Hanifah was the grand son of Zuta who was a Kabul royalty. Zuta was a Tajik Zoroastrian who converted to Islam, during the Kufic (new Arab) invasion in Afghanistan he was born in 706 A.D in Kabul / Afghanistan he believed that an ethical God gave legal norms through

divine revelations. Abu Hanifah's great contribution one that was revolutionary in its implications was to approach the Law not situation ally but systematically. He determined to find principles, Sifting through the vast legal witting of his time he sought universal and standards that would be applicable regardless of time or place. He held to the philosophy of the Golden Mean, he permitted use of natural Law the findings of reasons based on the physical and sciences. This approach was as ancient as Aryana Philosophers' he put a balanced emphasis on several of truth. 425 B. C to 773 A.D the continuity of science and Philosophy from Aryana-Khorasan-Afghanistan lanai through Greek and thence to northern Europe is one of the brightest threads in the skein of history. Aryan science though long since enfeebled by obscurantism, misgovernment and poverty was still alive in Babylon when the Moslems came at the very time of conquest, from B. C 300 until A.D 250 The United Kingdom of Afghan-Greek the Capital was Bactria north of Afghanistan after Empire Timur transferred in 1360 A.D the Capital from Heart to Samarkand he need five thousand camels to transport the Heart Government Library to Samarkand. Few Private Libraries were as large as the state Library at that time. Heart was already known as the Jewel of the World at the time, and Timur chased to improve Samarkand with this in mind.

The Gold age 0f Afghanistan

993 A.D Empire Sutan Mahmud of Ghazin, Empire Mahmud Ghanawi at the age 27 announced his claim to the throne of Khorasan (New Afghanistan) are his claim to be Empire from the Great city of Bactia Mahumd defeated his brother in Ghani capered him and imprisoned him for life the Province of Jowzjan Meanwhile he defeated the Samani Empire and capture Toes, Empire Mahum intoned to make his Kingdom more Powerful and sought to bring wealth to his capital in Ghani, his influences reached Babylon and captured Gorjistn from Abu Nasser, sistan from half Bin Ahmed by 1002 A.D Empire Mahmud Ghaznawi defeated the mighty khalif Bin Ahmed Ami Omar and stopped his western conquests and concentrated toward the Easter fronts. In 1001 Empire Mahmud defeated Jeebal 1005. He it his center for his forces from his strategic location Mahmud were able to capture India. Emperor Mahmud contributed to Universities which

were formed whose subjects of Math, Religious studies; humanities and Medicine were thought only within the Laws of Sahria, as Islam was the Main of his religion of his kingdom and Dari Kabuli language replaced the many different languages spoken at times, (Province of Ghani 100 km west of Kabul)

900 A.D Jewish Community of Afghanistan city of Samna, city of Shibarghan and Bactria oldest city of Afghan (Aryan) the concept of the other is an integral component to the revised interpretation of any cultural identify to the post-modern theoretical, perspective one forms his or her seen of cultural and ethnic identity, "Other, therefore, there is a dialectical relationship between the self and the other, through the dial interaction, a cultural is understood to be dynamic and in the process of Becoming as well as cultural identities are formed, not in a vacuum but rather in a matrix of history, economic mode of power relations, the power relations shape cultural identity, are the center stage of the concept, the be focused is the concept of other, since each culture defines itself in relation and over the other understand the other within each medieval Jews of Afghanistan, most of the literature about the Jews of Afghanistan is inaccessible to most of the scholars concentrate on this geographical area, most of the recent studies about the history of the Afghan-Jews in Hebrew Furthermore, the majority of the material is saturated with folklore and little concrete, are evidence, however there are some things that are known about the Jewish community in Afghanistan, in 2000 B.C first wave of Aryan migration to Egypt.

From 1218 until 1401 Mongols in Afghanistan(Khorasan) the empire of Genghis with five hundred wife, between Mongols society marriage, was not recognize, Genghis khan at his death in 1227, his empire left 500 wife inherited to his son, 1198 A.D Genghis (Temujin) changes he is also known as was born in the year 1162 to a Mongol chieftain, refugee and his wife, he was born with the name of Temujin, which means ironworker, in his native language, when Tumuli were born his fist was clutching a blood clot, which the Wiseman declared as an omen that Tumuli would be a heroic warrior which history has proven to be true, for Temujin he was around age 13 when his father declared that his son was to find a fiancée and get married, after several days of travel

Temujin and refugee came across a tribe of Eastern Turkistan that were very hospitable and welcoming, Temujin was not there long when he noticed a certain girl would be destined to become his first wife, born the daughter of the chieftain of that tribe. She was to become his wife, She was 14 years of age now a with wife for his son refugee to head for home and leave his son with his fiancée however on his wee back to his home tribe, he encountered a group of Tatars, which just happened to be the archenemy nearly emery Mongol, yesugei, was murdered and very quickly word come to Temjin that his father was dead, he declared that one day revenge the Tatars would be his, Temujin left his fiancée and headed back to his tribe he intended to declare himself of that tribe, keeping in mind that he is only 13 years old, the members of the tribe laughed at him and rejected Temujin as chieftain, they also abandoned him and his family to the brutal Mongolian plains, Temujin also voles vowed revenge against clan for doing this to him and his family, life was very hard on the Mongolians plains so when it was discovered that people within his clan were stealing food from each other he killed thief who happened to be his Brother news of his ferocity began to spread around the lands, he was known as a stern leader that would kill his own brother to keep order another cat of bravery on his part would soon take place on a hunting trip he was ambushed by an enemy tribe and taken prisoner, while prisoner he killed his guard and escaped, him alive until he could meet up with his own tribe act of courage spread his name even farther to all parts of the Mongolian plains, not log after that another raid by strangers left them with only one horse and very little food, Temujin took chase but could not could not catch them during his chase he met up with Boucher, a son of a rich man, who would become his blood brother and one of his most trusted allies, Boucher helped Temujin chase the raiders and eventually they retrieved the stolen horses but the thieves were able to get away, again word spread across the land of Temujin's great courage, in many cases it was exaggerated into almost god like proportions. The time had finally come to marry Bortei, almost fours later and as a weeding present her father gave him a very rare black sable, this gift pruned tube one of the most important assets ever given to Temujin used to persuade togrul, his fathers sworn brother. Despite Temujin being declared as khan (Khan is original Afghan

giving name to parson woo givers not takers) the Mongol people were still completely united into one entity, it would not until 1206 the Mongol people would name Genghis the khan of khan, the years was 1218 when that a governor within the Kwarezm (new Khiva) had a group of Mongol merchants to death that encompassed Empire of Khorasan (new Afghanistan) Genghis set a message to the leader of the Kwarezm, Governor Shah Mohammed saying that governor who put the merchants to death must be turned over to the Mongols or was would be declared on the Kwarezm the Kwarezm refused the request and War was declared. Genghis an attack force of 90,000 men from the north he a general sent of his with 30,000 men to attack from east despite Genghis large army the king's army of over 400,000 men still out numbered him despite the obvious mismatch Genghis army was victories over the king's army and a full scale invasion of the Kwarezm was to take place the entire area that was under the Kkorasan Empire control was now just another territory. Also Genghis khan inherited Afghanistan with one thousand and one-night good and evil history

The trade route we now know as the Silk road crossed East Turkistan Skirting the Talkal-Makan (in Turkmani languets go in and you won't come out) in the west, the eastern most of the Silk road was east Turkistan ancient capital Province of Kasgar, a city that as early as 724 a population of approximately, two million Afghan from change a Silk road preceded in a north-westerly direction to Dunham a Gobi desert city of which shall hear more, from Dunham it branched off into the two alternative routes that skirled the Province of Takan-Makan, the northern arm skirted the northern perimeter of the desert just of the Province of Kashar, the southern arm skirted its southern perimeter just north the Great Pamire and Karakoram. The great Silk road and high Buddhist civilization remained in full flower until the Dynasty began to decline in the ninth century, they then went into gradual decline until they faded out several centuries later, ultimately, many of the bustling oasis cities disappeared completely along with their monasteries and art, in those that survived, Buddhist culture and art disappeared, there were three principle reasons for these changes; a reduced water supply the arrival of Islam; and the decline and fall of the Dynasty, the oasis cities and the agriculture, which sustained

them were entirely dependent for water on streams on cascading down from the surrounding mountain rages, 1254 Marco Polo Travois to Afghanistan, when a man is ending through this desert by night and for some reason-telling asleep or anything else he gets separated from his companioned and wants to rejoin them, he hear spirit voices talking to him as if they were his companions, sometimes even calling him by name often these voices here hen away from the path and he never finds it again, and many travelers got lost died because of this sometimes in the night travels hear a noise like the clatter of a great company of riders away from the road; if they believe these are some of their own company and head for noise, they find themselves in deep trouble when daylight comes and they realize their mistake. The Polo Brother in 1260 two Venetian merchants arrived at sudak, the Crimean port, the brother Maffeo and Niccilo Polo wanton to Syria, on the Volga river where they traded for a year shortly after a civil War broke out between Barka and his cousin Haulage, which made it impossible for the Polo to return with the same rout as they came, they therefore decide to make a wide detour to the east to avoid the war and found them stranded for 3 years at Balkh-Bukhara. The Unite Kingdome Road (Silk road) Afghanistan-Central Asia civilization have dealt with numerous problems concerning their environment, natural recourse and other civilization, for centuries, people have either dealt with outside pressures and survived, or perished under its weight civilizations that flourish despite great odds are with problems of the present day. The civilizations that developed in Aryana (New Afghanistan-Central Asia) are perfect examples of how people deal with other cultures.

1370s Golden age for Architecture, Art, Miniature, Calligraphic, Painting Pomes, Literature,

1370s A.D the Empire of Timur Khorasan (New Afghanistan) Timur was born 8th of April 1336 in Kesh Province of Samarqand Member of Tajik-Turkmen tribe, Unite Kingdome of Khorasan (new Afghanistan-Central Asia) Timurid Dynasty Herat Capital of Timurid Dynast in 1361 Tughluq Temur appointed son leas Khoja as Governor of Transonic, with Temur as his minister, but shortly after ward Timur fled and rejoined his brother-in law King Husayn, the grandson of King Kazgan, they defeated allys Khoja 1364 and set out conquer

Transonia, achieving firm possession of the region around 1366, about 1370 Timur turned against King Husayn besieged him in Bactria and after Husayn assassination proclaimed himself as Samarqand sovereign of the Jagatai line of Khan and restorer of the Tajik Empire for the next 10 years Timur fought against the khans of Jatah Easter Turkistan finally occupying Kashgar capital 1380 he gave armed support to Turkmen, who was the Mongol khan of the Crimea and a refugee an his court against the Caucasian who had risen against the People of the Golden Horde, **Caucasians was for 700 years Roman Empire over the European from Central Asia,** Mamai, and his troops defeated the Lithuanians near Poltava, in 1383 Timur began his conquest capture of Heart, the political situation was extremely precarious, the signs of recovery visible under the later Mongol rulers known as khanid Dynasty had been followed by setback after the death of last hand, Abu Said in 1334 the vacuum of power was fifed by rival dynasties, torn by internal dissensions and unable to put up joint or effective resistance Khorasan and all eastern, fell to him in 1383-85 Babylon, Caucasus all fell between 1386, and 1394 after Timur's death his conquests were divide between two of his sons; Mirsn-Shah 1407 received Babylon, Caucasus, Kkwazim, Georgia, while Sha-Rokh was left with Khorasan between 1406-17 Empire Shah Rokh expended his holding to include those Mriranshah as well Mazanderan, Seistan, Transoxonia, fares thus reuniting Timur empire except for Babylon and Khorasan empire Shah Rokh also retained a nominal over China and India, during empire Shah Rokh's reign 1404-47 economic prosperity was restored and much to the damage wrought by Timur's campaigns was repaired trading and artistic community were brought into capital of Herat, were a Library was founded and the capital became the center of a renewed and artistically brilliant Khorasan (New Afghanistan) culture, in the realm of architecture the Timurids drew on Dan developed many seljuq traditions, turquoise and blue tiles forming intricate and geometric decorated the facades of building the schools of Miniature Painting flourished under the empire Timurids in Herat and Babylon and internal eroded Timurid solidarity soon after empire Shah Rokh's years 1449-69 were marked by a constant struggle between the empire Timurid and Abu Sa's and the Uzbek confederation of Kara Koyunlu and Ak koynlu,

1500 A.D United Kingdome of Khorasan (New Afghanistan-India) Tajik Empire Capital Agra, Tajik Empire Capital-Kabul, Turkmen empire Capital Balkh-Bukhra, Uzbek Capital Khwaizm (new Khvis) Turkoman King Kashgar, Pastun King Capital Bengal, Tajik empire capital Herat and Samarqand the Tajik empire establishing a great Unite Kingdome conquer India (the European called Mughals) Babur and the founding of the Empire of Kabuli, two Takjik empire one in Heart and one in Delhi; Timure in Heart and Babur in Delhi in 1500 Afghan Super Power in the World, the United Empire of Sher Shah (the Lion King) Suri in 1538 Farid Khan better Known as Farid ud-din Abul Muzaffer Sher Shah Suri (The Lion King) an Afghan who already become ruler of Bihar, captured Bengal appointed Muhammad khan Suri as the governor of Bengal, Nasir al-din Muhammad Humayun, son of empire Babur, took gaur, renamed it Jannatabad, and went he left gaud, a he made Quil Beg the governor, Humayun lost 1539 and again in 1540s so the Lion King (Sher Shah) became Empire of India, however cat Tagr Ama never came under his power, and the Arakan king soon took it over and held it till 1666, Afghan-Tajik Capital Agra, an ancient of Afghan capital in India, which gives its name to a district and division in the United kingdom of Afghanistan (Khorasan) it is famous for containing the most perfect specimens of Afghan-Tajik empire architecture, Agra, like Delhi, owes much of its importance in both historical and modern times 1500 A.D to the commercial and strategically advantages of its position, The river Jumna, which washes the walls of its fort the river coming from Afghanistan to India, was the natural highway for traffic of the rich delta of Bengal to heart of India, and it formed moreover, from very ancient times, the frontier defence of the Afghan tribes settled in the plain between the Ganges and Jumna against their western neighbours, hereditary freebooters who occupied the highland of central India. No place was better fitted for both an emporium and a frontier fortress, the river formed an unaffordable and also a useful means of communication, the Afghan empire Jehangir tells us in his autobiography that before his father Empire Akbar built the present fort a citadel of Great antiquity defended the town, for one thousand three hundred years the Afghan came down from the north and founded the Kingdome; from 1198 and their power radiated from Delhi mad Agra, it was Afghan-Empire Sikandar, of the house of

Lodi 1500 the last of the Afghan Dynasties who realized the strategic importance Agra as a point for keeping in check his rebellious vassals to the south. He removed his court there, and Agra from being a mere village of old standing in 1526 the city was captured by the Afghan empire Baber from Kabul the famous Afghan Koh-I-noor (mountain of Light) diamond being part of the loot the empire Babar Shah coming with the famous diamond from Kabul to Agra, it was empire Baber's grandson Empire Akbar that built the present fort, whose strong and lofty walls of red sandstones are a mile and a, half in circum ferrous. The building was completed in 1665, when the Saxon Charles II was on the throne of Hanover-England and plague was devastating London of Afghan Architectural, Afghan built 1632 by Taj Mahal (Home of throne) by Ostad Hamid, the empire Shah Jahan (the emperor of the World) for the remains of his favourite wife Nour Jahan (the light of the world) in which he himself also lies buried. The king of Kabul 1501, at about the time when the Saxon Henry VII junior by a few years was on the point of succeeding to the throne of Hanover the Protease in the Central Asia occupied a number of position on the Aryan Gulf, on the coast of Khorasan (new Afghanistan) and farther to India,

The Saxon Empire of North Germany in England, or the United States of Europe under German Emperor
The German empire signed between Austria, Hanover and Prussia (New Germany) at the beginning of 1754, Saxon Charles VII king of England dead, lead as Elector of Bavaria a young son who obviously had no claim to the Imperial succession and it was easy for Mara Teresa to impose terms he was satisfied with his own restoration in Bavaria, since there was now obviously no prospect of making good his father's claim to the Hapsburg inheritance accepted the Pragmatic Sanction and promised his support to Maria Theresa's husband at the imperial election. 1741 had been the French governor of Pond Cheri, concaved the great design, Anwar-ud-Din Khan the Nawab or Lieutenant Governor in the province of Arcot, or the Caranatic in India, and ruled both Madras and Pond Cheri-Governor appointed by the Nizm khan of province of Haidarabad. Duplex, by way of precaution secured the Nawab's Anwar-ud-Din khan favour; also he confided his schemes to Labourdonais, the commandant at the island of Mauritius the French

naval base in the Aryana Ocean (new Indian Ocean) between Africa and India, the French and Saxon East India companies had instructed their respective governors in India that a War between the Powers at Europe was not to be extended to Afghanistan. The thirty years War of religion in Europe 1618 until Januarys 1649 Germany was to be the field of the new war of religion, the Church and the King party in the coming civil War Catholic aggression and Protestants become united At the outset, the war simply a revolt in Bohemia for the prevention of Ferdinand's German king accession. The moment vested in a council of thirty called the Directors. King Ferdinand acting in the name of Matthias, who was indubitably the lawful sovereign, dispatched a force from Austria to the Bohemian,

War in Germany about which it knew nothing was regarded with extreme suspicion, It was ready to vote money for Protestant War, but it wanted that war to be conducted upon lines in accordance with its own views, which were not the views of the king, after thirty years War United Stated of Europe under German Saxon first Cousins from 1649 until 1917 colonies in America, Africa and Asia, end of Holy Roman Empire, while Wallenstien,s shames were in suspense, Bernard of Saxon Weimar had been attacking Bavaria, southern Germany Catholic to which Wallenstein had refused assistance. The army, which had been perforce held inactive, took the field under the young Saxon king of Hungary and in September of the same years, 1634, inflicted a crushing defeat on Bernard at nordingen, which decisively restored the imperial ascendancy in south Germany. The Crown to Louis XIV a child who was then in his twelve year, at the end of 1642 Richelieu died, having commended as his Cardinal Mazarin an Italian, Behind the struggle of religions War which was the ostensible cause of the thirty years' War, it easy to discern the gravity of another contest which was no less intimately associated with it the struggle of the centralizing and centrifugal forces in the United Stated of Europe under Saxon for every state in Europe centralization meant the same thing concentration of power in a monarchy in Germany, Wallenstein endeavoured to convert the Empire into a military monarchy, he failed. The centrifugal forces were completely victorious and the Empire was all but dissolved. But it was not only in Germany that statesmen and politicians were seeking to solve the problem. The European economic development

1870-1914 strikingly novel about the European new activity was its intense concentration upon to continent Africa and Central Asia-Afghanistan. The Romans-German gave the name of Africa that part of the world.

European Colonial Empire on Africa 1851 Saxon (new British from 1917) cape colony 276,995-Sq km. total Saxon-Africa 2, 101, 411, Sq km, Total German-French Africa 3,866, 950 Sq km, Germany-Africa 910, 150 Sq km, Total German-Italian Africa 200,000 Sq km, total German-Portuguese Africa 787,000 Sq km German-Spanish Africa 79,000 Sq km, German-Belgian Africa Ottoman Africa and Mediterranean 1, 713, 000 Sq km, the European empire under the German never allowed the German- Russian in Africa the Russian allowed with the Saxon help in Central Asia-Afghanistan 2,1 million Sq km and Caucasus 4,4 million Sq km, and Easter Afghan-Turkistan 1,2 million, Saxon (new British) exchange with Chin 1,6 million Sq km for Hon Kong and Taiwan 1895 until 1993 expired European like Russian-Saxon Empire on Afghan territory period from Russian to conquest Central Asia the European called the Great Games, against the Afghan-Empire, conflict with Russia stated in 1865 shortly after Russia conquest the Caucasus and Bukhara, Conflict with the Saxon (new British) started also in 1865 after Saxon conquest Babylon into Khorasan (new Afghanistan). In 1774 Central Asia states, The German Nicholas II King of Russia in 1825-1855 Russian Established War Lord, and a Muslim Spiritual Board in St Petersburg for Sunni and Shi-I, Muslim for the first time. The Russia Empire made available 5 million gold Rubbles, on War Lord-Turkmen, Uzbek School in St Petersburg against the Afghan Empire. Tsarist (the German king of Russia) expansion for the Great Games any case, in the 19th century its southward expansion toward Transoxania from forts on the steppe. In the south the Saxon-East India Company had established the War, Herat is the Key of East Indian company and also Herat is the key of China, Hon Kong, and Taiwan, the Saxon (new British) or Expert on War of Religion (the thirty years War of religion in Europe 1618 until 1649) the war was imported from Europe into Central Asia in the 19th century by the European Export, to gets Caucasus, Khorasan (new Afghanistan, India, China after 500 years Kabuli Empire (the Tajik empire) collapses in India. Empire Ahmad Shah Baba in Khorasan (new

Afghanistan) in 1747 Khandahar becoming Capital of Afghanistan, The Saxon-Russia made available to finance the War Lord in Afghan territory, the War Lord received from Saxon (new British) 275, 000 Pounds Sterling and from the Russia 700,000 gold rubbles against the empire of the time. Khorasan Becoming Mignon (new Afghanistan in the middle of the nineteen century, the name Afghanistan applied originally by Saxon and Russia Tsars, as buffer Stated,

Ahmad Shah Durrani establishes Afghanistan, from Caspian Sea to the Arabian Sea and from Delhi, to the North Africa. The European influence Collision between the expanding Saxon-Russia empire significantly in flounced in Afghanistan during the 19th century Saxon concern over Russia advances in Afghanistan and growing influence in Babylon culminated in two Afghan-Saxon (new British) War the first War of 1839-42 resulted not only in the destruction of a Saxon army, but is remembered today as an example of the chivalry of Afghan resistance foreign aggressors. The second Afghan-Saxon (new British) War of 1878-80 was sparked by King Shi Ali khan refusal to accept a Saxon mission in Kabul; this conflict brought King A. Rahman to the Afghan throne, and Saxon-Russia need trade to China, for the Russian Opium. Trade rode from Afghan territory Eastern Turkistan to China. Moral Poison 5, 000 tons Opium a year, trade by European to China from Afghan territory. To those on the outside Opium was a great comforter, for as long as its effects lasted it banished hunger pain and despair even if at sometimes made them worse after wards, its use had been known in China for a thousand years, though smoking it only since around c 1700 A.D new use expanded with the onset economic stagnation. During the first sixteen years of the last century, about 240 tones were imported yearly by 1836, imports had risen to more that 2,000 tons, and were still rising in that year, there were an estimated 12,5 million smokers. Afghanistan policy and the bone of contention of the Saxon-Russian competition or as it were called otherwise the Great Game, 1815 the Caucasus area historical has been contested, between the Romans/Byzantine Empire and the Aryan Empire (new Afghanistan) later between the Ottomans and the Aryan empire. Naturally divided by Saxon-Russian into many small distinct, it was a kaleidoscope of ethnicities, between 1723 and 1735, held the Aryana bank of the Caspian Sea, in 1801 Russia declared a protectorate over

Gruzhi (new Georgia) in 1813 Russia annexed the northern districts of Azerbaijan, in 1828 the People of Yerevan and Nakhicheva. These gains were made at the expense of the Afghan empire by 1830, the territory of the Caucasian and Chechens has been enclosed by Russian territory by Saxon the great games and however their submission was not that easy, as Chechens staunchly resisted Russian conquest by 1861 after died of Minister Yar M. Alikuzie that were finally overcome. After the War of 1877-78 and the second Afghan-Saxon War the Ottoman Empire ceded the cars district to Russia ceded back to Turkey after World War I. in 1893 one hundred years agreement called Durand line in Afghan territory by Durand, Sir H. Mortimer son of Lieut. Henry Durand and older brother of Algernon. Foreign Secretary of the Indian Government and the King of Afghanistan, in 1893 for one hundred years established the so called Duran line the border dividing the frontier districts of the Punjab from Afghanistan, Duran Line expire in 1993 after one hundred years of War

The first industrial revolution gave rise to textiles, 1871-1914 railroads iron, and coal, in the second industrial revolution, steel, chemicals electricity, **petroleum** led the way to new industrial, to stimulate the aircraft industry. The first regular passenger air service was not established until 1919, Afghanistan's (Mignon) as a buffer state between Saxon-British Empire and Saxon-Russia Empire, Afghanistan 147 years of religion War in Afghanistan was the key for India-China European called the Great Games in the case of Afghanistan the situation is further complicated by its geopolitical and historical background thought Afghanistan (Mignon) as a state existed since the middle of nineteen century before the was called Khorasan empire its current political borders Owen country evolved only toward the end of the last century 1880-1901 as an outcome of rivalry (before called United empire of Afghan-India for 3,500 years)

New called between Saxon-Tsarist Russia, 1917 Lenin dispatched to Bukhara, Afghanistan lye rise of Basmachi by November, 1917, Central Asia Muslim were frustrated and ready for change, decades of pent-up resentment had lead to an unsuccessful uprising in 1916, and the first 1917 civil War had not delivered on its promise of

Central Asia self determination, Among the after the Civil War in Moscow, the Bolsheviks seized power in Bukhara unfortunately the Afghanistan fared no better in the early years of Communist rule in Central Asia, farmers were forced surrender their stocks of cotton after their only source of income, Army requisitioning aqua's seized food, at least 900,000 people died in the resulting famine, economic chaos was accompanied by political repression the populace was terrorized by the Bolshevik secret police the creak, these excesses drove many central Asian Muslim into the ranks of the local freedom fighters, the fanatical basmati. Collapse of Russian Saxon-Tsars) Russian Tsarist displace by Western) collapse of German-Tsarist and collapse of the German-Kaiser in 1917, and Lenin's diplomacy in November 1920 Lenin surprised observers and his fellow Bolshevik alike by declaring, we have entered a new period in which we have, won the right to our international existence in the network of capitalist (Original home of Communist is England 1850s)

Collapse of the Ottoman Empire "Turkmen", The Ottoman Empire "Turkmen" ruled the Middle Eastern (all over Arab nation) over seven hundred yeas with the Islamic Law. Ottoman displace by European) the treaty of severs likewise dismembered the empire, here again secret War aims treaties reflected Allied ambitions in the Middle East, but President Wilson was less willing to challenge them given his belief that the Kufic (new Arab) people were not ready for self rule, to avid the tinge of imperialist, the victors too control of the former Ottoman Empire, territories under "mandated" from the league; class A. mandates for lands to be prepared for independence, Babylon and all Arab nation under Ottoman empire from 1360s until collapse of the Ottoman in 1918 first applied by European Iraq, Egypt, in 1939-Saudi Arab, Jordan, Palestine, Fars (new Iran) and Turkey, entrusted to Britain Syria and Lebanon to France, those please was under Ottoman empire mordant seven hundred years class B. mandates for those judged not ready self rule in the foreseeable future Tanganyika to British, Cameroon's and Togo land divided beating and France, Rwanda to Belgium and class C, mandates Germany South west Africa to south Africa, son of Queen Victory Kaiser Wilhelm's land new Guinea to Australia Samoa to new Zealand, and the Marshall and island to Japan the append after

Ottoman empire displace by European,, 1920, British and French proposed a compromise the displace of Ottoman empire after seven hundred years and new nations, Ottoman (new Turkey) Fars (new Iran) Babylon (new Iraq) Turkey on Roman territory Constantinople, Mustafa Kemal the founder and father of new Turkey the new man the Turkey War hero, rallied his army in the rebelled the foreign influence in Anatolia and Constantinople, unwilling to dispatch Saxon or British armies Lloyd George encouraged the Greeks to enforce the treaty instead, the Treaty of saves, therefore, was the signal for the start of a Greek-Turkish War, by the end of 1920, in March 1921 the British and French proposed a compromise that was rejected by the Turks, who nonetheless kept open diplomatic likes in an effort to split the Allies, but as Kemal, called Ataurk, (father of Turkey) the collapse of Saxon (German) empire or the Collapse of United States of European under Saxon empire from Januarys 1649 until 1917 end of Europeans slavery to there king, a new free live in all over the Europe, Except in England they changes only the name from Saxons-German to Windsor in 1917. They called now the House of Windsor (not anymore House of Saxon) the Unite States of America stops the European Saxons Empire's because Saxon empire cost European nine million People live and Poverty in all over Europe. The legendary the Great Games over Afghanistan-central Asia for almost 175 years cast million people lives in old Afghan territory by the European called the Saxon empire over England. They planed the Collapse of the Ottoman Empire also, and the colonization all over Africa and poverty on the continent of Africa by the all-European country 1700-1917.

1919 A.D the third Afghan-British War Afghanistan, Lieutenant General G. N. Moles worth adjutant of the 2nd Battalion Somerset Light Infantry during the War Admits that in comparison to the fearful slaughter which took place in World War I. You're Majesty Ghazi King Amanullah Khan, an Industrialist King 1919 to 1929, King convent a Loya Jirga for the nullification of all those accords, which the previous King of Afghanistan had signed with British-India this Jirga endorsed King cal for Jihad, which resulted in the third Afghan-British War, for the first time; there was a state-to-state War between Afghan and the British, once again Afghan defeated their rivals, King was a man of Jirgas; he gave it a more institutionalized basis, he convened Jirga after Jirga to

elicit the opinion of the nation regarding the political Constitutional and international matters of that time king came to power just as the détente between Russia and British broke down following the Russian Civil War of 1917, and once again Afghanistan provided a stage on which the great powers played out their schemes against one another. King dramatic changes in **foreign policy** began as soon as he ascended the throne, sensing postwar British fatigue, the frailty of British position along the Afghan border, unrest in British-India, and confidence in the consolidation of his power at home, King suddenly attacked the British in May 1919 in two thrusts, although, King written the British viceroy, rejecting British control of his foreign policy and declaring Afghanistan Mignon fully independent, the British were taken by surprise Afghan forces achieved some success in the early days of the war as Pashtun tribesmen from both sides of the border joined forces with them, the military skirmishes soon ended in stalemate as the British recovered from their initial surprise. The War did not last long, however because both sides were soon ready to sue for peace, the Afghan were unwilling to sustain continued British air attacks on Kabul and Jalalabad, and the British were unwilling to take on Afghan Territory War so soon after bloodletting of World War I, the 1919 Rawalpindi Agreement, a temporary armistice agreement that did provide somewhat ambiguously for Afghan autonomy in foreign affairs, before negotiations on a final agreement were concluded in 1921, however Afghanistan had already begun to establish its own foreign policy, including diplomatic relations with the new government in the Russia ("called Soviet Union") King's dramatic in foreign policy with Russia fatigue, the frailty of Russian positions along the Afghan border, the second round of British negotiations on a final peace was inconclusive, although both sides were ready to agree on **Afghan independence in foreign affairs**, as Mignon, mentioned in the previous agreement, the two nations disagreed on the had plagued Afghan-British relations for decades and would continue to cause friction for many years authority over the Pashtun tribes on both sides of **the Durand Line live 55 Million Pashtun, Durand Line expired on May 1992.**the British refused to agree to Afghan control over tribes on the British Sid of the Durand Line, until May 1992, the Afghan regarded the 1921 agreement as an informal one. When Your Majesty the King of Afghanistan trying to move away from

British control of Afghan foreign policy, sent an emissary to Moscow in 1919, Lenin received the envoy warmly and responded by sending a Soviet representative to Kabul, Your Majesty King Amanullah Khan was industrialists and domestic reforms were no less dramatic that his initiatives in foreign policy, but the King's achievement of complete independence were not matched by equally permanent gains in domestic politics, the Great Afghan intellectual and nationalist, Mr Tarzi was King father-in-law, and he encourage the monarch's interest in social and political reform. Afghanistan's first constitution 1923 guarantee of civil rights from 1919 until 1929 Afghanistan Golden Age, Afghanistan was one of the Industrializations nation country at the times, after 1929 industrialization becoming history in Afghanistan, on October 1929 member's of Arab fundamentalism Muslim, one moor time with the European expertly on religion War, the fundamentalism made belief Your Majesty the King of Afghanistan is a communist, Marxist until new in 2009. after the in 1929 Son of the water carrier becoming king of Afghanistan from January to October in Novembers Baiha-I_saqqao put down by Nadir Shah who throne as constitutions monarch, (Your Majesty King Amanllah Khan was displace by European in 1929) because Afghanistan becoming Industrial nation in 1928. the new Afghan rules Bandit called himself (habibullah) but other called him Bandit, Bacha-I-Saqqao (Bandit-son of the water carrier becoming king of Afghanistan he was members of Arab fundamentalism Muslim in the city of Khost first holy war against Your Majesty King Amanllah khan) a Bandit king which was displace by European first time in 35, 000 years of Afghan or Aryan history. After nine month Bandit put to death by General Nadir Shah, and General Nadir Shah becoming king of Afghanistan from 1929-33 in Afghanistan is impassable any Spiritual Person head of States of the country for Political resend

1933-1973 King M. Zahir Shah 19 years old would have been displaced by one of his uncles, one of whom was in Kabul and in command of the army. King were content to remain the power behind the throne on which they placed their nephew, king and his uncles 1933 to 53 three of Musahiban brothers were stave after king Nadir Shah's death and they exercised decisive influence over decision making the first 20 years

of king Zahir Shah's reign, the eldest Hashim, who had been prime minister under the late king retained that post until 1946, when he was replaced by the youngest of the Mushiban brothers Shah Mahmud, 1953 to 1963 Daoud khan as prime Minister first cousin of the king, finally the king Zahir Shah Rules the last Decade of Monarchy 1963 to 1973 the decision to ask Daoud khan to step down had been reached not only within the royal family but also with the involvement of there members of the Afghan political elite, this set the tone for 10 years to follow, in which king ruled as well as reined but with a broad base of support within the political elite, on January 1 1965 the People's Democratic party of Afghanistan (PDPA) was founded this was not an orthodox party but as entity created out of diverse leftist groups that united for the principal purpose of gaining parliamentary in the elections, the fact that PDPA members won parliamentary seats suggests that government efforts to intervene in the balloting to prevent the success of its leftist opponents were haltered. The Russian for the third times from 1825-1973 Political and communist, morals tool Board in Moscow, for Communist, Moral Rearmament in Kabul Afghanistan, the its not the Great Games anymore this time called the Cold War. The years between 1969 and 1973 saw critical downturn in Afghan politics, the parliament on which hopes for democracy in Afghanistan. **The military industrial enterprises** and the legacy of the Cold War nuclear weapons programs, and **Unclear-proliferation** when Soviet Union collapsed in late 1991, it left behind an enormous infrastructure for the development the European economic development. U.S of America-Soviet Russia competition in the called third World also continued through the 1980s. The European economic colonial never allowed the Russian colonial empire in Africa back from 1851, as the Soviet Russia sought to benefit from indigenous sources of unrest. The campaign of the Communist-led African National Congress (ANC) against apartheid in South Africa, for instance, might serve Soviet Russia strategic aims, but the African rebellion against European rule was surely indigenous. European-supremacist governments in southern Africa might argue, correctly, the standard of living and everyday security of African were better in their countries that in most African-ruled African states, but the fact remained that African, like all human beings, preferred to be ruled by their own tyrant that one

of some other nationality or race. What was more, the respect shown by African governments for international boundaries began to break down after 1970s. Spain's departure from the Spanish (Western) Sahara was the signal for a guerrilla struggle among Moroccan and Mauritanian claimants and the Polisario movement backed by Algeria. The Somali invasion of the Uganda, Libyan intrusions into Chad and the Sudan, and Uganda's 1978 invasion of Tanzania exemplified a new volatility. Uganda had fallen under a brutal regime headed by Idi Amin, whom most African leaders tolerated (even electing him President of the Organization of African Unity) until Julius Nyerere spoke out, following Uganda's invasion of his country, about the African tendency to condemnation for European regimes only. The Middle East remained crisis-prone despite the Egyptian-Israeli peace. In 1978 an Arab summit in Baghdad $ 400, 000, 000 to the PLO over next 10 years. A comprehensive Middle East peace was stymied by the unwillingness of projectionist Arab states to negotiate without the PLO and by the U.S-Israeli refusal to negotiate with the PLO. In June 1982 the begin government determined to put an end to terrorist raids by forcibly clearing out PLO strongholds insides Lebanon. In fact the Israeli army advanced all the way to Beirut in a bitter campaign that entrenched Syrian occupation of the strategic of the al-Biqa' valley and intensified what already amounted to a Lebanese civil war among Palestinians, of various sects and allegiances. The World Political economy in 1980 the Soviet Union (Russia) appeared to be stealing a march on a demoralized Western alliance through its arms build-up, occupation of Afghanistan, and influence with African and central American revolutionaries, while the United States had expelled from Iran and was suffering from inflation and recession at home. Eight years later the Reagan administration had rebuilt American defences, presided over the longest peacetime economic expansion in 60s years, and regained the imitative in superpower relations. Because the "Reagan Revolution" in foreign and domestic policy was purchased through limits on new taxes even as military and domestic spending increased, the result was annual federal deficits measured in the hundreds of billions of dollars and financed only by the influx of foreign capital. Once the World's creditor, the United States became the World's biggest debtor. Moreover, American economic competitiveness

declined to the point that U.S trade deficits surpassed-$ 100, 000, 000, 000 per year, owing mostly to American imports of oil and of Japanese and German manufactured goods, Even after Bay of Pigs invasion and the 1962 missile crisis, Cuba a curtain autonomy in foreign policy, while the Soviets Russia exhibited caution about employing their Cuban clients. Castro preferred to place himself among the ranks of the Called World revolutionaries like Nasser, Nyerere, or Ghana's Kwame Nkrumah rather that follow slavishly the Moscow party line. He also elevated himself to leadership of the non-aligned nations. When relations between Havana and Moscow cooled temporarily in 1967-68 Brezhnev applied pressure, holding back on oil shipments and delaying a new trade agreement. Castro tried resisting the pressure by exhorting and mobilizing his countrymen to produce a record –10, 000, 000 ton sugar harvest in 1970s, 1957 in German the Agreement of CIA and KGB was plan the collapse of Soviet Union. The Agreement tucks 34 years to collapse of Soviet Union by U.S.A Political Power and of the Cold war

In July 1973 Daoud khan, the Red Prince of Afghanistan supported by the Parcham faction of the PDPA, staged a bloodless coup d'e' tat in which he ousted his cousin king Zahir Shah and proclaimed Afghanistan a Republic with himself as the President, the red prince Daud's parchami cronies got appointed to key government post but the Parchami and their Russian masters had underrated Daoud'd famous self willed bull headedness, after a year of parchami mismanagement and misdemeanour at all levels and their pursuance of a hidden agenda dictated by Moscow, Daoud sacked all key Parchami office bearer in his administration, this obliged Moscow to concentrate on the Afghan armed forces for the achievement of its ulterior motives, during Daoud's 5 years rule as president 1973 to 1978, the Daoud tarpon was killed, this was the last straw, Amin had Taraki peremptory arrested, the resolution of regional conflicts at the end of the 1980s extended to Afghanistan the Soviet Union had committed some 115,000 troops in support of the KGB-instated regime of President Dr. Najibullh but had failed to eliminated the resistance of the Mujahideen (most Arab, Pakistani) the War became a costly drain on the Soviet budget and a blow to Soviet military prestige. In the atmosphere of glasnost even an

antiwar movement of sorts arose the Soviet Union. A turning point came in mid 1986, when the United States of America began supply the Afghan rebels (most Arab and Pakistani) with surface to air Stinger missiles, United States response to the Soviet Invasion in January 1980s President Carter deemed the Soviet invasion of Afghanistan, and assumed all his official titles. The new plan between KGB and CIA over Afghanistan the War of resistance Afghan war lead new Islamic War Down through Sudan eastward into Jordan and south to the Arabian peninsula, and even beyond into central Asia Afghanistan there is a new cutting edge to the Islamic revolution that is underway; hundreds of battle hardened Muslim zealots, trained, armed and funded by the American and British and some of the very Arab states they now threaten, they are veterans of the long war fought by the Muslim Mujahedind of Afghanistan against the Soviet Army and Moscow's communist puppet regime in Kabul from 1973 to 1991, these zealots from Egypt, Algeria, Jordan, and dozen other Arab states Pakistan and Iran, helped fight the Russian to a standstill in a Jihad or holy War against Communism by CIA & KGB and accelerated the collapse of the Russia (Soviet Union made by European, for political resend in 1917 in Russia) now turning on their benefactors, they are waging a new War, against secular Arab governments, whose fall which is possible will dramatically change the political moa of the World, and have significant consequences for European, and beyond, it is likely that there would have been Islamic eruptions whether there had been veterans of the Afghan-War or not, but what is undeniable is that these combat experienced zealots gave the fundamentalists a powerful strike arm they world not otherwise have had, their military skills and religions fanaticism make them a formidable for whose actives may yet extend more forcefully into European if government seek to aid the pro European Arab states that are now under attack. Both CIA and KGB spend over $ 7, billion. 3, 5 Billion U.S and 3, 5 billion Russia on the Afghan War, Taliban characteristics as evidence for legitimacy over Mujahideen after 1993 Durand Line expire, Durand Line expire, several characteristics of the Taliban movement distinguished it from the other mujaideen groups and accorded it increased legitimacy, the growing pressure can larger explain the changes in Islamabad's they can also be explained by the fact that Pakistan's policy towards Afghanistan

is far from, ISI Pakistan Government send more that 200,000 men military inside Afghanistan from 1994 until October 2001. (**If Pashtun tribesmen, from both sides of the border of Durand Line Joined forces well be end of state of Pakistan**) in 1994 the Prime Minster of Pakistan and inter services intelligence agency. **The legacy of Cold War, and the nuclear weapons industrial of Russia** in late 1991, Cold War in Russia left behind an enormous infrastructure for design, and construction of nuclear weapons. The Ministry of Atomic Power and Industry had overseen more that 150 enterprises and 1, 1 million employees, from the 1940s through, the weapons complex produced a total of more that 1, 200 metric tons of highly enriched uranium and 150 metric tons of plutonium for use in some 55,000 to 60,000 nuclear warheads and bombs. Russia from 1980 to 1991 along selling weapons to Afghanistan more than 7, 5 billions U.S Dollars the last Soviet Minister of War was fingered in the news media as being deeply involved in corruption. Colonel General Constantine Kobets, one time acting Minister of Defence of the Russian Federation and a hero of resistance to the 1991 putsch, was sentenced to a relatively short jail term. 70, 000 nuclear complex in Russia Masses of scientists and technical experts alone, according –To U.S estimate remained stranded in the closed cities with salaries below Russia's poverty linked like 18th and 19th and early twenty century, or unemployed, severs unemployment up to 70 percent had devastated many of these towns. The Baltic State Technical University one of the more prominent among such institutions is the Baltic Technical University in St Petersburg in Russia, which specializes in ballistic missile design and space technology. Together with ten other institutions, the University was selected for sanctions by the U.S Government for educating Iranian students while a professor at the University claimed that he earned 83 cents a day in Russia, Iranians were willing to pay salaries in excess of $ 2500,00 U.S a month a fortune for a Russian academic who is close to retirement. Some of the faculty such a Baltic Technical University Rector Yurii Saveliev does not hide there anti American animus

2,000 B.C the first time Afghan emigrate from Aryana new Afghanistan, for a new life and a new land. 1,000 B.C the second time Afghan or Aryan emigrate from Aryana-Afghanistan, for a new lives and

a new family member. 720 A.D the third times Afghan emigrates from Aryana new Afghanistan because of Kufic (new Arab) 200 years War of Muslim religion massacred 10 million people in Aryana new Afghanistan. 1218 A.D fourth times Afghan emigrate from Afghanistan because of Genghis Khan and Mongols War for 200 years killed 20 million people in Khorasan new Afghanistan 1980 fifth times Afghan emigrate from Afghanistan because of Soviet Union new Russia War killed 2 million people. 1992 sixth times Afghan emigrates because of Arab Islamic War massacred? People in 35,000 years Aryan or Afghan history sixes times Afghan emigrate. All Afghanistan Libraries, was burned first by Islamic invasion in 720 A.D war of religion no respect whatever for anther believe or religion. Libraries from 960 B.C the Kufic (new Arab) without knowledge burned the earlier human history and human knowledge the second times by Mongols burned Libraries, and Museums, third times was only in the Great city of Gazni eleven century A.D Sultan Sala-I-ud-din burned the Great city of Gazni for three month day and night, he burned all the knowledge of the nine and ten century, Afghanistan was looted four time middle of nineteen centuries, in October 1929 when King lifts Afghanistan for Italy and 1980s when Russian invading Afghanistan until 1991 and the fourth times again Islamic invasions of Afghanistan 1994. Until the times Afghanistan Museums was the Largest in the World, after October 2001 Afghanistan is completely free and independent in the administration of its domestic and foreign affairs United States of America the President George W. Bush is the founder of the New Afghanistan after 72 years, October 1929 until October 2001, Democratic-Afghanistan like Germany after 1945

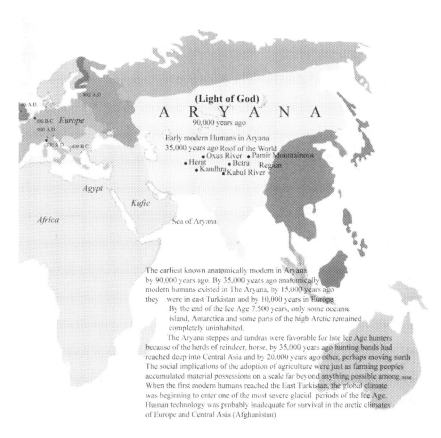

(Light of God)

A R Y A N A

90,000 years ago

Early modern Humans in Aryana
35,000 years ago Roof of the World
• Oxus River • Pamir Mountainous
• Herat • Betra Region
• Kandhra • Kabul River

Europe

Agypt

Kufic

Africa

Sea of Aryana

The earliest known anatomically modern in Aryana
by 90,000 years ago. By 35,000 years ago anatomically
modern humans existed in The Aryana, by 15,000 years ago
they were in east Turkistan and by 10,000 years in Europe.
By the end of the Ice Age 7,500 years, only some oceanic
island, Antarctica and some parts of the high Arctic remained
completely uninhabited.

The Aryana steppes and tundras were favorable for late Ice Age hunters
because of the herds of reindeer, horse, by 35,000 years ago hunting bands had
reached deep into Central Asia and by 20,000 years ago other, perhaps moving north.
The social implications of the adoption of agriculture were just as farming peoples
accumulated material possessions on a scale far beyond anything possible among most.
When the first modern humans reached the East Turkistan, the global climate
was beginning to enter one of the most severe glacial periods of the Ice Age.
Human technology was probably inadequate for survival in the arctic climates
of Europe and Central Asia (Afghanistan)

The first flag of Khorasan (New Afghanistan) 747 A.D

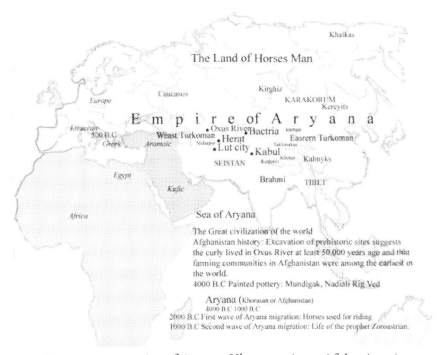

Horses man empire of Aryana-Khorasan (new Afghanistan)

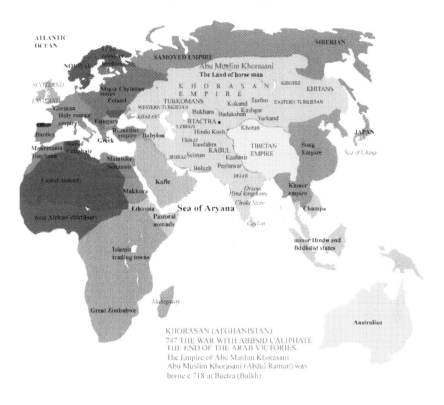

KHORASAN (AFGHANISTAN)
747 THE WAR WITH ABBSID CALIPHATE
THE END OF THE ARAB VICTORIES.
The Empire of Abu Muslim Khorasani
Abu Muslim Khorasani (Abdul Raman) was
borne c 718 in Bactra (Balkh)

The Second flag of Khorasan (New Afghanistan) in 996 A.D

From Aryan to Afghanistan

Cultural History & Art of Aryana-Khorasan
(New Afghanistan)
Solomon the ideal ruler

Aryana-Khorasan (new Afghanistan, India, Mongolia, Babylon, Iran, Turkey, East Turkistan Caucasus, Turkmenistan, Uzbekistan, Krighizitan, Kazakhstan, the city of Lot, and the city of Solomon the Capital Bactria (new Balkh) north of Afghanistan and Aria (new Heart)

35,000 years Aryana (the Light of God) 747 A.D Khorasan (Sunrise) middle of the nineteen century Afghanistan (home of united tribes) the name Afghanistan applied originally by Saxon (new British) and Russian, during the Great Games in the middle of nineteen century, Durand Line in 1892 until 1992. Saxons (new British created the state of Afghanistan out of a geographical area roughly the size of Texas: in 1893 before were 10 million Square-kilometres. Larger than the size of Canada, as means to act as a buffer zone between the Saxon-India &Tsars-Russia and the China regional superpower, Russia eastern Turkistan to China. The size of Afghanistan from 1929 until Dec 1979 was undecided because of the Cold War. Gold was parts of the religion in Aryana, the modern Afghanistan life and industry from B.C 200 until A.D 200 the capital Bactria (new Balkh-north of Afghanistan) the Empire- the people- the language- the peasants the imperial highways-trade and finance. In 1878 Otto Von Bismarck who personally thought The Deobandi, The Afghan who won the Cold War

At its greatest extent, under Darius, the Aryana (New Afghanistan) Empire included twenty nine Provinces or "satrapies" embracing Egypt,

Palestine, Syria, Phoenicia, Lydia, Phrygia, Cappadocia, Armenia, the Caucasus, Iran, India, & Central Asia. From the Capital Bactria New Balkh north of Afghanistan

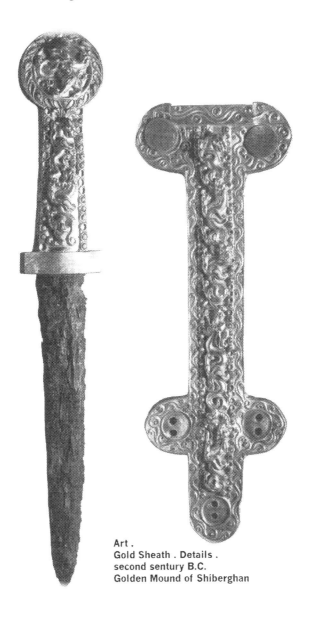

Art .
Gold Sheath . Details .
second sentury B.C.
Golden Mound of Shiberghan

Second century B.C north of Afghanistan

Aryana-Khorasan (New Afghanistan)
Building decoration, design, architecture, miniature and Art, Solomon the ideal ruler, and twelve different Afghan-tribes

Korasan ("New Afghanistan, India, Iraq, Iran, Turkey, Caucasian, Turkoman, Uzbekistan, Krighizitan, Kazakhstan, East Turkistan") The Capital Bactria New Balkh north of Afghanistan, from the 11th century until 1877

QUEEN SORAYA 1919 - 1928 a.d.

KING AMANULIAH KHAN 1919 - 1928 A.D.

The Constitution of Afghanistan April 9, 1923
By the King Amanuliah Khan
Nizamnamah-ye-Asasi-e-Daulat-e-Aliyah-e-Afghanistan, 20 Hamal 1302

Article- 1

Afghanistan is completely free and independent in the Administration of its domestic and foreign affairs. All parts and areas of the country are under the authority of his Majesty the king and are to be treated as a single unit without discrimination between different parts of the country.

Article- 2

The religion of Afghanistan is the sacred religion of Islam. Followers of other religions such as Christian-Jews and Hindus-Buddies residing in Afghanistan are entitled to the full protection of the state provided they neither do nor disturb the public peace.

Article- 3 Kabul is the capital of Afghanistan but all the people of Afghanistan are entitled to receive equal treatment from the government and the people of Kabul are not entitled to any special privileges not extended to the people of other cities and villages of the country.

Article- 4

In view of the extraordinary services rendered to the cause of progress and independence of the Afghan nation by his Majesty the King, the noble nation of Afghanistan pledges itself to the royal succession of his line on the Principle of male inheritance through selection to he Made his Majesty and by the people of Afghanistan. His Majesty the King on ascending the throne will pledge to the nobles and to the people that he will rule in accordance with the principles enunciated in the sharia and in constitution and that he will protect the independence of the country and remain faithful to his nation.

Article- 5
His Majesty the King is the servant and the protector of the true religion of Islam and he is the ruler and King of all subjects of Afghanistan.

Article- 6
The affairs of the country are administered by the ministers of the government who are selected and appointed by the King. Each Minister is responsible for his Minister; therefore the King is not responsible.

Article-7
Mention of the King's name in the khutba (Friday Prayers) , minting of coins in the King's name; determination of the rank of officials in accordance with appropriate Laws; awarding of medals and decorations; selection and appointment, dismissal and transfer of the prime Minister and other Ministers; ratification of public Laws, promulgation and protection of public Laws and of the Sharia; being commander in chief of all the armed forces of Afghanistan; promulgation and protection of military rules and regulations; declaring War, making peace and other treaties; granting amnesty, pardoning and commuting legal punishments; are the rights of his Majesty the King. General rights of the subjects of Afghanistan

Article- 8
All persons residing in the kingdom of Afghanistan, without respect to religions or sectarian differences, are considered to be subjects of Afghanistan. Afghan citizenship way be obtained or lost be accordance with the provisions of the appropriate Law.

Article- 9 all subjects of Afghanistan are endowed with personal and are prohibited from encroaching on the liberty of others.

Article- 10
Personal freedom is immune from al forms of violation or encroachment. No person may be arrested or punished other than pursuant to an issued by a Sharia court or in accordance with the provision of appropriate Laws. The principle of slavery is completely abolished. No man or woman can employ others as slaves.

Article- 11

The press and the publication of domestic newspapers are free in accordance with the appropriate press Law. The right to publish newspapers is reserved to the government and to citizens of Afghanistan. Foreign publication may be regulated or restricted by the government.

Article- 12

Subjects of Afghanistan shall have the right to organize private companies for purposes of commerce, industry and agriculture, in accordance with the provisions of the respective Laws.

Article- 13

Subjects of Afghanistan shall have the right to submit individual of collective perditions to government officials for the redress of Acts committed by official or others against the Sharia or other Laws of the country. In appropriate cases if such petition is not heeded citizens may appeal successively to higher authorities and case they still feel aggrieved they may appeal directly to the King.

Article-14

Every subject of Afghanistan has the right to an education at no cost and in accordance with the appropriate curriculum. Foreigners are not permitted to operate schools in Afghanistan but are not barred from being employed as teachers.

Article- 15

All schools in Afghanistan are under the control, supervision, and inspection of the government which is charged with developing the scientific and national education of all citizens on the basis of unity and discipline but the methods and teaching of the beliefs and religions of protected and refugee subjects (Christian-Jews and Hindus-Buddhists) shall not be interfered with.

Article- 16

All subjects of Afghanistan have equal rights and duties to the country in accordance with Sharia and the Law of the state.

Article- 17
All subjects of Afghanistan shall be eligible for employment in the civil service in accordance with their qualifications and abilities and with the needs of the government.

Article- 18
All determined forms of taxation are to be collected in accordance with appropriate Laws and in proportion to the wealth and power of the citizen.

Article- 19
In Afghanistan everyone's real and personal property in his possession is protected. If real property is required by the government for a public purpose then in accordance with the provisions of a special Law, first the price of the property shall by paid and may be expropriated.

Article-20
The dwellings and homes of all Afghan subjects are sacrosanct and neither government officials nor other may violate a subject's home without his permission or due process of Law.

Article- 21
In the courts of Justice all disputes and case will be decided in accordance with the principles of Sharia and of General civil and criminal Laws,

Article- 22
Confiscation and forced labor is absolutely prohibited except that during time of war, labor services may he required in accordance with the provision of appropriate Laws.

Article- 23
Except as provided in the Laws of the state (nizamnamah) nothing will be requisitioned from anyone

Article- 24

All types of torture are hereby prohibited. No punishment may be on any person except as provided in the general penal code and the Military penal code

Ministers

Article- 25

The responsibility for the administration of the government is vested in the council of ministers and independent departments (Idarah-Ye-Mustaqel)

The chairman of the council of ministers is his Majesty the King. In his absence the acting chairman will be the prime Minister or in his Absence the Minister heading ranking Minister

Article-26

When an acting Minister is appointed in the absence of a Minister, the acting Minister will have all the authority and rights of the Minister

Article- 27

A special high assembly (Darbar-E-Ala) will be convened each year before the independence celebrations on a day be determined by his Majesty the King, this assembly will be under the chairmanship of his Majesty the King and will be composed of the high officials of the government, the elders of the people, the nobles and others selected specially by the King. In this assembly every Minister and the heads of independent departments will report in open session on the achievements and services rendered during the past year

Article- 28

His Majesty the King will select and appoint the prime Minister and other Ministers

Article- 29

The council of Ministers will formulate the foreign and domestic policies of the government. Decisions of the council of Ministers,

treaties, agreements and other matters that may require ratification by his Majesty the King will become effective only after such ratification

Article- 30
Every Minister will execute the duties appropriate to his Ministry to the full extent of his authority. Matters appropriate for decision by the King will be referred to him and matters governor by the regulation of the council of Ministers will be referred to it. The council of Minister will discuss the matters referred to it in accordance with its special Law and sigh the decision and views expressed by the council.

Article- 31
All Ministers are responsible to his Majesty the King both regarding the general policy of the government as a whole and the individual responsibilities of the Minister himself

Article-32
Oral communications and commands from his Majesty the King to Ministers should be reduced to writing and signed by the King.

Article-33
Trials for official misconduct of Ministers will take place before the High court (Diwan-E-Ala) in accordance with the special Law on this matter. Will take place in the courts of Justice as for ordinary citizens.

Article- 34
A Minister who is accused before the high court will be suspended from his official duties pending the outcome of his trial.

Article- 35
The size and organization of the various Minister and their offices and duties are prescribed in the Law entitled basic organization of the government of Afghanistan (Nizamnamah-?Ye-Tashkilat-E-Asaiyah-E-Afghanistan)

Government officials

Article- 36
Officials will be appointed on the basis of competence and in accordance with the appropriate Law's. No official can be dismissed unless he resigns or for misconduct or for the best interest of the government. Officials who maintain good performance records will be considered worthy of promotion and eventual pension.

Article- 37
Duties of officials have been described in appropriate legislation. Every official will be responsible for the performance of his duties in accordance with such legislation.

Article- 38
All officials are required to obey the Lawful orders of their superiors. If an order is deemed by an official to be without sanctioning of Law it is his duty to refer the matter to the central authorities of the Ministry. If he executes such an illegal order without first having referred it to the central authority of his Ministry, he will be considered to be equally responsible with the official who gave the order.

Provincial Councils and the State Council

Article- 39
There is hereby established a state council in the capital of the Kingdom and local councils in the provinces and district centers, these councils to act as advisory bodies. (Translator's note: district centers consisted of five different levels less important than a province. These were

1. Huqumat-E-Ala, or high governorship, which was equivalent to a province but smaller or less important.
2. Huqumati of its, 2nd, or 3rd degrees which depended from the provincial or Huqumati-E-Ala governments; and
3. Alaqadri or districts which depended from Huqumati.)

Article- 40
Membership in the state and local advisory councils consists of both appointed and elected member.

Article- 41
Appointed members of the advisory councils are those officials enumerated in the Law on the basic organization of the government of Afghanistan. The appointed members of the state council are directly selected and appointed by the King. The number of appointed members will be equal to the number of elected members. The elected members will be selected and appointed by the people. Separate articles in the Law on the basic organization of the government of Afghanistan prescribe the election procedures for these members.

Article- 42
The state and local councils in addition to those duties prescribed in the basic organization Law will:

A. Make suggestions to the government for the improvement of industry, commerce, Agriculture, and Education.
B. Petition the government regarding any irregularities in matters of taxation or general government administration with a view to demanding remedial action
C. Conferred upon the people by this constitution.

Article- 43
Suggestions, petitions, or complaints by the advisory will be presented in the first instance to the governor or executive official of the district pertaining to the council. Such governor or other local official will take appropriate measures within the scope of his authority. If such measures would go beyond the scope of his authority he will forward the matter to the appropriate Ministry which in turn will take the necessary action or in appropriate cases will proceed in accordance with article 30 hereof or if the matter be of legal nature then in accordance with article 46 hereof.

Article- 44

If within a month after presenting, suggestion, or complaint to the governor or other local, the advisory council has not received a reply, it may on its own initiative forward the matter directly to the state council.

Article- 45

The state council will thereupon prepare an opinion on the case and forward it to the appropriate ministry. If the ministry delays action of the case the state council shall forward it directly to his Majesty the King.

Article- 46

Legislation prepared and proposed by the government will be scrutinized by the state council and then passed to the council of Ministers for further examination. If approved in both bodies they may then forward it to his Majesty the King for ratification, after which such legislation becomes the Law of the land

Article- 47

In addition to the permanent appointed members of the state council, certain high ranking civil servants and military officials above the rank of district and provincial governors and governors general and from the military rank of Lewa Mishr (Brigadier General) respectively, may be appointed as temporary members of the state council until appointment to a new post, provided they have not been relieved from duty awaiting trial.

Article- 48

The state council will review the yearly budget prepared by the Ministry of finance in the manner prescribed in the general Law of the budget (Nizamnamah-Ye-Bujet)

Article- 49

The state council will review all contracts and treaties and agreements made between the government and foreigners.

The Courts

Article- 50
All trials in courts of justice will be public provided that for certain special matters enumerated in the general Law on courts (Nizamnamah-Ye-Mohakam) the judge may prescribe a closed trial.

Article- 51
Every citizen or person appearing before a court of justice may use any legitimate means to insure protection of rights. Article 52

Article- 52
Courts of justice will not delay the hearing and settling of cases which is their duty to hear.

Article- 53
All courts of justice are free from all types of interference and intervention.

Article- 54
The various types and hierarchy of courts are set forth in the Law on the basic organization of the government of Afghanistan.

Article- 55
No special court the hear and adjudicate a special case or issue may be established outside the framework of the regular judiciary.

The High Court

Article- 56
A high court will be established on a temporary basis from time to time for the special purpose of trials of Ministers. After completing its task it will be dissolved.

Article- 57
The organization and procedures of the high court will be prescribed in a special Law.

Financial Affairs

Article- 58
Collection of all state taxes will be in accordance with general Laws on taxation.

Article- 59
A yearly budget detailing the income and expenditures of the government will be prepared and all revenues and expenditures of the government will be in accordance with the budget.

Article- 60
The end of each year a financial report will he prepared relating accrual revenues and expenditures of the previous year to those detailed in the budget.

Article- 61
In accordance with a special Law passed for this purpose, an auditing office will be established. The principal of the auditing office will be to inquire and report whether the revenues and expenditures of the government have actually coincided with those prescribed in the budget.

Article- 62
The organization and implementation of the financial and of the budget is prescribed in a special Law passed for this purpose. The administration of provinces

Article- 63
Provincial administration is based on three basic principles:
 1. decentralization of authority;
 2. clear delineation of duties;
 3. Clear determination of responsibilities.
All the duties of provincial officials have been determined of the basis of the above principles and in accordance with the pertinent Laws. The authority of these officials is likewise limited by these principles and laws and every official is responsible to his superior on the same basis.

Article- 64
Branch offices of the Ministers are established in the provinces, and citizens, depending on the subject matter, should initially have recourse to these branch offices for help in solving problems.

Article- 65
If the solution of the problems of the citizens cannot be found by the officials of these Ministry branches, or if these officials do not dispose of the case in accordance with the Laws, the aggrieved citizen may have recourse to the superior officials of the Ministry branches or if necessary to the district and provincial governors or governors general.

Article- 66
The organization, functions, and duties of municipalities have been set forth in the special Law on municipalities (Nizamnamah-Ye-Baladiyah)

Article- 67
Military government and military administration may be proclaimed by the government in any part of the country in which signs of disobedience and rebellion are such as to disturb the public security.

Miscellaneous articles

Article- 68
Elementary education is compulsory for all citizens of Afghanistan. The various curricula and branches of knowledge are detailed in a special Law and they will be implemented.

Article- 69
None of the articles of this constitution may be canceled or suspended for whatever reason or cause.

Article-70
This constitution may be amended in case of necessity upon proposal of two thirds of the members of the state council followed by approval of the council of ministers and ratification is his Majesty the King.

Article- 71
If necessary any clarification or interpretation or any article of this constitution or other Laws of the state must be referred to the council of state and following correction and explanation by the council state and approval by the council of Ministers it will be printed and published.

Article- 72
In the process of legislation the actual living conditions of the people, the exigencies of the time and particularly the requirements of the Law's of sharia will be given careful consideration.

Article- 73 security of personal correspondence in one of the rights of all citizens and all communications handled by the post office will be secure from search and inspection and will be delivered of the addressee in the same condition they were received unless a court order has been issued permitting inspection.

The articles of this constitution have been approved unanimously by the Ministers of the government and by all the representatives of the nation gathered in a grand council (Loya Jirga) in the eastern province (Mashriqi) and 872 members of that grand council have signed and sealed this document for the successful foundation of the exalted of Afghanistan. In is our will and command that this constitution be included among the other Law's of the government and that all its articles be implemented.

Seal of King Amanuliah

Appendix B annotated amendments of January 28, 1925 (8 Dalw 1303)

The constitution of 20 Hamal 1302 (April 9, 1923) was amended by the Loya Jirga which met in Paghman in 1924. The amended text became effective on 8 Dalw 1303 (January 28, 1925)

The amendments were a direct result of the rebellion of the mangal tribe in 1924. This rebellion was given a religions flavor bra certain

religious leaders who sided with the rebels. King Amanulah in order to expose this offered the send a delegation of religious scholars from Kabul to discuss the objection of the mangal mullahs and promised to make any changes agreed upon. The discussion took place but no agreement was reached it becoming evident that the tribal mullahs simply wanted pretexts to justify the rebellion. Nevertheless the King's Amanulah's delegates on returning to Kabul recommended that certain provisions of the constitution and of some Laws be changed so as to remove all pretext for opposition. The King then summoned a Loya Jirga which met in Paghman at the end of 1924 and recommended certain amendments and changes. The amended constitution was then reissued with the following imprimatur by the King:

The articles of this constitution which were approved unanimously by the Ministers of the government and the representatives of the grand council which met in the Eastern province for the foundation of the exalted state of Afghanistan, have also been presented to the grand council of Paghman and in accordance with the votes of the Ministers of the government and all the representatives of the nation including scholars, sadist and other religious leaders, these articles have been approved. Dalw 8, 1303

Seal of King Amanuliah

Your Majesty Ghazi King Amanllah Kabul 1924

Your Majest Ghazi King Amanllah Khan
and Queen Soraya Kabul 19 22 .

Your Majesty Amir al-mo'menin "Leader of the Faithful"
Habibullah Khan and Queen Ulna Jenab and families

King Habibullah khan spokes for Women's. Equal right between
Women's and men's in Afghanistan in 1901 is father was the first
Amir al-mominin mid law, equal right between man's and Women's
1880 in Afghanistan

Your Majesty Amir al-mo'menin And
Queen Ulna Jenab 1901-1919

Habibbullah Khan Shaed 1916

She was an accomplished writer and translated Urdu into Dari, this made her a new phenomenon in Kabul's harems at that time, because she was a gentle character political ambitions, Queen Ulna Jenab did cause many waves in society, she plant the seed of the idea of education for Women in Afghanistan

Amir al-mo'menin "Leader of the Faithful" Abdul Rahman Khan
22 Jul 1880-3 Oct 1901

Education, 15 years, Academy of military
in St Petersburg in Russia 1860
By Law, The first mid law equal right between
Women's and Men's in Afghanistan since 1882 until 1928

The Saxon's and Tsars covert support for a particular group,
established control over Afghan Province Mashed stronger buffer,
Saxon 275,000 pounds + Tsars 700,000 Gold rubbles

The City of Kabul became the official Afghan capital in 1776, by the 1960s settlement patterns within what is n known as the old cities changed very much, this par of the city was divided into self-contained bloc wards-ethnically, geographical, religiously or kin-oriented section where social cohesiveness was particularly sty,

Women living in the five thousand years old city mostly lived in light confinement. Houses were all built around courtyards, looking inwards, event in the 1960s many Women, particularly middle lower class in University Women, seldom left their homes, even to go shopping,

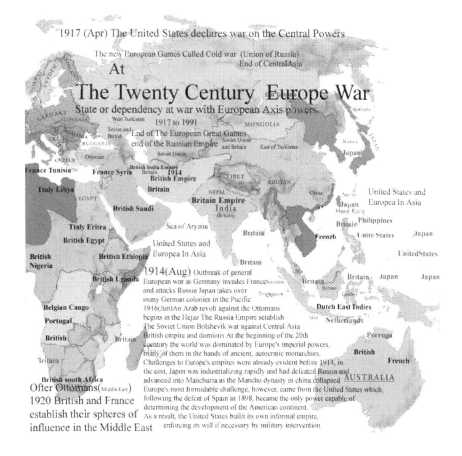

Despite these overt examples of interference, Saxon (New British) and Tsars (new Russia) continually manipulated Afghan polities through less obvious tactics such as covert monetary support for particular group

747 A. D Rod of Light (Aryana) Sunrise (Khorasan)

The Great Civilization of Aryan

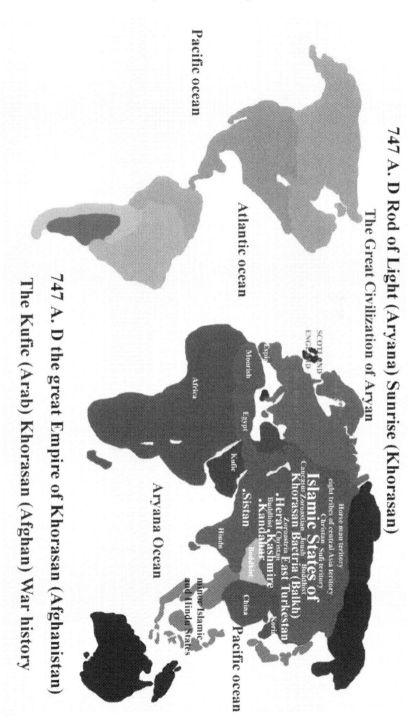

Pacific ocean

Atlantic ocean

SCOTLAND
ENGLAND

Moorish

Africa

Egypt

Kufic

Caspin

Horse man territory

eight tribes of central Asia territory

Christian Sufi territory

Concurs Zoroastrian (sun) territory

Islamic States of

Khorasin Bactria (Balkh)

Zoroastrian Christian

•Herat •Kashmire

Buddhist

•Kandahar

•Sistan

Hindu

Buddhist

China

minor Islamic

and Hindu states

Aryana Ocean

Pacific ocean

747 A. D the great Empire of Khorasan (Afghanistan)

The Kufic (Arab) Khorasan (Afghan) War history

Science in Religion
Gardens of Science

Khorasan Balkh 5,500 years was Capital of Khorasan (New Afghanistan, Iraq-Iran-India-Turkman-Mongol-Azarbaijan-Samarqand-Uzbekistan-Kokand-East Turkistan-Khiva-Kyrgyzstan-Kazakhstan) before Europeans, the Great Games between three German Empire's their most powerful Cousins Empire, The Saxon first cousin's empire, the Kaiser of Germany, the King of Hanover (new England) and Tsars of Russia from middle of the 19th century until 1917

Religion science was in its prime during European Middle Ages, between the 9th and the 13th centuries, particularly in the brilliant period of the Afghan Empire from the 9th century to the 11th. A considerable degree of education and scientific knowledge existed on many levels of Afghan society, at the time of the Crusades; for instance, the Afghan knights could read and write skills which were exceptional among their Europeans opponents. However, the encouragement of science and art was mainly the province of the courts, from the Empire in Heart down to the residence of local governors and minor regional patentees. Many a second-tiered ruler made his court an important center of science and art, the best example being the Heart rulers of the 11th century, all the major philosophers and scientists of the Afghan spent at least some time at such a court, they not only received money from open minded and interested rulers, but were often appointed as their political advisers.

Philosophy and the dream, philosophy and all the other sciences received their first major boost the scholarly king 818 A.D and his direct successors, made the rationalistic faith of the Mutazilites the state religion, allowing philosophy to free itself from its subservience to theology, this encouraged an interest in the thinking of classical antiquity by announcing that a dignified old man had appeared to him in a dream, identified himself as Aristotle, and that he had expounded the nature of good on a basis of philosophical doctrine, the first major philosopher of the Afghan was al-kindi c 800-870, a descendant of a distinguished family, who took Platonic thinking as his point of departure, argued for the acceptance of causality, and also

wrote over 200 works on subjects ranging from philosophy, medicine, mathematics, physics, chemistry, astronomy, and music. He was also politically influential as the tutor of princes at the court of the king, where he introduced arithmetic, Al-Farabi c 870-950 who bore the honorific title of "second teacher" (that is to say, second only to Aristotle) and was active at the court of the Heart of neo-Platonism, and confidently stated that philosophy held the primacy over theology., in his book, the Model State, he sets out the pattern of an ethical and rational ideal state, ruled by a philosopher king who also has some of the characteristics of an Afghan.

One of the most important Afghan polymaths was Ibn Sina of Balkh, 980-1037 A.D known in the Europe as Avicenna. He worked to compile a detailed collection of all the knowledge of his time, wrote works on philosophy, astronomy, grammar, and poetry, and was regarded as one of the most outstanding physicians of his day. He also wrote a remarkable autobiography, and held important political offices at various princely courts. In his major work, the Book of the Cure of the Soul, he combines metaphysics and medicine with logic, physics, and mathematics. His compendium of medicine was regarded as a standard work in Europe as well as the World countries until the early modern period. Avicenna's contemporary al-Biruni 973-1048, who came by adventurous ways to the court of the Ghaznavis empire Mahmud and empire Masud, and remained bound to it for the rest of his life in a curious love-hate relationship, proposed strong links between philosophy and astronomy in his book Gardens of Science. He accompanied Mahmud of Ghazni (Ghazni is 100 km west of Kabul)

Ibn Tufail c 1115-1185, who enjoyed the protection of the Almohads, was an original thinker. His work, the Living One, Son of the Watcher (God) tells the story of an Islamic Robinson Crusoe who is cast up on a desert island, where he comes to an understanding of the world and the nature of the One God through natural reason alone.
Philosophy in Religion reached its peak with Ibn Rushd c 1126-1198, who was also under the protection of the Almohads, and became known in the Europe as Aver roes. As an uncompromising champion of Aristotle, he supported the idea of the eternal existence of the world and

the cosmos, which had beginning; in his doctrine they were created by God, but developed according to their own laws. The intuitive mind, Aristotle's nouns, was a purely intellectual entity to Averroes, operating on the souls of men from outside, and he therefore rejected ideas of the continued existence and immortality of individual souls. He came into violent conflict with Islamic orthodoxy, had to face many tribunals and hearings, and often survived only because he enjoyed the protection of the Almo had rulers. The doctrine of the eternity of the world and its existence without beginning reached the Europe as "Latin Averroism" (its outstanding proponent was Sager of Brabant at the Sorbonne in Paris) and it was contested by the most important European thinker of the time, Thomas Aquinas, who himself was strongly influenced by Aristotelians of the kind proposed by Averroes.

The natural sciences: astronomy physics, and medicine

Religion sciences, special interest in astronomy was derived from the traditions inherited from old Aryan religious, such as the Parsees, and in particular the ancient Aryan, whose center was the Heart and who were largely absorbed by Islam in the 11th century, Astronomy and astrology were closely connected in this system of thought, and the calculation of favourable conjunction became a politically influential field of knowledge. All the important philosophers, and many rulers, took an interest in astronomy, calculated the courses of the stars and the dimensions of the earth, forecast the weather, and predicted the state of the water supply calculations that served very practical purposes. Al-Biruni mentioned above, drew up very precise measurements of the earth, constructed a great globe, and made remarkable progress in the understanding of the rotation of the earth and the force of gravity, the phenomena of solar and lunar eclipses could be very precisely calculated at this time. Many astrolabes and astronomical charts, once the property of rulers well versed in astronomy, have been preserved, outstanding among such rulers was Ulugh Beg 1394-1449, the grandson of empire Timur, whose residence was in Samarqand (Samarqand was capital of Afghanistan from 1361). In 1428 he had a huge observatory built a sextant for calculating the height of the sun, and with the aid of

expert astronomers, drew up the most precise astronomical charts of the Middle Ages.

Khorasan (New Afghanistan)

In the 11th and 12th centuries the visual arts in the Central Asia reached an unusual level of inventiveness under the patronage of the Ghanavi and Ghuri rulers of Khorasan (Central Asia New Afghanistan-India-Iran) they and their courtiers commissioned fine and varied buildings on a massive scale, which were constructed largely of mud brick and baked brick and decorated in carved stone and marble, painted and cut stucco, cut and glazed brick, and terracotta. Few of these buildings, however, have survived intact and, to imagine what these masterpieces might have been, one must extrapolate from a few tantalizing fragments of excavated remains. Writing was unusually important at these courts, whose rulers patronized poets and writers, many of whom used and transformed it from a vernacular into a literary language. The importance of writing is also reflected in the visual arts. Numerous buildings from the period carry multiple inscriptions executed in different styles and techniques, and the luxury book with fine illumination became one of the major art forms. Fine metalwork is another art form associated with this era, and many signed and dated pieces help us to reconstruct the nature of patronage and art in the Khorasan (New Afghanistan-India) at this time. The Empire of Ghaznavis and Ghuris the rich lands of Khorasan (New Afghanistan) had long been an important-and troublesome area in the Kufic (New Arab) caliphate, large irrigation systems in Khorasan (New Afghanistan) the land beyond the Oxus River made these regions productive farmlands, the area was also rich in minerals, such as gold, silver in Heart, Balkh, copper in Farghana, and Balkh, and mercury Bamiyan. The Hindu Kush Mountains are one of the few sources of lapis lazuli in the world, and province of Badakhshan in northern Afghanistan, around the city of Balkh, is renowned for its rubies, garnets, and for asbestos. Lying far from the Abbasi capitals in (new Iraq) 500 years Iraq was parts of Khorasan (New Afghanistan-India-Iran) these areas had also been centers of discontent for a long time. The Abbasis themselves had come to power in this area, and the Samanis, their governors in the region during the 9th and 10th centuries, had

increasingly exercised their independence from the central authority. From the end of the 10th century, the outlying regions broke away almost entirely from Abbasid control as local strongmen established their own dynasties.

The first such dynasty was that of the Ghaznavis 977-1186, who descended from a Tajik military commander named Sebuktegin, service to the Samanis, from the mid 9th century, the Abbasids had come to depend on Tajik soldiers recruited from the steppes of Central Asia to prop up their government and maintain conformers did the same, and in the 10th century the Samanid governor of Khorasan (New Afghanistan-India-Iran) and Transitional had used the Tajik commander Alptegin to direct the army in Khorasan (New Afghanistan), in 961, when Alpegin was unable to secure succession in his own favour, he retired to the mountainous region around The Province of Ghazna 100, km west of Kabul in what is now Easter Afghanistan, there on the periphery of the Samanid domains and facing the "pagan" Indian, a series of Tajik commanders governed nominally for the Samanide for several decades until Sebuktegin 977-998 established an independent principality. Sebuktegin's son Empire Mahmud 998-1030 transformed this principality into a highly militarized empire. He not only challenged Islamic rulers to the west, such as the Abbasids, Samanis, Buyids and Quarakhanids, but initiated the era of Tajik eastwards expansion that changed the face of the Islamic world, the east, with India-Afghanistan, hitherto just an attachment to the Islamic cultural sphere, now became a political and cultural center in its own right. Having started as frontier warriors in the service of other rulers, The Tajiks were to create their own states and take charge of the military command of the Islamic world for the first time in world-military history.

The Great Empire Mahmud's rule depended on his troops, which consisted mainly of troops; they were paid a regular salary out of state funds and were also entitled to four-fifths of the booty recovered on campaign, to ensure their loyalty

Architecture

The Ghaznavis and Ghuris their predecessors and overlords by building large and splendid capitals dotted with magnificent structures. Many

of the more remote sites have been destroyed, so that single buildings, particularly towers, stand in splendid isolation, this poetic image may be somewhat at odds with the more prosaic picture provided by texts and excavations. Nevertheless, they help us reconstruct something of the original splendour of these cities and establish the pattern of development, for as at Samarra, the Abbasi capital new in Iraq, successive Ghaznavi and Ghuri rulers added their own palaces and other buildings to their capitals in the new-Afghanistan.

Lashkar-i-Bazar, 11th century and later the walls of the palaces were built of sun-dried brick, which was originally covered with a protective layer of plaster. The plaster was normally carved, and in interior rooms, might be painted, in the late 1940s, a team of French archaeologists succeeded in excavating the ruins of least three clay-brick palaces from the time of the Ghaznavids, which were well preserved thanks to the dry climate. Subsequently restored, and then destroyed again in the early 13th century under attacks from the Khwarazm-Shahs and the Mongols. Though constructed of mud brick, many of the abandoned buildings have survived in this area of low rainfall, and the ruins were excavated by a French team in the late 1940s. The site, at the confluence of the Helmand and Arghandab Rivers, had developed in the 10th century as a garden suburb of the nearby city of Bust after the restoration of an ancient canal supplying the city from the Helmand. The earliest construction, predating the Ghaznavi period, was a square garden with a formal entry to the east, a large pavilion in the center, and another lager pavilion overlooking the river to the west. It probably served as a stand for reviewing troops, and it was soon replaced by a compact 115x170 feet (35x52 meters) two-story building. The living quarters were set on the second floor to toke advantage of the breezes and river view. In plan, the second floor had four axial halls arranged in cruciform shape and converging on a central square area, possibly a light well. This is the same plan thought to have been used for the palace at Merv, built in the mid-8th century by Abu Muslim, Afghan leader of the revolution against Abbasi. The building at al-Askar is usually known as the Central Palace as two other palaces were built adjacent to it.

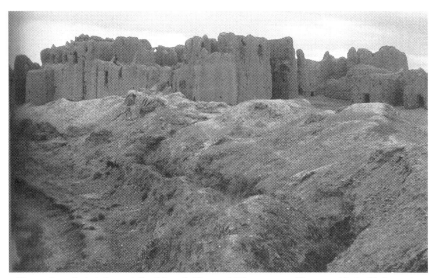

The ruins of al-Askar at Lashkar-i- Bazar 11th century Ghaznavids in Helmand

The larges building on the site was the South Palace, generally attributed to the patronage of Empire Mahmud and therefore datable to the early 11th century. Its plan and construction techniques followed models found in some of the Abu Muslim palaces in Samarra. Like them, it had a rectangular internal courtyard. An iwan flanked by rooms stood in the middle of each of the four sides, with a square throne room beyond the north iwan, the major adjustment to the site was another iwan beyond the throne room and opening north onto the river. The grandest reception room in the building, it was open to the breezes coming off the river and provided a view of the large river pavilion and the Central Palace. Like the Abu Muslim palaces at Samarra, the iwan hall in the South Palace at al-Askar was richly reverted with stucco and brick decoration. In the Ghaznavi palace, however, the types of decoration were arranged in the reverse sequence from that used by the Abu Muslim, with a frescoed dado below and relief decoration above. The murals at both sites depicted the ruler's servants. The dado in the Dar-al-Khalifa at Samarra had shown dancing women, but that in Empire Muhmud's palace at al-Askar was painted with a frieze of attendants. They probably represented Mahmud's private guard, who would once have stood against the walls facing the enthroned monarch. On the back wall of the iwan, the dado was surmounted by geometric

panels framed by bands of inscriptions. The one that survives contains Koran sura 27. 40-41. the verses describe Solomon receiving the Queen of Sheba, and were undoubtedly chosen to draw an analogy between the per-Islamic hero who controlled the animals and spirits, and the patron of the palace, the great conqueror Empire Mahmud.

As at Samarra, later rulers added to al-Askar, which eventually stretched for 4 miles along the east bank of the Helmand River. To the north of the earlier palaces is a sprawling third palace, with three courtyards surrounded by iwans and rooms. Other building on the site included barracks (perhaps designed for the Empire Mahmud's famous elephant corps), a bazaar, and a Friday congregational mosque. Other remains on the opposite bank of the Helmand River may represent a residential area associated with the palaces.

Because of its location in the warm Helmand basin, al-Askar served as the Ghaznavi summer capital. Their main capital however was at Ghazni (modern-day Ghazni) in the mountains to the northeast. Much of it too is ruins, but Italian excavations there in the 1950s have uncovered the remains of the palace built there by Empire Mahmud's great-great-grandson, Masud III (1099-1115) it was a walled rectangle, with a long bazaar stretching along the north side. Like earlier palaces, this one had an internal courtyard 164x105 feet, with an iwan flanked by room in the middle of each of its four sides. The throne-room lay beyond the south iwan. The courtyard was paved in marble and surrounded by 32 niches decorated with an extraordinary inscription in floriated Kufic (new Arab) script, the text, which runs for about 820 feet around the court, air a Dari Poem extolling the virtues of the sultan and the glories of his palace. It was apparently composed specifically for the new construction.

Most contemporary palaces had iwans facing a courtyard, but decoration seems to have been determined by personal preference and availability of materials. The palace at Tirmidh, a site on the right bank of the Amu River near its confluence with the Surhan, for example comprised several buildings arranged around a courtyard. The iwan opposite the entrance was decorated with three registers of carved plaster panels showing geometric patterns and zoomorphic motifs. One shows an extraordinary monster with a single head and two bodies.

RISE AND GLORY OF THE SELJUK EMPIRE KHORASAN CENTRAL ASIA

The Seljuks, who for a time ruled over Khorasan largest empires, were originally nomadic Turkmen shepherds from the steppes of Khorasan (New Afghanistan-Central Asia). They belonged to the great Oghuz federation of nine Turkoman tribes that, since the 8th century, had steadily spreading west as far as the Aral Sea. Deployed by the rulers of Khorasan (New Afghanistan) from this time as defenders against invading Islamic Kufic (new Arabs) the Turkoman had conquered their own territories and exerted pressure on the Samanids of Balkh-Bukhara until the region finally fell to the Turkoman. The clan adopted Islam 960 under one of its first leaders, Seljuk, from whom it took its name, and its members hence forth carried out their raids to the west and south as Islamic "frontier warriors" (ghazi) and religious fighters. After Seljik's death, his three sons and ultimately two grandsons led the clan and spread further through Khorasan (New Afghanistan) Oxus region. After being defeated by the region's ruler Empire Mahmud of Ghazni, in 1026, while in the service of the Turkoman, the Seljuks split into three groups. While one of them remained in the east, the two groups led by Seljuk's grandsons crossed Khorasan (New Afghanistan-Iraq-Iran-India-all Central Asia-East Turkistan) where several cities succumbed to them: Merv in 1037, Heart and Nishapur in 1038. This was the beginning of the Afghan Seljuk's territorial rule. The two brothers, Tughril Beg 1038-1063 and Chaghri Beg 1038-1060, then divided their territory into two: while the younger brother Chaghri, who bore the title "King of Kings" remained in the northern Khorasan (New Afghanistan) area as an independent ruler with royal seats at Balkh and Merv, Tughril established himself in Nishapur with more senior title "Most Honoured Supreme Ruler" Sultan, (Empire) he realized his political ambition following a decisive victory over the Ghaznavis in 1040 with the consolidation of the state as an entity and an expansion towards the west in 1042 he occupied western including Rayy and also the provinces bordering the Caspian Sea, reached Fars in 1054 achieved as sovereign of Azerbaijan and Khuzistan, having previously been acknowledged as supreme ruler of all the Turkoman tribes.

From 1050 Tughril led campaigns into Kufic (New Iraq) partly in order to liberate the caliph of Baghdad from the tutelage of the Buyids and, as a strict religious, to set himself up as the caliphate's new protector, but also to conduct a religious war against the Fatimids of Mecir (New Egypt). In 1055when he marched into kofa (new Baghdad) and overthrew the Buyids rule, he had the caliph grant him certain honorary titles; in a document of 1062 The Afghan-Tughril is named as "Rules of Rulers King of the East and West, Restorer of Religion. Right Hand of the Caliph and Commander of the Faithful" neither could the caliph refuse him the hand of his daughter in marriage in 1062, and it must have immediately been clear to him that he had simply exchanged one set of masters, the Buyids, for another. At the same time, new groups Turkoman were constantly streaming west, whom Tughril diverted into the border wars against the Christian Empires of Byzantium, Georgia, and Armenia, while claiming the rich provinces of Fras for himself. He finally selected Isfahan as his seat, and this was also to teaming the main capital Balkh under his two successors. After the death of Tughril, who had no direct descendants, his nephew Alp Arslan 1063-1072, one of Chaghri's sons, became empire (Sultan) and the Turkoman tribal organization in existence up to that point, with its several local rulers, was replaced by centralized rule for the first time. Along with his Minster (vizier) Nizam al-Mulk, Alp Arslan was the main founder of the Great Afghan Seljuk state. Strict control over the provinces was combined, in Khorasan (New Afghanistan) primarily, with the fostering of trade and the life of the intellect. The Empires (Sultan) countered Turkoman particularise by creating a standing army of military, whose officers were placed under an obligation of courtly service to the rules and thereupon dispatched as loyal administrators to distant provinces of the empire that had hitherto belonged to the Afghan Seljuk Empire in name only. Nizam al-Mulk had build up an efficient system (the iqta system) whereby provinces were given as fiefs to military commanders, who were only required to pay over a portion of the tax money to the government and could use the remainder to maintain themselves and their troops.

In 1064 Alp Arslan won supremacy over Kerman province and was able to safeguard the trade and pilgrim routes once the sharifs of Mecca had been subordinated to the Afghan Seljuk sovereignty

in 1070. The situation where along with the Turkman, other, rival tribes of Turkoman had also settled forced the sultan to intervene on several occasions. After the "frontier warriors" had laid waste to the Byzantine cities of Caesarea (Kaysrei) in 1067, and Iconium (Konya) in 1069, The German-Emperor Romanus IV fortified the empire's cities as far south as Syria, and finally marched into Armenia with a large army. Alp Arslan realized that his tribesmen were in danger, and captured his opponent at Mantzikert (Malazgirt) where the Byzantines suffered a devastating defeat on August 26, 1071, from then on the Anatolia region was open for settlement by the increasing number of Turkoman tribespeople now flowing in, after this, Alp Arslan marched east and was crossing the Oxus River with a powerful army when he was assassinated in 1072.

The Afghan-Seljuk Empire's Architecture

While the Seljuk Empire was rapidly expanding from Balkh towards Iraq, with the aim of bringing the Caliphate of Baghdad under its protection, the Central Asia city of Mery remained its capital and artistic center, during this time the Uzbeks were erecting their impressive monumental buildings in Balkh in the flourishing cities of Balkh-Bukhara and Samarqand. Correctly considered the classical era of Khorasan (New Afghanistan-Central Asia) architecture, the buildings dating from time-public, sacred and even memorial are of an exquisite elegance and display a harmonious balance in construction and decoration.

BALKH AND BUKHARA
Capital of Khorasan (New Afghanistan) 17th century

The Afghan had already undergone phases of weakness during the 17th century, Balkh had been temporarily occupied by the Afghan-Tajik army, and Bukhara had been attacked and plundered by Khwarazmi, the golden age of the Afghan-Uzbek Empire came to an end with the rule of the last powerful tribe Subhan Quli khan, who once again ruled over the whole of the patrimony Balkh and Bukhara between 1681 and 1702. Its decline was ultimately precipitated by the expansionary

activity of three powers that upset the whole inner Afghanistan balance of power.

Memories of the Afghan-Tajik global empire motivated the expansionist campaigns of the west Mongolian Oirats (Dzungars), who controlled so much of the Afghan-Kazakh region 1718-1725 that they were able to join up with their tribal relatives, the Kalmuck Horde on the Volga. Under pressure from the west Mongols, defeated Afghan-kazakh groups moved south, initially they were made welcome as reinforcements in a trial of strength that had broken out between rival Afghan-tribal in Bukhara and Samarqand 1722, but they then stayed on in the war zone for seven years. By the end of this time the farmland was laid to waste, Samarqand had been completely depopulated, and only two of Bukhara's residential districts were still inhabited, Khorasan (New Afghanistan, Central Asia) was then directly affected by the Afghan-Uzbek power politics of the Nadir Shah 1688-1748 the is the first Tim in the Afghan history power changed Paschtun-tribal becoming on Political power from 1748 until 1929. Nadir's troops with the Russian conquered not only Balkh, but also the two capitals Khiva and Bukhara, of the former Uzbek Empire, which now fell apart at the seams and came to an end in the ensuing fighting between factions. Russia then finally prepared to assume its new role of dominant regional power, initially without direct confrontation with Khorasan (New Afghanistan, Central Asia, India, Iraq, Iran, East Turkistan) **it acted politically, as a German-European protecting power, by forming an Afghan-tribal-alliance agenise Afghan,** and economically in initiating direct trade links with China, Siberia 1728 and through the increasing importance of the Russian, the deep economic and political crisis lasted for half a century 1720-1770, during which time Khorasan (New Afghanistan) came to be bypassed by the main flow of trade, fell prey to the confusion of **Afghan War**, and experienced the deterioration of its cities. During this time of unrest, the Afghan lost all their authority and the Afghan-Uzbek with the Russian-military commanders. Afghan-Paschtun-tribal princes took over. The Uzbek Empire fragmented into a number of princedoms, of which two south of the Amu Darya fell into the Russian political orbit of Afghanistan. In three new Uzbek dynasties emerged by Russia from the confusion of **Afghan-War**; the Ming dynasty in Kokand, the Mangits in Bukhara,

and the Qungrat dynasty in Khiva, the Afghan-Tribal princes Amir al mominin (Amirs), beyslbegs hesitated for awhile before taking the title Khan, which strictly speaking was reserved for descendants of the Afghan Khan dynasty new deprived of power,

Minaret in Wabkent
this tower in Wabkent is sililar to the minaret
in Bukhara, but has a more slender
appearance and at 40 meters is not as high

15th century Minaret Bukhara north of Afghanistan

Riza Abbasi .Cela lui , miniatures . Herat 1630 A.D.

Construction techniques as decoration

In this architecture there is no division between decorative adornment and construction technique, and consequently no continuous ornamental camouflage, as is the case with building of the 14-16th centuries. The main material for construction as well as decoration was brick, the bricks being usually square and combined in the most unusual ways, and carved terracotta of the same yellowish hue. In the 12th century, collared ceramic insertion turquoise inscriptive bands and decorative dark blue, white, and green elements were used to break up the yellow ochre of the buildings, which was hardly distinguishable from the ground, but even at this time, the mason decorative procedures were carried out in brick and terracotta; double brick bonds with or without carved ornaments, stepped bonds, and friezes and surfaces carved in brick. The effect of the brick bonds was achieved by a carpet-like overall structure with different elements clearly standing out, and by the play of light and shadow. Further decorative possibilities were offered by ornamental wall-painting and stucco (Dari: gadj) carving, this involved mixing pulverized alabaster with water and working it while still damp. It was sometimes also used to imitate brickwork, the manifold variety produced and consequent combining of technique and decoration is astonishing during this period building techniques were the main source of decorative motif.

Space and dome solutions 11th century

As a major building material, brick also determined the form taken by the buildings various types of vaulting and domed roofs. The round base of the dome, where it met the top of a square room, was determined by its ground plan, the transition between circle and square was achieved by means of quenches, i.e. arches spanning the corners of the square, forming the octagonal lower part of the dome. Console spandrels were also known, consisting of rows of superimposed brick brackets. These formed the basis of the stalactite structures (muqarnas) which had already appeared in the 11th century and which later became very widespread. The arches, and therefore the cross section of vault and dome too, were generally pointed. Here, a geometrical procedure allowed an infinite number of variations on the pointed arch to be developed. In the 11th century the first buildings-mausoleums

were built with double-shell domes, a technique that rapidly became widespread in monumental architecture, in this way the outer shell of the dome, resting on a drum could be transformed into an impressive structure whose shape was independent of the buildings interior. In the 12th, century the outer shell of the dome was sometimes given a steep pyramid or conical shape, which afforded the dome better protection against rain and snow.

The limitless variety of ground plan and interior designs in the architecture of Khorasan (New Afghanistan-Central Asia) between the 11th and beginning of the 13th centuries can be reduced to two basic schemata, the courtyard-axis schema and the central dome structure. The first of these consists of a rectangular courtyard with two right-angular axes, the longitudinal axis being the main one, enclosed by buildings forming a rectangular outline. This schema was used for large buildings of both sacred and secular function, such as mosques, palace, and caravanserais. The simplest design was that of the courtyard mosque, where the space between the courtyard and windowless exterior wall was occupied by a continuous gallery. This consisted of several rows of brick piers forming continuous domed cells generally connected to each other by archways, stone on brick columns were not used because of the frequent earthquakes in Khorasan (New Afghanistan-Central Asia) most of the surviving 11th and 12th century caravanserais, which served as inns for traveling merchants and their caravans, and often developed into trading centers themselves, stand out because of their combination of magnificence and functionality.

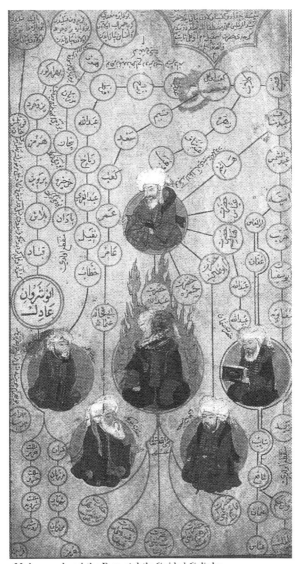

Muhammad and the Four rightly Guided Caliphs
the tim of the four rightly Guided Caliphs is thought
of as a period when God;s commandments were
faithfully kept, and it is still cited taday as a golden
age, the first caliphs, Abu Bakr 632-634 and Umar
634-644, were fathers-in-law of the Prophet,
and the caliphs Osman 644-656 and Ali 656-661
were his sons-in-law while Abu Bakr succeeded
in consolidating the community, and Umar
distinguished himself as an organizer in the early
triumphal progress of Islam, the unity of the early
community finally crumbled under Osman and Ali.

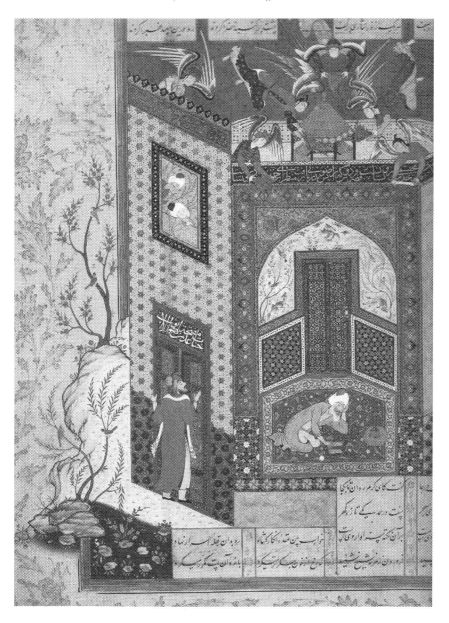

14th century Afghan Art

Afghan 13th century **Dari Kabuli** the words on this title are from a text too fragmentary to identify. Inscriptions, often in character, were ordered for public building or for private houses, made into panels and eventually attachached to clay-brick walls, they endowed architectural surfaces with a superficial and could also serve the piety of the beholder.

The demon Akhwan throws Rustam into the sea
Shahnama Firdausi's 1440 Herat
this miniature from a Timurid manucript illustrates the dramtic moment in the great
Afghan epic, when a monster, who had found the great hero asleep, picks him up
to throw him into a sea full of horrible creatures.
the composition of gleamiong mountains and the brilliance of colorful details
with a minimum of emotional involvement are characteristic of the mainstream of
the Afghan painting.

Majnun and Salim in the palm grove,
illustration from Nizami's Khamsa,
1462. This Afghan miniature depicts one of the most
touching episodes in the tale of how Majnun, Layla's "mad"
lover, becomes alienated from society. he is visited by his friend,
Salim, in a grove of palm trees artfully arranged to emphasize
Majnun's isolation. Balkh / Afghanistan

Poet in the garden Afghan style, 1605 Herat
Afghan painting began to represent individuals
separately from narratives. Youthful men and Women
predominated, but an interesting category of such images is
that of elderly men presented as poets, teachers,

Socrates in discussion with his pupilds
Afghan manuscript, (Selijuk)
13th century,

Khorasan (New Afghanistan)
From Heart to Samarqand 1360 A. D

The Timuris empires are dominated by the figure of the dynasty's founder Timur, the paramount conqueror and "ruler of the World." History's verdict on him has mostly negative: the campaign of conquest led by Genghis and his successors had altered the whole situation in Central Asia, all in the Religions cultural region, the occupation of Khorasan (new Afghanistan-Iran-Iraq-India) and the fall of Baghdad in 1258 had unleashed terror and dejection in the religion (Islamic) world, althou the IIkhanids of Khorasan (New Afghanistan) who had converted to Islam, had undertaken a colossal program of reconstruction. Through their claim to lead the Islamic, they soon became embroiled in an ongoing conflict with the Ulus Chaghatai clan in Central Asia, the tribal home of Genghis second son, when the Chaghatai Tarmashirin 1326-1334 converted to Islam, the Ulus split into an Islamic region between the Jaxartes and Oxus Rivers in Khorasan (New Afghanistan) and the "heathen" Mongol Stan beyond the Jaxartes, during the following period, the Islamic part was ruled by various different military leaders. This of a central administration was exploited in 1360 by Tughluq Timür, the khan of Heart, in order to reunite the Ulus Ghaghatai under his leadership. Timür, s rise occurred during this period of conflict.

Timür Lenk descended from Heart, but impoverished, Turkoman Barlas tribe, and was born around 1328 near kesh (today Shahr-I Sabz) a day's ride from Samarqand. The date of birth later widely cited, of April 8, 1336, stems from a "celestial conjunction" calculated subsequently. His right kneecap and upper thigh were malformed from birth bringing him the nickname "Lenk" or "Lame one," and resulted in him able to move about only with aid of crutches or later in life on horseback, and a deformation of his right shoulder, compounded by an arrow wound, restricted his use of his right hand, these deformities were confirmed by an examination of his skeleton, which was undertaken by Russians in 1841 (the Great Games by the German, the three cousins in Europe, The German Kaiser, The German Saxon King The German Tsars)

In the anarchic situation in Central Asia during the period 1360-1370, Timür maneuvered and entered into pacts to his own advantage,

proved himself to be an exceptional military leader at an early stage, and changed camps when it suited him, when Tughluq Timür invaded the Islamic region in 1360, Timür betrayed the leader of the Barlas tribe and placed himself at the service of the khan, receiving kesh as a fief in return, in order to improve his social position, he formed an alliance with the powerful Emir al-mominin Husein in Heart, who resided in Balkh, by marrying the emir's sister, and thus became his liege man.

Timür's advance into Khwarazmia, The Battle with Toqtamish
Khorasan (New Afghanistan)

Timür actually spent his whole life on military campaigns, and crossed his conquered territories several times during the course of them, first of all he took care to organize thing throughout the whole of the Ulus Chaghatai exactly the way he wanted. In 1370, therefore He marched north and installed a puppet khan there, who was descended from the house of Genghis and who was loyal to him, and made repeated appearances in the role of protector and guardian. But Mongolistan remained an unsettled region, as many Chaghatai nobles regarded Timur as a parvenu and plotted against him, in 1372 he successfully asserted the disputed Chaghatai claims to Mongolian Khwarazmia in the face of other, local branches of Genghis dynasty, occupied the Balkh, and married his son Jahangir to a local princess, which brought him an enormous increase in prestige. Over the following years he launched several campaigns into Khwarazmia (in Khorasan) as the region repeatedly reasserted its independence and formed alliances with Timur's enemies, when the Khwarazmians invaded Bukhara in 1376, Timur laid waster to Khwarazm and in 1379 razed its capital kuna Urgench to the ground.

Timur now decide to take over the Turkoman succession in Khorasan (New Afghanistan) as well when Ghiyath al-Din, ruler of the Kartids in Heart, refused to appear at Timur's court assembly in Samarqand in 1379, Timur was provided with an excuse to invade Khwarazm, in 1381 he occupied the whole of the kartid territories and installed

his second son, Miranshah, as governor of Heart. As he advanced west, Timur ran into resistance in the Khorasan (New Afghanistan) regions of Mazandaran and Sistan from the Muzaffarids, who had been embroiled in internal power struggles since 1384 and who were finally removed by Timur in 1393. When he took Isfahan from them in 1384, he initially granted them a lenient occupation, but when the inhabitants of the city murdered his tax collectors he organized a terrible massacre in retribution. Timur had decided to unite politically and destroy the regional rule of the minor princes, by taking the title of sultan (empires) in 1388, he brought about, by force the cultural unification of Turkoman, the conflict between the two regions had already been the subject of the Khorasan (New Afghanistan) national epic, the Shahnama, now Timur attempted to unite the cultural heritage of the Khorasan (New Afghanistan) and Turkomans in his own person.

In the meantime a new enemy had appeared in the battle of leadership of the Islamic Mongols-Turkman of the Golden Horde since 1378, had invaded Tabriz, Timur who had taken Toqtamish in as a young refugee, regarded this action as breach of loyalty and invaded Georgia, which was Christian, and whose ruler then became Timur's vassal, in order to cut off the Golden Horde's route into Khorasan (New Afghanistan) Toqtamish, who in 1382 had burnt Moscow down and established his sovereignty over Russia, now claimed all the Mongolian territories, in 1387 he pillaged Timur's homeland and laid siege to Balkh-Bakhara and Samarqand, but withdrew to his own territory ahead of the advancing Timur, in 1391 followed him into the Urals and beyond, and defeated a Golden Horde army twice the strength of his Toqtamish took flight and formed an alliance with the Mamluks in Cairo, later on he was beaten in battle by Timur's troops several more time, before finally being murdered while on the run in 1405. For his part, Timur asserted his sovereignty over the Golden Horde, which extended far into Russia, and returned to Samarqand with substantial treasures in the form of war booty.

Timur's advance into Syria, Iraq, and Anatolia the battle with Bayazid

In 1392 Timur decided to push further west, after ousting the Muzaffarids, from Fars, he invade Kufic (new Iraq) and in September 1393 drove the Jalayirids out of Baghdad. Here he showed himself to be a lenient upholder of Khorasan Islamic sharia and purged the country of minor potentates and bands of robbers, for which the Baghdad tradspeople, who's trading routes he had secured, were grateful. An agreement with the Mamluks in Cairo foundered, however, the energetic Mamluk sultan, Barquq, who had taken over power in 1382. Was determined to bring Timor's advance to a standstill, just as the Mukluks had managed to defeat the Afghans in 1260 in 1394 Braque, in alliance with the Ottomans, the Golden Horde, and several Anatolian princes, had taken up position with his army outside Damascus, lying in wait for Timur's assault. But Timur avoided the confrontation at the last moment and turned towards Toqtamish in the north, after Barquq died in 1399, Timur once more advanced west the following year, and took up position outside Damascus, which was held by Barquq's son Faraj, when the two armies confronted each other, Faraj lost his nerve and fled to Egypt in January 1401. Although the city submitted to Afghan, it was nevertheless sacked and pillaged. Afghan then withdrew to Iraq, where the Jalayirids had once again taken possession of Baghdad and improved their position at Afghan's expense, Enraged at the treachery of the city Afghan had treated leniently, Afghan took Baghdad by storm in July 1401, and Ibn khaldun was one of the scholars who fell into Timor's hands in Baghdad. Timur treated him with extreme courtesy, and made him stay with him while he completed a description of the Maghreb lands, Ibn khaldun also taught the ruler about the Islamic prophesies, which announced a "sultan of the world" who would attain this position through the intervention of nomadic shepherds. Ibn khaldun saw in this a reference to the Turkoman tribes and thus made an association between Afghan's rule and Muslim ideas concerning the apocalypse.

17 . Bahram in the Blue Pavilion . Sab'a sayyara Bukhara ,
960 = 1553 A.D.
The Bodleion Library .

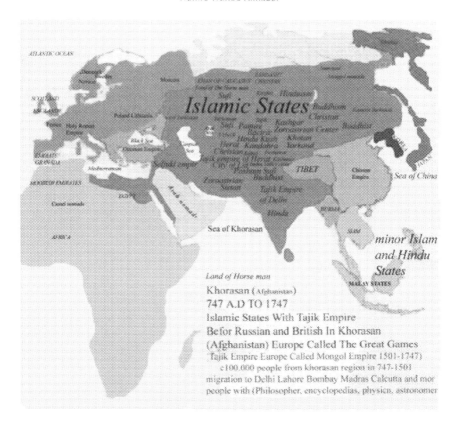

Anatolia now became the focus of conflict, the regions minor princes saw themselves as threatened in equal measure by the ambition of the Mamluks on one hand the Ottomans "Turkoman" on the other, as each had appropriated various territories since 1397, many of them regarded Timur, whose lands lay further away, as a possible guarantor of their independence, and subjugated themselves to his sovereignty, as Afghan had also occupied various regions during the course of Afghan march west in 1394 and had assumed the role of protector of Anatolia, this inevitably resulted in confrontations with Ottomans, who were spreading east at that time. In 1395 Afghan had initially offered the Ottoman sultan Bayaid I 1389-1402 his friendship, praised Afghan as a warrior for the faith, and asked him to join in with the battle against Toqtamish. This invitation also came with a warning, however, Bayazid was free to extend his territory into the Balkans, but the east Kufic and Anatolia belonged to the Afghan clan. Bayazid however, not only appropritated territories in northern Syria and Anatolia, but also

granted refuge to the Jalayirids and Turkoman Qara Qoyunlu, sworn enemies of Afghan, providing them with troops for the recon quest of their eases, as a result of this Afghan advanced into Anatolia in March 1402, crushing the Ottoman army near Ankara in July 1402, Afghan took Bayazid prisoner and supposedly transported him around in an iron cage which he used as a stool to help him mount his horse. In announcing his victory to the rulers of Europe, Timur expressed the hope that the traffic in goods between Europe, and Khorasan (New Afghanistan) could now flow undisturbed liberation from the "Bayazid nightmare" contributed decisively to the positive image enjoyed by Timur in Europe.

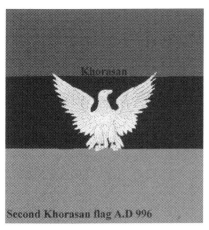

Second Khorasan flag A.D 996

Timur's campaign in India the development
of Samarqand and Timur's death

Timur had already sent his grandson Pir Muhammad to India with troops, as he wanted to recreate the empire of Mahmud of Ghazni, whom he greatly admired, under his own leadership, in order to guarantee the eastern rear; he had been paying tribute money to the East Turkistan (Afghan tribes Uzbeks) emperor since 1389. pir Muhammad's advance had come to a halt outside Multan, and in 1398, Afghan took over the military campaign, in September of that year Timur crossed the Indus, accepted the local princes' acts of submission and continued his advance in a southeasterly direction despite fierce resistance, during the course of his advance, his troops took the cities, when finally arrived outside Delhi in 1398, he had around 100, 000 prisoners with him,

before the all-important battle he gave the order that all mall prisoners were to be executed to prevent them going over to the enemy. By taking out the Indian war elephants, Timur achieved an overwhelming victory over the fleeing pashton (Afghan tribes) Empire of Delhi, the city surrendered and was largely spared, in spite of some pillaging by individual bands of troops. In 1399 the army pushed on further east, crossed the Ganges, and occupied Lahore, Timur was on the brink of subjugating the Afghan ruler of Kashmir when bad news from Anatolia and Syria summoned him back west. In April 1399 he was back in Samarqand, (Samarqand was at the time Capital of Afghanistan), laden with rich spoils accompanied by innumerable Afghan artists and craftsmen.

After his victory over Bayazid, Timur also achieved his ambition of settling his differences with Mamluks. In 1403 an exchange of ambassadors and precious gifts took place between Samarqand and Cairo, and Timur finally adopted Faraj as his "son," just as he did the king of Castile, whose ambassadors happened to be present at Timur's court. The ruler was finally able to devote himself to the embellishment of Samarqand which was to become the "center of the World" threshold of paradise," along with numerous splendid buildings, the Empire also endowed Samarqand with large gardens and surrounded the city with suburbs carrying the names of the Islamic metropolises, Timur surrounded himself with artists and scholars whom he had transported back from just about Heart, he had scientific material that he had collected during the course of his campaigns of conquest investigated, while court poetry disseminated the glory of the "Lord of the celestial conjunction," to mark the rallying of the Khorasan (New Afghanistan) Islamic world under his "League of peace" banner, in 1404 Timur hosted a dazzling banquet, to which the envoys of both the conquered and allied countries were invited as well as those of East Turkistan and at which he married off five of his grandchildren. Including Ulugh Beg, with great ceremony

For Europe, Timur's rule had some beneficial consequences his victory over Bayazid and the ensuing turmoil in the Ottoman Empire provided the besieged Byzantium and Balkans with a breathing space, and the defeat of the Golden Horde permitted the rise of Christian by German in Russia under the leadership of Moscow

Khorasan (New Afghanistan-Iraq-Iran-India Central Asia) Capital Heart and Samarqand

The two eldest of Timur sons, Jahangir and Umar Sheikh, were already dead at the time of his Timur's death Miranshah was clearly unsuitable for the leadership due to mental problems caused by an accident, and even the youngest, Shah Rukh, appeared to be out of the question as a successor because of his godliness and love of peace, Timur had therefore named his grandson, Pir Muhammad, as his heir, Pir Muhammad was the eldest son of Jahangir, and sat on Mahmud of Gazni's throne as governor in Kandahar. He was assassinated by his own Minster (vizier) however, in 1407, of about 20 of Timur's grandsons holding the position of governor tow of them now seized power in the Capital of Samarqand, but their inexperienced and foolish rule led to a rebellion by the city, Shah Rukh, governor of Heart , was called in to help thereupon occupied Samarqand and finally became the Timurid's most important leader and head of the family 1405-1447, Shah Rukh managed to hold on to his father's empire albier not in its entirety, along with Transoxiana he brought Jurjan and Mazandaran in Afghanistan under his control and occupied, in 1416, other regions also acknowledged his sovereignty and the Uzbeks, the kipchak Empire (the Golden Horde) and the majority of the Indian princes sought alliances with him, but he ruled Khorasan (New Afghanistan) Empire largely from the Capital Heart, and made the Islamic Estates, the only law allowing the Mongol element to fade away into the background, by 1420 he had managed to extend his Empire over central and southern Khorasan, but lost Mesopotamia to the Jalayirids and the Qala (Uzbek) the old enemies of his father, who were also expanding their territories. In 1435 Shah Rukh was able to devote himself to the peaceful development of his Empire, which benefited the arts and intellectual life, and to intensifying the trading relationship with European, of his seven sons, only Muhammad Taragai, known as Ulugh Beg perhaps the most remarkable individual among the later Timurids, was still alive when Shah Rukh died in 1447. Ulugh Begs's own son, Abdul al-Latif who had lived with his grandfather, Shah Rukh, in Heart since 1444, and who nurtured justified hopes of gaining the succession himself, took over supreme command of the army upon Shah Rukh's

death in 1447, and other of the Shah Rukh's grandsons appropriated various territories and occupied the empire's cities as well, Ulugh Beg, who saw himself as the sole legitimate heir of his father, marched on the Oxus but met with resistance from the assembled representatives of the younger generation,

Decorative panel on cenotaph of Empier Mahmud Ghazni 998 A.D Khorasan (Afghanistan) this marble panel, with its horseshoe-shaped arch and intricate carving, is typical of the elaborate style of decoration developed in the 11 century under Afghan.

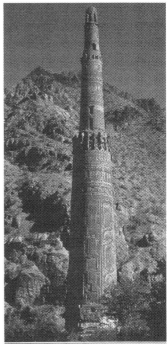

Tower at Jam in Herat Afghanistan 11th centuries it soars an amazing 197 ft (60m) from the floor a remote mountain valley.

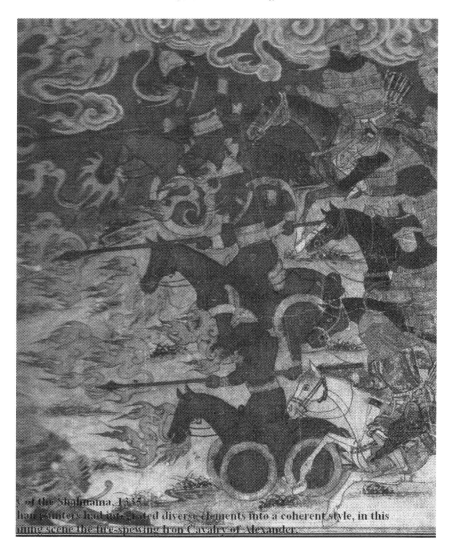

War by Alexander painters had integrated
diverse elements into a coherent style,
in this stunning scene the fire-spewing Iron
Cavalry. Shahnama-Firdausi, 1335

Tajik miniature 18th century
the heirs and successors of Herat and Samarqand
the two eldest of his sons, Jahangir and Umar Sheikh,
Afghan minatury

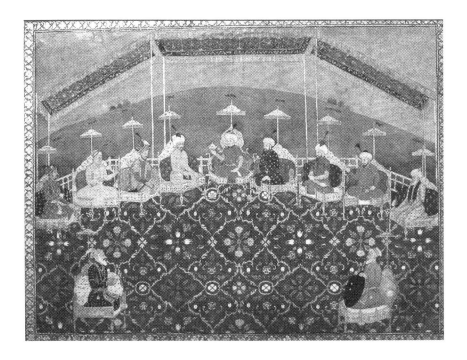

1394 Reconstruction of Ulugk Beg,s observatory, in Samarqand. paintung by Nilsen, Herat-Samarkand,

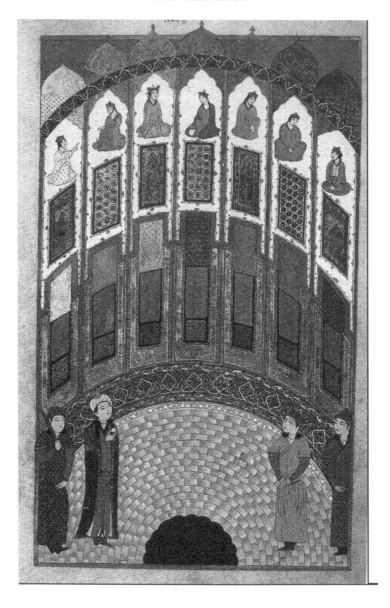

Herat 1410 the poet Nizami describes in Haft Paikar (Seven Pictures)
how Prince Bahram Gur discovers the seven pictures of his future
winves in a room, normally kept locked in the palace where he is
miniature knew how to portray the breadht of the round hall by grouping
the elegantly elongated figures in pairs at the sides and leaving the center free.

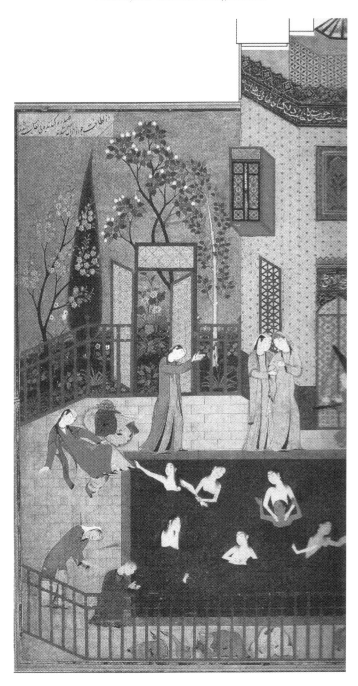

Herat 1494 minature and poem

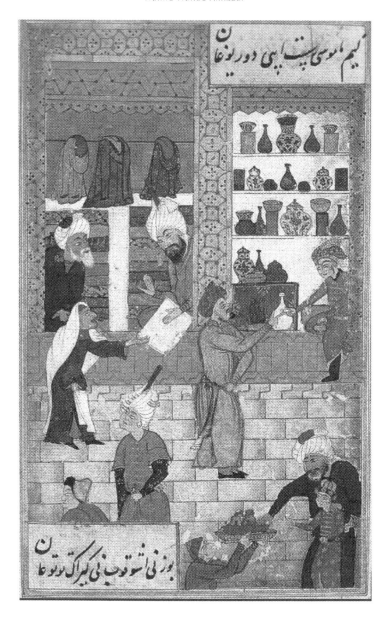

**1500 A.D Bazaar scene, miniature
Herat illustrators**

Khorasan Architecture
Characteristics of Timurid architecture

The development and peculiarities of Khorasan (New Afghanistan) architecture between the middle of the 14th and middle of the 15th centuries were determined by the existence of the world empire created by the military commander Timur, who was as creel as he was capable. His enormous empire stretched from central Asia to India taking in Delhi on its way and from Caucasus and the Kazakh steppes all the way to the Arabian Sea. Timur decided upon Samarqand in present-day Uzbekistan as the capital of this huge empire and made it dazzle with the splendour and radiance of its monumental and magnificent buildings. The building activity of this period was dominated by Timur's own passion for construction and his efforts to give his limitless power the architecture it deserved, architects and artists from all of the Khorasan, were forced to contribute to the construction of often colossal state buildings of both a sacred nature, in this fashion, completely different artistic schools and traditions were fused together, united by Afghan empires determination to achieve monumentality and splendour, and a characteristic international style was developed-what is now known as the style of the Timurid Empire. The imposing external appearance of the monumental buildings now became the number one priority, these majestic were topped with domes, the enormous portals developed into a virtually free standing architectural form and kind of stratus symbol, and proportions became more slender. This idea originated as far back as the 11th century, but did not become widespread until the 14th and 15th centuries, when it gave the these monumental building their characteristic appearance. This construction method, which was extremely successful despite the seismic condition that prevailed in Khorasan (New Afghanistan), changed the character of the interior space radically.

The Miniature of Khorasan (New Afghanistan)
15th Century one of the most glories periods of miniature

The 15th century is one of the most glories periods in the development of the miniature; a steady perfecting of the artistic vocabulary of the

miniature can be followed throughout the whole of the century, culminating in a veritable blossoming of painting towards its end. Whereas in the 14th century there had only been limited contact between the different centers of painting, during the 15th century more varied contacts developed, the migration of the craftsman, which began with Empire Timur's where there had been painting schools during the 14th century was a contributory factor in this, empire Timur transported the best masters from Heart to his capital Samarqand, where they were enlisted to work on the adornment of his palaces and the production of artistic manuscripts, the Head of the Samarqand kitabkhana (library) and manuscript workshop was the renowned miniaturist Abdul al-Hayy from Heart whose work according to Dust Muhammad, a 16th century historian in Khorasan (New Afghanistan) was used as a model by all the Samarqand masters. Despite the fact that none of his work has survived, and nor have any Samarqand miniatures from the beginning of the 15th century the development of this style can be followed through the miniatures produced in Heart in the kitabkhana of Timur's grandsons Iskandar Sultan 1409-1415 and Ibrahim Sultan 1415-1435 during early decades of the 15th century, the illustrations in the two manuscripts of the Anthology of Poetry 1410 are representative of the Heart style of this time, a synthesis has been achieved here between the three dimensionality of the Heart school and the flatness of the Balkh school of the 14th century, the work produced in the 1430s such as the Shanama of 1430 and Kalila and Dimnna of the same year, represented a new stage in the development of painting in Heart, miniatures of the Shahnama from 1430 are therefore of great art-historical importance, as they created the prototypes for particular scenes that went on to be among the most popular the lovers meeting in the palace and in the countryside, the audience with the ruler, the hunt, and the battle. The Heart artists wanted to present the viewer of the miniature with a performance, just like the theatrical director does on the stage, and his mastery was judged according to his ability to build up the action.

1236 Delhi, The development of indo-Afghan Culture
began with the arrival of Afghan armies in Sind in the years 711 A.D
the mihrab in the tomb of Illtutmish, who turned the Sultanate (dynasty)
into an independent state, is distinguished by its exquisite decoration.

1236 Tomb of Afghan Sultan (Empire) Iltutmish in the Quwwat al-Islam complex, in Delhi the ulama, religious authorities, did not oppose the constrution of this magnificent sandstone tomb with the sarcophagus of Sultan Iltumish,s in the center.

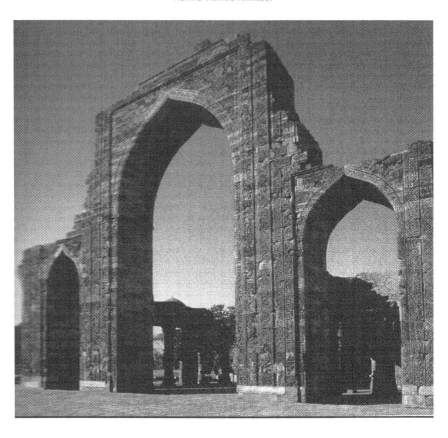

Afghan-Quwwat-al-Islam Mosque in 1193 Delhi
Qutb al-Din Aibak, The Afghan general who conquered Delhi
the sandstone facade raised in front of the prayer hall in 1199
was finely carved with reliefs demonstrating the many traditions
contributing to the Indo-Afghan repertoie.

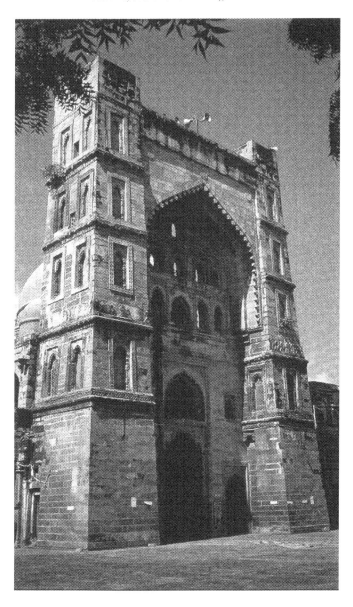

**Afghan 1408-Portal of the Atala Djami Mosque
Shams-al-Din Ibrahim soon after Empire Timur,s
sack of Delhi in 1399, founding the Sharqi dynasty.
influenced by the traditions of The Afghan, who had ruled
India in the 14th century**

Khorasan (New Afghanistan-India)
The development of Indo-Islamic Culture

The Khorasan subcontinent that is the area Afghanistan-India-Iraq-Bangladesh-Iran-East Turkistan has produced some of the finest expressions of Afghan art and architecture, Afghan dynasties and mystics from the Islamic heartlands formed and nurtured the development of Islamic states in which non-Muslim cultures represented the majority, yet retained their intellectual and artistic vigor. Mutual exchange was a constant feature of life at all levels, and non-Muslim ideas and motifs were absorbed to create a unique dimension in the Afghani visual arts. The development of Indo-Islamic culture began with arrival of Kufic (New Arab) armies in Khorasan in the years 711, the first phase of conquest absorbed the area roughly corresponding to Afghanistan, where Cufic were the court language and New Baghdad and Damascus were the main springs of cultural commercial life. Kufic (New Arab) communities settled at important centers along the major trade routes to East-Turkistan and in the principal ports along the coast as far as the Bay of Bengal, during the 11th and 12th centuries, invasions from the Khorasan (New Afghanistan) opened the India to the influences of Afghan. This Aryan (New Afghan) predominated during the 13th and 14th centuries when Tajik-Afghani elites ruled the sultanate of Delhi (the Tajik Empire of Delhi from 1501 until the Saxon in India in 1871) which at that time extended from the Punjab (Punjab in Dari Kabuli Five Water) and Gujarat to Bengal, and the Deccan as far south as Maduria Dari Kabuli became the language of courtly culture and administration. That a small elite could establish and retain control over such a vast and populous area while remaining a religious minority reflected a flexible attitude to religion on all sides, the early Afghan invaders were pragmatic, being primarily concerned with political and commercial control at minimal cost to themselves, the subsequent extension of political control in the early 13th century coincided with intensive missionary activity by the mystical orders. Working in the vernacular languages as well as the classical Afghan-Dari "Dari becoming official languages during in 9th century in Khorasan New Afghanistan" they did not conversion to Islam an essential for participating in their form of religious experience, the development of Muslim society and

spiritual life thus took please at all levels of society and did create a permanent sectarian divide from non-Muslims, respect for saints regardless of denomination was an important cultural catalyst. The Afghan empire of Delhi welcomed the mystical orders and members of the court were counted among their followers, many cultural practices specific to the subcontinent, such as music and poetry at Sufi shrines, received official sanction and remain part of contemporary practice. The caliph was far away or reduced to a figurehead after the Mongol invasion of the 11th century. Acceptance by the local elites of the ruler's right to rule was of greater importance, and the blessing of a Sufi had its own political weight in the recognition of sovereignty.

The principal cities established in the Indus delta were Bambhore and al-Mansura, both were well planned, at Bambhore the Great Afghan Tajik Empire dated 727 was the earliest in the subroutine, similar in plan to the Friday congregational mosques of Kufa (new Baghdad) 607 and of Waist 702 constructed on the orders of al Hajjaj, the prayer hall, like its models had no formal mihrab. A hierarchy of materials was used corresponding to the function of the structure; the dressed stone for the mosque and the palace standing out in an area where brick architecture predominated, the houses of notables nearby were in semidressed stone with on the interior, lim-plastered walls and floors. Al-Mansura, the Friday mosque of which had a formal mihrab, became a metropolis celebrated for its palaces, gardens, mosques madrasas, As part of yet another raid on Multan in 1010, Afghan-Empire Mahmud of Ghazni 998-1030 destroyed the Sun Temple and annexed the province to the Ghaznavi Empire, Ghazni was the most important Islamic city of its time apart from Kufa (new Baghdad, and Hindustan was regarded as an almost inexhaustible source of treasure, it was also a recruitment area for troops, who were not required to convert to Islam as a condition of employment, by the 12th century Lahore, where Afghan-Dari was the language of the court and administration, was its most brilliant outpost in the Muslim subcontinent. Ghaznavi innovations in architectural form and techniques thus reached the Indian provinces, the new form of minaret with a tall and slender shaft, domes and pure arches in mosques and mausoleums, and the use of lime mortar.

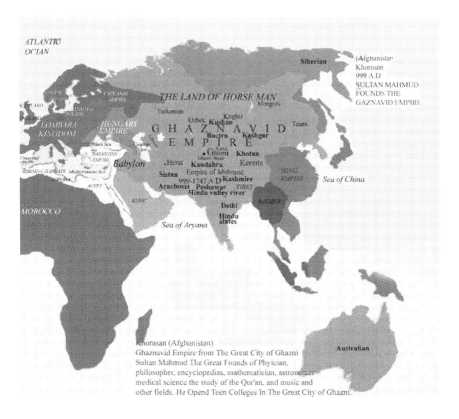

The Great Afghan Empires (sultanate) of Delhi

In 1181 Muizz Al-Da Ghuri (province of Ghurat) replaced the Gahznavi rule in India and began a series of dramatic conquests which brought India under Muslim rule, Delhi and Ajmer fell in 1192, the kingdoms of Benares and kannauj in 1194 and soon after Bihar and Bengal with its capital at Gaur. The Ghuri governor of Lahore assumed control of these dominions after Muizz al Din died in 1206, Khorasan, and (New Afghanistan) and established what became known as the sultanate of Delhi. This his successor Iltutmish 1210-1236 molded into a truly independent state, the sultanate of Delhi comprised five successive dynasties, the first of which was the "Slave Sultans" 1206-1290, followed by the Khaljis 1290-1320 the Tughluqs 1320-1414, the Sayyids 1414-1451, the Lodi dynasty from 1451- 1526 and the great Empire Suris (the lion king) 1540-1555. victories were celebrated by the construction of monumental architecture declaring the new dynasty,

first was the Friday mosque in Delhi, the Quwwat al-Islam, it was begun in 1193, with materials reused from Hindu temples which had been demolished six years later the combined skills of Afghan-Turkoman architects and calligraphers, and indigenous stonemasons, produced a great screen of finely dressed sandstone erected in front of the prayer hall, also started was the Qutb Minar, a victory tower to spread the shadow of God to the east and west, as the inscriptions proclaimed. The technique of salvaging temples was followed at Ajmer, where the Arhai-din-ka-jhonpra Mosque was built 1200.

Afghan-A.D. 1440 Jahaz Mahal, part of the main palace complex in Mandu-India after the governor of Malwa made himself independent of the Sultan (Empire) of Delhi, from 1406 he continued construction of the capital, the Jahaz Mahal exemplifies the splendid building style developed by Afghan.

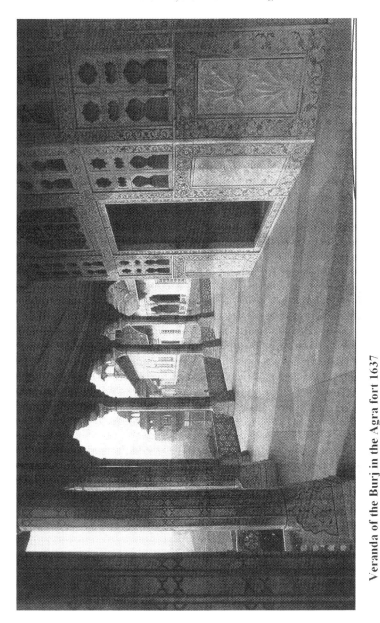

Veranda of the Burj in the Agra fort 1637
Burji is among the most magnificent< its dadoes are exquisitely carved with floral motifs also found in miniature painting and the border designs, similar to the Taj Mahal are inlaid with semiprecious.

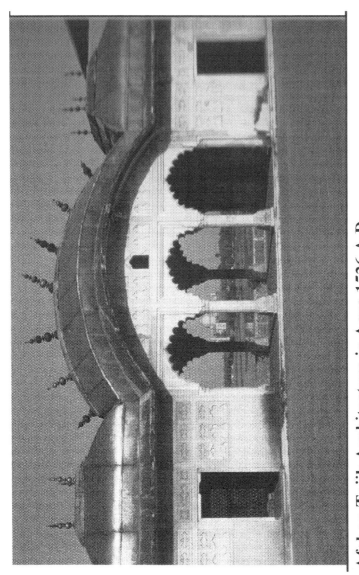

Afghan-Tajik Architecture in Agra 1526 A.D
Baburs described his architectural ambitions, but little remains beyond a few wells, garden pools, and three mosques

Afghan-Caravanserai in Punjab, 17th century Situated on the road from Ludhiana to Ambala in the Punjab, this grand caravanserai reflects imperial encouragement of trade Afghanistan-India

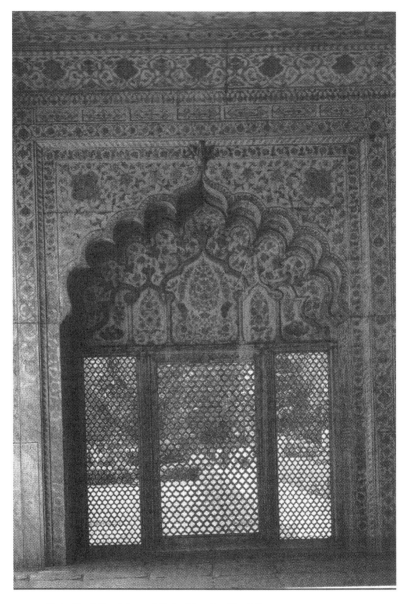

**Detail of the khass Mahal in the Red Fort
Shahjahanabad Delhi, 1639 Afghan-Tajik Empire
the khass Mahal seved as the imperial private
apartments. the River of Paradise flowed through
the central chamber**

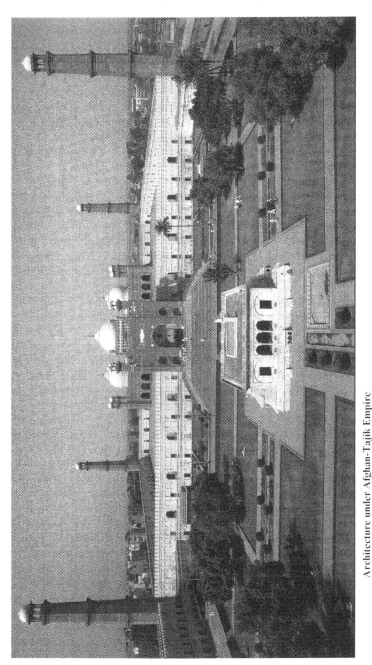

Architecture under Afghan-Tajik Empire
Badshahi Mosque, Lahore 1673 the King Mosque, constructed in the reign of Afghan-Tajik Empire Aurangzeb, is the largest Tajik mosque and the last great flowering of Afghan-Tajik architecture. Lahore suffered devastating invasions, in the 18th century.

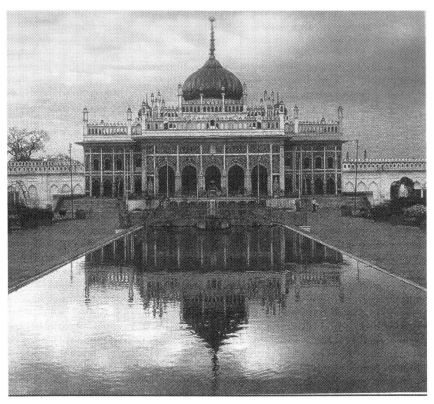

Afghan-Tajik Empire 1784
froms of religious architecture, often showing Deccani from the Tajik,
the capital at Lucknow

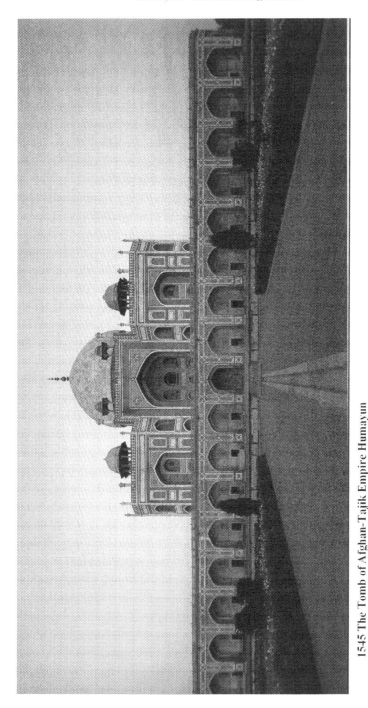

1545 The Tomb of Afghan–Tajik Empire Humayun

View and ground plan of the Tomb of Afghan-King Humayun, Delhi, Mirak Sayid Ghiyath and Sayid Muhammad. 1562–1571 the tomb of the second Afghan–Tajik ruler Humayun, was the first of the great Afghan–Tajik.

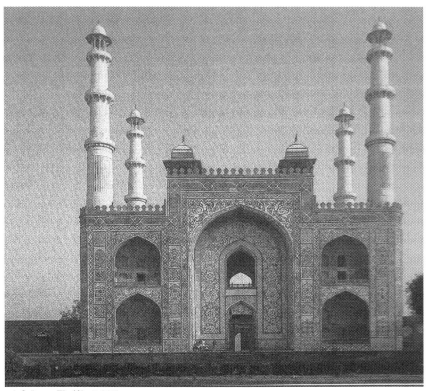

Afghan-Tajik 1612
Gateway to the Tomb of Empire Akbar, Sikandra,
the highly decorated surfaces were characteristic of
Jahangiri architecture

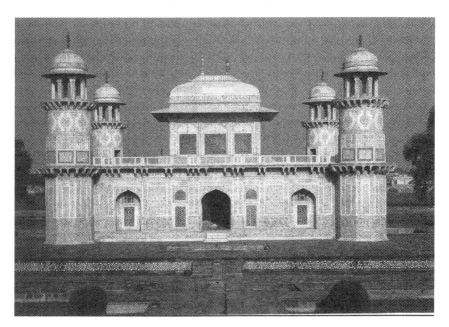

Afghan-Tajik Architecture Agra, 1626
Tomb of Itimad al-Dauala
This tomb was built by Queen Nur Jahan for her father,
Jahangir's vizier, and her mother Asmat Begam

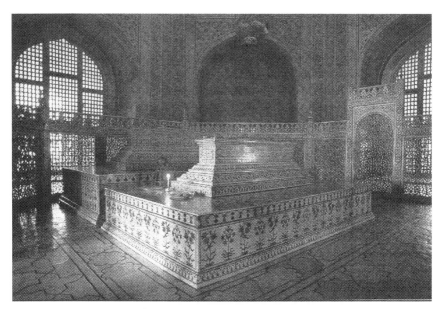

Afghan-Tajik Agra, 1632 Taj Mahal King and Queen
Cenotaphs of Mumtaz Mahal and Shah Jahan
the interior of the central chamber is decorated with translucent floral sprays
of semiprecious stones inlaid into the white marble

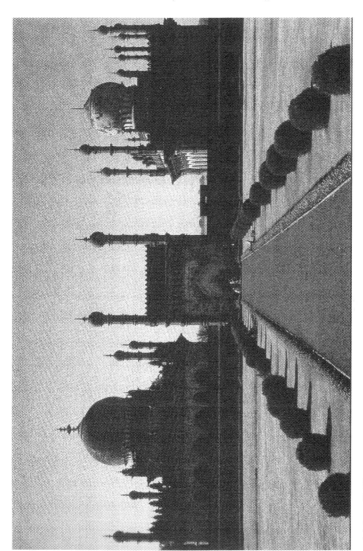

**Afghan-Tajik 1626 Architectural
Ibrahim Rauza Mausoleum.**
The tomb of Ibrahim Adil Shah II, originally intended for his wife, Taj Sultana, was used as
a family mausoleum.

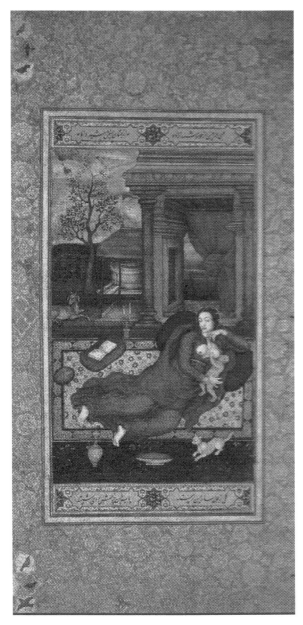

Afghan-Tajik 1590 Virgin and Child
miniature from a muraqqa album
Basawan

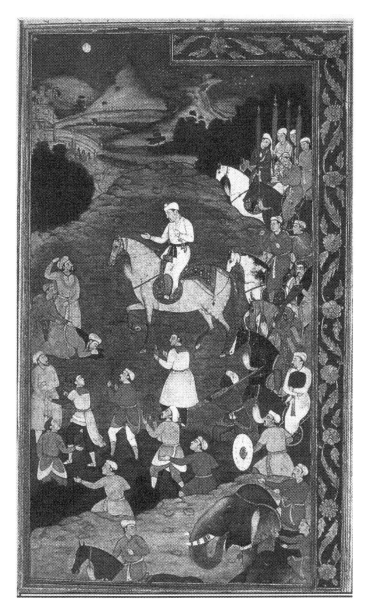

**Afghan-Tajik miniature
Akbar speaks to his people
of Abu l-Fadl, 17th century**

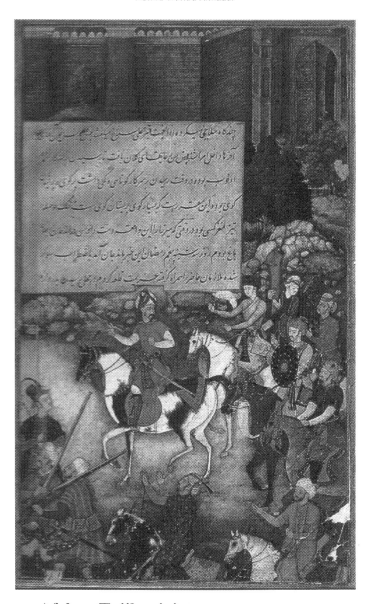

**Afghan-Tajik miniature
Babur approaching the fort
in Andijan on receiving news
of his father's accident**

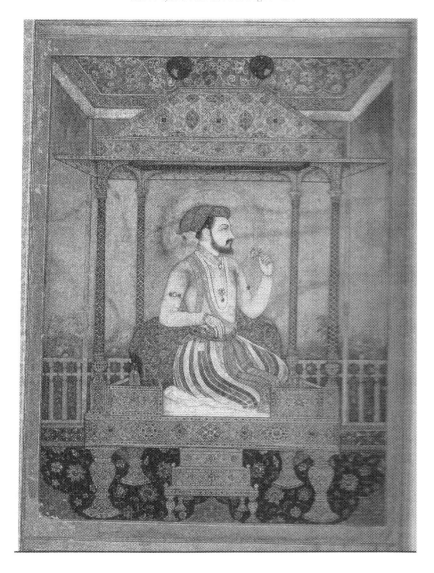

**Afghan Tajek-Empire Shah Jahan on the Peacock Throne Govardhan,
Afghan style 1635.**
Empire Shah Jahan on the Peacock Throne, first used for the New Year (22 March)
celebrations at the Agra fort in 1635, was transferred to the new capital
Shahjahanabad in 1648.

Decorative Arts, Calligraphy, and Painting
The Afghan-Tajik Empire's Babur the Emperor as Poet and Calligrapher
Khorasan (New Afghanistan-India)

Heart 1300 A.D the court of the empire Timuri was one of the greatest centers of book production in Heart, the early Afghan-Tajik emperors 1500 A.D revered the empire Timuri standards of excellence in Afghanistan until empire Akbar questioned the idea of accepting earlier models blindly, empire Babur 1526 himself was a calligrapher and poet in Afghan-Tajik, the Tajik' Dari, native language, and devised his own script using it to copy a Koran, which he sent to Mecca, like early Ghznavi empire in 1020 by the emperor, however, he did not have the resource, not perhaps the inclination, to develop a painting atelier, unlike empire Humayun, who retained a painter among his small entourage in exile in the Province of Heart, empire Humayun met calligraphers and artists, persuading several to join his court, Abdul Samad and Mir Sayid Ali established the court atelier, drawing to it religion painters courts, under their early supervision and empire Akbar's patronage, the Afghan-Tajik arts of the book were transformed for almost a century. Empire Akbar him self could hardly write and probably suffered from dyslexia his chroniclers described him as literally "unlettered" but he had an excellent eye and a good memory for the books which were read to him daily. As his chronicler Abu'l Fazl; "there are no historical facts of the past ages, or curiosities of science, or interesting points of philosophy with which His Majesty Babur is unacquainted." An extensive library was an essential requisite of sovereignty and by 1606 empire Akbar had amassed 24,000 volumes. They were catalogued and stored according to content, author, calligrapher, and language Dari, Hindi, Greek, Kufic (new Arabic) as well as the monetary value of the manuscript, among them were empire Timuri masterpieces inherited from empire Babur empire Humayun, and libraries acquired through conquest of the sultanates of Gujatat, Malwa, and Kashmir. Books were received as gifts, such as the Polyglot Bible prepared for the German Philip II of Spain, which the Jesuits brought when visiting the Afghan-Tajik court in 1580, the largest in a growing

corpus of European works, literati presented their manuscripts; the Dari translation of Babur's memoirs (baburnama) was received from the translator Abdul Rahim Khan in 1589. The library was expanded by the many volumes copied translated and illustrated by the imperial workshops. Project directors planned each manuscript and assigned the work to the papermakers, calligraphers, illuminators, gilders, burnishes, apprentices who prepared the pigments, and the painters. Empire Akbar guided the choice of subject and selected new cycles of illustration for the repertoire of Dari poetic texts familiar at the Timuri courts and had a weekly inspection of output conferring rewards according to the excellence of painting. Afghan-Tajik master from Heart calligraphers were welcomed, continuing an earlier tradition of migration to the sultanate courts where native-born calligraphers were trained by expert practitioners. Mir Masum Nami, a Afghan poet, physician, historian of Kabul, and Tajik ambassador at the court of Heart provided the chronograms and nastaliq inscription on the Buland Darwaza at Agra, Mir Dauri Katib al-Mulk of Heart work on the **Hamzanama**, empire Akbar's favourite calligrapher was Muhammad Husain Kabuli, called Zarin Qalam ("Golden Pen"), who copied the classical Afghan poetic texts essential to a Timuri king for illustration by his finest artists.

Empire Akbar believed in the power of the image and the didactic role of painting, the first major project of his reign was the **Hamzanama**, tales of chivalry and dentures featuring the Prophet's Uncle Hamza, then came Afghan-Dari translations of Hindu epics such as the **Razmnama** "Book of Wars" or the Ramayana, one could see the choice of works as a form of public relations to facilitate mutual cultural understanding, particularly in the harem, for empire Akbar's marriages with Rajput princesses brought non-Muslim customs into the heart of the imperial residence. A new genre was developed; illustrated histories and chronicles of the dynasty with the emperor as hero. The memoirs of empire Babur ("Baburnama") and the history of empire Akbar (Akbarnama) placed new demands upon the artists, requiring for credibility a realistic presentation of the principal personalities, material culture, and landscape involved. Empire Akbar sat for his likeness and ordered the nobility to do the same. He rejected crjected criticism from the orthodox with their own argument; "It seems to me that a painter is better than most in gaining knowledge of God.

Each time he draws a living being he must draw each and every limb to it, but seeing that he cannot bring it to life must perforce give thought to the miracle wrought by the Creator and thus obtain knowledge of Him"

Afghan Tajik Decorative Arts 1573
Mary sura, illuminated doublepage from a koran manuscript,
Only a few koran manuscripts of this quality have survived

Decorative Arts of Afghanistan
Early as the 2nd century B.C

Many contemporary texts describe the rich furnishings and objects used by the Empire Ghaznavi (in the Province of Ghazni 100 km west of Kabul) and Empire Ghuri courts (in the Province of Ghuri 900 km west of Kabul) but surviving finds give only a skewed sample, know of no textiles that can be clearly associated with the period, archaeologists working at Province of Bust and Province of Bamiyan green-glazed pottery, and the palace at the Province of Ghazni yielded some

monochrome glazed tiles decorated with animal motifs. Most of this pottery is second-rate especially in comparison to the superb frit wares produced at in Khorasan (New Afghanistan) at this time. The Ghazavi Empire and Ghuri Empire certainly used fine ceramics, but they seem to have been content to import porcelains from East Turkistan (new under Chinese rule) or lustre-decorated frit wares from Afghanistan.

Art of the Book Early as the 2nd century B. C

Tow arts in particular flourished under the patronage of the Ghaznavi Emperor and Ghuri emperor the art of the book and metal wares. Sources indicate that some books were illustrated with pictures, but none survives. We do, however, have several examples of fine books illuminated with no representations decoration, especially headings and fronts and finis pieces. Some of these illuminated manuscripts were made for the court of the emperor. All of these books are transcribed on paper, Papermaking, which had developed in Aryana ("New Khorasan-Afghanistan) as early as the 2nd century B. C when it was quickly adopted by the Abbasid invader bureaucracy in Kufa (new Iraq. The province of Khorasan was famous for its papermaking throughout this period. One of the first dated books to survive from Khorasan lands is a text about the physical and moral characterises of the Prophet Muhammad **Kitab khalq al-nabi wa l-khuliq**, composed by a certain Abu Bakr Muhammad ibn Abdullah, according to the colophon, it was transcribed in the province of Ghani by Abu Bakr Muhammad in Rafi al-Warraq (the copyist) the Gold ex-Libras on the front names the Ghaznavi emir Abd al-Rashid 1049-1052 A. D so the manuscript is datable to about 1050. It is a small volume with pages measuring 9.6 x 6.6 inches 24.5x16.7 centimetres and nine or ten lines of **Naskhi** script on each page. Titles and the line of the colophon are done in Thuluth, this book is one of the earliest surviving manuscripts written in these round scripts, which had been used in the chancellery since early Afghan Islamic times but were only adopted for fine calligraphy in the 10th century in Afghanistan. The text belongs to the Hadiths (traditions) reports about the words and deeds of the Prophet Muhammad as passed down through the generations, which would

have been of great interest to the Ghaznavi rulers in Afghanistan, who were pious Muslims.

The Ghaznavi Empire and the Ghuri Empire ordered fine presentation copies of the Koran made for the many mosques and madrasas they endowed. These Koran manuscripts were copies in several styles of script. The Bibliotheque National in Paris, for example, owns part of a large manuscript transcribed at Province of Bust in Afghanistan in the 505 hegira (1111). The 125 page section that has been preserved contains the fifth of a seven-part Koran, each large page 8x6 inches (20x15 centimetres) has seven lines of text surrounded by cloud panels, with the background filled with scrolling arabesques. Text is transcribed in a fluid round hand with many connectors it has been identified as a rare example of the script known as **tauqi**. Heading and other incidentals are written in another distinctive script, often known as "bent Kufic" this cursive script had been canonized by the Abbasi vizier Ibn Muqla d. 940 and later became popular for lager Koran manuscripts transcribed in the Khorasan (New Afghanistan) Islamic lands.

Manuscript of the Koran Province of Bust Afghanistan
1050 Ghaznvi- Empire of Ghazni

One example of a large manuscript is a copy of the Koran transcribed by Abu Bakr Ahmad ibn Ubaydallah al-Ghaznawi in year 573 of the **hegira** 1177. the same scribe penned another, similar copy of the

Koran dated in Ramadan of the year 566 June 1171, and now in the Dar al-kutub, in Cairo his nisba, or epithet of affiliation, al-Ghaznawi, shows that he was associated with the Ghaznavi's who maintained control of some parts of the region until 1186 A.D with the city of Ghazni, which had been under Empire Ghuri control since 1161. The distinctive broken cursive script had been used for large Koran manuscripts since the end of the 11th century, one of the earliest dated copies to survive Mashhad, Astan-I Quds no 4316. was completed by Uthman ibn Husain al-Warraq in the year 466 of the hegira 1073/74, the manuscripts by Abu Bakr are some of the latest known, for after this date broken cursive was relegated to heading and other incidentals, the high cost of these large manuscripts in broken cursive is conveyed by their spaciousness and rich illumination. The copies by Abu Bakr have only four lines of widely spaced text per page, an extravagant use of paper. Much of the illumination is painted in Gold, and the background is laboriously filled with scrolling arabesques. These sumptuous and extravagant manuscripts must have been made for the empire court, since few could after such luxury.

**Title page of the kitab khalq-alnabi wa -I khuliq
by Abu Bakr Muhammad ibn Abdullah Ghazni 1050
Abi Rafi of Ghazni**

**Page from a Afghan manuscript of the Koran
11th century Ubaydallh al-Ghaznawi**

Afghan-Tajik miniature 1562
The Prophet Elias rescuing Nur al-Dahr from the sea,
Mir Sayid Ali, miniature from the Hamzaname manuscript,

Folios of calligraphy were also bound in the albums with borders decorated with vignettes of court or country life or floral motifs, empire Jahangir particularly liked Nastaliq script and collected folios with pious sayings or pithy Afghan quatrains by the calligraphy masters Sultan Ali 1519 the Sultan al-Khattatin ("king of Calligraphers" and Mir Ali Haravi of Heart 1556, contemporary masters were commissioned to execute manuscripts or monumental calligraphy, for example Abdul al-Haqq Heart designer of the Naskhi and Nastaliq inscription on empire Akbar's gateway and mausoleum at Sikandra, he also designed the extensive koranic inscriptions in Naskhi on the Taj Mahal for empire Shah Jahan.

Most remarkable was the output of bijapur under Sultan Ibrahim Adil Shah II 1579-1627, one of the great patrons of his time, himself a musician and poet, and a mystic inclined to the essence of both Muslim

and Hindu thought, he sought to attract to his court the most creative artists, writers, and thinkers from throughout the Afghan world calligraphers included the master Mir Khalilullah Shah, of Kabul, was rewarded for his work by the Padishah-I qalam ("king of the Pen") and the right to sit on a throne, Ibrahim's mausoleum exhibited an extraordinary range of calligraphic styles, including, Kufic (new Arabs) square kufic, Thuluth, Naskhi and Nastalig, all superbly sculpted in hard black basalt.

The calligraphy of the Deccan surpassed that in all other areas of Khorasan, (New Afghanistan-India) and the sarcophagi of the Qutb Sultan at Golconda show a similarly amazing quality variety of inscription as at Bijapur, Painting in Golconda was also rich, the several coexistent styles retaining their vitality well into the 17th century after the sultanate had to recognize the authority of the Afghan-Tajik in 1635, it absorbed their influence creatively, following empire Aurangzeb's conquest in 1686 and 1687, Afghan-Tajik influence became more dominant for a while, but by his time it was combined with the Rajput idiom of Bikaner and Jaipur which at Hyderabad evolved into a charming courtly style the turn of the 19th century when the German Saxon (New British) art and architecture became the fashion.

Paqmani-Kabul

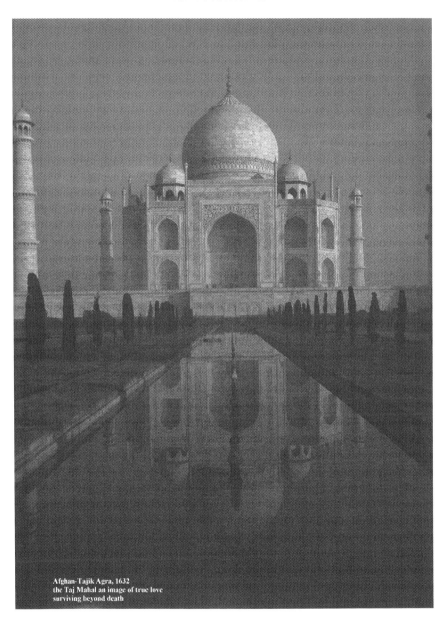

Afghan-Tajik Agra, 1632
the Taj Mahal an image of true love
surviving beyond death

Agra, 1632 Taj Mahal, designed by the Afghan Architects Ustad Hamid
View of the Portal Palace in the Park of the Taj Mahal,
One of the most emportan Afghan-Architects in the world History of Architects
fron the 15th century untli today in 2008

Afghan Gardens-of the Tajik Empire
This garden model was for the political
capital in the 10th century
The Garden as a Reflection of Paradise

There are gardens at both the beginning and the end of mankind's destiny the Garden of Eden and Paradise and this is equally true for Muslims, Christians, alike. The Koran gives detailed descriptions of the eternal garden, which is "as large as heaven and earth" and "in whose hollows brooks flow" in it stand "thorn less trees that spread their shade" with "fruits hanging low in clusters," and it is where the "Blessed, richly clothed, lie on couches lined with thick brocade" it is a garden of many springs, with rivers flowing with water, milk, honey, and wine ("that does not intoxicate") many of its springs are spiced with camphor or ginger, and their water, mixed with wine, is handed to the faithful by "boys graced with eternal youth" and "large-eyed, chaste hours," the Paradise virgins with "swelling breasts" comparable to "hidden pearls,"

Paradise appears to be a garden landscape enclosed by a wall, since both gates and gatekeepers are mentioned. Sura 55 tells of two similar gardens beside which lie another two different gardens, all four of them possess flowing springs, shady trees, exquisite fruits, and beautiful hours. There are also tents and buildings in the heavenly garden; dwellings, houses, castles, and chambers among which are "rooms in which streams flow," but all these buildings are scattered throughout the garden and in no way resemble a city, denote Paradise, Jannat ("garden," pl. Jannat) is the most common, Eden is called either and or Jannat and, there is frequent is mention of a garden of delights (Jannat nam) a garden of refuge (Jannat al-mawa) and a garden of immortality (Jannat al-khuld) the word roud is also used to denote the heavenly garden, but only a little later, in connection with Prophet Muhammad's grave "Garden" has also been etymologically linked with "cemetery," almost from the beginning. Our word "Paradise" derives from the Afghan term firdaus (Pairi,"around" and daiza, "wall") via the Greek paradeisos. The relationship between garden and Paradise in the Koran is very clear and well formulated; however, it would be wrong to consider the very real Afghan art of the garden exclusively as often

happens in a religious and literary context. Between heaven and earth there is a multitude of diverse and beautiful gardens,

The Koran gives no precise guidelines for the creation of a garden, all that can be inferred from the sacred text is the importance of shady trees, flowing water, a protective outer wall, the scattered richly decorated buildings that adorn the landscape, and the absence of flowers, grottoes, the Afghan parades parks if only from the accounts of others, in the Maghreb, Since the majority of Islamic countries are located in hot, dry regions with an oasis culture, one of the main problems of the art of the garden has always been irrigation, both the western and eastern parts of the Islamic world had inherited the qanawat system from Afghanistan.

Afghan-Tajik 1560s
The Empire Jahangiri Mahal was constructed by Empire Akbar as a residential palace for ladies of the royal household

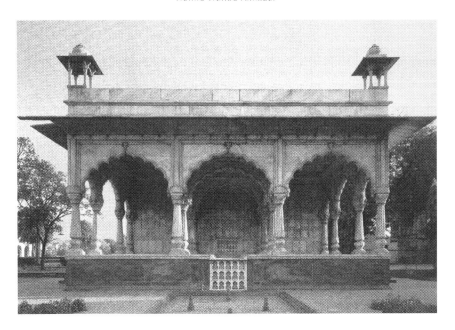

Sawan Pavilion in the red fort completed in 1648 the fort developed into a city within a city, with a large bazaar and workshops, to satisfy the requirements of the court, the private areas of the Afghan royal family's palace apartments included gardens with pavilions cooled by flowing water and cascades.

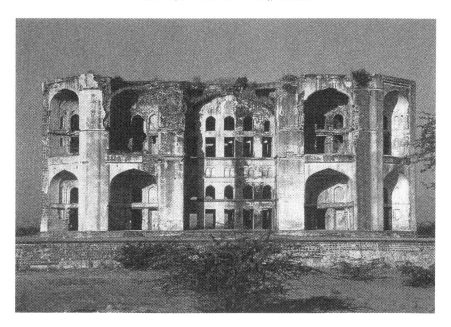

Farah Bagh ahmadnagar, Deccan, 1576-1583

The Deccan established its independence from the Delhi Sultanate in the 14ᵗʰ century and during the 15ᵗʰ and 16ᵗʰ centuries it was subdivided into smaller states where the architectural forms introduced by the Afghan-Tajik elites were modified by indigenous traditions, this monumental palace in the center of a large tank, built as an irregular octagon prototypes in its scale and the deep ogee arches.

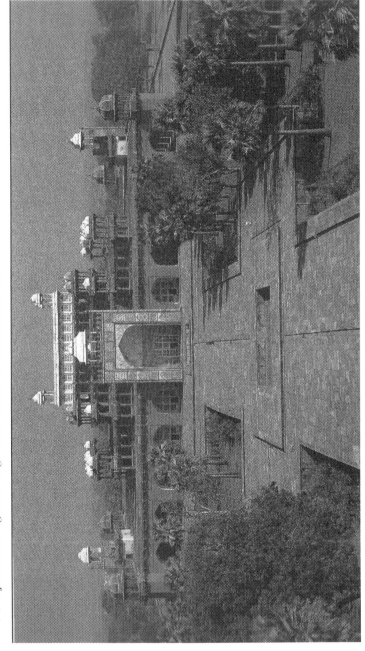

Afghan-Tajik 1614
Tomb of Akbar, the gardens of the Afghan-Tajik emperors
the Tajik interest in garden design was not limited to funereal architecture

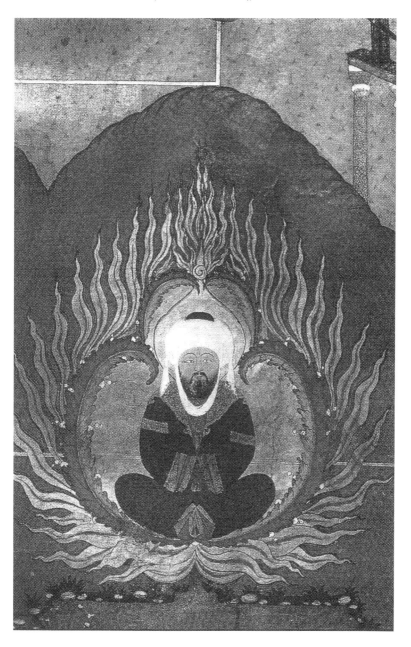

**Balkh 1583 miniature
The Prophet Abraham**

Khorasan (New Afghanistan) 12th century Literature and natural sciences In Balkh-Herat-Bukhara Literatures is 3000 years old Vedas, Zoroastrians, Buddhists, Sanskrit

As in many cultures, literature, in the classic centuries of Religion, mostly in Afghani-Dari, was a major source of inspiration for the Arts, most of it was highly secular in mood and subject matter, although, especially in the case of Afghan-Dari lyrical poetry, mystical thoughts and attitudes can be clearly detected, just as poetry itself an impact on the symbolism of mystical writing, the ways in which literature inspired the arts can be discussed in three different ways. The first, and most obvious one, is iconographic, Literature subjects inspired artists working in many different media "ceramics, wall painting, metalwork, even textiles" while from 9th century onward, book illustration became a significant artistic activity in Khorasan (New Afghanistan), the variety of genres illustrated was considerable and only a few of the most significant, Abu Zaid, the illustrations of the various manuscripts, executed over a period of a century and a half, aimed to depict the stories involved, and through them, the urban milieu in which they were supposed to have taken place, the epic Sahmama ("the king's Book") composed by the Afghan-poet Firdausi d. 1020 A.D around the year 1000, consists of a heroic and largely mythical history of Afghanistan from the time of Creation to the beginning of Islam. Its many stories of the Afghan kings weirs, battles, feasts, and love lent themselves to illustrations, of which hundreds have survived from the end of the 13th century onward, most of them exhibit a dramatic mood and a highly symbolic rendering, the Afghan animal fables **Kalila wa-Dimna (Kalila and Dimna)** translated in the 8th century from Afghan-Dari into Arabic by Ibn al-Muqaffa, are in fact a "Mirror of Princes" used for the moral and political edification of rulers, but they contain wonderful anecdotes, which are illustrated in Afghan-Dari as well as Kufic (new Arabic) manuscripts, and as a final example, one must mention Afghan-Dari lyrical poetry, especially the beautiful romances known as the Khamsa (Quintet) composed 1200 by the poet Nizami d. 1209, from the end of the 14th century, these were often illustrated, as were also, but more rarely, the poems of the Afghan Hafez d. 1389. histories were occasionally illustrated,

although, for the most part, they hardly qualify as literature; several examples exist of illustrations provided for the moralizing stories of the mystic poet Saadi 1229-1292, enormous variations exist between these texts and the ways in which they were illustrated, as a general rule, imagery was created which directly reflected the written content but, over the centuries, complex relationships developed between images relating to different texts, most of this iconography was restricted to book until fairly late in the 17th century, and except for the epic stories of the **Shahnama**, there is little evidence that it was used in wall painting or in other forms of decoration. Altogether although not as varied nor as huge as the repertoires found in religion art, the primarily scapular of Afghan painting provides examples illustrating a vast range of historical, legendary, and romantic events. The second way in which literature inspired the arts is more interesting than a simple recital of topics, as early as the last decade of the 12th century "at least insofar as preserved examples are concerned", literary works were used to express messages other than simply the illustration of a story, many manuscripts were provided with frontispieces and dedications intended to reflect the glory of ruling princes. They could also be used as lessons in statesmanship, and in many instances, served as ways to recollect, and to interpret, contemporary events through reference to past heroes, satire could also be a feature, as in 13th century Afghani, some 15th century Afghans-manuscripts, and especially from the 17th century onward, in the depiction of individuals. It is possible to argue that as literature inspired painting, it also used painting to make itself more immediately responsive to the pressures of any one time; Painting permitted constant aggiornamento, and thus the continuing relevance of Afghan-Literature. The deep involvement of Afghan speakers in their literature affected art in yet another way, as early as the 7th century; debates discussions arose on literature topics, the qualities of poets or writers, and the hierarchy of the genres they used. Literary criticism became the subject of theoretical analysis, and of endless debates, some of this analysis, such as that of al-Jurjani in the 11th century dealing with semantics or with metaphors and their psychological effect, or of Ibn al-Rami in the 15th century aiming to define beauty by describing ideal women, can be used to understand art. Just as with philosophy and the natural sciences, it is unlikely that many of these often abstruse

theories of literature were commonly held or even known the general public. Their existence in written works is, however, certain, and through them it is possible to imagine the critical climate within which art was created. A word should finally be added about a literary genre which, mostly, emerged after the 15th century, and apparently, was restricted to the Afghani world. As exemplified by Afghani artists like Qadi Ahmad, Dust Muhammad, and Sadiqi Beg, the Afghan artist's autobiography is the most important factor understanding Afghan painting. Such personal artistic statement became particularly common in the Afghan-Tajik period in India, where the memoirs of the Afghan rulers, like the Babur-nama (Book of Afghan-Tajik Babur) in which the Afghan emperor Babur recounts the story of his Kabuli-life and his opinions on nearly everything, are essential in constructing the framework within which the Kabuli arts can be understood.

Shrine of Sheikh Salim Chishti, fatehpur Sikri, 1580

Situated in the courtyard of the Friday Mosque, the shrine are similar to earlier tombs in Gujarat a Mandu, a single-story square chamber surround by an enclosed corridor for circumambulation.

Muhammad's wet nurse Halima breastfeeds the orphaned child
Turkman miniature 2nd half of the 16th century
Muhammed was born in Mecca in 570,
(Museum of Istanbul)

Miniature, Art of Ghaznavi most important in the world history

Miniature from the Siyer-I Nabi 16th century
The long section dealing with the Afghan-history

In contrast to illustrations in earlier manuscripts, which are generally square, most of the illustration to the historical text horizontal strips occupying about one third of the written surface of each page, indoor scenes are usually tripartite composition but outside scenes are more varied, as artists attempted to expand the pictorial space. Figures at the sides are often cropped, lances, lances and hooves project beyond the frame into the text area, and figures occasionally turn directly toward or away from the viewer, landscape elements such as clouds, trees, mountains, and water (depicted as imbrications), were modeled on Turkmen prototypes, as the technique of black ink heightened with collared washes. Other features, however, which Ilkhani artists might have known from manuscripts and painting, a scene such as the Birth of the Prophet Muhammad, for example, is loosely based on a depiction of Christ's Nativity, probably because such a scene was not of the standard Islamic repertory, another new feature of his manuscript is the selection of certain narrative cycles for illustration so that the paintings became a visual commentary on the text. The section on the Ghaznavi's 1020 A.D example has the most, the largest, and some of the most inventive illustration in the Afghan manuscript. By contrast, the long section dealing with the Afghan-history of the Afghan-Empire, the decided preference for the Ghaznavi, who in the larger scheme of the world history, the important role of illustrations continues in the finest Afghan-manuscript made by the next generation, a large cope of the Afghan national epic made in the 1330s. Now dismembered and disperse, the Great Afghan-Shahnama originally had some 300 illustrations and was bound in two volumes in the great city of Heart. The painting are larger than those in the world history, sometimes taking up almost half the page, and the formats are more varied, sometimes with stepped frames, the compositions have been expanded to include more figures and deeper space, the greater size of the illustration seems to have encouraged artists to integrate larger figures into more developed

landscapes than are found in earlier illustrations, for example, the scene showing the Bier of Alexander is still based on a tripartite scheme, but the central are inspired by figures in European representation of the Lamentation, but the artist has combined individual elements to create a dramatic sense of pictorial space unknown in the earlier illustrations made at rashi al-Din's scriptorium. Another scene from the Great Afghan Shahnama, depicting Alexander's iron cavalry battling the Indians, can taken to exemplify not only the arts of the book, but also the Afghan-Tajik period as a whole, to counter the huge elephants of the Indian army, Alexander devised the ingenious strategy of an iron cavalry, wheeled metal horses and riders filled with naphtha, the artist has dramatically depicted the scenes with expensive pigments; the iron soldiers are painted in silver, their nostrils breathe flames of gold, Alexander's horsemen dressed in laminated armour of Turkmen and casqued like helmets, bear down on the black-faced Indians who wear striped tunics, the figure on the upper right glances backwards over his shoulder, leading the viewers to imagine pictorial space beyond the picture plan.

Afghan-Tajik 1574
View from the Panch Mahal into the inner palace area of Fatehpur Sikri
the palace city an area of numerous courtyards and gardens,

Afghan–Tajik 1639
Gateway to the Red Fort of Shahjahanabad Delhi

**Afghan-miniature Bihzad 15th century
Herat A Muslim giving alms**

Afghan miniature 1700 A.D
Jesus on a donkey and Muhammad on a
camel, riding together
from a work by al-Biruni

Afghan miniature 17th century
Muhammad and Abu Bakr in a cave

Afghan-Tajik Architecture 1637
Musamman Burj in the Agra Fort
the Agra Fort was constructed
for Akbar by Qasim Khan in 1565

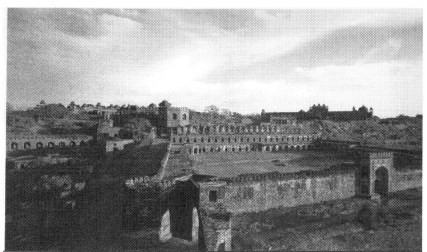

Afghan-Tajik Architecture 1569
Fort and palace areas of Fatehpur Sikri
Situated 38 km west of Agra fatehpur Sikri served as capital together with Agra
until the court moved to Lahore in 1584

Afghan-Tajik The Qutb Minar 1199 this Tower of Victory erected by Qutb al-Din Albak following the model of the minaret of Jam

The Great Afghan-Tajik Mosque of Delhi
1199 A. D

The best surviving Afghan-example of a Ghuri (province of Afghanistan) Friday mosque is that erected at Delhi by Qutb al Din Aibak, ("from the province of Aibak in Afghanistan") commander of the Afghan region for Muizz al Din Muhammad. Known as the Quwwat al-Islam ("Might of Islam") it was the not the first conquest India ("Afghan-religion-mosque built in Delhi after conquest of India from 1000 B.C until 1877") construction in the 1199s on the site of a Hindu temple. Like pre-Afghan-Muslim temples in the region, the mosque is set on a raised platform reached by staircases on sides; the Mosque itself comprises a large open courtyard surround by halls supported by columns reused from ancient temples. The available columns were not tall enough to create a lofty space, so two or even three temple columns were set on top of each other to gain the necessary height, the columns supported beams, which in turn supported a flat roof, the traditional tabuled construction technique found by Afghan (Aibak) because of the warm climate, the building was largely open to the elements.

This original mosque in Delhi was obviously unsatisfactory and was quickly modified. In 1198 Qutb al-Din Aibak ordered an arched wall added to screen the prayer hall in front of the courtyard. The screen consists of a high and wide central arch flanked by pairs of lower and narrower arches. Because the local masons did not know how to build true arches, which were unknown in India, they had to imitated them with corbelling, in which each course of stone is projected out slightly from the one below until the courses meet in the middle, A corbelled structure, however, cannot support any weight, so it could not serve as a support for a dome (as would have been the case elsewhere) and the arch serves only as a screen to mask what lies behind it. The Aibak screen is richly decorated with naturalistic vines and calligraphy, this carved decoration shows how native masons adapted local techniques to serve the needs of new Muslim patrons. Hindu and Jain architecture erected often decorated with exuberant figural sculpture, including gods and goddesses with multiple arms and legs. Muslims naturally found this idolatry horrific, so offending images were defaced on reused materials, and purely vegetal and geometric ornaments were carved on

new construction, the mosque at Delhi was insufficient to meet either the size of the rapidly growing Muslim population of the city or the pretensions of the local rulers, who also saw public architecture as a fitting symbol of their expanding power. In 1199constrution began on a huge sandstone tower known as the Qutb Minar. Like earlier towers erected by the Ghaznavi and Ghuri in Afghanistan, the Qutb Minar comprises several superposed flanged and cylindrical shafts decorated with inscription, and separated by balconies carried on Muqarnas corbels, later rulers added more to the tower, so that by the time the fifth story was completed in 1368, the tower soared an amazing 238 feet (72.5 meters) Aibak had been the architect of the Afghan-Ghuri Emperor conquests in India, but after his master Muizz al-Din Muhammad died in 1206, Abak assumed independent power, with the title of malik (King, ruler) his son-in-law and successor Illtutmish 1211-1236 severed the Indian provinces from the Afghan-Ghuri domains and was the real founder of the dynasty of the Delhi sultans. To mark his authority and to meet the demands of the expanding Muslim population of Delhi, Sultan (empire) Iltutmish tripled the size of the Quwwat al-Islam Mosque so that it measured some 230 x 330 feet (70x 100 meters) with the enormous Qutb minaret standing in the southeast corner of the courtyard. It took several decades to carry out this gargantuan project, which was completed only in 1229.

Herat 15th century miniatures

Herat 1427
Humay sees the portrait of Humayun
in the magic palace herat

DIWAN SULTAN Hoseyn Baykara Herat 1500 A.D. Sultan Ali

Sultan Husain Baiqaras Herat 1468-1506
The World most important history of Miniatures-Bihzad 1460-1535

As a general rule the main scene of the action has been cleared of trees, rocks and peripheral figures, the latter take on the role of extras who have been pushed to the edges of the miniature, the miniatures produced in Herat during this time are distinctive for their rich, rhythmical drawing, which stems from the strong lines given to the colourful, the multiplicity of details of differing sizes, and the spatial focal points. This rhythm was beginning to be adapted to the subject of the illustration; in the audience scenes, for example, the drawing is measured and slow, in the hunting and battle scenes, it is more dynamic, the elaboration of rhythm in the miniature is another of the important achievements of the Great City of Heart school of the 15th century, also remarkable is its use of color, the richness, purity, and harmony of which are particularly captivating, as is the perfection of the lines which outline every detail and give each one a sense of completeness and independence. Another center of intensive cultural activity was in The Afghan-Capital of Samarqand, which was under the rule of Timur's Afghan-Uzbek Empire's grandson Ulugh Beg 1409-1449, while the few surviving Samarqand work from 15th century do not give a complete picture of the development of the miniature there they do demonstrate the high standard achieved by the miniature in this region, its originality its magnificent execution, and its pronounced decorative construction, it is characterized by three special features. Firstly, its space is only sparsely filled in complete contrast to the Herat composition, in which every available space is used and everything worked out in great detail, secondly, its composition has a strong sense of order and clarity, based on clear vertical and horizontal lines and thirdly, Samarqand miniatures feature a relatively small number of figures, which in turn are so self contained that not even a hand movement is able to dissipate this sense of self containment, all the miniatures radiate a sense of complete peace, and the use of large areas of color gives them a special painterly beauty. During the first half of the 15th century, contact was established between the cultural centers of Heart and Samarqand, which explains why similar characteristic

are evident in the miniatures of each school, because they developed within the Timuri empire, which embraced a large number of different, they were able to gather in a wide variety of Afghan experience of the most divers styles, and this was the basis for the glorious flourishing of Afghan painting that took place in Heart in the 15th century **under Sultan Husin Baiqaras 1468-1506.**

The multiplicity of painting genres and the individual stamp of the artists are both features of Herat miniatures from this time, **Bihzad, Mirak, Khoja, Muzaffar** Shah and Qasim Ali all belong to the group of great Afghan-Miniaturists active in Herat. The most famous of them was **Kamal al-Din Bihzad,** whom the **Swedish scholar F. martin called a "Raphael of the East"**

Bihzad 1460-1535 was closely associated with the circle surrounding the poets **Jami** and **Nawai**, whose claim that their work was an artistic interpretation of daily life was a strong influence on his painting, in each of Bihzad's miniatures an interest in people and their lives and the attempt to depict these as fully as possible can be seen for the first time in history. In particular he extended the boundaries of the "represent able" world; the limited space of the miniature now took in not only a multiplicity of individually characterized men and women, whose positions were precisely calculated, But also architecture and gardens, streams, reservoirs, and mountain landscapes.

Bihzad worked out an ideal relationship between all the different elements of the composition by subordinating them to a unifying rhythm and making everything geometrically self-contained. He gives the representation of the room a great depth and sebse of reality than it had before, his architecture is more three-dimensional and varied, the architectural decoration fascinates with its delicacy and the splendour of its details, its richness of color and the sparkling of its liberally applied gold. Bihzad and his circle were especially fond of light pavilions and tiled courtyards, separated from gardens by red wooden fences and gates with open carving. In landscapes, plans trees in their spring foliage ("seldom their summer one"), slender cypresses, blossoming spring trees, and young poplars, were all characteristic of their work. Also frequently encountered are tree stumps springing new shoots, bushes of dried twigs, irises, green glades, small watercourse with stones on

their banks under which flowers are growing, large-leafed plants, and rocks of various colors with fine, jagged contours.

Afghan miniature Herat Timur on his Throne Timur officially began his rule in 1370

The bier of Alexander the Great manuscript of the Shahname by Firdausi 1335 Gasni Afghanistan

علیها النار وتمام ثلاثة ایام بلیالیها ∗ ثم اضعها بیدو ماحرا وانتحیها نحا
قد صعد علی الوجه جوهرا کاند الحفیظة البیضاء محذها ∗ واعلم انک قد حزت
ملک الدنیا ∗ فاخرتها فی انآ زجاج ∗ واحکم الوصل بکلما تقدر علیه ∗ فا
الحکمه بالشد الجید ∗ لیلا یروحن ویفرمن ملک فاعلم ذلک ∗ ثم خ
من الحجر الاو لطری فاغسله واجعله فی فرعه وانبیو الی اثلثها او نصفها بلای
ورکب علیها الانبیو الواسع المزراب والحکم وصلها واو قد علیها نارا لبن
مثل حرارة الشمس یطلع الما صافیا ∗

فاعلم یا ولدی ان کانت بارک
مدین طلع الما اصفر مطرب الی الحمن نیکون منسد
نیکون بارک برشد نال ما ترید بسرعه بمشیة اللهو عون
ی اعزل المعل حتی نحتاج اله ثم خذمن ذلک الما
بیمن عشر دراهم التی منها ثلاثة دراهم ونصف من ذلک النشادر کا لا ینحل د
یمیز فی اثد یامن من اللبن الحلیب وهوالذی یقال لدابن العذری فاجعله
ح المعقد ولحکم وصلها بالطف ثلاثة ایام بلیا لیها باین ما تقدر علیه و
لقاده لیس نطلع فی النعدم المونان عرقه ابته ∗ فاعلم انه انعقد وثم ضف

**Tortois and two cranes
13th century Afghan
Painting**

KHORASAN (NEW AFGHANISTAN)
The Rise and golden age of the Afghan Uzbek Empire 1500 until 1700

The Uzbeks were religions Turkoman, Tajiks from the steppes, Afghan-made up of around twelve different tribes who had formed themselves into a confederation under leadership of a member of Tajik dynasty; they led a nomadic existence on the Kipchak steppes, roughly the area occupied by present day Kazakhstan. The Shaybanid, Uzbeks, under Muhammad Shaybani khan 1500-1510, conquered cultivated Afghan regions further south, lying in areas occupied by Uzbekistan in the north Afghanistan, Mawarannhr, as it was then called, between Syt Darya amuDarya Rivers, and parts of the old Afghan region. The Kazakhs had pulled back out of the confederation of tribes and remained "by the German, their most powerful Cousins empire's The German Saxon first cousin's empire, The Kaiser, The King and Tsars of Russia 147 years of war," remained freely roaming (**qazaq**) lords of the steppes, between three and four million people may have lived in the conquered regions, and these can be roughly divided (leaving aside a bilingual upper strata) into two man population groups; Tajik, Pashtun, speaking city dwellers and farmers in the fertile, irrigated oases, and Turkoman-speaking in the rest of the hinterland. The army of the Uzbek conqueror numbered 50-100-000 men, while the tribal confederation itself amounted to perhaps 200-400,000 individuals, once more and for the last time on such a large scale, the people, of the Afghan steppes had succeeded in exploiting the military potential of their Afghan-tribal organization and turning the mobility and strike power of their Afghan-horsemen, which had been repeatedly tested in smaller pillage-and plunder raids, into a lager-scale assault on the main centers, the Afghan-cities.

Afghan-Uzbek Cultivated Conquerors

Despite the competition the existed between them for power and pasture land, the Uzbek were in fact quite close to the population groups of the conquered territories in terms of language and culture, the urban nature of Herat dynasty 1361-1500 civilization, on the other

hand, would initially have been quite alien to the migrant nomads from the steppes, this distance did not result in the malicious devastation of arable land the cities, however especial as the Uzbek Amir ("king") were apparently quite open to the benefits of urban civilization from the very beginning, and quickly tried to shake off the stigma, which became attached to the Afghan-Uzbek in his new surroundings, of being a backwoodsman. The great conqueror Muhammad Shaybani had already lived in the cities of Astrakhan and Bukhara northern of Afghanistan for periods as child, and had later had contact with Herat princely courts, even one of his enemies in trying to represent the capture of Heart in 1507 as a catastrophe, stops far short of depicting him as a crazed annihilator. What was upsetting was that this half-educated man from the steppes behaved like a connoisseur of refined city culture, had the extreme arrogance to lecture the religious scholars on the Koran, attempted to create an image of himself as a poet, and took it upon himself to "improve" out and out masterpieces of miniature painting and calligraphy with own hand.

In the second generation of Shaybani, this adoption of the city courtly ideal, originally regarded as crude and foolish, was accompanied by tutoring and polishing from experienced local masters, these spiritual masters, recruited from the Naqshbandi order, also continued to maintain the closest of relationships with the ruling dynasties from this time on. Alongside them was a throng of artists and intellectuals from Heart circles who had lost their positions and were now engaged at various Uzbek courts as princely tutors, "cultural representatives," and "image consultants," they were so successful in imparting the Afghan-culture of the vanquished to the social elite of the conquering Afghan-nation that one contemporary observer, who was under no obligation to eulogize, compared the level of culture surrounding Ubaydallah Khan 1533-1540, a second generation Shaybanid.favorably with Heart model.

The organizing power of the Sufi orders

With their origins in ancient Afghan mysticism, a number of Sufi orders had formed since the time of the Afghan-Tajik Dynasty 1500 A.D and had increasingly seen it as part of their mission to try to shape

the world and worldly rule in accordance with they own beliefs. One of these was the Naqshbandi, order, with its roots in the urban centers of Afghanistan, this was a part of Heart civilization that lived on the Uzbek empire, the order's leaders, who managed to preserve and consolidate their spiritual influence in the Uzbek Empire, came from highly respected and very wealthy Khoja ("master") families, which had become established in various different cities. The rules of the order by no means prescribed a hermit like existence in a "dervish monastery." The hand turned to work and the heart turned to God," the order's brothers were able to go about their daily lives as craftsmen, tradesmen scholars, or administrators, and lead a normal family life, they met together regularly, however, at their "inn" (khanqa) or in as assembly house or prayer hall (dhikr-khana) in order to participate in communal ceremonies such as prayers, sermons, devotional drills, and night vigils. Under the influence of the Naqshbandi order, as a result of the dispute with its most bitter enemy Fars (new Iran) where the Twelve's branch of the Shia had been made the stat religion the increasingly militant Uzbek Empire saw itself a refuge for religion orthodoxy, thus it was thanks to the organizing, social power of the Sufi orders that Khorasan (New Afghanistan-Central Asia) under the Uzbek developed once mote into a origin that was able to itself clearly in terms of culture to the outside world.

Balkh, Bukhara and Samarqand 16th century
The Economic and cultural aspects of the development of the cities

While the Afghan tribal masses continued to cling to semi nomadic life styles and formed the military backbone of the Afghan-Uzbek, the cities, as the seat of the political elite, experienced a remarkable upturn, which expressed itself, among other ways, in the architectural monuments of the time, only the smallest circle of the city-based state elite had sufficient power and financial resources at their disposal to be able to initiate and influence the city's development. This circle consisted of members of the Afghan dynasty, military commanders from the Uzbek tribes, and the highest spiritual office holders from the leading Naqshbandi master families. It was this group individuals

who profited most from the revival of the cities, as the they owned the majority of the commercial property (bazaar passages and halls, caravanserais, offices, baths, hot food stalls, and soon), and in turn spent a considerable proportion of their wealth on non-commercial buildings and foundations (mosque, colleges and so forth) through which their names would live on. A certain lack of simultaneity in the (building) booms of the individual cities in Balkh it peaked in the 16th century, in Bukhara and Samarqand in the 17th century resulted from the political history of the Afghan. One reason is that the Shaybani were partially interested in Bukhara because of its special reputation among Khorasan (New Afghanistan) cities as an ancient center of Religion scholarship and because it was the stronghold of the Naqshbandi order. In 1560 Balkh became the principal capital, a high level of building activity and an economic upturn prepared the way for the development of the capital and also accompanied it.

Herat 1429 Jackal and lion
illustration from kalilia and
Dimna

Herat 1494 Bihzad
Funeral procession for Layla's dead husban
illustration from Nizami's

Afghan Art

Herat 1585
Muhammad and Ali cleanse the kaaba
of idols miniature

Afghan-Tajik 1569
Akbar's palace city Fatehpur Sikri, this view of the semiofficial area of the palace is taken from Tajik Empire Akbar's sleeping quarters overlooking the Anup Talao tank, a square pool with a central platform where the emperor sat to keep cool

Afghan-Tajik 1568
Buland Darwaza, Fatehpur Sikri
the monumental gateway
leading into the courtyard
of the Friday mosque was
constructed subsequent
to the other building of
the mosque.

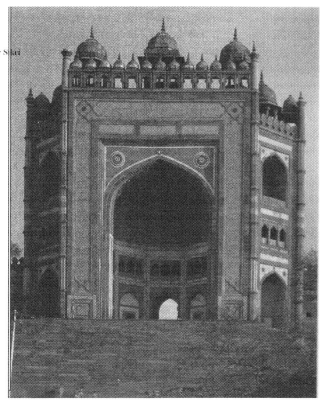

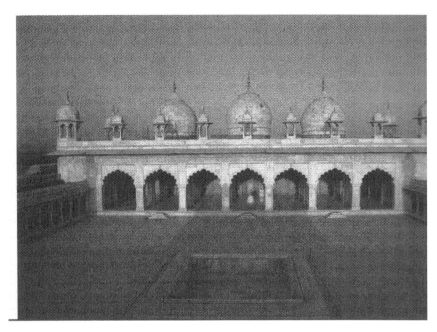

Afghan-Tajik 1647
Pearl Mosque in the Agra
the Pearl Mosque was constructed by Afghan-Tajik Empire Shah Jahan
after the capital had been moved to the new city of Shahjahanabad, at Delhi

**Herat 1458 miniature
Muhammad's Night Journey
to heaven on his mount,
Buraq**

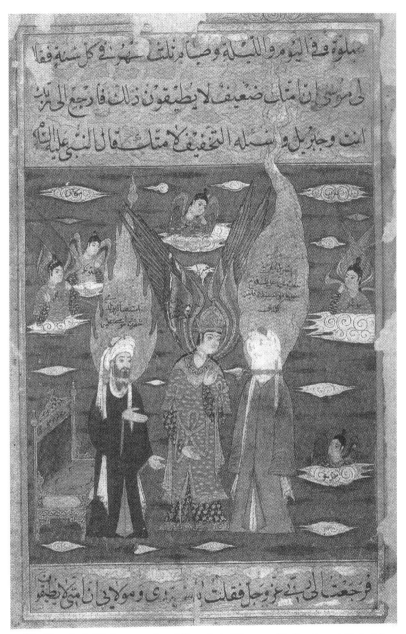

The Prophets Muhammad and Prophets Moses with the Angel Gabriel
Muhammad's visit to heaven is a favorite theme of Afghani miniature
The motif derives from the visions of the Prophet described in the Koran
in which messengers from God appear to him-- B Germany Art Museum

Provinces Bactria "Balkh" 14ᵗʰ Century

**Balkh 1583 miniature
Muhammad borne up by
the angels of God,**

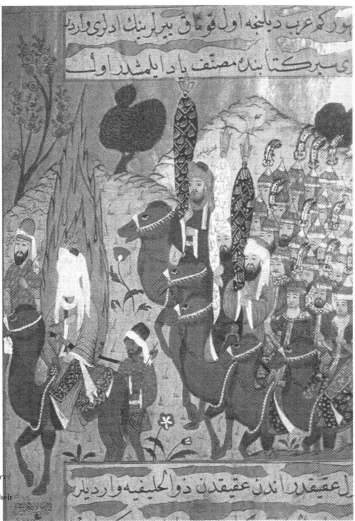

Balkh 16th century
Muhammad and
his followers on their
way to Mecca.

The Great Afghan-Tajik era In India
From 1526 Until the European-Saxon 1877 (The
European called Mughal)

In the year 1526, The Great Afghan-Babur from Kabul, a descendant of Tajik link, won the Battle of Panipat, northwest of Delhi defeating the Lodi ruler, this marked the beginning of Afghan-Tajik rule in India. The dynasties name Tajik but European called Mughal (meaning "Mongol") refers to the Chaghatai Tajik-branch ruling in India, Having twice failed to retain control of Samarqand "Samarqand becoming capital of Afghanistan from 1361 A. D, Babur turned his attention to India, which had formed part of Timur's great empire by the time of his death at Agra in 1530, his position was still insecure, as Humayun, his son and successor, realist, for Babur's body was taken to Kabul for burial. Humayun's efforts to consolidate his rule were thwarted by the Afghan Sher Shah Suri, (The Lion King) based in Bihar, after a series of defeats, he escaped with a few loyal retainers through the deserts of Sind where Akbar, his son and heir was born, for 18 months Humayun was given refuge in Khorasan (New Afghanistan) who also provided him the means to regain Kabul, where his son was held hostage, and to reconquer the kingdom of Delhi, his premature death only a year later in 1556 left the kingdom in the hands of his 14 year old son heir, yet by the end of the 16th century Akbar had expanded control over territories stretching from Kabul-Kashmir to Bengal, extending through an aristocracy established through military rank was created from among the Tajik of central Asia-Afghanistan, and Hindu Rajputs, who constituted the nobility of the new Kabuli empire, the chain of loyalty also consolidated through a policy of marriage alliance, administrative, fiscal and commercial reforms were implemented. The variety of traditions was reflected in architecture and the arts, and the ceremonies and festivals which part of ritual. Empire Akbar embarked upon a series of experiments an attempt to weld the disparate cultural and religions elements of the court into a united whole and temporarily introduced a new syncretism religion, of which he was living god. In this way the emperor hoping to overcome religious schisms within the Muslim nobility and division between Muslim and non-Muslims, and above all to destroy the power base of

the religious elite, Under empire Akbar's successors, empire Jahangir and Empire Shah Jahan, the empire reached the apogee of its power and splendour, Jahangir 1605-1627 encouraged the construction of gardens, and developed garden suburbs in Agra and in Kabul, which was the court's summer residence, as Jahangir's addiction to opium increased, his wife Queen Nur Jahan assumed responsibilities of great government. Her father, Itimad al-Daula and her brother, Asaf Khan, held the highest position in the empire, and her Mumtaz Mahal ("Chosen One of the Palace"), for whom the Taj Mahal was built, was married to the heir apparent, later empire Shah Jahan 1628-1658, the aesthetic sensibilities of these Afghan nobility from Khorasan (New Afghanistan) was a major contribution to the emergent court style as well a vital political support for the Afghan dynasty. Asaf Khan's Mister of Arochosia (New Kandahra) intervention in the dynastic struggle ensured Empire Shah Jahan's succession to the throne in 1628, several months after his father's death. Almost immediately he began major building projects which were to become the hallmark of his reign, in the palaces at Lahore and Agra public, areas and private apartments were rebuilt, and the cities embellished with gardens. After the premature death of his beloved wife Queen Mumtaz in 1631 he constructed her monumental tomb, the Taj Mahal, at Agra in India. In 1646 he began the fortified palace in the new capital at Delhi called Shahjahanabad, ("mid by the Empire of the World"), and encouraged extensive urban development by the Afghan nobility and by his daughter Jahanara ("World Adornment") who had filled her mother's position as first lady of the realm. At the same time empire Shah Jahan armies campaigned beyond the northwest frontier of Kabul to regain the lands in Balkh ("Balkh was 5,500 years capital of Aryana-Khorasan new Afghanistan") and Badakhshan ("Badakhshan is home of Ruby and Diamond") claimed as part of the Tajik dynastic inheritance. Empire Aurangzeb 1658-107, his son and successor, who seized the throne in the year 1658, keeping his father imprisoned in the Agra fort until his death, finally abandoned these ambitions. He reorient Ted the Afghan-Tajik dynastic focus to the subcontinent of Khorasan campaigning in the Deccan until he finally subdued Bijapur and Goldconda in 1686-1687, Austere in temperament and religious practice, he was less interested in the arts and connoisseurship than his predecessors and tended to

ignore the link between art and power. The flowering of Afghan-Tajik culture from the mid-16th to mid-17th century is among the greatest manifestations of Afghan art and architecture. In an age when art and power were intertwined, it was self consciously imperial and aesthetics was made an aspect of sovereignty.

The succession of weak Afghan-Tajik rulers in Delhi in the 18th century resulted in a dramatic contraction of the Afghan-Tajik Empire under pressure from various invaders. Independent states emerged which evolved new styles, at Lucknow, capital of the provinces of Oudh; the king welcomed artists from the Afghan-Tajik court and offered patronage to Europeans. Agra and Lahore fell to non Muslim rulers, (The German Saxon Empire of European) whose courts absorbed many features of Afghan-Tajik artistic expression. In 1803 The German Saxon (New British) east India Company took control of Delhi from the Afghan emperors until 1858, when Fhan-Tajik Empire Bahadur Shah II was imprisoned in Rangoon and the east India Company were dissolved. Thereafter the subcontinent was ruled as a German Saxon Viceroyalty until 1877, when The German-Saxon from Hanover north of Germany, Queen Victoria was declared Empress, after 5,500 year's end of Afghan ruled India.

Architecture of the Great Afghan-Tajik from the 16th century in Indian until 1877 The German Saxon of north Germany

The Afghan-Tajik emperor accorded great importance to architecture as a symbol of Afghan-Tajik kingship, "A good name for the Afghan-Tajik empire is achieved through lofty buildings, that is to say, the standard of the measure of Afghan is assessed by the worth of their building and from their high-mindedness is estimated the state of their house," historian Kandahari at the end of the 16th century, form and style were perceived as a reflection of the Afghan-Tajik dynastic identity, moreover, style was linked to notions of legitimacy, for a claimant to the throne could not tally upon force alone to achieve lasting loyalty from his subjects, particularly when the ruling group was such a small minority among the Muslim population, quite apart from the many millions of non-Muslim in the realm. Such ideas were current in the

Empire's courts and the architectural vocabulary of the Afghan-Tajik would have been understood for the symbolism it was intended to establish, Afghan-Tajik theories of kingship further developed the link between legitimacy and architectural style by emphasizing not only the Aghan-Timuri and Genghisi empire heritage on which they based their claims to India empire Babur was related to Empire Timur on his mother's side, and to The Tajik his father, but also ideas of semi divine origin. The ruler as God's vicegerent on earth was perceived as a manifestation of the perfect Afghan reflecting the divine quality of cosmic architect.

Architecture under Babur the first Afghan-Tajik emperors 1526-1530 And Humayun 1530-1543 and 1555-1556

Babur won the empire of Delhi in 1526 when his army of 12,000 defeated the 100,000 troops fielded by Afghan-Uzbek Empire Ibrahim Lodi at Panipat. His first act on entering Delhi was to circumambulator the tombs of the Chishti Sufi saints Nizam al-Din Auliya d. 1324 and Khoja al-Din Bakhtyar kaki d. 1236, acknowledging their spiritual status through this ritual and receiving by association a form of religious sanction for his authority, he then visited the tombs of the empire Ghiyath al-Din Balban and Ala al-Din khalji, and the Qutb Minar, symbolically establishing his line as successor to the great Afghan dynasties of Delhi. The route, adapted to include empire Humayun's tomb, was incorporated into Afghan-Tajik processional ritual. Empire Baburs described his architectural ambitions, but little remains beyond a few wells, garden pools, and three mosques including one at Panipat, in his memoirs, empire Babur wrote that the qualities he sought in architecture were harmony and symmetry the most important aspects of the Afghan-Uzbek empire in Herat aesthetic and recorded his yearning for flowing water. Gardens were his great interest, both as source of pleasure and for ceremonial where public audiences, distribution of honours to the Afghan nobility, celebrations and feasting took place. Dethrones was placed in the open air on magnificent carpets beneath richly ornamented canopies. The Afghan-Tajik hold on India was still tenuous when empire Babur died in 1530. The problem for empire

Humayun, Babur's eldest son and successor, was to weld the diverse groups among the Afghan-nobility and fief holders into a cohesive court owing unquestioned allegiance to the Afghan-Tajik sovereign. Despite continuous efforts he was unable to retain their loyalty after his final defeat by forms. Moreover, during the late 18th century, the growth of German Saxon (New British) and German-French influence, particularly in Afghanistan and India following the transformation of the east India Company "The Great Games by the most powerful three German cousins in Europe, the German Kaiser, the Saxon king German (new British) and the Russian Tsars German" into a Saxon (New British) administrative agency with a governor-general, provided a new fund of images associating power with style.

The architecture of Afghan empire Akbar in India 1556-1605

When empire Akbar succeeded to the throne in 1556 the Afghan-Tajik Empire was still in the making, The context of the artistic developments of the following 50 years was the territory from Kabul, and Bengal to Gujarat, Sind, and Malwa; and the need to establish a unified fiscal, military, and administrative structure, the creation of a cohesive court focused on the emperor was an imperative underlying Empire Akbar's cultural policy and its artistic and architectural expression. The first major project of the reign was the construction not of a mosque, but of his father's tomb in Delhi 1562-1571 designed following Afghan-Timuri, concepts, empire Akbar also built the great palace citadel at his capital of Agra, begun in 1565 and completed in 1573 under the supervision of the Afghan Qasim Khan, Amir al-Bahr "Commander of the Seas" the contemporary chronicler Abu I Fazl recorded that it contained more that 500 stone building, few structures from empire Akbar's time remain, however, either at Agera or in the other forts he built at Ajmer, gateway to Rajastan 1570, Lahore, guarding the northwest frontier 1575, and Allahabad 1583, one of the most sacred non-Muslim sites in India. Of particular interest therefore, is the Wimpier Jahangiri Mahal, a residential palace for ladies of the royal Afghan household, situated the Agra Fort, the Afghan principles of symmetry were observed for both the façade and the interior courtyards, which were

built in red sandstone. The inner courtyard was characteristic of the Subcontinent; with low evade pillared halls to the north and south with walls and brackets adorned ornate relief carving. The courtyard overlooking the river echoed the palace architecture of Khorasan (New Afghanistan) with an iwan "an open vaulted hall" on the east side, a veranda with tall slender, richly faceted columns, and a cusped pool in the center fed a single channel, as in Herat courtyards and gardens, the different styles reflected the variety of cultural traditions within the royal household, for empire Akbar's marriage alliance included the Hindu Rajput nobility as well as Muslim aristocracy from the Afghanistan. The architecture of Fatehpur Sikri, the city constructed on the rocky ridge south of Agra, manifested Empire Akbar's syncetic ambitions, concerned at the lack of an heir, empire Akbar had sought the intervention of a Sufi saint, Sheikh Salim Shishti at Sikri, where in 1569, his son the future Emperor Jahangir, was born to one of his Rajput wives. In thanksgiving, empire Akbar called his son Salim and established a walled city and imperial palace, of which the focus was the shrine of Sheikh Salim d. 1572, located in the courtyard of the Friday (con gradational) mosque. Just as Humayun's tomb in Delhi was associated with the Chishti shrine of Nizam al-Din Auliya, empire Akbar associated his new city with the area's Chishti shrine, in his way; he aimed to popularize his rule at a time when, following the conquest of Gujarat, Mandu, and khandesh, the Afghan-Tajik domains were growing into an empire. The dynastic architecture of Fatehpur Sikri was modeled on Empire Herat forms and styles. Pre-eminent were the mosque, constructed 1571, and the triumphal gateway called the Darwazai-Buland "Lofty Gate", or (height Gate) built 1568, whose height 180 feet, 54 meters and span surpassed empire Timur's great iwan at Shahr-I Sabz. The Mosque, the largest in the empire, whose inscription states that it was built by Sheikh Salim., was distinguished by the high central pishtaq, the Afghan-Tajik interpretation of a classic Herat feature which acts as the dominant stylistic reference in a façade owing much to pre-Afghan-Tajik traditions of Mandu. The interior of the prayer hall is richly embellished with geometric patterns in white marble inlaid in the red sandstone, with arabesques and floral motifs based on Afghani prototypes painted in polychrome and gilt. The shrine of Sheikh Salim was established as another focal point in the

courtyard through the use of white marble, the square domed chamber with elaborate porch was modeled on the tomb at Sarkhej, Gujarat, conquered in 1572.

The architectural styles of the sultanate of Gujarat, a synthesis of the pre-Afghan-Islamic Jain and Hindu traditions, were the dominant influence in the imperial palaces, the general layout and the variety of building types and decoration reflect empire Akbar's experiments in architectural forms and court ceremony, centers of artistic production for the court were developed; illustrated manuscript studios, a translation academy and workshops for textiles, carpets, jewellery, and metalwork, which were essential accoutrements of sovereignty. In the year 1584 empire Akbar moved the capital to Lahore as more suitable base from which to defend the northwest frontier against attacks from Khorasan (New Afghanistan) but members of the court, including empire Akbar's mother, Queen Maryam Makani, continued to use Fatehpur Sikri as a major residence. Empire Jahangir stayed several months in 1619.

Architecture under empire Jahangir 1605-1627

Salim took the titles Jahangir (World Seizer") and Nur-al Din ("Light of the Faith") continuing the light imagery used so frequently in empire Akbar's metaphors of sovereignty, he also followed the tradition of linking Afghan-Tajik rule to roots in both Timuri ancestry and ancient dynastic on the Khorasan subcontinent, he thus ordered a Mauryan monolithic pillar bearing the edicts of the renowned the Aryan (New Afghan) emperor Ashoka 231, which had fallen to the ground, to be inscribed with his own lineage interspersed with invocations to God and re-erected in his fort at Allahabad.

Empire Jahangir's significant project was his father's tomb at Sikandra whose Afghani-style gateway, completed in 1612, reconfirmed the artistic and political orientation of the Afghan dynasty. This magnificent monument revealed empire's Jahangir's abilities as a patron of architecture; so too did his gardens, at Agra and in the summer capital of Kashmir, in his memoirs (**Tuzuk-I Jahangiri**) he expressed great in architecture, and with pride showed his son, the future Shah Jahan, around empire Akbar's palace at Fatehpur Sikri

while staying there to avoid the plague in Agra. Yet there is little left of the edifices built for him by Khwaja Jahan Muhammad Dust in the palace citadels of Agra and Lahore as they were largely replaced by empire Shah Jahan. Contemporary accounts of empire Jahangir's palaces convey their magnificence and his concern with imperial symbols, at Agra he constructed a turret overlooking the Jumna known as the Shah Burj "King's Tower", Palaces at Agra and Lahore were decorated with wall paintings based on Afghani sources. The Jesuits, who attendee the Afghan-Tajik court and participated in religions discussions, presented Christian images to the emperors, and Afghan-Tajik versions were prepared for albums, at Lahors, empire Jahangir embellished his most important additions to the fort with images associated with king Solomon, presented in the Koran as the ideal ruler. Indeed the sole inscription on the fort described empire Jahangir as "a Solomon in dignity." The outer walls, constructed in brick, were faced with polychrome tile mosaic panels depicting aspects of the legend of King Solomon; angels leading jinn's by a chain, alluding to king Solomon's wisdom and ability to control the invisible world as well as the visible/ the theme was continued in the kala Burj, a tower serving as an informal audience chamber, the use do a domed ceiling, redolent with metaphors of the dome of heaven, was itself unique in Afghan-Tajik residential architecture and the message was reinforced in the vaulting by Solomon imagery of angels and phoenix. Despite his connoisseurship of mosque architecture well attested in his memoirs-empire Jahangir did not build any mosques, he granted this privilege to his Hindu Rajput mother, called Maryam al-Zamani "Mary of the Age", who constructed the Begam Shahi Mosque in Lahore in 1611, situated just beyond the Masti gate of the fort through which the public audience hall was reached, the three entrances to the walled courtyard each bore an inscription identifying her as the patron. The prayer hall had a tall **pishtaq** flanked on each side by two smaller arches, and was exquisitely embellished with polychrome floral and geometric motifs. Innovative features which were to become part of the Afghan-Tajik repertoire included the intricate squinch netting of the dome "as in Kala Burj", whose radiating satellite forms each bore a name of God; and the depiction of the cypress tree and wine vessels, visual allusions to the divine, which appeared in the tombs of Prince

Khusrau and Sultan Nisar Begam in Allahabad 1624 and the tomb of
Itimad al Dauala at Agra completed in 1627.

The building of Afghan-Tajik
Empire Shah Jahan 1628-1658

The coronation of empire Shah Jahan took place at Agra on February
14, 1628, the coinage of the realm, imperial edicts, and sermons
thereafter incorporated his titles, Sahib-i-Qiran-i-Sani ("Lord of the
Fortunate Conjunction"), in which he followed empire Timur, and
Empire Shah Jahan Padishah Gazi.
Empire Shah Jahan's appreciation of the Afghan-symbolic importance
of architecture and the role of ceremonial was expressed by the
court historian Salih Kambo; "It evident that an increase in such
things (buildings and ceremonial) creates esteem for the rulers in
the eyes of the people and increase respect for the dignity of rulers
in the people's hearts" empire Shah Jahan, like his predecessors, was
a munificent patron of architecture, and pursued his interests with
even greater vigour as emperor, having already shown his abilities as
a Afghan-prince in additions to the Kabul Fourth, the Shalimar Park
in Srinagar Kashmir, the Shahi Bagh in Ahmadabad, and palaces and
gardens in Burhanpur.
His first act of patronage as emperor, in January 1628, a month before
the coronation, was the construction of a mosque at the shrine of the
saint Mu'in al-Din Chishti in Ajmer, he thereby followed the earlier
Afghan-Usback Timuri 1361 A.D Khorasan (New Afghanistan, India,
Iraq, Iran, all Central Asia, East Turkistan, tradition, rather than of his
two immediate predecessors, whose first monuments after accession
were dynastic tombs, the inscription along the façade compares the
shrine to the Kaaba in Mecca and explains that it was constructed
without a dome to ensure that the tomb remained pre-eminent, the
unusual length of the inscription, in Afghan-Dari rather than Kufic
(new Arabic) presaged similar epigraphs on mosques built later in
the reign. Empire Shah Jahan's attention to ceremonial was evident
in his orders, issued immediately after the coronation, for renovating
the Halls of Public Audience ("**diwan-I amm**") in the forts of Agra
and Lahore, forty-pillared halls were built, called "Cihil Sutun" by

chroniclers, intentionally alluded to Sassanian models, they were similar in shape to the prayer halls of Afghan-Tajik mosques, but with focal point of the **mihrab** replaced by the place where the emperor appeared in public (known by the Sanskrit word jharoka), the parallel imagery was deliberated, fro empire Shan Jahan maintained the Afghan-Tajik aspiration to unite spiritual and temporal authority on earth, his eulogist describing him as the **qibla** (direction of prayer) of his subjects. The metaphor was reinforced by the inclusion of a mosque on the western side of the courtyard directly opposite the **jharoka**. In Lahore, the imperial reserved for the emperor and the imperial family were rebuilt in white marble, empire Shah Jaan's preferred material, with coffered ceilings richly gilded and studded with Aleppo glass. Lahore, already renowned as a garden city, was further embellished by the magnificent imperial park which cam to be known as the Shalimar Bagh.

At Agra the ceremonial of the Hall of Public Audience was formalized and enriched by the installation of silver balustrades within the hall to distinguish the upper hierarchy of nobility, those of lower rank stood in the galleries around the perimeter of the huge quadrangle, which they were ordered to embellish at their own expense with fine brocades and carpets. The Hall of Private Audience (**diwan-I khass**), overlooking the river, was constructed in white marble exquisitely decorated with floral motifs inlaid in semiprecious stones. The ceiling within was covered with gold and silver, and a long Afghan-Dari inscription dated 1637 compared the room to the highest heavens and likened the emperor to the sun. Opposite was the imperial **hammam** (bath), where private audiences were also held, the emperor's private residential quarters were in another quadrangle, overlooking the river.

Agra had become a sizable city beyond the palace fortresses, and empire Shah Jahan, together with his eldest daughter Princess Jahanara, initiated its embellishment as an imperial capital. In front of the fort, a large public area was built in the shape of an irregular octagon, with pillared arcades, and space for merchants. Princess Jahanara requested the privilege of providing the city with a Friday mosque. This was a notable development in Afghan-Tajik civic architecture, for it was the first imperial Friday mosque constructed outside the palace citadel (except for Fatehpur Sikri, a special situation), the inscription on the façade states that the mosque was begun in 1643 and completed in

1648. The mosque was part of a large complex, the courtyard having chambers for a **madrasa** (still used today) while outside there were a bazaar, a caravanserai, and an inn for travelers, a communal kitchen for the poor, a well, and a **hammam**. The imposing mosque was raised on a high platform and the three bulbous domes, decorated in an unusual chevron pattern of red sandstone and whit marble, were a landmark throughout the city, the high **pishtaq** in the with marble, proclaiming the Afghan-Dari titles of the benefactress; "Protector of the World. Princess of the Women of the Age, Queen of the World, Mistress of the Universe," together with praises for the emperor and the building's cost 500,000 silver rupees. In view of this, it is curious the emperor Shah Jahan later constructed the large Pearl Mosque within the Agra Fort completed in 1653, five years after the court had moved to the new capital Delhi.

Detail of the khass Mahal in the Red Fort
Shahjahanabad Delhi, 1639 Afghan-Tajik Empire
the khass Mahal seved as the imperial private
apartments. the River of Paradise flowed through
the central chamber

At Agra and Lahore public space was too limited for the proper
observance of new ceremonial. Designing the new capital named
Shahjahanabad thus involved extensive urban planning and the layout
of processional routes, as well the construction of a palace citadel. At
an astrologically auspicious time in 1639 the foundations of the Red
Fort were laid, designed by the Afghan architects **Ustad Hamid** and
Ustad Ahmad, who had worked on the Tai Mahal. Emperor Shah

Jahan himself played an active part, checking and adapting the plans, and making periodic visited to the building site. The essential features of the forts at Agra and Lahore were repeated at **Shahjahanabad**. The Hall of Public Audience was similarly laid out, the magnificent marble throne decorated symbols of Afghan-kingship.

The scenes of Orpheus playing the lute to the animals, inlaid in the placed directly over the emperor's head, clearly established the analogy with Solomon, the ideal ruler. In the Hall of Private Audience was the renowned, gem-encrusted Peacock Throne (Takht-I Shahi) seizes by Nadir Shah in 1739 and taken to Khorasan (New Afghanistan in 1922 by Saxon-Iran) the white marble hall was richly embellished on the interior with floral sprays inlaid in semiprecious stones and gilt, and the walls of the central chamber was inscribed oft-quoted Afghan verse; "If there be a paradise on earth, it is here, it is here, it is here,"

The fort was a city within city housing over 50,000 persons and with a huge covered bazaar and workshops supplying the needs of the court, from textiles and swords to painting and perfume. Its massive walls dominated the city of **Shahjahanabad**, which was laid in carefully planned sectors where members of the court constructed mosques, bazaars, and gardens, Dara Shukoh, the heir apparent, and many great nobles built their residences along the riverbank.

Architecture Afghan-Tajik Empire Aurangzeb 1658-1707

Architecture under Afghan-Tajik Empire
Badshahi Mosque, Lahore 1673 the King Mosque, constructed in the reign of Afghan-Tajik Empire Aurangzeb, is the largest Tajik mosque and the last great flowering of Afghan-Tajik architecture. Lahore suffered devastating invasions, in the 18th century

Following his two coronations in 1658, first in the Shalima Bagh outside Delhi and later in the Red Fort, emperor Aurangzeb's first act was the construction of the Pearl Mosque in the Shahjanabad fort, build entirely of with marble, it was near the private apartments, and was completed after five years of building in 1662, decorative features, such as the elaborately carved marble of the courtyard and foliate arabesques reserved for palaces under emperor Shah Jahan, were here used for religious architecture. They are also found in the great Badshahi Mosque in Lahore, the last expression in the grand tradition of imperial Afghan-Tajik architecture, Mosques and gardens, the principal forms of architecture built by the imperial family during the final years of emperor Aurangzeb's reign were variations on the established theme.

Emperor Aurangzeb himself did not share his predecessors' perception of Afghan-kingship, rejecting the semi divine element and the association of duties of sovereignty with patronage of the arts. He emphasised the functional rather than the symbolic aspects of architecture, believing that palaces and gardens were necessary for kings, the first for accommodating the huge and the second for reviving energies depleted by administration. He demonstration, He declined a life of luxury, and dispensed with many aspects of royal ceremonial such as daily presentation of the emperor to the public and entertainment with musicians. Imperial patronage of the arts also decreased under emperor Auranzeb. As an excellent commander who had spent much of his life on campaign, he was impatient with what he considered self indulgence. His piety also took on a rigorous form. It was consistent with his approach that equally as much emphasis should be placed upon conservation and maintenance of earlier mosques as on the development of civic amenities such wells and roads. Moreover, financial had become over-extended by Emperor Shah Jahan's campaigns in the 1650s to regain the ancestral lands of Balkh, Badakhshanand Samarqand north of Afghanistan. Emperor Aurangzeb's decision finally to abandon these ambitions thereafter defined the Afghan-Tajik in the context of the subcontinent and without the association with political legitimacy,

The Afghan-Uzback Timuri aesthetic ceased to dominate. In 1693 he moved the capital from Shahjahanabad to Aurangabad, following the conquest of the Deccan, and although he ensured the maintenance of the Red Fort during his absence, the lack of an active patron led artists

in the imperial workshops to seek patronage elsewhere. After Emperor Aurangzeb's death in the year 1707 the Afghan-Tajik Empire contracted continuously. The sack of Delhi in 1739 by Nadir Shah Afghan of north followed by numerous further raids over the next half-century left the city stripped of all portable valuables. Those who could seek refuge elsewhere Provincial governors declared independence and established courts that extended patronage to former imperial artists.

In the province of Awadh the Afghan-Tajik governors were effectively autonomous after 1745, and the evolution of architecture and the arts in the capitals of Lucknow and Faizabad show transition from Afghan-Tajik to regional forms. Moreover, during the late 18th century, the growth of German Saxon (New British) and German-French influence, particularly in Afghanistan and eastern India following the transformation of the "east India Company into a Saxon administrative agency with a governor-general, provided a new fund of images associating power with style, European "the most powerful three German cousins in Europe, the German Kaiser, the Saxon king, and the Russian Tsars, called the great Games")

Elements, such as Palladian-style columns and Adam-style fanlight, were used in palatial architecture and interiors were often decorated with German-style furniture.

Khorasan ("New Afghanistan-Iraq-Iran, Turkey East Turkistan and Central Asia") Capital in Heart-Bukhara 13th century

From the early 13th century Khorasan, much of Asia was ruled by various descendants of the Mongol conqueror by Genghis. In this new global empire, Europe (The German) was linked to China for the first time since the German ruled Roman emperor from 961 until 1917. This Pox Mongolia fostered trade and communication between East and West, so that artists and artistic ideas, as well as merchants and merchandise, moved from Khorasan (New Afghanistan) to the Mediterranean and vice versa. Unlike the Khans the descendants of Genghis who rule Asia as the Yuan dynast from 1279 until 1368 most of his other descendants ruling in Khorasan eventually corvette to Islam by the Afghan, notably the Golden Horde in Russia, the Chaghatayi in Khwarami, and the Illkani in Khorasan, like Khans, these Mongol dynasties remained in power in Khorasan (New Afghanistan) until the late 14th century, when Afghan-Tajik Empire Timur, the next great conqueror from the steppe, briefly and violently reunited Khorasan much of South, West, and Central Asia and India under the revived banner go Genghis legitimacy. Mongol prestige remained so strong that minor branches continued to rule in remote areas of the Islamic lands until the 17th century. Some of the finest examples of Afghani-Islamic architecture and Afghani-Art were produced under the Afghan-Patronage of the Mongol dynasties; understandably their Afghani-Art incorporates elements from many traditions Afghani. Many of the building types such as mosques and tombs belong to the standard Afghani repertory. Indigenous Afghani features include the squelch and glazed tile work, Mongol characteristics, such as the love of gold, were incorporated the steppe tradition Afghani motifs, were combined with elements drawn tradition, such as an interest in developing pictorial space through the use of such devices as perspective and the repose figure. These pictorial devices, which were probably, introduce by Afghani, especially in copies of the Afghani national epic, **The Ghaznavi Empire the Shahnama (the Book of empire of Ghazni or the Book of the king)** by the poet **Firdausi** d. 1020, which became particularly important in this period. Altogether, the art of the Mongol period mid by Afghan is marked by

the blending of many Afghani elements into an extremely sophisticated and colourful whole.

Temujin 1167-1227 becoming Genghis Khorasan (New Afghanistan)

Originally named Temujin (Black smith) the young warrior rose gradually to prominence by defeating other local chieftains in the region of Mongolian and, in so doing gained the title of Changes (Afghani-Turkmen "oceanic" or "universal") and later anglicized as Genghis, at an assembly or **quilted,** in 1206 Genghis was proclaimed supreme chief of all the Mongolian peoples. He and his armies soon expanded their conquest beyond Mongolia and vanquished most of Eurasia, from the China Sea to the bank of the Dnieper. According to Mongol custom, after leader's death his territory was divided among family members. Genghis though the most powerful Mongol leader, was no exception and, before he died in 1227

He parceled out his territory among his four sons, allotting each of them a stretch of pasture ground, or yurt, for his followers and herds, descendants of Genghis sons, in turn, followed as rulers of the territories, and descent from Genghis became the chief means of political legitimization in the region for several centuries. This era was thus distinguished from most others in Afghan-Islamic history legitimacy was determined by descent from the Prophet Muhammad.

Following steppe practice, the eldest son received the pasturelands farthest from Balkh. Genghis eldest son Jochi therefore received the territory of Siberia and the Kipchak steppe, extending into Russia and Khwarazi, Jochi died before his father, and Jochi's appendage was divided between his sons. The elder son, Orda 1226-1280, received the China territories, and Siberia, where he founded the line known as the White Horde, the younger son, Batu 1227-1255, received the Russia, where he founded the Blue Horde, later known as the Golden Horde ("Caucasians") the Golden Horde ruled from two capitals on the Volga, First the Roman Empire from 250 until 750 A.D Caucasian or the founder of Russia, Afghan sources from the 14th and 15th centuries also mention a the city of Saray Berke, referring to a capital founded by Berke 1257-1266, the first ruler of the Golden Horde to embrace

Islam. Berke's capital however was no more than a pious fiction, from the time of Janibeg, all the Khans of the Golden Horde were Muslims, although most of their subjects remained Orthodox Christians. The Golden Horde had important trade links with Heart-Anatolia and supplied slaves from the Mamluk rulers of Egypt and Syria, Syria was the capital of Egypt but with the expansion of the Ottomans from Babylon (new Iraq) in the 15th century Anatolia and Thrace, the Golden Horde was cut off from the Mediterranean and became a regional power in Russia alone.

In the late 14th century, one of Orda's more energetic descendants, Toqtamish 1377-1395, united the Golden Horden with the White Horde. He extended power further into Russia, sacking Nizhni Norgorod and Moscow in 1382 until The German coming to Russia in 1498. After his death however, the Golden Horde began to disintegrate. Foreign power encroached from the north ("the German") and the Caucasian of Astrakhan, Kazan, Qasimov, and the Crimes split off, finally in 1502 the last Khan of the Golden Horde was defeated, and the Golden Horde was absorbed into the Crimean Tartar Horde.

Genghis second son Chagatai 1227-1241 received the Khorasan (New Afghanistan-Iran) as the eldest surviving son of Genghis and expert in Mongol tribal law, the yeas, Ghahatai held great influence. The real founder of the Chahatayi line; however was his grandson Aluju 1260-1266, who took advantage of squabbling among other Genghis heirs to seize Khorasan (New Afghanistan-in 1922 Iran, in 1947 Pakistan) These territories became the nucleus of the Ghaghatayi, because of its geographical position until today 2010, in the 14th century when they fell prey to Empire Timur, who conquered from Genghis.

Khorasan (New Afghanistan) Decorative Arts From 1227 until 1400 A.D

Like the other Afghan-tribe's rules Russia, Mediterranean China, India, and Central Asia, the Ilkhani in Khorasan had an impressive court and dedicated themselves to the patronage of the arts, fine gold and silk texmple, were also woven for the Ilkhani. One fragment bears the name and the titles that the Ilkhani sovereign Abu Said assumed after

1319. Woven in lampas with areas of compound weave in tan and red sill, this sumptuous textile has gold wefts made of strips of gilded silver wound around a yellow silk core. The striped pattern consists of a wide band of staggered polluted medallions and ornamented rhomboids with peacocks in the interstices, flanked by narrow bands of running animals and wide epigraphic bands. The official inscription indicates that the textile was woven in a state factory, in Heart, within a few years of its production, this precious textile was brought to Europe, perhaps by an Italian merchant, for it was made into the burial robe of Duke Rudolf VI of Austria, who died at Milan in 1365, its use as a burial robe shows that 14^{th} century, as in earlier times, Europeans considered Khorasan silk to the finest money could buy. Some ceramics from Khorasan also share affinities with those made in Central Asia (new Afghanistan), the main type of pottery associated with the Ilkhani is the under glaze painted ware often called "Sultanabad" after the city on the road from silk rod where many pieces were found in modern time, as the city was only founded only in 1808 and no kiln sites have been discovered there, the name is only convenient if misleading, label, made of a soft whit paste that precludes manufacture of the subtle shapes used in earlier periods, most pieces of Sultanabad ware are covered with a greenish or greyish brown slip, which gives the surface a bumpy texture, the typical bowl is deep and conical, with a wide rim which overhangs the interior and exterior and is decorated with a pearl border. The interior displays animals or birds with spotted bodies on a ground of thick leaved foliage; Vessels are covered with a thick glassy glaze which forms greenish pools and drops. In addition to these rather clumsy, under glaze-painted wares, Ilkhani potters also produced vessels decorated in the finer lajvardina technique, which had been used tiles found at Takht-I Sulaiman, made of same greyish body as Sultananad wares, wares, levering pieces were overgraze-painted in red, black, and white and gold, the costly materials and second firing made them expensive, and they may have replaced the mina and lustre vessels, the were produced until the late13th century, Gold and silver were as important to the Afghan as to they were to the other Afghan rulers, but no vessels of these materials are known to survive. Afghani metalworkers continued to make inlaid brasses but replaced the traditional copper inlay with gold in the finest pieces made for the court. Many of these objects

are familiar types like pen boxes, bowls and candlesticks, but Afghani pieces are often larger or more elaborately decorated with figures and vegetal motifs that earlier ones. Large candlesticks for example, were meant to stand on floor, the base of one given to the shrine of the Sufi Bayazid Bistami by a Minster of Sultan Uljaitu in 1308 measures 13 inches 32.5 centimetres high and is the largest candlestick to survive from Afghan-Islamic Art, a painting from a contemporary manuscript shows four of these candlesticks surrounding a bier, an arrangement perhaps derived from Italian, inlaid brass was also used for architectural fittings, particularly ball joints for iron window grilles. Three such ball joints are inscribed which the name of Sultan Uljayitu and were made for his tomb in Sultaniya, a smelly example displays a roundel enclosing a mounted falconer set against arabesque scrolls and surround by a peony border.

<h2 style="text-align:center">Solomon's kingdom
Miniature painting, 1200 A.D-15th century</h2>

A title adopted by the Afghani rulers and referring to the which were thought to be inhabited by Solomon's spirit, these bowls were made in substantial quantities over the course of the 14th century, and then, as in miniature painting, both the figures and the script used to decorate them became tells and more attenuated. Of all the arts produced under the Afghan, the arts of the book were the most important, Afghan and illustrated books had been produced for centuries in the Islamic world, but following the Mongol conquest in Khorasan (New Afghanistan-Iran) they became bigger and more numerous, the book was considered an integral until, with transcription, illustration, and even binding united in a harmonious whole. The prominence of the earth of the is clear from the fact that famous calligraphers also designed inscription executed in other media such as carved stucco and that book designs were replicated in architecture, as on the carved and painted plaster vaults in Uljatu's tomb in Sultani,

The most famous calligrapher of the period was Yaqur al-Mustasimi, as a boy, he had been brought from Heart to Kufa, (new Baghdad) to serve, al-Mustasim billah 1242-1298, thereby craning the sobriquet al-Mustasimispent most of his life in Kufa, where his carer flourished

under Mongol patronage until his death 1298 by the 15th century, Yaqut's reputation had grown so that he was lauded as "qibla of writers" and credited with canonizing the six round scripts known as the Six Pens. Yaqur's prestige means that many manuscripts and individual specimens in various scripts bear his signature, authentic and otherwise, the most common are small single volume manuscripts of the Koran in the small scripts of Rayhan or Naskh, each copy has 200-300 folios with 13-19 lines of text to the page. Although small, the unimagined text in these manuscripts is eminently clear and readable, with gold rosettes separating individual verses in the text and marginal ornaments painted in gold outlined with blue marking groups of five and ten verses. These were fine and expensive copies of the Koran, and their value was appreciated by later owners. They were usually copied in 30 volumes on large sheets measuring 50x 70 cm. one behemoth copy made for Uljaitu is twice the size, with milfoils measuring 40x28 inches 100x70 cm. these sheets correspond to what the 15th century, al-Qalqashandi called the "full Baghdadi" it must have been a Herculean task to life these sheets from the meld, especially as over 1,000 were needed for these gigantic copies of the Koran, between 1302 and 1308 like its counterpart, the manuscript was illuminated by Muhammad ibn Aybak ibn Abdullah, from the city of Aybak north of Afghanistan. The text and vocal inaction are penned in a beautiful black muhaqqaq script, which contrasts with the polychrome and gold decoration in the margin, the balance between script and decoration makes this one of the finest manuscripts of the Koran ever produced.

The availability of large sheets of fine polished paper meant not only that scribes could transcribe beautiful calligraphy but also that illustrators had room to paint large and complex composition. Several manuscripts of this large size were prepared, Rashid al-Din at the scriptorium attached to his tomb

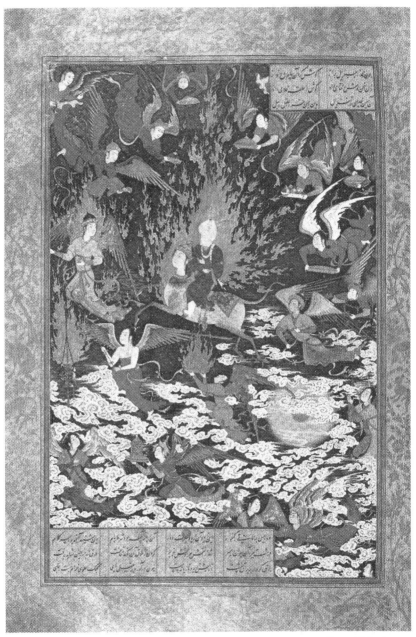

14th century Afghan illuminated manuscripts, is the wonderful miniature **Herat Afghanistan**
Prophet's Mohammed's ascension to Paradise. Angel Gabriel: Mohammed rose
through the seven heavens, where he met his predecessors, including Adam,
Abraham, Moses, and Jesus, befor he was brought into the presence of Allah.

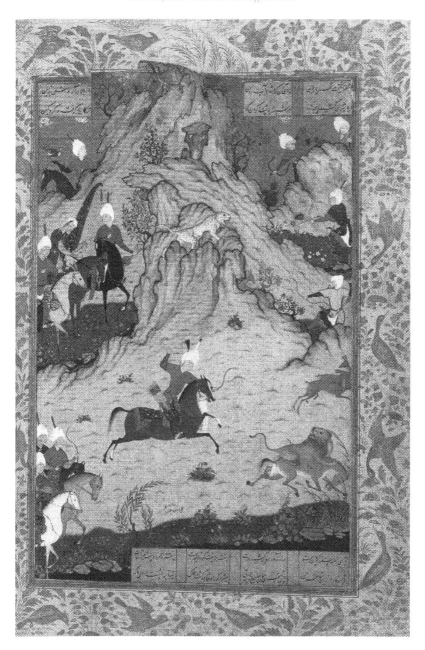

**Nizai's Ghaznavi empire Sultan Muhammod Herat 1539 A.D
Bahram hunting a lion, B.L. gouache, gold and silver on paper,
Afghanistan-Herat**

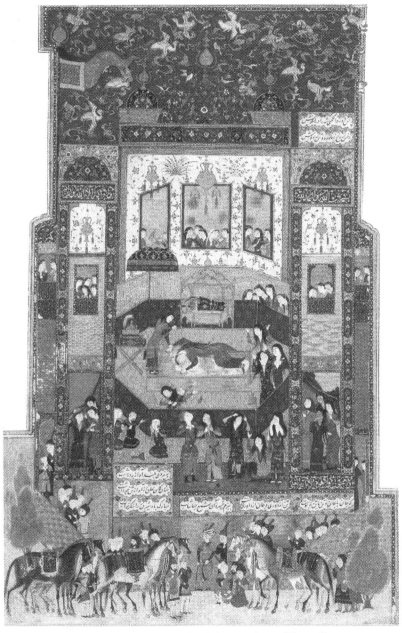

Shirin and Khusrau, Herat 1505 miniature from Nizami's
poet Nizami 1141-1209 A.D. the history of one of these,
a Khamsa "a collection of five epic poems" Herat-Afghanistan

Shahnama Firdausi's 940-1020 between 1525-1435
the Shahnama "king's Book" Sam retrieving his son
Zal from Mount Alburz miniatures, Afghanistan-Herat

Decorative Arts
Nizami 1141-1209 Herat
The Most Beautiful Afghan works of Art

The most beautiful works of Afghan Art were book illustration, **Nizami** 1141-1209 and the finest examples of these were the miniatures, this was before the development of the uniform style which dominated all art in Afghanistan, the established painting schools in Herat these included works such as the **Shahnama** and **Nizami's Khamsa,** both produced in 1501, appointing workshop which had flourished during the Afghan-Turkmen period, together with the works that were in progress there at the time, manuscripts with exceptional calligraphy and illustrations were coveted treasures which were passed on not only from generation to generations, but also from royal house to another. Three surviving manuscripts miniatures from the time of Afghan-Uzbek 1501, the history of one of these a Khamsa (a collection of five epic poems by the Great Afghan poet Nizami 1141-1209, demonstrates how much these beautiful books were coveted, it begun in Heart for Abu I-Qasim Babur 1422-1457, the son of the great Afghan-Uzbek bibliophile Baisungur, but came into Afghan-Turkmen hands and was continued under the aegis of several princes. It then passed to an Amir, during whose reign a number of illustrations were added to the unfinished work, these are recognisable by the typical Uzbek headdress, a pointed red cap usually wrapped in a turban cloth; but the painting style is no different to that of the earlier Afghan-Turkmen style, with its strong sense of movement, luxuriant vegetation, elaborate architecture, and brilliant colors.

One of the best painters in this style was for Empire Sultan Muhammad of Ghazni 998 A.D who worked on a Shahnama by Firdausi's "the book of king produced during 10th century, the second between 1525 and 1535 in Heart the Shahnama, an epic poem of approximately 60, 000 verses written by Firdausi in 940-1020, is still today honoured as the Afghan national epic,

The Empire Sultan Muhammad, personal interest in calligraphy and painting,

One the great Shaname was presented as a gift to the Ottoman Empire Selim II 1566-1574, and remained in the Ottoman collections in

Istanbul until the beginning of the 20ᵗʰ century. In 1903 it came into the possession of Baron Edmond de Rothschild, and in 1959 it was sold to an American collector who had it taken it apart and sold the individual illustrations at auction thereby destroying unity of an Afghan work of Art which had remained for over 400 years.

The Great Master, for all time's Bihzäd 1475 Herat Master Kamal ad-Din Bihzad

The document translated occurs in a collection of official papers, drawn up by Khwändamir and entitled Nämab-I Nämi, it is of interest not only for the appreciation it reveals of the work of Bihzäd, but also for the high place it assigns to the art of the painter, though written in a highly rhetorical and artificial style of mixed poetry and prose, it is obviously inspired by feelings of genuine sympathy for painting and altogether ignores the hostile attitude of the older generation of theologians. The album must have contained specimens of both painting and writing, and by weaving the praise of the two arts together Khwandamir endeavors to secure for the former the consideration which was universally accorded to the latter.

the talented minister of Sultan Husayn Bayqarä in Herat Afghanistan and like his master a patron of men of letters and artists; Master Bihzäd was himself a writer both of prose and verse 1501 A.D

'A description of an album put together by the Master Bihzäd, in whom have been made manifest the (divine) guidance and leading.

> The Eternal Painter' when he made the sun
> Adorned an album with the sky for leaves
> Therein he painted without brush or paint
> The shining faces of each beauteous form

Since it was the perfect decree of the incomparable Painter and the all-embracing wish of the Creator "Be and it was" to bring into existence the forms of the variegated workshop, the Portrait-painter of eternal grace has painted with the pen of (His) everlasting clemency the

human form in the most beautiful fashion in accordance with the verse "And He has fashioned you and has made your forms most beautiful", and has adorned the comeliness of the condition of his company (I.e. mankind), endowed with such charming qualities, by decking them out with various wondrous branches of knowledge and marvelous arts-in accordance with his gracious words, "We have favored them beyond many of Our creation"

> God's grace and art became revealed in men,
> When with his pencil he designed their forms
> When God displays his skill, his art adorns
> The course of time, like pages in a book
> Sometimes his pen's point, redolent of musk
> Draws lines whose excellence is unsurpassed
> Sometimes a moon-faced beauty stands revealed
> Whine' err he mixes colors with his brush
> Sometimes his art doth cause a stream of gold
> To flow within the garden of fair speech
> Sometimes he rose up a lofty tree
> Whose fruit gives comfort to the troubled heart?
> Sometimes his magic pen makes roses blow
> In all the flower-beds of the written word
> When're he decorated words with gold
> Each tiny fragment puts the sun to shame
> God's writing and his draughtsman ship amaze
> The wise man by their magic loveliness;
> The eye rejoices at the curving line
> Although the mind may fail to grasp the sense
> God's form and meaning both create delight
> And shed illumination on man's eye

"By the pen and what they write." This verse is a sign of the perfection of the super excellence of writing. And the verse, "he has taught with the pen" expresses the abundant merits of penmanship.

> Imagination cannot grasp the joy
> That reason drawled from a fine drawn line

It is impossible to express the delight of the soul of man at a design and picture made in such a way that it represents a king (Amir) and Minister (wazir) and rich and poor, and it is impossible to describe with the help of pen and fingers a particle of the beauty and grace and delight and reposefulness of this marvelous art. from the beginning of the world the most distinguished of the sons of Adam (on whom and our Prophet be peace so long as writing is formed by ink and pen!) have busied themselves in these two noble tasks, and they have carried off the palm of superiority over their like and their equals on the field of perfection and superiority and on the plain of skill and excellence. Accordingly, the distinguished names of some of these persons have been mentioned in the preface to this album and the fine specimens of their handwriting and their famous pictures, executed with their marvelous pens, have been given a place the pages. Among these perfect painters and accomplished artists are the compiler and arranger of the pages of this album, the producer of wonderful forms and of marvelous art, the marvel of the age, whose faith is unsullied, who walks in the ways of love and affection, Master **Kamal ad-Din Bihzad**.

His brush, like Main's wins eternal fame;
Beyond all praise, his virtuous qualities;
Bihzad, acknowledged as supreme in art,
The master of the painters of the world,
Unique among the artists of his age,
Has turned the name of Main to a myth,
Hairs of his brush, held in the master's hand,
Give life unto the forms of lifeless things
His talent is so fine that 'tis no boast
If we maintain, his brush can a hair
If still you doubt that in the painter's art
His mastery has reached perfection's height
You need but look with an impartial gaze
And contemplate the marvel of these forms
Wherewith he has adorned these beauteous leaves
And perfected the marvels set therein
For never yet has any page received

Pictures so fair or writing so refined

For without taint of flattery or risk of pride, it may be maintained that ever since the cheeks of rosy-cheeked beauties have been adorned with musk-like down, no pen has ever set down upon the surface of any paper specimens of writing such as are written in this album; and since the album of the sky has been fashioned with the light scattering form of moon and sun, the rays of the intelligence of no expert draughtsman have ever fallen on the like of the forms which decorate these pages. Every drop that the pearl scattering pen, like diver, has brought up from the sea of the inkstand to the shore of these leaves is a most precious pear, each figure which intelligence becoming a painter, leaving marvelous memorials behind it, has transferred from the tablet of heart to the pages of this books, is a hour enchanting the soul.

> Within the sea each pearl is be found
> That love has fostered' neat the waves of joy
> All eyes flash out with radiant loveliness
> Each heart is joyous as a lover's tryst

But since the praise of the delicacy of these precious pearls and the description of the fineness of these unique figures is not the office of any one who has no store of ability, and is not the function of any one who is without due provision, my musk diffusing pen must content itself with a quatrain which has been recited in praise of the **MasterKamal ad-Din Bihzad**.

> Thy brush, albeit set with hairs so small
> Has wiped out Main's face past all recall;
> What lovely forms have other pens produced
> But the good genius' has surpassed them all

Praise and thanks be to God, the Painter of the forms of his servants, and blessing and benediction be on our Prophet Muhammad, so long as a line is written by the pen and the ink, and on his family who are the manifestation of the form of right guidance and righteousness, and on his household, who are our intercessors on the day of the summons.

17 . Bahram in the Blue Pavilion . Sab'a sayyara Bukhara ,
960 = 1553 A.D.
The Bodleion Library .

Platon conseille Iskandar . Tajik Empire 1597 Delhi Basawan Amir Khusraw Abul I Fazl

(European Called the Mughals Empire

2 . Khwaja Abdallah Ansari talks with four disciples . Hayrat
al - abrar . Herat , 890 = 1485 A.D
The Bodleian Library ,

23 .Navoi among the great poets . Sadd-i Iskandar . Herat ,890
1485 A.D.
The Bodleian Library .

The Great Afghan-treasures,
Painting, Miniature's, written in the-

Public collection in London, the University Libraries of Oxford and
Cambridge and Edinburgh, Leningrad and the Bibliotheque National
in Paris, the Libraries of Berlin, Munich, and Vienna, Boston and
New York

The student of the art of painting in the Afghan-Islamic world is faced
with peculiar difficulties, the subject-matter of his interest is so widely
scattered that fortunate indeed must be the individual who can succeed
in gaining access even to the most important examples. The Great
Afghan public collection in London, the University Libraries of Oxford
and Cambridge and Edinburgh, furnish abundant material but some
of the most noteworthy achievements in Afghan-Islamic painting are
to be found in the Asiatic Museum in Son's Petersburg in Russia and
the Bibliotheque National in Paris; the Libraries of Berlin, Munich,
and Vienna also, though not so rich, cannot be neglected, apart from
these public institutions, access to which is not hard to obtain, there
are numerous private collections which are some instances jealously
guarded, and no publication have yet revealed the contents of the
Afghan-treasures and Literature. Like many other treasures of art that
were once available in Europe, a considerable number of some of the
finest painting produced by Afghan artist have crossed the Atlantic to
America, and must be studied in Boston and New York, the Afghan
itself parted with some of its most magnificent treasures of pictorial art
at a time when their beauty was not appreciated by their Afghan-owners,
but some still remain in Persia, and India. A shab Namah decorated for
Baysunqur, the prince to whom the authoritative recession of this epic in
its present form is attributed, still exists in the palace, and must contain
some of the delicate and charming work of the school of Herat but it
has never been described, and shares this obscurity with other treasures
of the same kind. The fall of the Afghan in 1928 Imperial House and
the confiscation of its inherited works of art by the new government
has revealed the unsuspected existence of a number of Afghan-Painting
of the best period, but still await an adequate account of the contents
of the Museum of the Kabul, and other places in which they are now
stored. For India some account has been published of the illuminated

MSS. In the Afghan Oriental Public Library, and the Government of Bihar and Orissa has had photographic reproductions made of the Afghan-miniatures in the three manuscripts, but no account is yet available of the contents of the Library of H.H. the Nawab of Rampur, and there are doubtless other private collections in India which will in time add to my knowledge of Afghan art, from Heart, Balkh, Bukara, Agra, Samarqand, Kabul, Ghazni.

But apart from the fact that the existing materials are difficult of access or, as being still undesirable are practically unknown, or at least not available for purposes of study, the student is faced by a further difficulty in that examples that have thus survived form but a very small part of the total number of works of art that once existed. Consequently there are great gaps in his knowledge a whole school of painting can only be guessed at through the survival of a single example; the sources of such schools or groups of painters as can be distinctly recognized often remain obscure; the advent of new influences can be observed, without its been possible to trace them to their source. These and similar difficulties are in great measure the result of the enormous destruction that has deprived of all knowledge of hundreds if not of thousands, of pictures; more particularly is this the case with regard to the earliest examples of this art.

With the exception of frescoes upon the walls of palaces, practically all the Afghan-Islamic pictures of which have painted in Heart, Kabul, Kandahra, Bukara, Samarqand, Agra, painted on paper from 2nd century until easily 20th century. Manuscripts and painting require special care and watchfulness in countries where the ravages of white ants and other insects can be so successfully achieved in an incredibly short space of time, and where semi-tropical rain may ruin by damp the painted page without the space of a few minutes.

**Prophet Muhammad seated among his Companions
Afghan-Islamic Art at Hreat 1500 A.D for the brilliancy
the picture is a fine piece of composition remarkable
the harmony of its colouring**

Afghan Religion Art
And Miniature

In Afghan-Religion art the representations of the Prophet Muhammad that most commonly occur show him as riding on Buräq, the consideration of which demands a separate chapter. Such pictures and majority of the other scenes in which he occurs are generally found as isolated paintings or as illustrations in poetical works where the text happens to provide suitable occasion for them. It is rare to find incidents of his life represented in works of history, and none of the standard biographies of the Prophet accepted by orthodox opinion appear to have been at any time provided with pictures. In such historical works of more general contents as happen to be illustrated which in itself is rare-the painters seem to have felt some hesitation in inserting pictures of the founder of their faith among those of meaner folk, and it is hard to find a parallel to the frequent occurrence of the Prophet in the illustrations of Rashid al-Din's Jmi at-Tawärikh. Messrs. Luzac &Co possess a MS of Mirkhwand's universal history, entitled Rawdat as- dated 1595, which contains several pictures of incidents in the Prophet's career, such as the mysterious event known as the splitting of the chess, the death of Abü Jahl in the Battle of Badr the casting down of the idols from the roof of the Ka'bah and Muhammad proclaiming Ali as his successor at Ghadir al-Khumm. Ali who is provided with as magnificent a flame-halo as the Prophet himself,

There is another historical work in which portraits of the Prophet might well be expected, namely Qisas al-Anhiya (the legends of the Prophets), the tightly adopted by several authors for their account of the sacred annals of Islam-but though of course a biography of Prophet Muhammad is always included, the only incident illustrated in the MS. In the Bibliotheque National Paris, is the first meeting of Prophet Muhammad with Khadijah, and the same is the case with the MS. It is more common to find isolated pictures of what may be termed a Santa Conversazione, in which the Prophet is seated among his Companions, several of whom it is possible to identify, even when their names are not given. Such groups are undoubtedly in many instances tendentious and are intended to sub serve the cause, as may be judged from the prominent or isolated position assigned to Ali and his sons, Hasan

and Husayn. One of the finest of these groups is in a MS. Of Nazm al-Jawahir by Nawai dated A.D 1485, the Prophet is seated in the prayer niche of a mosque, which forms the background of the picture; it is a superb example of a building such as the painter himself may have known in the City of Herat in the days of their greatness, with a green dome and a front covered with intermingled blue and green tiles; with a similar disregard for the local conditions of Medina, the artist has set in front of the Prophet a great brazier from which rise up bright yellow flames of fire. Prophet Muhammad is engaged in dictating either a passage of the Qur'an or some official letter to a secretary, possibly Zayd ibn Thabit, who seated on the ground before his master, is busily engaged in writing; by his side is another seated figure, and opposite these two other Companions of the Prophet, at whose identity it is only possible to guess, but they are possibly intended for the three devoted friends of Prophet Muhammad, who succeed him as leaders of the Muslim community. Standing in the left hand corner is Bilal, the first of the Muslim appointed to give the call to prayer; he is easily recognized by his black face, he being always thus represented on account of his Abyssinian birth. On the right stands Ali holding under his arm his famous two pointed sword; in the foreground just inside a slender railing, are seated four more of the Companions, The picture is a fine piece of composition, remarkable for the brilliancy and the harmony of its coloring.

Afghan-Islamic Art -Jesus conversing with the devotee and the reprobate Bustan Sa'di- Jesus rebukes him in the same spirit as in the Gosple narrative he expresses his commendation of the Publican 1567 A.D Herat

Abraham and the first-worshipper, Afghan-Islamic Art Herat Bustan Sa'di Abraham hurries after the first-worshipper and brings the old man back again into his house and treats him as an honoured guest.

The Remarkable Work of Religion-Art in Herat
One of the most beautiful stories
that Afghan writers tell of Jesus

In the delineation of other incidents in the life of Jesus, the Afghan's artist in the 1500th has had Christian exemplar to follow-necessarily so, in cases where the Afghan's-Islamic account differs from that given in the Gospels. G. the Qur'an does not describe the birth of Jesus as taking place in a stable, but in a remote and desolate place ("Qur'an xix. 22") In his presentation of the Nativity, therefore, the Afghan-artist had to create his own types, and "so far as the writer is aware" the picture reproduced is unique in Afghan, religion-Art. The Virgin in an attitude of exhaustion and dejection leans against the withered date-palm, which at the touch, bursts into leafage and fruit, and from its roots a stream gushes forth, unfortunately, the silver used by the painter to depict water has, as in almost every other case in these Afghanistan pictures, become tarnished and has turned quite black, the new-born babe , wrapped in swaddling clothes, lies on the ground with a Great flame halo of Gold, which seems almost to serve as a pillow. Among the countless pictures of the Nativity to be found in the world, this one has characteristics that exist in no other, and though remarkable as a work of art in Herat Afghanistan, in itself particularly beautiful, it is unique in its conception and execution Similarly, no other Muslim representation of the Baptism of Jesus is known except that in Al-Athar al-Baqiyah, and though other Christian subjects suggest that the painter had some knowledge of earlier Christian art, he has treated Baptism in a manner peculiar to himself. The types he has selected for Jesus and St. John the Baptist are Afghanistan-Herat and peculiarly unattractive, the dress also is Afghanistan-Heart, and the huge shoes which Jesus has put down in a prominent place before stepping into the water are such as are worn in the Afghan-Provinces of East Turkistan (new China 1939) to the present day. The dove swoops down from the sky almost like a bird of prey and looks as if it were made of brass. A more unsympathetic representation of this important event in the life of Jesus it would be difficult to imagine. Other incidents in the Gospel narrative, which receive no mention in the Qur'an, are illustrated in a MS. Of Mirkhwand's Universal History in the Bibliotheque National

Herat 1567 A.D such as Jesus casting a stone at the devil and the last Supper, a variant of the parable of the Pharisee and the Publican was woven by Sa'di into the text of his Bustan, Jesus is said to have been one day in the company of a devout person, when a reprobate overhearing their conversation repents him of his evil ways and resolves to amend his life. So, humbly he draws near the two holy personages; but the devout ascetic, annoyed at the interruption, wishes harshly to drive him away; whereupon Jesus rebukes him in the same spirit as in the Gospel narrative he expresses his commendation of the Publican.

One of the most beautiful stories that Afghan writers tell of Jesus is that one day, while walking in the in the bazaar with his Disciples, they passed the body of a dead dog lying in the gutter; one after another began to express his disgust at the sight; one exclaimed, "How it stinks" said another, "Its skin is so torn, there is not enough left wherewith to make a purse". But Jesus selecting the one characteristic of the poor beast that was worthy of commendation, said; "Pearls cannot equal the whiteness of its teeth" this story first occurs in the literature and was afterwards popularized by the poets, notably by **Nizami** in his **Makhzan al-Asrar**. Unlike so many of the sayings attributed to Jesus in Afghan-Literature, this story does not appear to be of Christian, origin as it occurs neither in the Gospels nor in Apocryphal literature. But it is told by Haribhadra, a Jaina monk of the second half of the ninth century, and might well have been made known in the Afghan world by the Afghan-Tajik in India thinkers of the Sumaniyyah sect who holding disputations with the Afghan theologians of Babylon and Basrah just at the same period. In which the story first makes its appearance in Afghan literature connects the story with Jesus, it was made part of the literature of Europe by Goethe in the notes to his West-Östlicher Divan.

4 . Shaykh Iraqi overcomeat parting . Hayrat al-abrar. Herat ,
890 = 1485 A.D .
Bodleian Library .

25 . Iskandar on the Mediterranean Sea .Sadd-i Iskandar . Herat ,
930 = 1525 A.D
Bibliotheque Nationale . Paris ,

31 .Friends visit the Shaykh of San'an , tending swine . Lisan
at-tayr , Bukhara , 960 = 1553 A.D.
Bibliotheque Nationale Paris ,

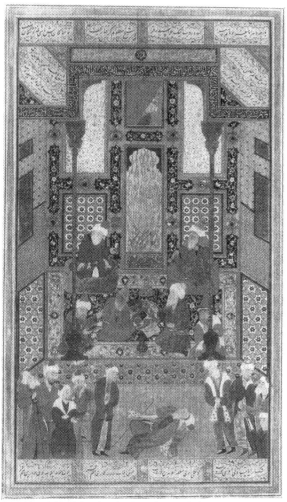

30 . The Shaykh of San'an in love insensible .
Lisan at-tayr , Bukhara , 960 = 1553 A.D.
Bibliotheque Nationale Paris ,

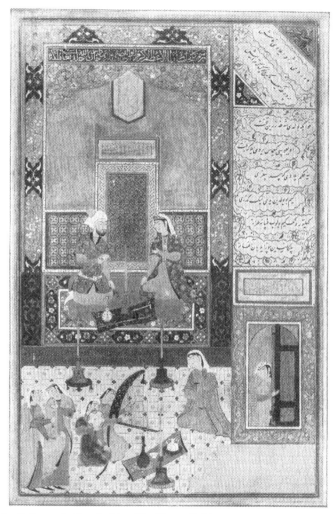

14 . Bahram in the Golden Pavilion . Sab'a sayyara .
Bukhara . 960 = 1553 A.D.
The Bodleian Library .

The Great achievements of the Afghan-Genius

The Great Religion Art and Miniature of Afghanistan
The History of the Prophet Abraham 15th century

The story of Abraham is often illustrated; see him destroying his father's idols and as a punishment for his blasphemy being cast into the flames of a huge fire by order of king Nimrod, and there comforted by an angel, and later, about to sacrifice his son, who is generally given by Afghan writers the name of Ishmael, rather than Esaq (Isaac). As the painters were most commonly employed to illustrate the poems of Sa'de Nizami, and other popular writers, such incidents in the life of Prophet Abraham as these poets recorded were those most frequently selected for pictorial treatment; thus often see Prophet Abraham and his son praying before the Ka'bah, which they built on the spot where it still stands in the city of Mecca ("Qur'an, ii, 121") Bustan tells the story of Prophet Abraham's entertainment of the first worshipper, which was introduced into English literature by Bishop Jeremy Taylor at the conclusion of his Discourse of the Liberty of Prophesying, it was the custom of the Prophet never to sit down to his morning meal until some traveller had come, with whom he could share it. One day an aged man made his way across the desert and was invited by Prophet Abraham to be his guest. When they sat down the Prophet said grace but the old man did not utter a word, and when Prophet asked him, Is not our bounden duty when we break bread, to do so in the name of the Giver of it?' he replied, 'I observe no rite that I have not learned from my spiritual guide, the first worshipper'. Prophet Abraham is so filled with horror at the thought that he has unawares been entertaining an idolater that indignantly he drives the old man away. Then God sends down an angel to rebuke the Prophet for his intolerance, and the message of the angel is this; "If have borne with this aged man and given him his daily bread for a hundred years, can you not bear with him for a single hour?' filled with shame at this rebuke, Prophet Abraham hurries after the first worshipper and brings the old man back again into his hues and treats him as an honoured guest. In a sixteenth century MS. Of this poem, the painter selects this last moment in the story as the subject of his picture; the Prophet, a tall dignified figure, is

seen commending to the members of his household the white bearded first worshipper, bent double with age, while a brilliantly coloured angel swoops down in a mass of flame that floats behind him like broken fragments of cloud. None of the great figures of Old Testament history have so profoundly stirred the imagination of Afghan-writes as that of yosef "Joseph". The Qur'an had given them a lead, in that it devoted a whole chapter, the Surah of Yosef "Joseph" (chapter xii), to the recital of his story, but this narrative was much amplified by succeeding generations. His adventures were taken as the subject of Great poems by some of the most famous of the Afghan poets, and the YÜSUF AND ZULAYKHÄ by FIRDAWSI, written about A.D 1010, and that by Jämi in A.D 1483, are counted among the greatest achievement of the Afghan genius, but neither was Firdawsi the first nor Jämi the last of Afghan poets to put the tale of **Yüsuf and Zulaykhä** into verse, and the list of such poems is a long One.

Nie years after the completion of Jami's romance the **Alisher Navoi** poet, completed his own popular poem which was modeled on those of his famous predecessors, and it still remains the finest Alisher Navoi poem on the theme, though it was taken up by many others in succeeding generations. This story not only made the same romantic appeal to Afghan readers as it has done to the Christian world for centuries, but receiving at the hands of the Afghan poets an allegorical interpretation, was made the vehicle for the inculcation of mystical doctrine. Yosef "Joseph" was taken as the type of the Celestial Beauty, i.e. God; and Zulaykha, as the personification of overmastering and all compelling love, was made to represent the soul of the mystic the love of the creature being regarded as the bridge leading to love of the Creator. This application of the story to the apprehension of divine knowledge was set forth in the following verses of **Jami,**

> Though in this world a hundred tasks thou tryst,
> This Love alone which from thyself will save thee
> Even from earthly love thy face avert not
> Since to the Real it may serve to raise thee
> Ere A, B, C, are rightly apprehended
> How canst thou con the pages of the Qur'an?
> A sage (so heard I) unto whom a scholar

Came craving counsel on the course before him
Said, 'If thy steps be strangers to Love's pathways
Depart, learn love and then return before me!
For shoal's thou fear to drink wine from form's flagon
Thou canst not drain the draughts of the Ideal
But yet beware! Be not by Form belated
Strive rather with all speed the bridge to traverse
If to the bourn thou fain wouldn't bear thy baggage
Upon the bridge let not thy footsteps linger

The most popular details of the story, selected by the painters as subjects for illustration, were the drawing of Yosef "Joseph" out of the well into which his brethren had thrown him his sale in Egypt his temptation by Zulaykha (for this is the name by which Polisher's wife is known to the whole Afghan world) his imprisonment his subsequent greatness. Though so far the Afghan version corresponds to that of the Bible, in no case does any Afghan painter appear to have taken any Christian picture as his model.

In regard to other details of the story, no such borrowing would even have been possible, because both the original account in the Qur'an and the additions made by Afghan-Poets and other find no place in the Christian Scriptures, but are peculiar to the Afghan and Muslim version. Thus Zulaykha, in order that Yusef "Joseph should entertain no doubt as to her feelings towards him, is said to have had pictures of herself and Joseph painted on the walls of her room, on the ceiling, and even on the floor, so that wherever he turned his eyes he saw himself and his mistress, embracing or seated side by side, Zulaykha kneeling at his feet. Such a picture, painted in 1475in Heart Afghanistan,

The Qur'an (xii. 31-2) relates that the ladies of Egypt were so scandalized by the behaviour of Zulaykha and took such good care that she should come to know of their disapproval, that she invited them to a feast, and having first set fruit before them, put into the hand of each a knife with which to skin it; just at his moment she called Joseph into the room and as soon as they saw him, all the ladies cut their hands, crying out in amazement, 'O God! This is no mortal being! This is none other that an angel!'

The implication appears to be that ladies of Egypt were thus compelled to recognize that there was sufficient rustication for Zulakha's passion for Joseph. This subject became a favourite one especially among the later Afghanistan illustrators, but nowhere received such attractive presentation as in the MS. Of **Jami's Yusef and Zalaykha in the British Museum in London (or. 4535, fol. 104)**

The Afghan poets carried the story far beyond the point reached in the Book of Genesis. Polisher dies and Zulaykha is reduced to a state of abject poverty, and with hair turned white through sorrow, and eyes blinded by continual weeping, she dwells in a of reeds by the roadside, and her only solace in her misery is listening of the sound of Joseph's ("Yusef") cavalcade as from time to time it rides past. After fruitless prayer to her idol for relief, she turns in penitence to the true God, and one day she prays in a loud voice for the blessing of God upon the head of Joseph ("Yusef") he hears her cry and orders her to be brought before him, and learns to his surprise that this wretched woman is his former mistress. He then prays to God on her behalf; her sight and her beauty are restored to her, and a divine message bids Joseph ("Yusef") marry her. This happy sequel to the story seldom finds an illustrator, but in the MS. In the Bodleian Library (Elliot 149, fool 190) there is a picture of the interview between Josef ("Yusef") and the decrepit, affected woman.

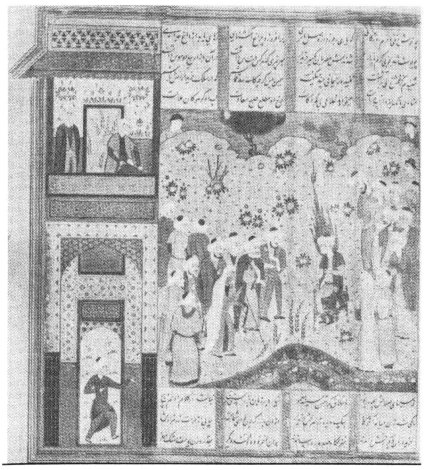

Yusef and Zulaykha painted in 1470 in Herat-Afghanistan
thus Zulaykha, in order that Yusef should entertain no doubt as to her feeling
towars him, is said to have had pictures of herself and Yusef painted on the walls of her room
Zulaykha as an old woman brought before Yusef

Painted in 1470 Herat-Afghanistan
Yusef and Zulaykha on the ceiling and even on the floor, so that wherever he turned
his eyes he saw himself and his mistress, embracing or seated side by side
or Zulaykha kneeling at his feet

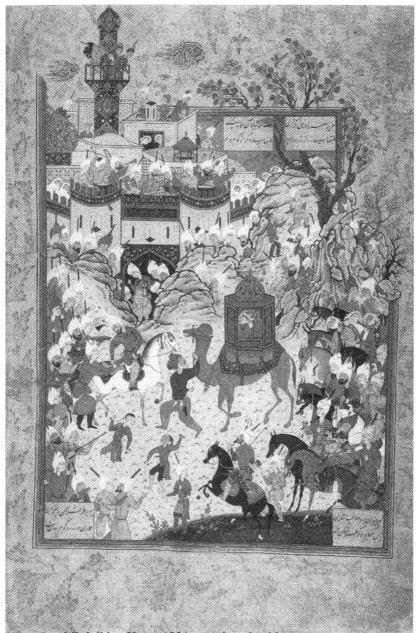

Yusuf and Zulaikha, Herat 1556 gouach and gold on paper
the vazir "prime minister" and greeted by the people
the beautiful Zulaikha, seated in the back of a camel
Afghanistan-Herat

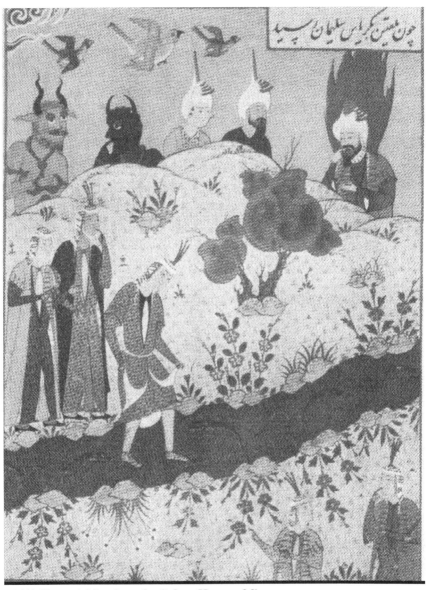

1400 Herat-Afghanistan by Sultan Husayn Mirza
Solomon and the Queen of Sheba, the surprise of her attendant ladies and of
Solomon and his Jinns is naively indicated by the conventional gesture of
putting the finger to the lips. how Solomon met Bilqis, the Queen Sheba

Large place in Afghan literature is Solomon
1485 Herat by Sultan Husayn Mirza

Prophet Solomon the Old Testament who fills a large place in the Afghan literature is Prophet Solomon. Mention is made of him and his marvellous doings in four separate chapters of the Qur'an (xxi, xxvii, xxxiv and xxxviii) how God subjected to him the wind, and the birds and the Jinn's, and how he met Bilqis, the Queen of Sheba, and put her wisdom to the test. The painters found ample scope for the exercise of their imagination in illustrating this story, as it was elaborated by the commentators and, after them, by the poets Pictures showing the two wise monarchs seated together, surrounded by birds and beasts and strange monsters of various kings, are common, especially in the opening pages of romantic poems. One obscure verse in the Qur'an (xxvii.44) it was said to her, "Enter the palace'" and when she saw it, she thought it a lake of water and bared her legs. He said, "Lo! It is a palace smoothly paved with glass" is explained by the commentators to have reference to a rumour that had reached to the ears of Solomon to the effect that the Queen of Sheba had hoofs and hairy legs like those of an ass; so Solomon had a courtyard of the palace flooded and stocked with fish, and then covered with glass. Apparently the Queen of Sheba, for all her wisdom was not acquainted with the transparency of glass; so when she saw the fishes swimming about, she lifted her skirts with the intention of wading through the water, and (according to the common account) Solomon recognized that her feet and her legs were beautifully formed, but that the rumour as to their being hairy was unfortunately true; so he refused to marry her until this blemish had been removed by means of a depilatory. The painter of a charming picture of his incident in a MS. Majalis al-Ushshaq by Sultan Husayn Mirza, in Heart-Afghanistan, new in the Bodleian Library Queen Bilqis as entirely free from any such disfigurement; but at the same time he has so misunderstood the story as to depict the fear of the queen as actually covered by the water, the surprise of her attendant ladies and of Solomon and his Jinns is naively indicated by the conventional gesture of putting the finger to the lips. In connexion with Prophet Solomon, some of the earliest representations of the Jinn's, those strange beings intermediary between the angelic and the human

creation, make their appearance in Afghan religion-art. According to the theologians, some of the Jinn's were true believers, while other was infidels; to the former class, of course, belonged those who did service to Prophet Solomon. But even these, as depicted by the painters, are terrific in appearance, being coloured either black or a corpse-like white, and wearing bristling horns on their heads. While these hideous, but virtuous, beings are not uncommon in Afghan religion painting, devils and demons as ministers of evil are comparatively rare until a later date. In Afghan-art the devil has never played so prominent a part as in the art of the Christian world, and the picture which depicts his first historic appearance as a rebel against God, when ordered the angels to bow down before the form of Adam before the breath of life had been breathed into the newly created man (Qur'an, xv. 30 sqq.) the rebellious angel Iblis, appears as a dignified figure, in human form, seated on a prayer carpet. There the Afghan manuscripts like the Uighur MS. Of the Mi raj Namah, full of pictures of the progress of Prophet Muhammad through heaven and hell painted in the fifteenth century at Herat, probably for the great empire Timuri sovereign, Shah Rukh. It is not impossible that the illustrators of this manuscript were influenced by the Buddhist representations of hell, of which their neighbours in Afghanistan were so fond; but for some reason difficult to determine they did not find imitators in later Afghan painting.

Equally rare are pictures of Heaven, the most charming of these are found in the same Mi raj Namah in the Bibliotheque National where the blessed are seen in a beautiful garden paying visits to one another on their camels and exchanging bouquets of flowers, the vast literature, in Dari-Afghani, describing the ascent of the Prophet to heaven and his passage through the various circles of the realms of the blessed might have provided abundant subject matter for the activity of the painters, had not such book as a rule been regarded as belonging to the domain of theology and been thus protected from the sacrilegious touch of the painter's brush, in consequence of the hostile attitude of the students of such literature towards his art.

The story of Abraham Herat-Afghanistan
Abraham about to sacrifice his son, Painted in 1475 by Jami

Herat 1475
the Queen of the island of Waqwaq

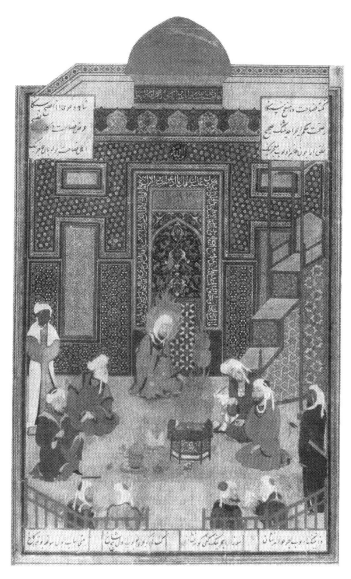

1 . The Prophet and **Companions** . Hayrat al-abrar
Herat , 890 = 1485 A.D
The Bodleian Library .

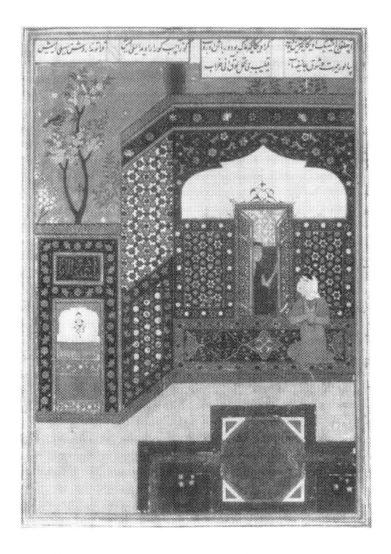

7 . Majnun at the house of Layli wa Majnun . Herat
890=1485. The Bodleian Library .

The Settlement of the Europe during social and political edifice
The power of the Old World was human power
(nineteenth Century)

Some such interlude had to happen, and some such patched up settlement of Europe as the Concert of Europe, because there was no worked in Europe upon which a new world could be constructed, and even the concert of Europe had in it an element of progress. It did at least set aside the individualism of Machiavellian monarch and declare that there was a human or at any a European commonweal. If it divided the world among the German's kings, it made respectful gestures towards human unity and the service of God and man. The permanently effective tats before mankind which had to be done before any new and enduring social and political edifice was possible the task upon which the human intelligence is, with many interruptions and amidst much anger and turmoil still engaged, was and is, the task of work and applying a Science of Property as a basis for freedom and social justice, a Science of Currency to ensure and preserve and efficient economic medium in Europe, a Science of European Government and Collective Operations among the Germans kings whereby in every German community European may learn to pursue their common interests in harmony, a Science of The World Polities in 1860 in Europe, through which the stark waste and cruelty of warfare between races, peoples in Europe and nations may be brought to an end and the common interests of mankind brought under a German king control, and above all, a world wide System of Education to sustain the will and interest of German king in their common human adventure.

The real makers of history in the nineteenth century in Europe the Germans whose consequences will be determining human life a century ahead, were those who advanced and contributed to this German-fivefold constructive effort. Compared to them the foreign ministers and "Statesman", and politicians of German period were no more than a number of troublesome and occasionally incendiary schoolboys and a few metal thieves playing about and doing transitory

mischief amidst the accumulating materials upon the site of a Great building whose nature they did not understand.

And while throughout the nineteenth century the German first time-mind of Western civilization, which the Renascence had released, gathered itself to the task of creative social and political reconstruction that still lies before it, there swept across the world-today a wave of Germans-universal changes in human power and the material condition of Germans-life that the first scientific efforts of that liberated mind had made by Germans-possible in the World. The accumulating knowledge and confidence of the little succession of German, who had been carrying on the development of science, now began to bear fruit that common men could understand. The most obvious first fruit was the steam-engine. The steam-engines in the eighteen centaury by German were pumping engines used to keep water out of the newly opened coal mines.

These coal mines were being worked to supply coke iron-smelting for which wood charcoal had previously been employed by the German's

History Setting
King Muhammad Nadir Shah 1929 to 1933

The new ruler quickly abolished most of King's Amanullah's 1919-29but despite his efforts the army remained weak while the religious and tribal leaders grew somewhat in strength. There uprising by the Shinwari and another Tajik leader in 1930, and in the same year a Soviet force crossed the border in pursuit of an Uzbek leader who had been harassing the Soviet from his sanctuary in new-Afghanistan. He was driven back to the Soviet side by Afghan army in April 1930, and by the end of 1931 most of the country had been subdued. King Nadir Shah named a 10-man cabinet, consisting mostly of members of his family, and in September 1930 he called into session a Loya Jirgah of 286 men to confirm his accession to the throne. At the king's direction, the Loya Jirgah chose 105 members to make up national council. This body, with which the king was supposed to consult on legislation, automatically approved decision by the cabinet. In 1931 the king promulgated a new constitution. Dupree's analysis of the 1931 constitutions concludes that although it incorporated many of

the ideals of Afghan society and appeared to establish a constitutional monarchy, in fact the document created a royal oligarchy, popular participation being only an illusion. Although king Nadir Shah placated religious elements with a constitutional emphasis on orthodox religious principles, he also worked to modernize new-Afghanistan in material ways; he worked on the construction of roads, especially the great north road through the Hindu Kush, and improved the means of communication. Commercial links were also forged with the foreign powers with King Amaullah Khan had Established diplomatic relation in the 1920s, and under the leadership of several leading entrepreneurs, a banking system and long-range economic planning were started, School which had been closed during the 1929-33 interregnum, were reopened, although his efforts to improve the army did not bear fruit

1930 Nadir-Zahir king Zahir Shah 1938 king Zahir 1959

King Muhammad Zahir Shah and his Uncles, 1933 to 1953, three of Musahiban brothers were stave after king Nadir Shah's death, and they exercised decisive influence over decision making during the first 20 years of Zahir Shah's reign. The eldest, Muhammad Hashim, who had been prime minister under the lat king, retained that post until 1946, when he was replaced by the youngest of the Musahiban brothers, Shah Mahmud. Hashim khan is described by Fraser-Tyler as states of great administrative ability and high personal integrity that devoted all of his energy to his country. In the months immediately following Nadir |Shah's assassination, while the tribes remained quid and the followers of Ex-King Amanullh khan remained disorganized and impotent, Hashim began to put into practice the policies already

planned by the Musahiban brothers. Internal objectives of the new Afghan government, up to the outbreak of World War II were focused on improving the army and developing the economy including transport and communications, both goals, however, required external assistance, seeking to avoid involvement with the Soviet Union and British, Hashim turned to a far-off nation that had both the interest and the technical expertise require-Germany, by 1935 the Afghan government had invited German experts and businessmen to help set up factories and build hydroelectric projects. Lesser amounts of aid were also accepted from Italy and Japan, but these two countries did not achieve Germany's level of prominence in Afghanistan's foreign relations, by the beginning of the 1940s Germany was Afghanistan most important foreign fried.

Afghanistan joined the League of Nations in 1934, in new-Afghanistan, the same year that the Unite states were reinforced by the conclusion in 1937 of friendship no aggression pacts with Turkey, although never implemented because World War II intervened, Dupree Notre notes that the pacts laid the groundwork for coordination among the three states in later periods. The relationship with Turkey was especially close. Disorganized and impotent, Hashim began to put into practice the policies already planned by the Musahiban brothers. Internal objectives of the new Afghan government up to the outbreak of World War II were focused on improving the army and developing, the king issued a proclamation of Afghan neutrality on August 17 1940s but the American-Allies were unhappy with the presence of a large group of German no diplomatic personnel, in October the British-Russia government demanded that Afghanistan expel all no diplomatic personnel from the Axis nations. The Afghan-government considered this an insulting and illegitimated demand, but it undoubtedly found instructive the example of Iran, which British and Russia had invaded and occupied in August 1941 after the Iranian government ignored a similar demand, king Zahir Shah and his advisers found a face-saving response, ordering all no diplomatic personnel from the belligerent countries out of Afghanistan. A Loya Jirgah called by the king at this time supported his policy of absolute neutrality. Although World War II disrupted Afghanistan's incipient foreign relationships and to some extent the government's domestic goals, it also provided larger markets

for Afghan agricultural produce, by the War's end the government had exchanged official missions with china and Russia and United States, and the latter had replaced British as the major marked for Afghanistan's principal export, Karakul skins. Shortly after the end of the war, Shah Mahmud khan replaced his older brother as prime minister, ushering in a period of great change in both the internal and external politico of Afghanistan, among other thing the new prime minister presided over the inauguration of the giant Helmand Valley Project and the beginning of relations with the newly created of New-Pakistan, which inherited the Pashtuns on the side of the Durand Line 45, million Afghan's formerly ruled by Britain. The issue of Pashtunistan agitation for an independent or semi-independent

The Pashtunistan Issue "Cold War or Pakistan" Cold War + Durand Line in 1950 the United States of America replaced Britain as the major Western Power "1947 Pakistan as cold war"

In their colonial period, European nations created frontiers throughout Asia and Africa that left legacies of bitterness, and often War, for the independent nations that emerged from rule. Although it was never colonized, Afghanistan was no exception. **The Durand Line mordent 750 kilometres** had been bitterly resented by King Rahman khan 1892 to 1992 and none of his successors gave up the **notion of Pashtun** unity, even though they cooperated with the British-India government in other matters. **The line dividing the Pashtun people** became extremely irksome to the Afghan and the Pakistan government from 1947-92, which inherited the frontier upon the partition of British-India in 1947 "The Cold War Pakistan" the fragility of the new nation of Pakistan, may have incited the Afghan to reassert the concept of Pashtunistan in 1947 by British. Although the issue became most vexing at the time of the partition, British policy in the area before 1947 also contributed to the development of the Pashtunistan problem. In 1901 they had created a new administrative area, the NWFP, which they detached from Punjab, and had divided the new province into Settled Districts and Tribal Agencies, the latter ruled not by the Provencal government but by a British political who reputed

directly to Delhi. This separation was reinforced by the fact that the experiments in provincial democracy inaugurated in 1919 were not extended to the NWFP. In the 1930s Britain extended provincial self-government to the NWFP. By this time the Indian national congress, which was largely controlled by Hindus, had extended its actives to the province. The links between the political leaders of the NWFP with the Hindu leaders of congress was such that a majority in the NWFP cabin ally voted to go with India in the partition, a decision that might have been rejected by a majority of voters in the province. In July 1947 the British held a referendum in the Settled Districts of the province that offered the population the choice of joining an independent India or a now-inevitable Pakistan. Although local leaders now leaned toward indolence, a position officially supported by Afghan government, this was not an option offered in the vote. Although these leaders advocated a boycott of the referendum, an estimated percent of the eligible voters participated, in the Tribal Agencies a Loya Jirgah was held. Both the Afghan and Indian leaders objected to both procedures, declaring that, because the tribes had same kind of direct links to the British as the princely states of India, the Pashtun tribes should be treated the same way, i.e., they should be offered a third option of initial independence until they could decide which state to join. The birth, along with India, independent nation, accompanied by massive dislocation and bloodshed, was thus further complicated by the agitation for independence or provincial autonomy by a significant minority, and perhaps a majority, of the residents of the NWFP. This poisoned relations between Afghanistan and India for many years.

The conflict between Afghanistan and Cold War "Pakistan" over the **Pashtunistan** (Cold War) issue was manifested not only in bitter denunciations but also by such actions as Afghanistan's casting of the sole negative vote on commodities to its landlocked neighbour. Although both Afghanistan and Pakistan made conciliatory gestures including Afghanistan's withdrawal of its negative UN vote and the exchange of ambassadors in February 1948 matter remained unresolved. In June 1949 an air force plane bombed a village just across the frontier in one of the government's attempts to suppress tribal uprisings. In response, the Afghan government called into session a Loya Jirgah, which promptly proclaimed that it recognized "**neither the imaginary**

Durand nor any similar Line, 1892 until 1992" and declared void all agreements from the 1893 **Durand agreement onward related to the issue**. There was an attempt to set up an independent Pashtun parliament inside the Pashtun areas, which was undoubtedly supported covertly by the Afghan government. Irregular forces led a local Pashtun leader crossed the border in 1950 and 1951 to back Afghan claimed. The Pakistani ("British") government did not accept the Afghan government's claim that they had no control over these men, and both nations' ambassadors were withdrawn, "**Cold War**". Ambassadors were exchanged once again a few months later. In March 1952 the assassination of the Pakistani prime Minister by an Afghan citizen living in Pashtunistan (Cold War) was another irritant in bilateral relations although the Pakistani government accepted Fagan denials of any involvement on its part. The Pakistani government, despite its preoccupation with many problems, adopted from the beginning a very conciliatory attitude toward its Pashtun citizens. The residents of the Tribal Agencies were permitted to retain virtual autonomy, expenditures on health and other services in the NWFP were disproportionately higher than in other areas of the country, and only a few units of a locally recruited frontiers Corps were left in the tribal agencies (**"in contrast with the 48 regular army battalions that had been kept there under British rule**") the government also continued to pay subsidies to hundreds of mails (chiefs or leaders) in the tribal areas. The issue of the international boundary through Pashtun areas was of the greatest possible importance to the policymakers in Kabul, just as it had been in the days of King Rahman 1892. The beginning in recent times of Afghanistan's ties to the Soviet "Cold War" grew at least partially from the Pashtunistan (Cold War) and related issues. By the 1950s the United States, which had replaced Britain as the major Western power in the region, had begun to develop a strong relationship with Pakistan. When in 1950 Pakistan stopped vital transhipments of petroleum to Afghanistan for about three months, presumably to retaliate for the attacks across the border by Afghan tribes, the Afghan government became more interested in offers of aid from the Soviet and in July 1950s, signed a major agreement with Soviet Union

Early Links with the Soviet Union (old or new Russia) The Cold War

Although Afghanistan had established diplomatic ties with the Soviet Union in one of its earliest gestures of independence in 1919 and although extensive bilateral trade contacts had come into being by the late 1930s the cut-off of petroleum by British over the Pashtunistan ("The Cold War") issue and the consequent trade agreement between Afghanistan and the Soviet were major watersheds in bilateral relations. As Dupree States, the 1950 agreement was far more that a barter agreement to exchange Soviet oil, textiles, and manufactured goods for Afghan wool and cotton; the Soviet offered aid in construction of petroleum storage facilities, oil and gas exploration in northern Afghanistan, and permission for free transit of goods to Afghanistan across Soviet territory. The new relationship was attractive to the Afghans not only because it made it difficult for Pakistan ("U. S. A") to disrupt the economy with a blockade or a slowdown of transhipped goods but also for a political purpose traditionally dear to Afghan rulers, i.e., it provided a balance to American aid in the Helmand Valley project. In the years following the 1950 agreement, Soviet-Afghan trade increased sharply, and the Afghan government welcomed a few Soviet technicians and a Soviet trade office

Experiment with Liberalizes Polities the third major policy focus of the immediate postwar period in Afghanistan was the experiment in political liberalization implement by Prime Minister Shah Mahmud Khan. Young, Western-educated members of the political, the prime Minister allowed national assembly elections that were distinctly less controlled that ever before, resulting in the "liberal parliament" of 1949. He also relaxed strict press censorship and allowed political groups to come to life (Cold War). The most important of these groups was Wikh-i-Zalmayan (Awakened Youth) a movement made up of diverse dissident group founded in Province of Kandahar in 1947. As the new liberal parliament began taking its duties seriously and questioning the king's Ministers, students at Kabul University also began to debate political questions. A newly formed student union provided not only a forum for political debated but also produced plays critical of Islam and the Monarchy. Newspapers criticized the government, and many

groups and individuals began to demand a more open political system. The liberalization clearly went further than the prime Minister had indented. His first reaction was to ride the tide by creating a government party, but when this flailed, the government began to crack down on political activity. The Kabul University student Union was dissolved in 1951, the newspapers that had criticized the government were closed down, and many of the leaders of the opposition were jailed. The parliament elected in 1952 was a large step backward from the one elected in 1949; the experiment in open politics was over.

The liberal experiment had an important effect on the nation's political future. It provided the breeding ground for the revolutionary movement that would come to power in 1978 (Cold War). Nor M. Taraki, who became president following the 1978 coup detach claimed in his official biography to have been the founder of the Wikh-I-Zalmayan and the dissident newspaper, Anger (Burning Embers). Writer Beverley Male notes, however, that the claim appears exaggerated. Babrak Karmal, who became president after the Soviet invasion of December 1979 ("Cold War"), was active in the Kabul University student Union during the liberal period and was imprisoned in 1953 for his political activities. Hafizullah Amin later claimed to have also played a role in the student movement, although his activities were apparently not so noteworthy as to bring about his imprisonment by the government.

The government crackdown in 1951 and 1952 suddenly ended liberalization and alienated many young, reformist Afghan who may have originally hoped only to reform the existing structure rather that radically transform it. As Male suggests, "The disillusionment which accompanied the abrupt termination of the experiment in liberalism was an important factor in the radicalization of the men who later established the People's Democratic Party of Afghanistan for the Cold War"

Daoud Khan as Prime Minster, 1953 to 1963
Cold War

In the wake of the failed political reforms of the 1949 to 1952 period came a major shake-up within the new royal family. Fraser Tyler notes that sine the advent on King Nadir Shah to the throne in 1929, the new

royal family as a united group had ruled Afghanistan. By mid- 1953, however, the younger members of the new royal family ("including perhaps the king himself") had challenged the dominance of the king's uncles, and in September 1953 the rift became public when the king's first cousin and brother-in-law, Daoud khan (son of the third Musahiban brother, M. Aziz khan, who had been assassinated in Berlin in 1933), became prime Minister. The king's uncle Shah Mahmud khan, left his post, but he continued to proffer his support and advice to the new leaders. The change occurred peacefully, entirely within and apparently with the consent of the new royal family. Prime Minister M. Daoud khan was the first of the young, Western educated generation of the new royal family to wield power in Kabul. If the proponents of the liberal experiment hoped that he would move toward a more open political system, they were disappointed. Daoud was, as Fraser-Tilters put it, by temperament and training.... Of an authoritarian habit of mind' "by all accounts, however, he was a dynamic leader whose accession to power marked major changes in Afghanistan's politicising, both domestic and foreign Cold War".

Although Daoud khan was concerned to correct what he perceived as the pro-Western bias of previous government, his keen interest in modernization manifested itself in continued support of the Helmand Valley project, which was designed to transform life in south-western Afghanistan. Another area of domestic policy initiative by Daoud khan included his cautious steps toward emancipation of Women. At the fortieth celebration of national independence in 1959, Daoud had the wives of his ministers appear in public unveiled. When religious leaders protested, he challenged them to cite a single verse of the Quran that specifically mandated veiling. When they continued to resist, he jailed them for a week. Daoud khan also increased control over the tribes, starting with the repression of a tribal War in the contentious Khost area adjacent to Pakistan in September 1959 and the forcible collection of land taxes in Kandahar in December 1959 in the face of antigovernment demonstrations promoted by local religious leaders and Pakistani religious leaders "the Cold War".

Prime Minister M. Daoud Khan 1953-63

Doud's khan social and economic policies within Afghanistan, reformist but cautious, were relatively successful; his foreign policy-which was carried out by his brother, M. Naim khan although fruitful in some respects, resulted in severe economic dislocation and ultimately, his own political eclipse. Two principles guided Daoud's khan foreign policy: to balance what he regarded as the excessively poor Western orientation of previous governments by improving relations with the Soviet Union but without sacrificing economic aid from the Unite States "Cold War", and to pursue the Pashtunistan (Cold War) issue by every possible means. The two goals were to some extent mutually reinforcing because hostilities with Pakistan caused the Kabul government to fall back on the Soviet as its trade and transit link with the rest of the World. Daoud khan believed that the rivalry between the two superpowers for regional clients or allies created the conditions in which he could play one off against the other in his search for aid and development assistance The Cold War.

Relations between Afghanistan Russia in the 1953 to 1963 period began on a high note with a Russia development loan equivalent to U.S $ 3.5 Million in January 1954. Daoud's desire for improved bilateral relations became a necessity when the Pakistani-Afghan border was closed for five months in 1955. When the Iranian and American governments declared that they were unable to create an alternate Afghan trade access route of near of 5,800 kilometres to the Arabian Sea, the Afghan had no choice but to request a renewal of the 1950 transit agreement. The renewal was ratified in June 1955 and followed by a new bilateral barter agreement Cold War: Soviet petroleum, building materials,

Ana metals in exchange for Afghan raw materials. After a December 1955 visit to Kabul by Russia leader Nikolay Bulganin and Nikita Khushchev, the Russian announced a U.S $ 100 Million development loan for projects to be mutually agreed upon. Before the end of the year the Afghan also announced a 10-year extension of the Russia-Afghan Treaty of neutrality and non Aggression, originally signed in 1931 by King Nadir Shah.

Afghan-Russian ties grew throughout this period, as did Afghan links with the Russia east European allies, especially Czechoslolovakia and Poland.

Despite these strengthened ties to the Russia, the Daoud khan regime sought to maintain good relations with the United States, "Cold War" which began to be more interested in Afghanistan as a results by Dwight D. Eisenhower's administration to solidify an alliance in the "northern Tier" (Turkey, Iraq, Iran, Afghanistan new-Pakistan). Adhering to its non-aligned stance, the Afghan government refused to join the American-sponsored Baghdad Pact, although Eisenhower's personal representative was courteously welcomed when he came discuss regional issues in 1957. These rebuffs did not fetter the United States from continuing its relatively low-level aid program in Afghanistan. Its other projects in the 1953 to 1963 period include the Kandahar International Airport (which became obsolete with the advent of jet aircraft), assistance to Ariana Afghan Airlines, and continuation of the Helmand Valley Project "Cold War"

The United States was reluctant to provide Afghanistan with military aid, and the M. Daoud khan government successfully it from the Soviet Union and its allies. These nations agreed to provide Afghanistan with the equivalent of U.S $ 25 Million worth of Military in 1955 and also undertook construction of Military airfields in Province of Mazar-a-Sharif, Shindand, and Bagrami. Although the United States did provide Military training for Afghan officers, it made no attempt to match Soviet arms transfers. Dupree points out that eventually the United States and Soviet aid programs were bound to overlap, and when they did there developed a quiet, de facto cooperation between the two powered "Cold War". All other foreign policy issues faded in importance, given Daoud's khan virtual obsession with the **Pashtunistan** "Cold War" issue. He policy disrupted Kabul's

important relationship with Pakistan and because Pakistan landlocked "Cold War" Afghanistan's main trade route-the dispute virtually cut off development aid, except from the Soviet Union "Cold War", and sharply diminished Afghanistan's external trade for several years "1947" in 1953 and 1954 Daoud khan simply applied more of the same techniques used in the past to press the **Pashtunistan** "Cold War" issue, i.e., hostile propaganda and payments to tribesmen ("on both sides of the border") to subvert the Pakistani (the British) government. In 1955, however, the situation became more critical Daouid khan point of view Pakistan, for reasons of internal politics, abolished the four provincial governments of west Pakistan and formed one provincial unit (like east Pakistan). The Afghan government protested the abolition of rhea NWFP (excluding the tribal agencies), and in March 1955 Student in Kabul attacked the Pakistani embassy, burned the embassy and consulate, and soon both nations recalled their officials from the neighbouring "Cold War" state. Despite the failure of mediation by a group of Islamic states, tempers eventually cooled, this incident left great bitterness in Afghanistan, however, where interest in the **Pashtunistan** "Cold War" issue remained high, and the closure of the border during the spring and fall of 1955 again underlined to the Kabul government the need for relation with the **Soviet** (new Russia) to provide assured transit routes for Afghan trade.

Although the Afghan side was not resigned to accepting the status quo on the **Pashtunistan** "Cold War" issue, the conflict remained dormant for several years, during which relations improved slightly between the two nations ("Afghanistan and England) nor did the 1958 coup that brought General Ayab to power in Pakistan bring on any immediate change in the situation. In 1961, however Daoud sent Afghan troops across the border into Bajaur in an unsuccessful and foolhardy attempt to manipulate events in that area and to press the **Pashtunistan** "Cold War" issue. The Afghan forces were routed by the Pakistani "British" military, but military skirmishes along the border continued at a low level in 1961, often between Pakistani Patton "armed by the Afghans" and new-Pakistani-British regular and paramilitary forces. The propaganda War, carried out by radio, was more vicious that ever during this period.

Cold War
Finally in August 1961
Daoud Khan of Afghanistan and Ayub of Pakistan

Finally in August 1961 British-new-Pakistani used another weapon on Afghanistan: it informed the Afghan government that its subversion made normal diplomatic relations impossible and that Pakistan was closing its consulates in Afghanistan, requesting that Afghanistan suit. The Afghan government, its pride severely stung, responded that the Pakistanis had one week to rescind this policy, or Afghanistan would cut diplomatic relations. When the Pakistanis failed to respond to this, Afghanistan severed relations on September 6 1961. Traffic between the two countries came to a halt, just as two of Afghan's major crops were ready to be shipped to India. The government to avoid trouble the grape and pomegranate crops, grown in traditionally rebellious areas. The Soviet Union (new or old Russia) stepped in, offering to buy the crops and airlift them from Afghanistan. When the Russians did not ship, Aryana Afghan airlines airlifted to India, so that in both 1961 and 1962 the fruit crop was exported successfully. Dupree notes that although the loss of this crop would not have been as disastrous to the average Afghan as observers generally suggest, the situation did provide the opportunity for a fine public relations gesture by the Russia. At the same time, although the U.S A attempted to mediate the dispute, it was clearly linked closely to Pakistan. More that the fruit crop was jeopardized by the closure of Afghanistan's main route, much of the equipment and material provided by foreign aid programs and needed for development projects were held up in Pakistan. Another outgrowth of the dispute was Pakistan's decision to close the border to nomads "members of the Ghilzai, variously known as Powindahs or Suleiman [Solomon] Kkel" who had been spending winters in new-Pakistan and India and Summers in Afghanistan as long as anyone could remember. Although the new-Pakistani government denied that the decision was owing to the impasse with Afghanistan, this claim appeared disingenuous, and the Cold War issue added weight to the growing conflict between the two countries. Afghanistan's economic situation continued to deteriorate. The nation was heavily dependent

upon customs revenues, which fell dramatically; trade suffered, and foreign exchange reserves were seriously depleted.

It became clear by 1963 that the two stubborn leaders, Daoud of Afghanistan and Ayub of Pakistan, would not yield and that one of them would have to be removed from power to resolve the issue. Despite growing criticism of Ayub among some Pakistanis, his position was strong internally, and it was Afghanistan's economy that was suffering most. In March 1963 King Zahir Shah, with the backing of the new royal family, asked Daoud khan for his resignation on the basis that the country's "Cold War" economy was deterioration because of Daoud's khan Pashtunistan "Cold War" policy. During the decade the public and more influential in the new royal family political elite had better know that Daoud khan was Prime Minister, the king, who was his peer in age. Because he controlled the armed forces Daoud khan almost certainly had the power to resist the king's request for his resignation, but did not do so (The Cold War)

Daoud khan bowed out, as did his brother Naim khan and king Zahir Shah named as the new Prime Minister Dr. M. Yousuf a non-Pashtun, German educated technocrat who had been serving as the Minister of mines and industries.

The Great President J.F- Kennedy Welcome King Zahir Shah at The White Hause May,9,1963 . H.W.A.

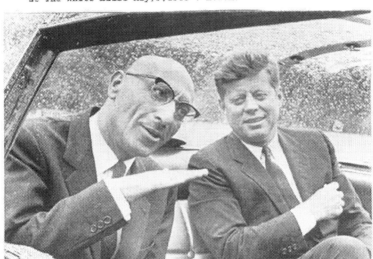

The King rules: the last decade of Monarchy, 1963 to 1973 the decision to ask Daoud khan to step down had been reached not only within the new royal family but also with the involvement of other members of the Afghan political elite. This set the tone for 10 years to follow, in which Zahir Shah as well as reigned but with a broad base of support within the political elite. The reaction to the dramatic change in Kabul was subdued. Although some Afghan attributed Daoud's khan falls to covert American intervention "because of Daoud's khan friendship with the Soviet (new or old Russia" others were delighted that the unnatural strain in relations with Pakistan "The Cold War" could be ended. A thriving black market trade had continued across the border, but the hostility had weighed heavily on the daily life of many Afghan's especially city dwellers, which had experienced a doubling of prices for many essential commodities since the 1961 border closing. Dupree observes that devout Afghan expected an end Daoud's khan secularization, intellectuals anticipated social and political reforms, and the population in general seemed to feel that while Daoud's khan economic reforms had benefited the nation, his stubbornness on the

Pashtunistan "Cold War" issue made his departure necessary. He notes that only three groups were unhappy over Daoud khan resignation: the Pashtunistan fanatics, new royal family members who worried about giving no family members any power in decision making and pro Soviet Afghan. Although it could not provide the immediate transformations the public expected, the new government clearly both represented and sought change. The prime Minister and at least one other cabinet member war one Pashtun, only four of the new cabinet was Durrani, and none was a member of the new royal family. Before the end of May the government had appointed a committee to draft changes in the constitution had ordered an investigation into abysmal conditions of Afghan prisons, and had reached agreement with Pakistan on the reestablishment of diplomatic. The single greatest achievement of the 1963 to 1973 "Cold War" decade was the 1964 constitution. Only two weeks after the resignation of Daoud khan, the king appointed a committee to draft a new constitution. By February 1964 a draft document had been written, and within a few months another royal commission, including members of diverse political and ethnic backgrounds had reviewed and revised the draft. In the spring of 1964 the king ordered the convening of a Loya Jirgah-a national gathering that included the members of national Assembly, the Senate, the Supreme Court, and both constitutional commissions. The Provinces elected One hundred seventy-six members, and 34 members were appointed directly by the king's as Dupree notes, Afghan monarchs had abused the mechanism of a Loya Jirgah in the past by allowing only their own supporters to attend. Although the assemblage of 452 persons "including six Women" that met in September of 1964 was composed predominantly of officials who could be expected to support the royal Line, the Loya Jirgah also included members elected from the entire nation. Dupree notes that the government did screen out many potential but concludes, "on the whole … delegates to the Loya Jirgah to represent the full range of social political, and religious opinion".

The 10-day deliberation of the Loya Jirgah produced heats and significant changes in the daft constitution. On September 20 the 452 members signed the constitution, and on October I it was signed by the king and became the constitution of Afghanistan (Cold War). The constitution and the deliberations that produced it-demonstrated several

interesting change in Afghan-political thinking, it barred the new royal family, other that the king, from politics and government a provision that was viewed as being aimed at keeping Prim Minister Daoud khan out of politics "Cold War". Individual, as opposed to tribal, rights were strongly championed by provincial delegates, and most conservative religious members were persuaded to accept provisions that they previously suggested were intolerably secular. The succession issue within the new royal family was settled to common satisfaction. The most interesting aspect of this discussion was one delegate's query as to why the throne should not go to the king's eldest daughter if there was no qualified male heir. Although some delegates were horrified and the question was not seriously considered, Dupree notes that the mere fact of its being asked was a sign of growing political sophistication among Afghan. Although there was lengthy debate over the use of the word Afghan to denote all citizens of Afghanistan ("many people regarding it as a reference to Pastuns alone"), it was agreed by Loya Jirah that this term should refer to all citizens. The constitution provided that state religious rituals be conducted according to the Hanafi rite and identified Islam as "the sacred religion of Afghanistan," but it was still necessary to persuade many conservative religious members of the group that Islam had been enshrined in the constitution. Although article 64 provided that there be no laws that were "repugnant to the basic principles" of Islam, article 69 defined law as resolutions passed by the houses of parliament and signed by the king, with sharia to be used when no such law existed. The constitution's provisions for an independent judiciary gave rise to heated debate among religious leaders, many of whom supported the existing system of religious Laws and judges "Cold War". The new constitution incorporated the religious judges into the judicial system, but it also established the supremacy of secular Law.

The new constitution provided for a constitutional monarchy with bicameral legislature, but predominant power remained in the hands of the king. Despite the difficulties imposed by widespread illiteracy, low voter turnout, attempts by some government officials (especially in the outlying areas) to influence the results, the lack of political parties, and the fact that Afghanistan was twelve tribes society with mo tradition of national elections, most observers described the 1965 election as

remarkably fair. The 216 member's wolesi Jirgah, the lower house of parliament, included representation by not only antiroyalists but the left and right of the political spectrum. It included supporters of the king, Pashtun nationalist, entrepreneurs and industrialists, political, small leftist groups, and conservative Muslim leaders who still opposed secularization. In heated early debates some members castigated the members of Yousufs transitional cabinet. A student sit-in in the Lower house of parliament was followed by demonstrations in which government troops killed three civilians, shocking many Afghans. The king nominated another Great Prime minister, M. Hashim Maiwandwal, who quickly established a firm but friendly relationship with the students. There were, of course, rumours in Kabul about outside support for these and subsequent demonstrations. Dupree, who was in Kabul at the time, finds it unlikely that they were the work of outside airside agitators but rather resulted from "home-grown dissatisfaction with the ministerial clique, who had played musical chairs during the Daoud khan regime and the succeeding interim regime".

On January I 1965, the People's Democratic Party of Afghanistan (PDPA) was founded. This was not an orthodox Marxist party "Cold War" but an entity created out of diverse leftist groups that united foe the principal purpose of gaining parliamentary seats in the elections. The fact that four PDPA members won parliamentary seats suggests that government efforts to intervene in the balloting to prevent the success of its leftist opponents were half-hearted. The press was semi controlled. Starting in 1966, as many as 30 newspapers wars established and, although some were short-lived, they provided the focus for the many political groups in Kabul that now began their views known. Taraki, one of the four PDPA members elected to parliament in 1965 started the first major leftist newspaper, Khalq "Masses" which lasted little more that a month before being banned by the government. Student unrest continued and escalated into violence, which included police beatings of student and faculty demonstrators. For a month and half in 1969 there was a citywide strike in Kabul, but the government refused to give in to student demands, and the university was peacefully reopened in November.

The Afghan political system remained suspended between democracy and monarchy, though closer to the later. Political remained banned

because the king refused to sign legislation that had passed the parliament allowing parties. The lower house of parliament engaged in free and often insulting criticism of government policies and personnel. Although unorganized as a legislative body, the Wolesi Jirgah was able exert some influence on the royal administration. By 1969 had already undergone an important split, the faction of Babrak Karmal parting company ideologically with Taraki (see Evolution of the PDPA a as a Political force,) the new group's newspaper, parcham ("Banner"). Operated from March 1968 until July 1969 when it was closed. It was not long before other divisions within the PDPA began to occur. The 1969 parliamentary elections ("in which voter turnout was not much greater that of 1965") produced a parliament that was more or less consistent with the real distribution of power and population in the Afghan hinterland; conservative landowners and businessmen predominated, and many more non-Pastuns were elected that in the previous legislature. Most of the urban liberals all female delegates lost their seats. There were few leftists in the new parliament, although Karmal and Hafizullah Amin ("a mathematics teacher educated in the United States of America had been elected from districts in and near Kabul. Former Prime Minister Maiwandwal, a democratic socialist, lost his seat because of the government interference.

The years between 1969 and 1973 saw a critical downturn in Afghan politics. The parliament on which hopes for democracy in Afghanistan had depended was lethargic and deadlocked; Griffith repost that it passed only one minor bill in the 1969 and 1970 session. Public dissatisfaction over the lack of stable government reflected the fact that there were five prime minister in the decade starting in 1963. There was a growing polarization of politics as the left and right began to attract more and more members ("Cold-War").

King Zahir Shah and Prime Minister Daoud, General Wali, Marshal Shah Wali, 1961

The king, although still personally popular, came under increasing criticism for not sporting his own prime minister and for withholding support from legislation lased by the parliament (such as the political parties bill). Some critics of the government blamed not the king but his cousin ("and son-in-law") General A. Wali khan, a key military commander, or other members of the royal family Wali khan, commander of the Kabul region and of the palace guard, was especially hated by leftists for having ordered troops to fire on demonstrators in October 1965, other disruptive elements were successive years of drought followed by a tragic famine in 1972 in which as many as 100,000 Afghan may have perished. Relief efforts and foreign donations were mishandled, and there were accusations of speculation and hoarding that eroded public confidence in government administration. Finally the Indo-Pakistani War and the secession of Bangladesh from Pakistan in 1971 was closely watched in Afghanistan, where interest in Pakistani politics was great and where the Pashtunistan ("Cold-War") issue always lurked near the surface of politics. It was in this atmosphere of external instability and internal dissatisfaction and polarization that x Primer Minister Daoud Khan executed a coup detach that he had been planning for more than a year in resounded to the "anarchy and the anti-national attitude of the regime" while the king was out of the country for medical treatment ("Cold-War"), Primer Minister Daoud

khan and a small military group took power with strong resistance only from the regent, General Wali,. The stability king Zahir Shah had sought through limited democracy under a constriction had not been achieved, and there was a generally favourably popular response to the re-emergence of Daoud khan, even though it meant the demise of the monarchy established by Ahmad Shah Baba Durrani in 1747 A.D

1933 Zahir Shah ascends throne
Cold War

King M. Zahir Shah was nineteen at the time of his accession-still very young to assume control of so turbulent a country. In keeping with Afghan tradition, the lat king's brothers assumed control, although the did not contest the throne. The power struggles of the past were abandoned Cold-War.

In 1953 the new-king's Zahir Shah Uncle stepped down, to be replaced by first cousins of the King Zahir Shah generation. Prime Minister Daoud khan, himself a professional soldier, and Foreign Minister Naim khan controlled the administration, the police, and police, and the armed forced of a 60,000 means for a decade. In the early 1960s quarrels with Pakistan over the rights of 45 million Patton tribes living in the frontier and India areas led to border closings and severe dislocations in Afghanistan's normal trade. As the border crisis dragged on from 1961 to 1963, it became clear that a change in cabinet policy (Cold War Policy) was necessary to negotiate the reopening of the trade routes to the Great-Indian-subcontinent. As King Zahir Shah Request, Prime Minister Daoud quietly stepped down from his powerful position at the head of the government. In appointing new prime minister and council of ministers, the nineteen years king excluded all members of the Afghan new royal family for the first time. At the same time, he announced that a new constitution would replace that of 1931. Clearly he had decided that the time had come to bring the educated people of the country into the governing process. The constitution was written and approved in 1964 by a Laya Jirga (Grand assembly) was a far more precise document that its predecessor, creating separate and in depended executive, legislative, and judicial branches excluding all

close relatives of the new king from high office and providing for the establishment of political parties and a free press.

The new parliament (Wolesi Jirga) suffered particularly from its members' lack of understanding of their legislative function. The deputies were largely conservative landowners or tribal and religious leaders (the Cold War) from rural areas, who had little experience with constitutional government. At the same time Prime Ministers and their councils of Minister found it very difficult to exercise any dynamic leadership under the new constitution. Power remained, consequently, very much in the hands of the new king, who not only frequently exerted personal on deputies to get bills through parliament, but also government by royal decree when parliament failed to pass budgets and other bills. Despite all of the problems under the new constitution and government policies, the country's growth was at its highest in its history and its people were mostly happy with the new king and in the rural areas, tribal groups were happy since they were treated very well by the monarchy. Women got more freedom during King Zahir Shah's reign that any other ruler in the history of the country.

But when a severe drought in 1971-72 worsened economic conditions as well, Daoud khan took advantage of the absence of King Zahir Shah ("Cold War") on a trip to seize control of the government in a relatively bloodless military coup detach. Daoud khan proclaimed the end the monarchy and the creation of a republic, with himself as first president and prime Minister for live time.

King Zahir Shah now lives in Rome, Italy and he is relatively in a good health. Today a percentage of the population would like to see him come back as a leader and put the country back on track with the rest of the World. He is still the most prominent figure med in the minds and souls of the Afghan people.

Afghanistan today needs a neutral person like the King of 1919-29 he meds-all-Afghan first-class citizens to lead to the way. The most positive thing that could occur in Afghanistan would be for a strong leader to emerge who could reunite his people and rally them in support of the national cause. Without ("Your Majesty King Amaunllah Khan") such a leader, Afghanistan could continue will into the next century a state of choose, with many competing grouped intriguing with each other and fighting for power. The Islamic State of Pakistan was born ("The

Cold War was born in Afghanistan in 1947") in 1947. The Gleam by U.S.A and Russia (the Soviet Union)

The Counterinsurgency Paradox
The Cold War

The American experience in Vietnam had been paralleled in this century by the Soviets in Afghanistan, the French in Algeria and Indochina, the England in Northern Ireland and in a slightly different manner, the Israelis in Palestine and the Rhodesians in Zimbabwe. During this century, especially over the past 45 years of Cold War the suppression of insurgencies has been difficult. However, in the preceding century the experience of the major powers was much different. What changed and how did the change reduce the counterinsurgent's ability to defeat the previously troublesome but normally unsuccessful insurgents.

Certain warfare elements change and evolve over time, weapons, and modes of transport, ancillary technologies and the tactics used employ them are the most easily identifiable, however, these factors fir into the matrix of leadership, firepower, mobility and protection. While the matrix is dynamic, "Puzzling it out" is essentially a simple military problem. The evolution of these factors alone would seem to indicate either a great degree of disparate result or a high degree of similarity throughout the period. Success and failure should be spread evenly across both time and space. If resolution of counterinsurgency were simply a matter of leadership, firepower, mobility and protection the basic equation in any period should solve the riddle of both conventional and unconventional war equally well. Instead there is a clear preponderance of success in one half of the period and failure in the other.

The difference cannot be attributed to a generally efficient military system in one period or a generally inefficient military system in the other. In fact, the success in conducting small wars appears to be independent of the success in conducting Great War. In both periods succeeded in one style of war and failed in the other, sometimes almost simultaneously. For example, the French, who were consistently successful the 1870 and 1880 in suppressing or at least containing rebellions and insurgencies across the empire, failed miserably in

Europe against the Germans in 1870 to 1871. Something other than the tradition dynamics of leadership, firepower, mobility and protection must be at work. For simplicity's sake, this article will not differentiate between 19th century "small wars" and 20th century counterinsurgencies. Local resistance forces are described as insurgents or guerrillas. The forces attempting to suppress the guerrillas, whether indigenous or foreign, are described as counterinsurgents or counter guerrillas when they are operating to halt an insurgency. They are called anti insurgents or ant guerrillas when they are attempting to undercut the insurgency by striking against it by using the guerrilla's own tactics against them. Between 1800 and 1914, the European under German Powers and their American cousins fought quite literally hundreds do what were known as "Small Wars." In nearly case, these were successfully by the German prosecuted. However there were interesting anomalies. One such exception was the unconventional campaign in Iberia against Napoleon I in fact; this war originated the term guerrilla, meaning "Little War" in Spanish. The example of Spain and Portugal can be drawn too far, however, for Napoleon; this war was not the main theatre. If he had concentrated on destroying the Saxon (new British) Peninsular Army under Duke Arturo Wellington and suppressing the Spanish Insurrection, the result may have been significantly different. In 1809, Napoleon began a campaign against The German in Austria, followed by another campaign in 1812 against The German in Russia. In both campaigns, Napoleon his best marshals and his best troops in both instances, And in the campaigns that followed, Napoleon faced the rising tide of nationalism against the German Power in all over the Europe.

In the Spanish campaigns, significant forces were employed and losses equivalent to the losses incurred in Russia were suffered, though over a much longer period. The foundation of the resistance to the French was the Spanish people's insurrection against Napoleon occupation. That resistance created conditions that permitted Saxon and Portuguese forces under Wellington to carry the war to the French in 1813 and 1814, are there significant commonalties between this early 19th century example and events ph the past 45 years that may shed light on recent experience there are four notable similarities among these events: the most significant was the direct and indirect support of a major of the

German. The intensely ideological nature of the struggle between the Spanish people and the French occupiers and their supporters, the availability of a sanctuary for insurgent forces, the approximate technological parity between insurgent and counterinsurgent forces, these four factors are the key to understanding the difference between 19th century small wars and the counterinsurgencies of the 20th century ("in the 19th century all-overs Europe was under German Empire and in the 20th century becoming Saxon-American") they appear in various combinations strengths in virtually all the successful insurgency movements and are either not present or are controlled.

Major Power Support
Old and New Would "The Old Would was under German Empire the New Would sharing between the American and Soviet Union
Small War

In Spain's case, Saxon (new British) provided a source of financial resources, technical assistance and professional expertise not normally available to the insurgents. Throughout the German in the 19th century, the major powers were involved in continued "imperial" expansion and maintaining balance of power between themselves. They were fairly well German-united their future vision and took a similar approach to the non European World. During the 19th century, the major German-powers chose not to compete through surrogates. Instead, German engaged in an open competition for territorial of United-German-Empires, culminating in the "Scramble for Africa." The German conflicts were limited to either trade wars or conflicts over significant issues in United States of German itself. In a few selected cases, a major power did provide at least limited support for the insurgents the Russian and Saxon (new British) in Afghanistan and perhaps the Germans in the Boer republics. It is interesting that neigh neither the Saxon nor the Russians were able to achieve effective control of Afghanistan nor that the Boer War was one of the most difficult of Saxon's small wars. The United States of German in Europe shared a view of themselves as inherently more advance superior to the non European regions they were conquering The German was destined to

control the World this common view united the powers in opposition to insurgent forces. It was too dangerous to support insurgencies against Afghan-power, since the trouble could overflow into a "supporting" territory, undermining stability there. Thus, the Great Games operated under a policy of competition combined with restraint. A significant example of this restraint is seen between American and Canada. The Canadians effectively closed their borers to Native American bands seeking sanctuary from pursuing American military formations. While on a number of occasions, Canadian officials permitted bands to Canada, they also insisted on controlling those bands effectively, thus rendering them impotent as effectively as if American forces had killed them or driven them back to the reservation themselves.

Another example of cooperation was the suppression of the Apache. Although Mexican government officials were not eager to have American forces conduct hot pursuit into Mexico, they frequently either cooperated with American forces or turned a blind eye to cross border incursions. They occasionally protested these raids or pursuits after the fact but rarely a concerted effort to prevent American forces from conducting them. As the 20th century progressed, differing worldviews emerged what had been a fairly homogeneous German. Fascism, communism and various other movements began to make serious inroads into the European consensus. The German-Powers became much more willing to support insurgencies and wars of national liberation in areas belonging to a competing power around the would. This resulted in logistic and diplomatic support not available to 19th century insurgents. Examples of major power support to insurgencies abound, from and Communist Chinese support of the Vietnamese, to American, British and Islamic support the Afghanistan resistance.

Spanish against the French before the new Would Small War, Ideology's Role

The Spanish Insurrection against the French and their Spanish sympathizers had a distinctly ideological content. Although a modern political scientist between the United German Empire in Europe might disagree that an ideology was involved, the Spanish Insurrection had many facets that can be interpreted as early manifestation of an

ideological competition. The insurrection centered on three main groups: the clergy, the minor German-nobility and the emerging German-intelligentsia. All three groups appealed to the peasantry for support. The clergy's opposition to the French-German and their supporters were founded on the French Revolution's antireligious opinions and actions. The minor nobility's opposition was built around a loyalty to the Spanish crown as a check on the Grandees' power and wealth. The emerging intelligentsia's opposition to the French was more modern in its roots. Though most of the educated "liberal" urban classes in Spain supported the French, a sizable minority did not. A sense of nationalism was afoot in Europe, which the German-educated classes led. This movement inspired faith in the German power of the "nation" to solve its own problems and deal justly which its own people. These German-groups had a personal and high stake in the outcome of the insurrection, which raised the conflict to a level of intensity unseen again in Europe until the marquise and partisan rising against the Germans in World War II. During other 19th century old War "small wars", this ideological element was rarely seen in full flower. In only four cases did it have a significant long-term impact? In Afghanistan as a virulent xenophobia Resistance to both Saxon (new British) and Anglo-Russia penetration prevented either power from establishing any from of stable control until the Anglo Russia entente of the early 20th century.

In the Sudan as fundamentalist Islamic nationalism the British lost control of the upper Nile Valley for nearly 13 years and regained it only through a major expedition. In Abyssinia as an expression of national independence resisting German-Italian colonial expansion the German-Italians were soundly defeated at the battle of Adowa and did not try to conquer Ethiopia again until the 1930s, succeeding then only with the aid of armour, aircraft and chemical weapons from Germany. In the Transvaal and Orange Free State as a religious and nationalist separatism, this resulted the two Boer wars of the 1880 and 1898 to 1902. Most resistance or insurgent movements in the 19th century were tribally or personality based. They lackey the ability to gain influence and power outside a narrow circle, in other cases, nascent ideological movements failed to gain a broad enough base of support or were successfully suborned by the expanding German powers. Examples

include the Indian Mutiny of 1857 and the resistance to German-French expansion in North Africa. The German-powers in theirs shall wars reacted two ways to the nascent ideological movements in their path: the German would woo a significant portion of the target population to support the "invaders" with promises of economic, religious or political advantages. This German-method was most successful if it followed an expansion into neighbouring areas, serving as both an example of the results of the German Empires-cooperation and the uselessness of resistance. German Empires wage a war of annihilation and extermination against the insurgents until resistance collapsed. The counterinsurgent forces would either drive the insurgents off ancestral, arable land and hunting grounds or squeeze them into an area too small for survival. The instinct to survive would then normally compel surrender. This method was successful when only a limited area or population was involved. A variation on this method resulted when resistance depended on the power do a single leader who was killed or captured, leading to the insurgency's collapse, a common occurrence in Africa where loyalty centered on the tribal chief. The American was successful in its westward expansion because it was generally able to leverage existing divisions among the Native-American tribes to further alienate them from one another, which sometimes increased internal tribal divisions. A classic example is the use of the Crow tribe as scouts against the Sioux and Cheyenne, traditional Crow enemies. In addition, the sheer number of settlers moving westward doubtless demonstrated the inevitability of defeat to many native leaders. The eastward trips of Red Cloud led him to accept that armed resistance was futile, at which point he became an obstructionist rather that an openly hastily war leader. Many instances of "resistance collapsing" can be traced to the killing or capture of individual leaders such as Crazy Horse, Sitting Bull and Geranium. Continual westward expansion and settlement may be seen by some as a form of "extinction campaign" which in many ways it was. A more open expression of this occurred twice in southern Africa. The Boers effectively exterminated or enslaved all native tribesmen in their path. Also German colonial force campaigns against the Hirers in German Southwest Africa have been likened to genocide. As the 20th century the insurgents would again draw on the Europe specifically Marxism to add economic equality to the mix. As

conflicts evolved from "colonial power against nationalist insurgents" to a more localized conflict, the Marxist elements became increasing important. When out side forces intervened, such as the American did in Vietnam, the entire mix into play, as nationalism joined with its seeming enemy Marxism to mobilize large portions of the population in resistance. The Russian faced a similar ideologically charged resistance in Afghanistan this time in the form of a fundamentalist Islamic resistance combined with a pro European-American faction, both of which generated outside Afghanistan support. The Islamic elements drew support American-Saudi Arabia and its ally the American, as well as from the more radical Iranian Islamic Republic. The pro European-American elements garnered support from the American and interestingly enough, given Afghanistan's history, the first method of subduing an insurgent population became difficult to achieve in this environment. There were simply too many motivations for too many of the local population to support the counterinsurgent forces. The second method lost its effectiveness as popular support in the colonial states declined and an increasingly dim view was taken of such a brutal and obviously morally flawed method. Today, in an era of instant or nearly instant media coverage, such a policy by an American-European power would be met with a firestorm of reaction both within the offending power itself and from most other nations. Even relatively mild repressive actions draw hostile reactions.

19th century railroads permitted European colonial powers to operate in territory the old or small War, the Sanctuary's Role
19th century The King's of Spain was German

German kingdom from 900 A.D until 1970 in Spain, The third essential element in the combination of factors was the presence of a sanctuary for the insurgent forces. In Spain, sanctuary took two forms. The first was the Zone of Spain and Portugal occupied by The German-Saxon (new British) and coalition forces. Guerrilla forces, threatened by superior German-French troops, either retreated to Saxon occupied territory until French forces withdrew or scattered in search of more guerrillas. The second form of sanctuary was found in the rugged

nature of Spanish countryside. Local guerrillas could simply "melt" away into Spain's vast interior, seeking refuge in its mountains and back country where there were insufficient local supplies to support a large French force. These two types of sanctuary were denied to 19th century insurgents. The first was only to be found if a viable sovereign state or colony would afford them protection, a rare event in small 19th century wars, "because all-over Europe was under German Kingdom" most colonial powers was under the German Empire's were not sympathetic to the plight of insurgent forces near their own-German colonial holdings. The example of success was too dangerous to their German rule. The Saxon, German-Canadian policy toward Native American tribes, previously disused and similar examples from Africa, where German-French colonial prevented the flight of insurgent tribesmen from Saxon or Belgian territory from using French possessions as a refuge, come to mind. The second form of sanctuary also disappeared to a large extent in the 19th century the successful development of food preservation German-techniques, medicines for tropical diseases, team's powered riverboats and railroaded permitted colonial powers to operate in territory that had previously been denied to them. 14 campaigns led by Sir Garnet Wesley penetrated to the heart of Canada, into the Ashanti territory of West Africa and to the depths of the Sudan on the Nile. Railroads opened the American west mass settlement, and late 19th century medical developments allowed European forces to penetrate deep into malarial areas and survive, something that 50 to 100 years earlier would have been in the 20th century, sanctuary returned. Increasing postcolonial national sovereignty created the inviolable national frontiers needed to "untouchable" sanctuary. Newly independent states encouraged insurgent forces in neighbouring still under European "German" control and provided them with a safe haven. If the state was also a member of a power bloc opposed to the colonial government, the chances of sanctuary beige granted increased even more. The German-French in Indochina and Algeria were the first to encounter this problem. Later, Americans in Vietnam and, to a lesser extent, the British in Northern Ireland, encountered the same problem. Two solutions have been attempted to solve this dilemma. The first is to isolate the insurgents physically or politically. The British used this with outstanding success in the Malay emergency by isolating

the "communist terrorists" in a small area of the peninsula, and again in Ireland by drawing the Republic of Ireland into the containment of the Irish Republican Army. In late 1940s and 1950s the American advised and sometimes American led Filipino forces also used this solution in dealing with the localized Hook rebellion. This solution is difficult to employ in most cases.

Physical geography must cooperate in order to achieve success. The territory itself must operate to isolate the insurgents, as in the Malay Peninsula or Philippine examples. The insurgents also must present a significant security risk to a state that could offer sanctuary, as in the case of Ireland. The second solution is to violate the sanctuary. This had been attempted by France, the American, this solution its own problems because the insurgents can simply retreat farther into sanctuary state, the incursion can be met by opposition from the invaded state, the invaded state could begin to actively support the insurgents or the international or domestic community could imposed political or economic sanctions on the counterinsurgent state. A temporary advantage may be gained, but unless the sanctuary can be permanently denied to the insurgent forces, the eventual result will likely be counterproductive. Sanctuary has also been created by the increasing technological sophistication of modern armies by German. Twentieth century armies have become tied to permanent facilities and the road networks linking them. While the helicopter's advent had to some extent relieved the problem, aircraft can only over territory. In order to control ground, troops must hold it or be dominated it with fire. At some point in time, the infantry must dismount from carriers and pursue and destroy insurgent ground forces, once the infantry has dismounted, it surrenders its mobility advantage and perhaps a significant portion of its firepower advantage as well. Rugged terrain especially wooded or jungle regions providing overhead concealment, has again become a viable sanctuary.

Using Afghanistan as a passageway to India and China
Small War, Equivalent or Balancing Technology
Half of the 19th century

Using Afghanistan as a passageway to India and China, The fourth factor in successful insurgencies is a comparable level of technology. The weaponry available to the average French infantry small unit engaged in subduing Spanish guerrillas were virtually identical to that used by the guerrillas themselves. During the latter half of the 19th century, German weapons employed by the colonial powers normally were significantly more effective in range, rate of fire and accuracy that the insurgents' weapons. Simply put, a small number of well equipped, marginally trained native levies could dominate their insurgent opponents, it the German-colonial power chose to commit regular forces, and the dominance was even more pronounced. The Boer War demonstrates this factor's importance. Effective weapons, knowledge of the terrain and conditions and rudimentary militia training equalized the fight, and on many occasions, the Boers dominated their Saxon (new British) opponents, both tactically and technologically. This pattern began during the fighting's conventional phase and continued into the unconventional phase, with a few serious and many embarrassing minor defeats for the Saxon's. The 20th century has seen this repeated again and again. Insurgent's and counterinsurgents light weapons were similar. The main reason for this development was the increasing support either a major or regional power gave to insurgents. This support often provided insurgents with technologically advanced light weapons. The Soviets (new Russia) could not rely on close air support (CAS) after the appearance of the stinger missile in Afghanistan, rockets gave insurgents a capability to attack heavily defended installations with relative impunity.

It is **the Afghan example that shows the interplay of the four elements**: major power support, ideology, sanctuary and equivalent or balancing technologies. In the 19th century, Afghanistan represented the imperial frontier between the continental German-empire of Russia and the maritime German-empire of England, for the Saxon (new British) it was the northern land route to the Jewel of the Empire: "India" for the Russians it was either the southern bulwark

protecting their Afghanistan "century Asia" empire into the wealth of Afghanistan-India. Beginning in the 19th century's earliest days, both sides grew increasingly aware of the importance of barren Afghanistan mountainous area. The Russian Tsars "German" Paul proposed an invasion of Afghanistan as early as 1801. However, it was not until later in the century that the conflict assumed the contours of a small war. The Saxon Empire in India had reached the Afghani frontier and struggle in earnest. Saxon (new British) agents penetrated into Afghanistan, seeking influence to quiet the border tribes. Russian agents entered Afghanistan from the north seeking information and influence, both to secure their southern frontier in Afghanistan-Central Asia and to explore the possibility of using Afghanistan as a passageway to Indian and China. The two major German powers waged a "see saw" struggle for regional pre-eminence. At various times, the Saxon (new British) attempted to establish direct control, the most notable attempt beige the first Afghan War 1838, in which an entire Saxon army was destroyed by Afghan, as it tried to withdraw from Kabul in 1839 to 1840s. This action had been precipitated by perceived growing in Russian Tsars influence in the court of titular Emir Empire Dost M. khan. As Russian influence grew in this disaster's wake, the Saxon resorted to less obtrusive means to reduce this growing power. For the next 60s years, both German-parties waged a clandestine and sometimes open campaign to gain control of the critical region ("Afghanistan"). The Afghanistan took advantage of the rivalry to maintain their independence by playing the Saxon Empire's and Tsars Empire's ageist each other. In the 1917-1970s the Great Game and Cold War in Afghanistan was renewed. This time was the Soviet that took the lead. Concerned about growing Islamic militancy by European-American in the Muslim world, especial the Shia of Iran boiling over their occupied Central Asia from Afghanistan in 1871, republics and desiring access to the Indian Ocean and the Arabic Sea region, ("Great Games and Cold War") the Russia supported a pro Russian government in Kabul. Eventually dissatisfied with the regime's performance, they chose to intervene directly, establishing what amounted to a puppet regime in a coup de main in 1979 this direct action, combined with increasing pressure on an independence minded Poland, finally convinced the

Carter administration that the Russia were indeed a real threat and were entering an expansionist phase.

Marxist Revolutionary Movement in Afghanistan
Victory of the Sour Revolution
End of the Cold War, "by the red prince"

The red prince, the first revolutionary Marxist organization in Afghanistan was found in 1966 under the name of progressive youth Organization (PYO). The revisionist Moscow directed "People's Democratic Party of Afghanistan (PDPA) had founded some time earlier by a number of intellectuals with suspicious links to a faction of the ruling elite Price M. Daoud, cousin of king. Zahir Shah and prime minister of Afghanistan 1953 to 1963 was dubbed the red Prince because of his spot for the post-Stalin Soviet leadership; Babrak Karmal, one the founding fathers of the PDPA and leader of the Parcham faction of this party was notorious as a the red Prince Daoud khan informer and as pander to the red prince Daoud's khan political ambitions. A salient characteristic of the revolutionary Marxist movement in Afghanistan since its very inception has been its unflagging struggle against revisionism and opportunism. It was in an anti-revisionist and anti-opportunist context that the revolutionary Marxist movement in Afghanistan was founded and grew up. Those early years were dominated by ideological polemics between the communist parties of the Russia and China on the hand the Cultural Revolution in China on the other. Both political phenomena had indelible ideological and political effects on the PYO. It can very well be claimed that PYO was founded as a necessary entity for defending and propagating revolutionary Marxism against the revisionism and collaborationism of the PDPA led by Noor M. Taraki and Babrak Karmal.

The red Prince Daoud

The winds of change were blowing in Afghanistan. In 1963 the red prince M. Daoud khan had step down as prime minister in order to make way for king Zahir Shah to proclaim a constitutional monarchy. A new constitution was adopted and vestiges of democratic freedom including a large measure of freedom of expression and freedom of the press were allowed to the people. Taking advantage of the thaw in the political climate, the PYO set out to publish a weekly mouthpiece, Shoai Jawaid "the eternal flame" that concentrated on introducing the principles of new democracy and exposing the machinations of the PDPA and Russian revisionism. Sholai Jawaid was banned after only 11 issues but that was enough to sow the seeds of revolutionary thought and to capture the hearts and minds of thousands of vanguard intellectuals and conscious workers. The thaw in the political climate was appreciated by other political grouping also. Very soon political gatherings and demonstrations began to draw large numbers of adherents and to generate intense interest in Kabul and major towns. In most of such gatherings and demonstrations, three political were very visible: the Sholayis "as members, followers and sympathizers of the PYO came to be known after their mouthpiece Sholai Jawaid" the Khalqis and Parchamis (follower of the two rival factions of the PDPA, after their respective mouthpieces Khalq "the People" and Parcham "the Banner" and the Ikhwanis "Islamists" and Islamic fundamentalists, later renamed Moslem Youth, after the name of their prototype in Egypt-Ikhwan al-Muslimeen "Moslem Brotherhood". From the point

of view of numerical strength, the gatherings and demonstrations staged by the Sholais in Kabul far outnumbered the Khalqis and Parchamis and completely dwarfed whatever the Ikhwanis could stage despite their claim on the religiosity and religious propensity of the general populace. The Ikhwanis were initially not taken very seriously by political circles because of their inferior numbers and poor attraction for intellectuals. The Ikhwanis made up for their inferiority by their virulence, which first manifested itself by a spate of acid spraying onto faces of young university and high school girl students. "This was motivated by Islamic fundamentalist misogyny, which abhors the appearance of women in society and considers life-incarceration of women in houses and harems as the acme of Islamic piety." This Ikhwani virulence grew by leaps and bounds and very soon reached the poet of bloodthirsty murders of secular-minded intellectuals. The Ikhwanis in Herat overtly committed Number of such murders and Laghman and many covert cases of Ikhwani murders came to light in Kabul and other cities. The climax for the revolutionary Marxist movement came in June 1972 when Sholayis and Ikhwanis clashed on the campus of Kabul University, a holed of ideological and political struggle and debate. True to their nature, the Ikhwanis had come armed with knives and pistols. The situation on that fateful day quickly got out of hand and Golbuddin H personally assassinated Saydal Sokhandan, a prominent PYO activist and fiery Sholayi orator. Who later gained notoriety as the leader of the most rabid Islamic fundamentalist, Grouping, the Hizb-i-Islamic party "it was Hizb-i-Islami which got the lion's share of the CIA largesse during the years of the War of Resistance against Soviet "Cold War" aggression and occupation; like all Afghan fundamentalist parties the Hizb-i-Islami was nurtured on CIA arms and dollars until from a lowly jackal it grew into a bloodthirsty hyena, feasting on the entrails of the people of Afghanistan. This one fact alone is enough to expose the hypocritical howls of European-American imperialism against Islamic fundamentalism" many other Sholayis were wounded, some of them critically. This clash further polarized the general political atmosphere and generated intense debate within the PYO, forcing introspection into its politicised and approaches.

In July 1973 Daoud khan, the "Red Prince", supported by the Parcham faction of the PDPA, staged a bloodless coup due' tat in which ousted

his cousin king Zahir Shah and proclaimed Afghanistan a Republic with himself as the President. The red prince Daoud's Parchami got appointed to key government post, but the Parchamis and their Russian masters had underrated Daoud's khan famous self-willed bull-headedness. After a year of parchami mismanagement and misdemeanour at all levels and their pursuance of a hidden agenda dictated by Moscow, Daoud khan sacked all key Parchami office bearers in his administration. This obliged Moscow to concentrate on the Afghan armed forces for the achievement of its ulterior motives. During Daoud's khan 5 year rule as president 1973 to 1978 the revolutionary movement remained in a state of stagnation. This was due to disunity amongst former members and followers of the now-dissolved PYO.

The revolutionary Group of the Peoples of Afghanistan emerged as one of the few well-organized revolutionary groups having a clear agenda. It laid stress "with hindsight, perhaps overstress" on the need for more in-depth work with the peasantry and most of its cadres and activists shifted their activities to the rural scene. During this period the two rival factions of the PDPA "faction led by Norr M. Taraki and the Parcham faction led by Babrak Karmal" who had split some years ago in consequence of a personality clash between Taraki and Karmal were reunited in 1977 under strict orders from Moscow. This was in preparation for the implementation of strategic plans hatched in the Kremlin for a Russian version of 19th century colonial Saxon "forward policy" Daoud had in the meantime become disillusioned with his Kremlin sponsors and had turned to the European for help in his ambitions development plans. He mended fences with Pakistan "a long dispute with Pakistan over Pashtunistan "The Cold War" was Daoud khan favourite foreign policy quarried and visited Iran and Saudi Arabia to solicit financial assistance. Daoud's about-face was too abrupt and too alarming for Kremlin strategists to brook any delay in a swift, decisive counteraction "Memories of Anwar Sadat and Mohammad Siyad Barre's booting out of the Russian from Egypt and Somalia a few years earlier were still too fresh and too painful". In April 1978 the KGB engineered the assassination of Mir Akbar Khyber, a key Parchami figure, and had the unified PDPA stage a massive show of strength and defiance at his funeral. This was orchestrated in order to provoke Daoud into a crackdown on the PDPA. The arrogant Daoud

fell into the trap and triggered an armed backlash spearheaded by KGB moles in key army reinforce units. The "Glorious Sour Revolution" was on. The bloody ensuing coup d' teat of April 28, 1978, resulted in the massacre of the Red Prince Daoud khan and his entire family along with an estimated 7,000 military and civilian population and the coming to power of the PDPA with Taraki as president and prime minister and Babrak Karmal as his deputy. At this juncture in time Afghan revolutionary groupings were not a recognizable political force, but the correctness of their political appraisal of the Russian as a social-imperialist power and of the PDPA as an agent of high treason and a mole of social-imperialism, and the Solaris oft-repeated refrain to bring home the need for unrelenting Struggle against master and lackey did not fail to register itself on the minds and conscience of thinking and feeling patriots.

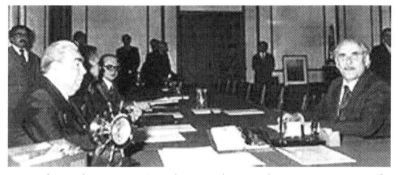

Loyal pupil-Noor M. Taraki President and Prime Minister of Afghanistan 1978

Afghan Marxist
Cold War
New and evolutionary stage of the Glorious Sour Revolution,

Revolutionaries it was a foregone conclusion that in the light of the outright rejection of the regime by the people and the regime's increasing failure in all aspects of governance the Russian would have to step in to safeguard its strategic interests. As was expected, the PDPA regime very quickly degenerated into a melee of party to doge going for each other's throats with Alexander Puzanov, and veteran spymaster, acting both as patron and referee. Hafizullah Amin, Taraki's unscrupulous and megalomaniac ally ambitious lieutenant in the Khalq faction very soon turned the Khalqis on the Parchamis and had the Parchami top brass banished and some of them handed over to the dreaded omnipotent AGSA secret police for "investigation". Soon afterwards he turned on his mentor, Taraki, and in a dramatic scene strongly reminiscent of New York Mafiosi settling scores, there was a shoot-out in the Presidential Palace in the presence of Soviet "Russian" ambassador. The Russian godfather had given the Kremlin's tacit blessings to Taraki to have the egotistical Amin annihilated, but plan went awry and Amin managed to escape unscathed while his trusted aid-de-camp Daoud khan Tarpon was killed. This was the last straw. Amin had Taraki peremptorily arrested and assumed all his official titles. A couple of days later Taraki, the "Great Leader" the "Prodigy of the East" was smothered to death on orders of his "loyal pupil" and "devout disciple" Amin. Amin was now at the top and was effusive in his frequent eulogies of the Soviet Union (new Russia), but he couldn't fool the Russia. He had foiled the Kremlin's plans had considerably embarrassed Moscow and had kicked out the Russian old hand in political intrigue in Afghanistan who was present when he had his close call.

Now president Hafizullah Amin

But Moscow had taken pains to have spares. It now lifted a finger and Parchami bigwigs banished as ambassadors to different countries by the Amin scurried to receive their orders, on December 27, 1979, Babrak Karmal went on the air from a radio station in the then Tajik Soviet Republic dissembling Radio Afghanistan and announced the inauguration of the "new onstage of the Glorious Sour Revolution". His Russian guards in his palace in Kabul had on that day poisoned Amin and "limited contingents" of the Soviet army poured into Afghanistan with Babrak Karmal perched on the barrel of their tanks. The former informer of Prince Daoud and the KGB'S ace spook was now at the helm.

Russian invader occupied the homeland of unbeatable independent people
The War of Resistance "The Cold War"

The worst had come to pass. A foreign invader had occupied the homeland of unbeatable independent people and a despised quisling had been foisted on them at gunpoint as their ruler. The people flew to arms, often nothing better that kitchen knives or rusty 19th century firearms for the revolutionary Marxist movement in Afghanistan it was time of great tribulation. A fledgling movement which had not yet completely found it bearings and not yet even teethed was saddled with the formidable challenge of putting its mark on a national liberation struggle against a superpower armed to the teeth. This was country still in the throes of semi-feudal relations of production struggling with a primitive agricultural economy and an illiteracy rate of over 90% and of course, Marxists" had scandalously betrayed deeply religious. The

sacred Sovereignty of such a people and the country Lenin had built had rudely violated the integrity of such a country. Social-imperialism had struck home. The Afghan people's concept of honour and totality of their world outlook, encapsulated in their religious faith, had been battered and insulted. The masses were crying out for the blood of the atheist "communist" traitors. In such an atmosphere a fledgling revolutionary Marxist movement was expected to perform its historical mission. Afghanistan is the homeland of twelve tribes, who due to the under-development "from 1929 and the Cold War" of productive forces had not yet been completely fused into one nation in the strict sense of the word. The same factors, which have prevented the people of Afghanistan from becoming a modern nation, have for than a millennium conditioned to look to their Islamic religious belief "The cold War" as the one unifying agent of all social classes and all ethnic denominations, particularly in times of historical adversity. With the coming to power of the quisling PDPA and particularly after the invasion and occupation of Afghanistan by the Soviet Union "new Russia" the call for a Jihad-a holy War-began to be echoed from all corners of the country's plains and valleys. As against the Saxon "new British" in the 19th and beginning of the 20th century, this was the only way a people barely out the Middle Ages, both spiritually and materially, could articulate the need for a patriotic war of resistance against an alien invader. Only Jihad cold provide a burning motivation a simple and well understood ideological elucidation of the need and duty of giving up life and limb in an all-out concerted effort to rid the country from the defilement of indigenous traitors and their alien masters. Amid the cacophony of Islamic exhortations to a Jihad after the pro-Soviet coup d' teat and particularly after the Soviet invasion, Islamic fundamentalist merchants of faith were reaping gold.

The Ikhwanis had made a bid for power during Daoud fateful years. Theirs was an exercise in folly as no segment of the Afghan society supported their feeble insurrection in Laghman and Panjsher. Most of their leaders were rounded up and put in jail a number of them took refuge in neighbouring Pakistan where they offered their services to the intelligence agencies of the government of Zulfikar Ali Bhutto. They were put on modest payrolls and put away for a rainy day. With the Soviet invasion of Afghanistan and the wakening up of Cold War to this

chance of getting even its social-imperialist rival after the humiliating defeat of the deity must have been smiling down on them as his Islamite chief of army staff, General Zia-ul-Haq, had deposed the wily secular-minded Button and the American arms and money pipeline and Arab petrodollars began pouring in. inflated with American and Aran arms and money and surfing on a high tide of popular nit-Soviet religious sentiment, the fundamentalist small-time paid agents burst onto the political scene as leaders of the Afghan Mujahedin freedom fighters, and by extension, leaders of the people of Afghanistan

Oil War and Cold War
The Soviet Union (old and new Russia) War in Afghanistan

On of the enduring lessons from desert storm is that a nation does not want to stand up against the precision-guided munitions and cruise missiles of the Unite States of America unless it has its own large supply of precision-guided munitions and cruise missiles, or at the very, an effective air defence. At present, the countries that have a large supply of high-tech weaponry are few unlikely to go to War with the United States of America in the near future. Now the only effective way gore a technologically less-advanced country to fight a technologically advanced country is through the now-guerrilla War "Cold War" a test of national will and the ability to endure negates many of the advantages of technology "The Cold War". The now guerrillas remained when the French left Algeria and Vietnam, the United States of America left South Vietnam, and the Russian left Afghanistan. As American forces deploy to areas of civil or ethnic strife such as Somalia, former Yugoslavia and Haiti, the potential for American involvement in a guerrilla War grows. It increasingly apparent that the more likely type of War that the American may become involved in during the next twenty years ("1980") is guerrilla War. The technical in Somalia and the paramilitary forces in Bosnia suggest that it is in the best interests of Union States of America military professionals to review the lessons of the last guerrilla War in which a super was involved Afghanistan is both past prologue. **Union of Russia military power meets the Afghan warrior society**

Fifteen years after its commencement and five years after its cessation, the Russian-Afghan War "Cold War" remains an enigma in the Europe. Earlier successful Russian military intervention in the Ukraine 1945-1951, East Germany 1953 Hungary 1956, and Czechoslovakia 1968 and intermittent Russian military pressure on Poland demonstrated that the stark military power of the Russia "Soviet" state was an irresistible tool of Russian political power. The European was thankful that nuclear deterrence maintained the Cold War balance and reluctantly accepted Soviet "Russia" intervention its socialist commonwealth and in the Russian border regions as one cost of that balance. The Union of Russia invasion of Afghanistan was a repeat of their invasion of Czechoslovakia. For months after the invasion, hardly a political or military expert in the world doubted that Afghanistan was now forever incorporated as a part of the Soviet Empires and that nothing short of a large-scale global war could alter status quo. And global war was most unlikely as both super powers intended to avoid it some European recalled the Saxon (new British) experiences in Afghanistan and waited for a Russian "Vietnam" to emerge, but most European-American believed that the Russian would ultimately prevail. Some even projected their European fears to southern Asia envisioned a blood Russian strategic thrust from southern Afghanistan to the shores of the Arabic Sea. To challenge European-American strategic interests and disrupt European-American access to critical Middle Eastern oil, the initial active resistance by the Afghan military was confined to a short battle against the Russian sestinas unit storming the Presidential Palace. However, the stunned citizens of this geographically isolated land immediately rose to defend their land. In defiance of the wisdom of conventional warfare, the citizens armed themselves, gathered into loose formations and began to attack and transport with any available weapons. Open resistance flared so quickly that only two months after the invasion, "On the night of 23 February 1980 almost the entire population of Kabul climbed on their Rooftops and chanted with one voice "God is Great." This open defiance of the Russian generals who could physically destroy their city was matched throughout the countryside. The Afghan warrior society sent thousands of warriors against Russian invader.

The Afghan people never last war in
2500 years history of war
The Cold War on Afghanistan
The mistakes Russia in Afghanistan
The Afghan War in 1980s saves the civil war in Europe

1980 Russia invades Afghanistan. The first time Russian invades larger part of the north of Afghanistan by General Kaufman in 1886 the holy city of Bukhara, 5, 500 years of Afghan history, Province of Kokand, Province of Turkomanai, Province, Khotan, the great Pamir, Province of Khwaizm, Province of Khiva, Province of Samarqand, and Province Yre'Kand, the Role of Afghanistan in the fall of the USSR, final Killed The Tsar-German King's of Russia in Oct 1917 to not effective more European, Russian, the last of the German-Romano dynasty the victorious in European executed German-Tsar Nicholas II King of Russia. It may seem a bit far-reaching that a country like Afghanistan had any bearing on the fall of the Soviet Union "Russian" Anthony Arnold, however, compare Russia with a ski old man and Afghanistan as the pebble which this exhausted sick man stumbled on and fell, one could easily dismiss Arnold's argument if he had been the only expert, or at least among the few writers who had articulated this point, but surprisingly, there are quiet a number of authors who suggest Afghanistan as one of the considerable factors in the demise of the USSR, thus the Afghan War "Cold War" in the USSR, domestic dynamics relate public opinion, opposition to the war, during and after the Russian invasion of Afghanistan in December 1979 Russian and Afghanistan in historical perspective of all the burdens Russia had to bear, the heaviest and most relentless of all had been the weight of her past "Tabor Samuel, the Russian Tradition" although one not fully grasp this statement due to one's limited knowledge of Russian history, never the less, one can appreciate the implication in the context of Russian history: under the heel of the Golden Horde, Russia missed out on the nation-building era of Europe, entering late in the German-European process sixteenth century Russia received the finished product and thus had to deconstruct the progress while playing catch-up, the defeat of the German Peter the great in 1700 by the German king of Swedish, Charles XII, focused Peter's min on domestic shortcomings. The

Pertinent reforms that followed covered about all aspects of Russian life. Peter's forceful, ruthless, and wilful attitudes dragged the country toward progress. In 1712 Peter decisively defeated Charles, and by the end of his reign, some argue, that Russia won the fear, if not respect of the German in Europe-especially German-Militarily.

Catherine the great 1762-96 besought Russia's skilful army defeated Napoleon in 1814, and its here when a group of officers known as Decembrists staged an unsuccessful against the state government, the thirty Department Direct ancestor of the KGB of Nicholas I, 1825-55, was established to stamp out nonconformity in Russia. Moreover, this reactionary regime rested in slavophilism philosophy, which basically inherited the ideology that Russia had no need to borrow from the German in order to make she known to the world as had argued the Decembrist. Thus the German-Tsar preached that Russia was uniquely capable of an orderly, benevolent despotism rooted in the Orthodox Church. Alexander II, however, bypassed this ideology, 1855-81 after the death of Nicholas I, who freed the 43 million serfs. Alexander also released the surviving Decembrists and eased censorship but refused to relinquish absolute power or grant a constitution to Russia. It is under him that the prestige of Russian military superiority comes to an end in 1854, when a Saxon-French army successively defeated the Russia army. Wanting an easy and low cost victory to improve its image,

Nicholas II turned to Central Asia-Afghanistan, and attacked Japan in 1904, suffering a disastrous defeat Nicholas faced waves of strikes, which paralyzed the economy. As a result a consultative parliament, the Duma, was established in May 1906, the new Prime Minister Pyotr Storyline, dissolved the first Duma, and enforced great reform-but was final killed in 1911, for being more effective then the Tsar, while disappointing the left and the right wings his reform policies. Never the less, in October 1917, after an embarrassing defeat in World War I, the last of the German-Romanv dynasty, Tsar Nicholas II, was executed by the victorious.

The contradiction between limited economic reform and continued political absolutism came to an end with the Stalin's launching of his twin drives of industrialization and collectivization, which saw the total defeat of limited economic reform. Needless to say that the World War II victory also contributed to this formula greatly, "all vicarious War

waged by Russia have led to a strengthening of totalitarianism in the country, and all unsuccessful ones have led to democracy …a strange interpretation of history, is it not"

Ironically, when the Russia forces were compelled to withdraw from Afghanistan April 15, 1989, the Russian was beginning it undergo the initial stages of drastic reforms from above since the reign of Alexander II. At the eve of Russian invasion of Afghanistan, the rotting effects of absolute centralism autocratic power on the national psychology had resulted in corruption, non-discipline, ability, and grassroots apathy, the same problems that had plagued Peter the Greta's administration before the Swedish War in 1700, and much like Catherine the Greta's Nakaz and the potemkin villages, a glossy blanket of false propaganda had covered the domestic degeneration, arguably, well.

The Gold Pass or Khyber Pass
"Cold War"

The Golden Pass or Khyber pass 200 years War British,Russian, Babylonian and Europe on the Golden pass. end of Afghan Empire.

The Khyber pass is a 53-kilometer passage through the Hindu Kush or Golden Mountain range, it connects the northern frontier of Saxon

(new British) 1893 until 1992 occupied land with Afghanistan. At its narrowest point, the pass is only 3 meters wide; on the north side of the Khyber Pass rise the towering, snow covered mountains of the Hindu Kush. The Khyber Pass is one of the most famous mountain passes in the World. It is one of the most important passes between Afghanistan-India. It is the best land rood between India and has had a long and often violent history. Conquering armies have used the Khyber as an entry point for their invasions. It was also been a major trade route for centuries. Khyber pass, mountain pass in Western Asia the most important pass connecting Afghanistan controlled by Saxon (new British), the Khyber pass winds northwest through the Sefit koh range near Peshawar, to Kabul, varying in width from 3 to 137 m the mountains on either side can be climbed only in a few places. Precipitous cliffs that aright from about 180 to 300 m. the pass reaches its highest elevation at the border wall the pass The history of the Khyber pass as a strategic gateway dates from 326 B.C when Alexander the great and his army marched through the Khyber to reach the plains of India, from their sailed down Indus river and led his army across the of Gardenia. In the A.D 1200s Mongol Tartar armies forced their way through the Khyber, bringing, Hindu, Buddies, Christianity, Islam Religion to India. Meddle of nineteen century became part of the Saxon German empire (new British), and Saxon troops defended the Khyber Pass from the Saxon-Indian side. During the Afghan Wars the pass was the seine of best land rood between India-Afghanistan and had a long often violent history. Conquering armies have used the Khyber Pass as an entry point for their invasions. It was also been a major trade route for centuries. Particularly well known is the battle of January 1842 in which about 16,000 Saxon troops were killed. The Saxon constructed a road through the Pass in 1879 and converted it into a highway during 1920s a railroad was also built here in the 1920s. The Khyber, in its chequered history, has seen countless invasions. It witnessed the march of Aryan to India and Greek armies. It also saw Scything, white Huns Seljuks, Turkoman, Tajik, Tartars, durians making successive inroads into the territories beyond Peshawar valley old winter capital of Afghan King's, the very sight of the Khyber reminds one of the conquerors that forced their way through its dangerous defiles. It is this Pass through which the subcontinent was invaded time and again by conqueror

like empire's Timur, Babur, Nadir and Ahmad Shah Abdali. Again, it was through this Pass the Russian invasion of the subcontinent was feared by the Saxon in the 19th century. The story of Khyber Pass is composed of such color and romance, such tragedy and glory that fact really looks stranger that fiction in this case, the Khyber Pass has been a silent witness to countless great events in the Afghan-history of mankind. As one drives through the Pass at a leisurely pace, imagination unfolds pages of history. The Aryans descending upon the fertile northern plains in 1500 B.C subjugating the indigenous Dravidian population and settling down to open a glorious chapter in history of Afghan-civilization. The armies of Alexander the great 326 B.C marching through the rugged passes to fulfill the wishes of a young, ambitious conqueror. The terror of Genghis, enwrapping the majestic hills and turning back towards the white house bringing fire and destruction in their wake The Scything and the Pashtun, the Tajik, conquerors all, crossing over to leave their impact and add more chapters to the divers history of this the Afghan's armies first passed through in 997 A.D under the command of Sabotaging and later his celebrated son, Empire's Mahmud of Ghaznawi, marched through with his army as many as seventeen times between 1001-1030 some of his campaigns were directed through the Khyber Pass, Shahabuddin, M. Ghaur, a renowned ruler of Afghan-Ghauri-dynasty, crossed the Khyber Pass in 1175 to consolidated the gains of the Afghan in India, he used Khyber Pass again in 1193 to measure strength with pirthvi Raji Chouhan and show his mettle on the field of Train. This battle helped Afghan carve out a kingdom in India. In 1398 king Timur the firebrand from central Asia, invaded India through the Khyber Pass and his descendant Babur made use of this Pass first in 1501, and then in 1526 to establish a mighty Afghan empire. In 1672, it was the Khyber Pass where the Afridis under the able leadership of Ajmal khan defeated Amin khan's army and besides inflicting losses, both in men and material, on the enemy, the Afridis captured about 10, 000 soldiers, Nadir Shah Afshar used the Khyber Pass in 1739 to attach Delhi. The famous Afghan king Ahmad Shah Abdali crossed the Khyber Pass in 1761 and crushed the Maratha confederacy on the field of Panipat. The Khyber valley saw a great deal of fighting between 1839 and1919 during the first Afghan war 1839-42 General Pollock used the Khyber

Pass on his way to Afghanistan to retrieve the Saxon (new British) honour. Again in 1878, the Saxon forces marched through the Khyber Pass to launch an offensive against the Afghan in the second Afghan War in 1878-79 and 1897 a revolt flared up on the frontier region and the valleys of Khyber started vibrating with the echoes of War.

The year of 1919 again saw the movement of British troops through the Khyber during the third Afghan War thru vslian sons of Khyber conversed upon Peshawar in 1939 to give vent to their feeling of resentment against the indiscriminate firing of the British troops on freedom lovers in the famous Qissa Khawani Bazaar. The chapter of fighting in Khyber, however, came to a close with the dawn of Independence of India in August 1957. Since the establishment of American,

The situation has changed altogether and sentinels of Khyber are now interested in the welfare of their country with which is linked their own future. But one thing remains unchanged. The invasion of the Khyber Pass, which is still on conquerors no longer traversing it, tourist does. The Khyber Pass for hundreds of year's great camel caravans traveled through the Khyber Pass, bringing goods to trade. These ancient merchants and traders brought luxurious silks and fine porcelain objects. In the point Afghanistan Kath from the Sea water because of British-Russian

End of The Great Games, and the new Games Gold-Oil and Gas in Afghanistan "only Gas 86 billon U.S a day"

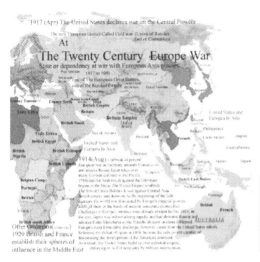

Gandhi 1943 in London, Gandhi returned to India in 1914 and turned himself into something like the opposite: a holy man dressed only half-naked walk, to the sea, leading a slow march of millions indiscriminately jumbled together, Gandhi was assassinated in 1947

To refer to the politics and economics of Afghanistan-central Asia and Caspian basin "the new Games" is to deploy as historical analogy. It is compare what is happening in Afghanistan and Caspian basin now with the imperial rivalry between Russia and Saxon (new British) in the Afghanistan, Caucasus and southwest Asia in the ninetieth century. The deployment of analogies in this way is familiar, useful, and perhaps even necessary. After all, past is only real guide to the future and historical analogies are instruments for distilling and organizing the past and converting it to a map by which can navigate. During the cold war American diplomats were perpetually concerned to avoid "another Munich" can military officials sought prevent, are being warned about the need to avoid, the appeal of this particular, moreover parallels between the events to which it refers that were important in the last century and those to witch it also refer that promise to be important in the next one, the region in question is the same, in both cases, high were involved in the nineteenth century the control of territory and the security of what were then the two largest empires on the planet, in the twenty first the enormous wealth that flows from exploitation of energy resources. Conflict is s feature of both cases. The two European

Russian and Saxon powered rivals, now although there is many players in this new game, they often have different interests, and lurking beneath the surface of current events, at least in the eyes of some, is the spectre of the revival of the great antagonism of global politics in the second half of the twentieth century, the one between the American and the Russian. While analogies are useful, however, they can also be misleading. They smuggle in assumptions that can be wrong. That the differences between the Saxon-Russian (German) rivalry in the 19th century and the politics and economics of central Asia-Afghanistan energy in the 21st are more important that the similarities. The first difference is captured by the term itself "the great game" on Afghanistan has a romantic overtone. The romanticism associated with this great imperial rivalry was typical of the 19th century, or at least of the 20th century's retrospective view of it this was a Game played by brave, "two German Empires" eccentric, often lone adventurers who journeyed into hostile, unknown territory, sometimes dying tragically, or heroically, or both. In Hanover in the 19th century the names of the players of the Great Game were well known: Connelly, beheaded by the king of Bokhara; Burnes, martyred in first Afghan War; young husband, the last in the line of Great explorers of east Turkistan. There were also Russian equivalents who were known in Russia in the 19th century but whose names were blotted out by a Bolshevik regime that had no use for them. East Turkistan was and is the Great part of Afghanistan. In the now great game these individuals played the same role in the culture as the great explorers of the 19th century and the early twentieth: Stanley, Sir Richard Burton. Lewis and Clark, the polar explorers Scott and amendment They were sealing figures because their histories exalted the individual in an age that was already beginning to be dominated by machines and organizations. But the exploitation of Afghanistan energy is pre eminently, quintessentially, the work of powerful machines and vast organizations, the participants are teams of executives, geologists, engineers and bankers. The contrast with the lone heroes of yesteryear could not be starker. Where the metaphor of the Game is concerned the differences are also stark. The players of today are different that the players of the 19th century. Then there were two more or less equal contestants, both present in full force in the stretch of central Asia-Afghanistan that they contested. They

were like prizefighters glowering at each other opposite corners of the ring: Russia from the northwest, Saxon-India (new British) in the southeast. The players in the Game of Afghanistan-Central Asia energy are different. There are many sovereign states, not just two. There are many private interests. Russia, of course is still important for reasons of geography, but the United States of America cannot substitute from Saxon-India because it is not and will not be physically present. There will be no American expeditionary force to Afghanistan-Central Asia. If the politics and economics of Afghanistan-Central Asia turn into a military contest the United States of America will not wage it directly. But it is not a military contest. The rakes are different. The Great Game in Afghanistan of the 19th century took place in the age of the German-Empires. It was a contest for direct control of Afghan-territory and its inhabitants. Today, or at least local, sovereignty imperial control is difficult to impose and costly to sustain. Nineteenth century Saxon-German found itself in direct control of distant Afghan-territory in the central Asia despite the fact that no one in Hanover or "London" wanted this. Today by contrast, while neo imperial impulses may live on in Russia, the obstacles to acting on these impulses are formidable. In fact, the stakes are different now then they were then. The 19th century Great Game in Afghanistan was in essence a contest for German-power. Such contest is zero sum Games: one player's gain is another's loss. That is why the logic of international politics is the logic conflict. Were Afghanistan-central Asia energy is concerned, the stake is economic gain; consequently, the logic is one of cooperation. There was, to be sure, some cooperation between the antagonists in the old Great Game. Afghanistan was tacitly as a buffer state between the two German empire's; at the end of the 19th century Afghanistan was divided into spheres of influence in anticipation of the larger conflict that began. And it is also true, of course, that conflicts or at least disagreements are involved in the division of energy resources of the Afghanistan-Central Asia,

In the new Game relative gains do matter. But absolute gains are more important. Every player would like to have a larger share of the pie that the others, but above all every one of them want to get something, which requires cooperation. So the essence of Afghanistan-central Asia energy politics is cooperation, and of that there has been a great deal, in

the form of multinational consortia, cooperation among governments, and cooperation between and among different firms from different countries for the sake of energy exploration and retrieval and the building and refurbishment of pipelines. And this cooperation includes Russia. The appropriate metaphor for the politics of Afghanistan-central Asia energy is therefore not imperial rivalry; the illuminating comparison is not with the Saxon-Russia "German" Great Game of the 19th century or the scramble. It bears a far closer resemblance to a large business deal put together by lawyers, executives and banks. All wish to maximize their own individual shares, but all need a deal of some kind or nobody gets anything. And in fact, the exploitation of Afghanistan-central Asia energy riches requires, and involves, a series of just such deals. Of Afghanistan energy riches requires, and involves, a series of just such deals.

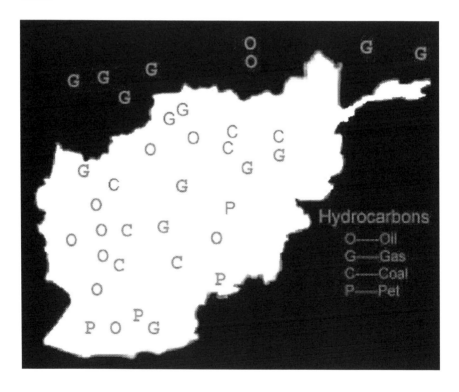

2500 years the Afghan War of resistance
Afghan-civil war of 1992

250s years the Afghan war of resistance has been regarded by many observers as one of the determining factors in the break-up of the Soviet empire, the fall of the Berlin wall, the reunification of Germany, the liberation of east European, victory of all Europe and save 300 million people live in Europe, Afghanistan civil war since 1994 the two main opposing forces in Afghanistan have been the Taliban movement, whose administrative entity is the Islamic emirate of Afghanistan IEA, and the ousted government, the Islamic state of Afghanistan ISA, which is led by a coalition of groups that call themselves the United National Islamic front for the salvation of Afghanistan, or the United front. For purposes of simplicity, will refer in this report to the two main grouped as the Taliban and the united front,

The Islamic Emirate of Afghanistan and Taliban
Pakistani Prime Minister Benazir Bhutto
is Mother of Taliban
Cold War-Deobandi movement, Durand Line Expired in 1993

The Taliban are the product of the network of private, rural-based madrasas, religious schools in Pakistan, during the Afghan-War against the Russian 1979-1989, these schools constituted one of the important sours of recruitment for mujahidin the guerrillas fighting "cold war" Russian forces in Afghanistan. The Taliban leaders are for the most part mullahs religious leaders from Pakistan trained in madrasas affiliated with the Deobandi movement in Pakistan. The head of the Taliban, Mullah M. Omar, assumed the title amiri-ul mominee ("commander of the faithful") shuras, or consultative bodies assist him. Mullah Omar renames the Islamic State of Afghanistan the Emirate of Afghanistan in October 1997. Arguably the most powerful agency within the emirate is the ministry of enforcement of virtue and suppression of vice ("al-Amr bi al Ma'ruf wa al-Nahi'an al-Munkir"), which is responsible for the enforcement of all Taliban decrees regarding moral behaviour.

Afghanistan largely on the claim it has brought security to the country's population after years of anarchy under the warlords that preceded it. In most of the areas it controls, the Taliban administration operates as a repressive police state. Most government offices barely function. After it emerged in response to the failure of the mujahidin parties to establish a stable government, the Taliban quickly attracted support of Pakistan and Saudi Arabia, which provided the military and financial resources to make the Taliban an effective military force. An estimated 15, 000 of the Taliban's fighting force comprises non-Afghan nationals of Saudi Arabia, other Gulf States, and even China. Through cash payments or other incentives the Taliban had also secured the support of former mujahidin groups, particularly those associated with Hizb-I Islami. In October 1998 a breakaway faction of Hizb-I Wahdat-I Islami-yi Afghanistan (Islamic Unity party of Afghanistan), by Hujjat-al Islam Sayyid M. Akbari, sided with the Taliban. Akbari is non-Hazara Shi's from Qizibash ethic group, with religious training in Iran.

The Afghan who won the Cold War
The united national Islamic front for the salvation of Afghanistan
"Jabha-yi Muttahid-I Islami-yi Milli Bara-yi nijat-I Afghanistan" or
United front by Pakistani Prime Minister Benazir Bhotto Durand Line-expired in 1993 and the collapse of the Cold War

In 1996, the groups opposed to the Taliban formed an alliance called the national Islamic united front for the salvation of Afghanistan, commonly known as the united front, which supports the ousted government, the Islamic state of Afghanistan ISA. The president of the ousted government remains the president of the ISA and the titular head of united front. The real power is the front's military leader, commander Ahmad Shah Massoud, who is also IAS's minister of defence. The alliance receives assistance of various kinds military, financial, and diplomatic from Iran, Russia, and neighbouring, States. The precise membership of the united front had varied has varied from

time to time, but includes: Jamiat-I Islamic Afghanistan "hereinafter known as Jamiat". Jamiat was one of the original Islamist parties in Afghanistan, established in the 1870s by students at Kabul University where its leader, remains the official head of Jamiat, the most powerful figure within the party is Ahmad Shah Massoud, and Massoud are Tajiks but from different areas. Massoud's ethnic power bats have historically been in parwan and Takhar provinces, where he established a regional administrative structure in the late 1980s, the supervisory council of the north. "SCN, Shra-yi Nazar-I Shamali" Massoud has received significant military and other support from Iran and Russia in particular. Hib-I Wahdat-I Islami-yi Afghanistan "Islamic unity party of Afghanistan, hereinafter known as Hizb-I Wahdat", the principal Shi'a party in Afghanistan with support mainly among the Hazara ethnic community, Hizb-I Wahdat was originally formed in order to unite eight Shi'a parties in the run-up to the anticipated collapse of the communist government "the Cold War collapse" government. Its current leader the leader of its executive council of the north commanded the party's forces in Mazar-I Sharif in 1997.

Hizb-I Wahdat has received significant military and other support front Iran, although relations between Iranian authorities and party leaders have been strained over issues of control. The party has also received significant support from local Hazara traders. Junbish-I Milli-yi Afghanistan "national Islamic Movement of Afghanistan, hereinafter known as Junbish", Junbish brought together northern, mostly ethic Uzbek, former militias of the communist regime who mutinied against President Dr. Najibullah in early 1992 "Durand line expired in 1993". It also included former leaders and administers of the old regime from various other ethnic groups, mainly Dari speaking, and some Uzbek mujahidin commanders. In 1998 it lost all the territory under its control, and many of its commanders have since defected to the Taliban. Its founder and principal leader Abdul Rashid Dostum, who rose from security guard to leader of Dr Najibullah's most powerful militia. This group took control of the important northern city of Mazar-I Sharif in alliance with other groups in early 1992 and controlled much of Provinces Samangan, Balkh, Jowzjan, Farjab, and Baghlan, a coalition of militias, the Junbish was the strongest force in the north during 1992-97, but was raven by internal disputes. Since 1998 the Junbish

has largely been inactive, although Dostum returned to northern Afghanistan in April 2001. Harakat-I Islami-yi Afghanistan "Islamic movement of Afghanistan" this is a Shi'a party that nicer joined Hizb-I Wahdat, led, and which was allied with Jamiat in 1993-95, it has since fought with Hizb-I Wahdat in central Afghanistan, its leadership is mostly non-Hazara Shi'a, most prominent commander is General Anwari, the group has received support from Iran.

Itched-I Islamic Bara-yi Azadi Afghanistan "Islamic union for the liberation of Afghanistan" this party is headed, during the war against the Russian occupation, Sayyaf obtained considerable assistance from Saudi Arabia, Arab volunteers supported by Saudi entrepreneurs fought with Sayyaf's forces, until August 1998, the northern areas under control by united front forces has four main administrative and political centers; Mazar-I Sharif, Taloqan, the headquarters of Ahmad Shah Massoud's SNC, province of Shiberghan, Abdul Rashid Dostum's headquarters and province of Bamian, headquarters of the Hizb-I Wahdat admonition of Hazarajat. On paper, Dostum was deputy to the president of the ISA and military commander of the northern regions; Muhammad Muhaqqiq was minister of internal affairs, and an official of the Akbari faction was a deputy primer minister, however, these four leaders did not merge their military and command structures, and they did not come up with a unified strategy in their struggle with the Taliban. Each had different patrons among Afghanistan's neighbours, and the latter's interest's fuelled divisions among their clients "Cold War".

End of the Cold War in 1992
History of foreign intervention

There have been three phases to the ongoing war in Afghanistan; in every phase foreign powers have intensified the conflict by supporting one side against another. The first phase was marked by the Russia "Soviet" invasion and occupation of Afghanistan 1979-1989. in the second phase, after the Russian withdrawal, various mujahidin parties, sponsored by American-neighbouring powers, vied for control over the country and its capital Kabul, against this backdrop, the Taliban emerged in 1994 and ultimately succeeded in taking control of Kabul

in 1996, in the third phase "continuing today" the coalition known as the united front, support by Russia and Iran, has faced off in the little territory it succeeded it succeeded in retaining ageist the Taliban, which received support primarily from America-Pakistan and Saudi Arabia.

On April 27, 1978 the people's Democratic Party of Afghanistan PDPA, a small, fictionalized Marxist Leninist party, took power in a coup. The government then embarked on a campaign of radical land reform over the opposition of regional elites. The campaign was accompanied by mass repression in the countryside that resulted in the arrest and summary execution of thins of thousands. Those targeted included political figures, religious leaders, teachers, students, other professionals, members of ethnic minorities, particularly Hazaras, and members of Islamic organizations. The government's repressive measures, particularly its attempt to reform rural society through terror, provoked uprisings throughout the country. Alarmed by the deteriorating situation and the prospect that a disintegrating Afghanistan would threaten its security on its southern border, the Russia "Soviet union" airlifted thousands of troops into Kabul on December 24, 1979. The president, Hafizullah Amin,

President Hafizullah Amin 1979

President, Hafizullah Amin, was assassinated after Russian intelligence forces took control of the government and installed Babrak Karmal as president. The Russian occupation force and the Karmal government sought to crush the uprisings with mass arrests, torture, and executions of dissidents, and aerial bombardment and execution in the countryside. These measures further expanded the resistance to the communist government in Kabul and fuelled a flow of refugees out of the country

that soon reached five million out of a population of about sixteen million. Islamic organizations that became the hear of the resistance based themselves in Pakistan and Pakistan and Iran. Seeing the conflict as Cold War battleground, the United States of America and Saudi Arabia, in particular, provided massive support for the resistance War, "the Cold War" nearly all of it funnelled through Pakistan, China, France, and the England also playing a part. The arms pipeline gave Pakistan a tremendous ability to bolster parties in Afghanistan that would serve its own interests. Negations to end the War culminated in the 1988 Geneva Accords, whose centerpiece was an agreement by the Russian to remove all its uniformed troops by February 1989. The last Russian troops did leave Afghanistan that month. With substantial assistance from the Russian, the communist government of Karmal's successor, Dr.Najibullah,

Dr. Najibullah

Dr. Najibullah, former head of the Afghan intelligence agency KHAD, held on to power through early 1992 ("Durand Line expired in 1992") while the Unite Nations frantically tried to assemble a transitional process acceptable to all the parties. It failed. On April 15, 1992, the mujahidin took Kabul. Eleven days later, in an agreement that agreement excluded the Shi'a parties and the Hizb-I Islamic led by G.H the protégé of Pakistan the parties in Kabul announced that Jabha-I Milli "national salvation front" would become president for two months, followed of the Jamiat-I Islamic for four. Rejecting the arrangement, Gulbuddin Launched massive and indiscriminate

rocket attacks on Kabul that continued intermittently for three years, until was forced out of the Kabul area in February 1995. In June 1992 Rabbani became president of Afghanistan, while Gulbuddin continued to bombard Kabul with Rockets. The U.N reputed that 500,000 civilians died in rocket attacks between May and August, two million people fled the city in fighting between two Islamic parties the hizb-I Wahdat and another mujahidin faction, Sayyaf's ittihad-I Islamic, hundreds of civilians were abducted and disappeared. When most of the partiers boycotted the shore that was supposed to elect the next president after Rabbani manipulated the process to his supporters on the council Rabbani was again elected president in December 1992, and fighting in Kabul intensified. In January 1994, Gulbuddin joined forces with Dostum to oust Rabbani and his defence Minster, Massoud, launching full-scale **civil war in Kabul**. Because of Rabbani and Gulbuddin-Islamist party civil War in all Afghanistan. In 1994 alone, an estimated two million Afghan were killed in Afghanistan, most in Kabul, them civilians. One million women, girl old and kids raped by the Islamist part. In rocket and raillery attacks One third of the city of Kabul ewe reduced to rubble, and much of the remainder sustained series damage. In September, fighting between the two Islamic major Shi'a parties, the hizb-I wahdat and harakat-I Islamic, left hundreds dead of them civilians. Thousands of new refugees fled to Pakistan that year. By 1994 the rest of the country was carved up among the various factions, with many mujahidin "Islamic" commanders establishing themselves as virtual warlords. The situation around the southern city of Kandahar was particularly precarious; the city was divided among different Islamic forces, and civilians had little security from murder, rape looting, or extortion. Humanitarian agencies frequently found their offices stripped of all equipment, their vehicles hijacked, and their staff threatened. It was against this background that the Taliban emerged. Former mujahidin who were disillusioned with the chaos that had followed the mujahidin victory became the nucleus of a movement that coalesced around M. Omar, a former mujahid who had returned to his home village of Singesar in Kandahar Province in 1992 where he became the village mullah and head of the local madrasa. The group, many of whom were madrasa students, called themselves Taliban, meaning students. Many other who became core

members of the group were commanders in other predominantly Pashtun Islamic-parties and former Khalqi PDPA members. Their stated aims were to restore stability and enforce "their interpretation" of Islamic law. The Taliban's first military operation has acquired mythic status in Taliban ranks; in early 1994 Taliban attacked the headquarters of a local Islamic-commander who had been responsible for numerous rapes, murders and lootings. Similar campaigns against other Islamic-warlords followed, and Taliban soon gained a reputation for military prowess and acquired an arsenal of captured weaponry. By October 1994 the movement had attracted the support of Pakistan, which saw in the Taliban a way to secure trade to central Asia and establish a Pakistani-government in Kabul friendly to its interests. The Taliban's first large military operation took place October 1994 when it seized the Pasha munitions depot and town spin Boldak on the Pakistani border, held at the time by Hizb-I Islamic commanders. The capture of the arms dump provided them with an enormous quantity of military materiel. Including rockets, ammunition, artillery, and small arms Two weeks later the Taliban freed a Pakistani trade convoy that was being held by Pakistani- commanders demanding exorbitant tolls outside Kandahar; the convoys real; objective was to examine the feasibility of constructing a rail line along the route-a priority for the government of Prime Minister Benazir Bhutto. Shortly thereafter the Taliban took control of Khandara after local commander, loyal to the Rabbani government, ordered his forces not to resist. In the process the Taliban captured heavy weapons and his forces not to resist. In the process the Taliban captured heavy weapons and aircraft, including MIG fighters, helicopters, and tanks. The Kandara attack was also notable for the appearance of large numbers of Pakistani madrasa students serving as soldiers for the Taliban, most of who centered Afghanistan by bus at the newly seized chapman Spin Boldak crossing with the knowledge of Pakistani border. By December 1994 the Taliban had spread north and east to the outskirts of Kabul and west toward Heart. Pakistani traders who had long sought a secure rout to send their goods to central Asia quickly became some of the Taliban's strongest financial backers.

In January 1995 the Taliban advanced on Kabul. Squeezing Hikmatyar between their forces and the ISA forces of Defence Minister Massoud,

In February, Hikmatyar abandoned his position at Charasyab and left behind significant stores of weapons. Under an apparent agreement with Massoud, who was preoccupied with fighting Hizb-I wahdat, the Taliban occupied the base at Charasyab. A massive assault by Massoud against Hizb-I wahdat the drove its leader, to strike a deal with the Taliban, but after a faction of Hizb-I wahdat joined with Massoud instead, Massoud launched a full-scale assault on the Taliban, driving them out of Charasyab. Combat resumed in the late summer and fall of 1995, with the Taliban defeating ISA forces in the west and occupying shindand and Herat by September 3, the occupation of the strategic town of Herat by Taliban was a terrible blow to ISA forces, and cut off the land route connecting the ISA with Iran. The Taliban's innovative use of mobile warfare hinted at a Pakistan role in the capture of Herat, in 1996 fighting shifted to the east, and the string of Taliban victories continued, culminating in September in its greatest victories to date, the seizures of Province of Jalalabad on September 11 and Kabul itself by the end of the month, although the bulk of the united front forces holding the city were able to withdraw to the north intact. With the fall of Kabul, the battle lines in eastern Afghanistan largely, stabilized, cutting across the fertile Shamali plain. Until early 1999, Massoud remained within artillery range of Kabul and repeatedly fired rockets into the city. Though he denied targeting civilians, many were killed, including more than sixty-five in a two-day attack in September 198, sometime after Massoud's loss of Kabul, he began to obtain military assistance from Russia as well as Iran. In the west, fighting resumed in 1997 as the Taliban attacked the predominantly Uzbek Junbish forces commanded by General Dostum had carved out what amounted to a mini state in northern Afghanistan comprising five provinces and administered from Mazar-I Sharif, and up to this point had appeared to be one of the strongest in Afghanistan. Hizb-I wahadt also maintained a significant force in Mazar-I Sharif in an uneasy alliance with Dostum, as had happened elsewhere, however the military stalemate was broken when one of Dostum's deputies, allied with the Taliban on Dostum on May 1997 arresting a number of Junbish commanders and as many as 5,000 soldiers

1917 (Apr) The United States declares war on the Central Powers

The new European Games Called Cold war (Union of Russia)
End of CentralAsia

At

The Twenty Century Europe War

State or dependency at war with European Axis powers.

1917 to 1991

End of The European Great Games
end of the Russian Empire

GERMANY
SLOVAKIA
West Turkistan
MONGOLIA
BULGARIA
Soviet Union and British
Soviet Union and Britain
Korea
Japan
GREECE
Ottoman
Soviet Union
End of Turkistan

France Tunisia France Syria
British India Empire
Britain 1914
British Empire
TIBET
BHUTAN

Italy Libya
Britain
NEPAL
China
United States and Europea In Asia

EGYPT
Britain Empire
India
(Britain)
Japan
Hong Kong

British Saudi

Italy Eritra
Sea of Aryana
Britain Philippines

British Egypt
Britain
French
Unite States
Japan

British Nigeria
British Ethiopia
United States and Europea In Asia
Britain
UnitedStates

British Uganda
1914(Aug) Outbreak of general
European war as Germany invades France
and attacks Russia Japan takes over
many German colonies in the Pacific
1916(Jun)An Arab revolt against the Ottomans
begins in the Hejaz The Russia Empire setablish
The Soviet Union Bolshevik war against Central Asia
British empire and domions At the beginning of the 20th
coentury the world was dominated by Europe's imperial powers,
many of them in the hands of ancient, autocratic monarchies.
Challenges to Europe's empires were already evident before 1914, in
the east, Japan was industrializing rapidly and had defeated Russia and
advanced into Manchuria as the Manchu dynasty in china collapsed
Europe's most formidable challenge, however, came from the United States which,
following the defeat of Spain in 1898, became the only power capable of
determining the development of the American continent.
As a result, the United States built its own informal empire,
enforcing its will if necessary by military intervention.

Britain
Japan
Japan

Dutch East Indies
Netherlands

Porruga

British
French

Belgian Cango

Portugal

British

British south Africa
Ofter Ottomans (Middle East)

1920 British and France
establish their spheres of
influence in the Middle East

AUSTRALIA

Pakistan was quick to seize the opportunity to recognize the Taliban as the government of Afghanistan, on May 25; Saudi Arabia followed on May 26 and the UAE on May 27, but the fortunes of the Taliban were suddenly reversed at the end of May as the alliance with Malik disintegrated, apparently after Taliban troops began trying to disarm the local Hazara population in Mazar-I Sharif, as the Hazaras turned on them, the Taliban soon found its fighters trapped. Hundreds of Taliban soldiers were killed in the streets of Mazar, and Malik took prisoner some 3,000 most of who were in Dostum's headquarters at Province of Shiberghan, nearly all of these detainees were then summarily executed. Within days, the remains of the Taliban occupation force had been driven from the city and commanders loyal to Malik had regained control of Province of Jowzjan, Sar-I Pol, and Faryab, establishing a front line with the Taliban along the Morghab

river in Baghdis province, however the Taliban were able to consolidate control over the province of Konduz, a predominantly Pashtun pocket in the north had come under its control after the Pashtun shore switched sides. The Taliban troops in Konduz attacked west towards Mazar-I Sharif in early September 1997, after being reinforced with men and munitions airlifted from Kabul and gaining further aid from the defection of several commanders holding positions in the area. In fighting over the next several weeks Taliban forces were again pushed to Province of Konduz, during its retreat the Taliban attacked villages along the way, killing at least eighty-six civilians. In August 1998 Taliban forces opened their assault in Mazar-I Sharif, and this time took city decisively. They massacred at least 2,000 people, most of them Hazara civilians, after they took the city, and killed an unknown number of people in aerial bombardments.

In August 1998, the United States of America launched air strikes against reputed training camps near the Pakistan border, the strikes, which the U.S justified as attacks on the headquarters of Osama bin Laden, came in the wake of the bombings of the U.S embassies in Nairobi and Dar as-salaams. Following these strikes, on August 20, the U.N and most international humanitarian agencies withdrew their staff from the country. In September 1998 the Taliban took control of the predominantly Hazara town of Province of Bamyan, west of Kabul; local activists and foreign observers documented reprisal killings in the city after the takeover. Massoud remained within artilly range of Kabul and repeatedly fired rockets into the city, killing civilians, while claiming to be targeting the airport, which is on the north-eastern edge of the city.

In late July 1999, ("1893") at peace talks held in "Bukahra" new Tashkent, the six plus two contact group issued the "Tashkent declaration" which called on all parties to resolve the conflict through "peaceful political negotiation," and pledged "not to provide military support to any Afghan party and to prevent the use of our territories for such purposes, almost immediately afterwards, both the Taliban and unite front resumed fighting with the Taliban focusing its efforts on territory heeled by Massoud's forces north of Kabul. As it pushed north, the Taliban forced civilians from their homes and then set fire to houses and crops and destroyed irrigation canals and wells,

ostensible to rout opposition sympathizers but effectively preventing the residents return, in the Sahmali region, men believed to loyal to Massosud were arrested or shot, and women and children either feed or were taken to Jalalabad and Kabul, over four days in August 1999, the U.N estimated that over 20,000 people arrived in Kabul, bringing the total to close to 40,000 in a two-week period, thousands more fled to the Massoud held Panjshir valley. In September, Taliban fighter planes bombed Taloqan, the capital of northern Takhar province. In October the U.N imposed sanctions on the Taliban, banning Taliban controlled aircraft from takeoff and landing and freezing the Taliban's assets abroad. In mid 2000 the Taliban mounted yet another offensive again with considerable backing from Pakistan on September 5, 2000 Taliban capered Taloqan fighting in the area combined with the effects of a sever drought drove thousands of civilians from the east to Faizabad and Pakistan or Takijstan, as of June 2001, Massoud's forces had regained territory to the north and east of Taloqan but remained well outside the city itself, his headquarters were reported to be loyal to Ismael and Dostum were responsible for guerrilla attacks on Taliban forces in western and northern Afghanistan in April and May 2001.

Civil War in Afghanistan
Afghanistan a state of perpetual humanitarian catastrophe

Violations of international human right and humanitarian law, the civil war in Afghanistan can be characterized as a non-international armed conflict under international humanitarian law "end of the cold war", both the Taliban and the parties constituting the united front have repeatedly committed serious violation of international humanitarian law, including killings of detainees, aerial bombardment and shelling, direct attacks on caviars, rape, torture, persecution on the basis of religion, and the use of antipersonnel landmines, these violations have come to characterize the conduct of the war and have been widespread and systematic, none of the events described is a unique or isolated instance. The applicable humanitarian law includes article 3 common to the four Geneva conventions of 1949, the 1977 second additional to the Geneva conventional "protocol II", and the customary laws of war, these apply to both state and non-state forces

involved in an internal armed conflict, Afghanistan became a party to the Geneva conventions in 1956. Although Afghanistan is not a party to protocol II, its fundamental provisions reflect customary international law. Common article 3 to the Geneva conventions provides that civilians and persons no longer taking an active part in the hostilities "including captured members of opposing armed forces" shall be treated humanely, prohibited at all times are violence to life and person, in particular murder of all kinds, mutilation, cruel treatment and torture, taking of hostages, outrages upon personal dignity, and summary trials. In the conduct of military operations, international humanitarian law makes a fundamental distinction between combatants and non-combatants. Legitimate military objectives include combatants, weapons convoys, installations, and supplies. The civilian population and individual civilians are prohibited from being the object of attack. Acts or threats of violence against the civilian population that spread terror are also prohibited. Moreover, objects normally dedicated to civilian use, such as houses, schools, and places of worship, are presumed not to be military objectives. Only if they are being used by the enemy's military can they lose their immunity from direct attack. International humanitarian law has historically use of the term "War crimes" to international armed conflicts, increasingly, serious violations of international humanitarian law committed in non-international armed conflicts have been recognized as war crimes as well as crimes against humanity. There is little to distinguish the summary execution of non-combatants or an attack on civilians committed in an international armed conflict and a civil war. All such acts must not only be condemned, but its perpetrators prosecuted. Until recently, prosecutions for crimes committed during the course of a civil war were considered the sole purview of the national coots. The international law commission's 1996 draft code of crimes against the peace and security of mankind accepts that certain acts committed in violation of the laws or customs of war "namely, acts prohibited by common article 3 protocol II" constitute war crimes when committed in internal conflicts, the international criminal courts for Rwanda and the former Yugoslavia treat certain violations committed in civil wars as war crimes. The 1998 Rome Statute of the international criminal court has defined as war crimes serious violations of common article 3

of the Geneva conventions, such as the exaction of non-combatants, also considered as war crimes are the serious violations of the laws and customs applicable in "no international" armed conflicts, "such as attacks on the civilian population and rape crimes against humanity, first articulated in the 1907 Hague convention, have been defined as "widespread or systematic attacks" directed against a civilian population whether during war or peacetime, the Rome Statue of the international criminal court includes as "crimes against humanity" attacks directed against the civilian population, including murder, extermination, rape, and persecution of certain identifiable groups, such as ethnic and religious groups. Crimes against humanity are deemed to be part of jus congest, the highest level of international legal norms, and thus constitute a non-derivable rule of international law, as such they are subject to universal jurisdiction, permit no immunity from prosecution, and do not recognize "obedience to superior orders" as a defence. The examples provided below of violations of international humanitarian law committed by the Taliban date, for the most part, from 1999-2001 when its forces were on the offensive or occupying captured territory. These offensives were accompanied by the use of scorched earth tactics in the Shamali plains north of Kabul, summary executions of prisoners in the north central province of Samangan, and forced relocation and conscription. Many of the violations of international humanitarian law committed by the united front forces described date from 1996-1998 when they controlled most of the north and were within artillery range of Kabul, since then, what remains of the united front forces, those fighting under commander Ahmad Shah Massoud, have been pushed back into defensive positions in home territories in north-eastern and central Afghanistan following a series of military setbacks. There have nevertheless Benn repost of abuses in areas held temporarily by united front factions, including summary executions, burning of houses, and looting, principally targeting ethnic, the versions parties that comprise the united front also amassed a deplorable record of attacks on civilians between the fall of Dr. Najibullah regime in 1992 and the Taliban's capture of Kabul in 1996. Durand Line expired 1992, what follow are some examples of violations of international humanitarian law committed by the Taliban and Islamic-parties constituting the united front, they are by no means comprehensive, merely indicative of the

warring paring parties conduct. They are listed here to underscore the seriousness of the situation in Afghanistan and the urgency of responding to the human toll of war,

Afghanistan the Taliban and the United States of America End of the Cold War-what about Afghanistan-Gold, oil, gas

The historical context of the crisis

Afghanistan is currently undergoing a humanitarian catastrophe of tremendous proportions, to which the international community displays only what appears to be systematic indifference. To understand the crisis in Afghanistan it is particularly important to understand its historical causes "the cold war". This is because the crisis is a direct result of self-interested American and Russia in the region "the cold war".

Afghanistan's coup of 1978 resulted in a new government headed by Nur M. Taraki coming to power in the Afghan capital, Kabul. The coup detach that brought Taraki's party the people's Democratic party of Afghanistan PDPA to power, had been predicated by the previous government's arresting of almost the entire leadership of the PDPA, an attempt to annihilate any viable opposition to the existing government, which was led by M. Daoud the leader of the PDPA, Taraki, was then freed in an uprising by the lower ranks of the military, and within a day Daud and his government was overthrown, with Daoud being killed in the process. In fact, many of the leaders of the PDPA had studied or received military training in the USSR; the Russia had pressured the PDPA, which had split, into two factions in 1967 to reunite in 1977. the PDPA had therefore been the principal orientated communist organization in Afghanistan; the military coup of 1978 was thus effectively engineered by the USSR, which had significant leverage over the PDPA and its activities, Afghanistan subsequently became exclusively dependent on USSR "Russia" aid, unlike previous governments which had attempted to play off the U.S.A and USSR against one another, refraining from exclusive alignment with either, ("US.A and USSR was allied from 1945") the PDPA did go on to implement certain programmers of social development and reform, like the previous government although these were primarily related to urban as opposed

to rural areas, for example, the previous government under Daoud had used foreign aid from both the USSR and the U.SA "primarily USSR" to build roads, schools and implement other development projects, thereby increasing the mobility of the country's people and products not that this necessarily eliminated the severe problems faced by masses of the Afghan population. For instance, 5 percent of Afghanistan's rural landowners still owned more than 45 percent of arable land, a third of the rural people were landless labourers, sharecroppers or tenants, and debts to the landlords were a regular of rural life. An indebted farmer ended up turning over half his annual crop to the moneylender, female illiteracy was 96, 3 pecan, while rural illiteracy of both sexes was 90, 5 percent, the communist PDPA government under Taraki had similarly imposed some social programmers like Daoud's government; it moved to remove both usury and inequalities in land ownership and cancelled mortgage debts of agricultural labourers, tenants and small landowners. It established literacy programmers, especially for women, printing textbooks in many languages, training more teachers, building additional schools and kindergartens, and instituting for orphans, once more, these policies should be understood in context with the fact that the government was established as the result of a violent military coup without any connection to the wishes of the majority of the Afghan people, and consequently did not engender their participation. The PDPA policies served to destroy even the state institutions established over the previous century, having constituted a stage in a revolutionary programmed which the government had attempted to impose by force, not by the approval of the population, the new government, like previous governments, was essentially illegitimate, with on substantial representation of the Afghan population. It was for example for arresting, torturing executing both real and suspected enemies, setting off the first major refugee flows to neighbouring-Pakistan, such policies of repression and persecution, resulting in the killing of thousands as well as the forceful imposition of a communist revolutionary programmed that was oblivious to the sentiments of the majority of the Afghan masses, sparked off popular revolts led by local social and religious leaders usually with no like to national political groups. These broke out different parts of the country in response to the government's atrocities, furthermore during the Russian occupation, despite the

modest modernizing policies that was primarily urban in character, the bifurcation of Afghan society and economy deepened greatly. The PDPA was therefore essentially a communist dictatorship that was allied with the Russian, this was unlike the previous government of Daoud's that was not exclusively allied to either of the superpowers "neither the U.S.A the nor the USSR" however, both the later superpowers wished Afghanistan to remain within their respective spheres of influence, due to the traditional brand of political economic and strategic interests. Their wishes resulted in one of the last brutal episodes of the cold war; the Afghanistan war that began several months after the 1978 Sauer coup, and that was a manifestation of the two superpowers USSR & U.S.A attempts to gain control of a region of very high Geostrategic significance

U.S.A pushes the Russians into invading Afghanistan Russian responsible for the civil war and its impact in Afghanistan
Afghanistan has been plunged into a state of perpetual humanitarian catastrophe; Russia has to give compensation for 22 million Afghan people

Although the USSR had been interfering in Afghan affairs long before the U.S.A it is worth noting that contrary to the conventional wisdom, the U.S. A appears to have begun operations in Afghanistan before the full fledged Russian invasion. Former national security advice under American-President Carter administration, Zingier Brzezenski, has admitted that an American operation to infiltrate Afghanistan was launched long before Russian sent its troops on 27, Dec, agency France press reported that; despite formal denials, the American launched a covert operation to bolster anti communist guerrillas in Afghanistan at least six months before the 1979 Russia of the country, according to a former top American official. Brzezenski stated that we actually did provide some support to the Afghan-Mujahedeen before the invasion. We did not push the Russians into invading? but we knowingly increased the probability that they would, he also bragged; that secret operation was an excellent idea. "End of the cold war" the effect was

to draw the Russians into the Afghan trap. Other words, the American appears to have been attempting to foster and manipulate unrest amongst various Afghan factions to destabilize the already unpopular communist regime and bring the country under American sphere of influence.

Lift Afghan President, the Russian puppet regime in Afghanistan
Russian backed government of Afghanistan

This included the recruitment of local leaders and warlords to form mercenary rebel groups, who would wage war against the Russian backed government, to institute new regimes under American control.

In Dec 1979, Russian intervened to reinforce its hegemony over Afghan, since the PDPA was, according to Brzezenski's testimony, being destabilized by an American operation to infiltrate Afghan that had commenced at a much earlier date. The American had therefore evidently also wished bring this strategic region under its hegemony. Anticipating this attempt by American to destabilize the pro Russian PDPA and install a new pro American regime in Kabul. Russian undertook a full-fledged invasion to keep Afghanistan under its own sphere of influence. Afghan analyst Dr. Noor Ali observes of the ensuing American policy following the invasion of Afghanistan by the Russian in late Dec 1979, hundreds of high ranking Afghan politicians and technocrats as well as army officers including generals entered into Pakistan with the hope of organizing the needed resistance to oppose the invader in order to liberate Afghanistan. Unfortunately and regrettably the American government in collusion with Pakistanis

leaders took advantage of the opportunity so as to exploit it full and by all manner of means to their own and exclusive illegitimate benefits and objectives, which had been threefold "Durand Line expired 1993" to rule out the creation of any responsible and independent Afghan organization among Afghan, interacting directly with American, to support Afghan resistance, to repulse the Red Army by using exclusively the blood of Afghans, and to make of Afghanistan a satellite if not an integrated part of Pakistan in return for Pakistani leaders services, but in complete disregard to Afghan people's sovereignty and sacrifices, the overall result was a brutal civil war in Afghanistan by the two American and Russian that drove 6 million Afghan people from their homes.

By 1991-92 the American and the Russian finally reached an agreement that neither would continue to supply aid to any faction in Afghanistan, the end of cold war. However, the numerous militant factions previously funded and armed by the American have been vying for supremacy. One of the armed Afghan factions funded by the CIA during this war was the Taliban, an apparently Islamic movement. With the departure of Russian troops in 1989, these factions began with one another for supremacy, the Taliban eventually arising as the dominant force in Afghanistan. As a coherent politico military faction or movement, the Taliban did not exist prior to Oct 1994, but were members of other factions such as Harakat-e Islami and Mohammad Nabi Mohammadi, or operated independently without a centralized command center. The ultimate result has been that post cold war in Afghanistan has remained in a state of anarchical civil war up to this day; with the Taliban having emerged as the most powerful faction in Afghanistan by the 1990s one can therefore conclude that as a result of a string of proxy wars. That were the result of manipulation by the American and Russian, Afghanistan has been plunged into a state of perpetual humanitarian catastrophe.

Development specialist Dr.J.W Smith, founder and Director of research for the California based Institute for economic democracy, summarizes the humanitarian catastrophe of Afghanistan, commenting on Brzeninski's admission of the American operation in Afghanistan; Afghanistan was also American destabilizations. In 1998, Zbigniew Brzezinski, President Carter's national security advisor admitted that covert American intervention began long before the USSR sent

in troops in Afghanistan, take note of what was "an excellent idea" Afghanistan rapidly developing and moving towards modernization was politically and economically shattered, almost 2 million Afghan were killed, the most violent and anti American of the groups supported by the CIA are now the leaders of Afghanistan, these religions fundamentalists set human rights back centuries to the extent they are even an embarrassment to neighbouring Muslim fundamentalists, and both Muslim and no Muslim governments within the region fear destabilization through Taliban fundamentalism. Smith fails; however, to take into account the illegitimacy of the Russia puppet regime and its policies of repression, the fact is that both the American and Russian bear responsible for having attempted to control Afghanistan, thereby shattering the country in the process; if these powers had merely attempted to aid the Afghan people to develop their country, rather that enforce hegemony over the country for their own self interested strategic designs, there would obviously had been no such humanitarian crisis. Thus, as Barnett Rubin of the council on foreign relations reports; despite the end of the proxy war, the massive arms supplies still held by American and Russian-aided army and the Islamic resistance fighters "backed by the American, with help from Pakistan, Saudi and other" continue to fuel the fighting. By August 1992, ongoing rocketing by the forces of Gulbuddin hekmatyar a one time favourite of Pakistani and American had driven out a million civilians from the capital city Kabul and killed over 2, 000 people. HRW reports that by end of the years "international interest in the conflict had all but vanished and Afghanistan appeared to be on the brink of a humanitarian catastrophe" while the American-Pakistani favourite masterminded the escalation of terror, "carried out with American and Saudi financed weaponry". The economic reputed that by summer 1993 about 30,000 people been killed and 100,000 wounded in the capital of Afghanistan. The bombardment of civilian targets has continued ever since, with causality and refugee figures rising rapidly and steadily "in 1993 Durand line expired" it is impotent to note the Taliban and forest of hekmatyar are two separate factions "for the Pakistani" moreover, it should also be emphasized that hekmatar and his forces are solely responsible for death of thousands in Kabul and the city's destruction. While hekmatyar's forces may have killed and destroyed more that other groups, factions

under Amed Shah Masoud, Burhanuddiin Rabbani, Abdul Rashid Dostum, Abdul Ali Maxari and karim khalili are equally responsible for the violence that raged between 1992 and 1996 in Kabul. Due to the ravages of such ongoing war, Kabul has been without municipal water and electricity since 1994. This state of affairs has not improved by the time of writing. Trade is frequently blockaded and subjected to extortionate "taxes" by local power holders. Nearly everywhere a new generation is emerging with minimal education in a land infested with landmines, due to which thousands of civilians continue to be killed or maimed. The UN reports that socio-economic conditions of the population are amongst the worst in the world, the investment of previous government into schools, roads and hospitals has been reduced to near insignificance, literacy rates are at an extreme low, with estimates showing that they have plummeted to as low as 4 percent for women.

The Great city of Kabul 35 years ago 1968

Healthcare is rudimentary at best, with much beige without access to even the basics. Every year thousands of children die from malnutrition and respiratory infections, and maternal mortality rates are one of the

highest in the world. Irrigation systems and the agricultural sector have been neglected and destroyed. Today's Afghanistan is plagued by a perpetual orgy of destruction, impoverishment and repression. Five million Afghan has been killed. There remain over 2 million Afghan refugees in Iran and 2 million in Pakistan, making Afghan the largest single refugee group in the entire world. the Taliban that now dominates Afghanistan has instituted a "system" in which much of the population is denied their social and human rights; torture, arbitrary detention, mass killings and ongoing warfare are the norm; the masses remain embedded in growing poverty; the rulers falsely legitimize their actions under the guise of Islam.

Poverty is now endemic, according to the UN office for the coordination of humanitarian affairs "million of Afghans have litter or no access to food through commercial markets, just as their access to food through self production has been severely undermined by drought. The purchasing power of most Afghans has been seriously eroded by the absence of employment. About 85 % of Afghanistan's estimated 21.9 million people are directly dependent on agriculture. The agricultural infrastructure has been severely damaged due to war and irrigation facilities are in urgent need of rehabilitation. Afghanistan also has one of the worst records on education in the world. UNICEF estimates that only 5% of primary aged children receive a broad based schooling for secondary and higher education, the picture is worse. As Kate Clark reports "twenty year of war has meant the collapse of everything. Both sides in the long running civil war prefer to spend money on fighting. However, the desire for schooling runs deep in Afghanistan, even among the uneducated, but the chances of getting decent educations are very slim, a whole generation of children is losing out, prompting questions about where this leaves the future of this devastated country. Need, there is no doubt that the Taliban has been ruling Afghanistan with an iron first. The faction's policies are repressive and involve the perpetration of countless human rights abuses, however, as the international Muslim newsmagazine Crescent international rightly observes, "Criticism of the Taliban, whether it cones from non Muslim or Muslims, is often heavily overlaid with prejudices or political interests," it is therefore important to ensure that facts are separated from propaganda. Nevertheless, Crescent admits that

the Taliban regime is undoubtedly repressive, to the extent that therein "the phrase Islamic justice used as a synonym for tyranny, "numerous reports of draconian restriction on women" being enforced falsely in the name of Islam unfortunately reveal harsh realities men responsible for enforcing public decency are said to beat women in the streets who show their laces or ankles. Most women are not allowed to work; they are forbidden to see male doctors, yet there are few female doctors available. Most girls' schools have been closed, and the only religions instruction is for girls who have reached puberty.

Afghanistan is the crucible strategic interest of American-European
Afghanistan is the World's heartland
Afghanistan is a major strategic pivot what happens there affects the rest of the World "Oil Gas and Gold" the cover America-Taliban alliance

Europeans-American motives become clearer when one recalled that it was the America that originally trained and armed the faction in Afghanistan even "long before the Russian sent troops in Afghanistan" which now constitutes "leaders of Afghanistan" the record illustrates the existence of an ongoing relationship between the American- and the Taliban, al reports that even though the "American has denied any link with the Taliban" according to then American secretary of state Robin Raphael Afghanistan was a "crucible of strategic interest" during the cold war, though she denied any American or support of factions in Afghanistan today, dismissing any possible ongoing strategic interests in Afghanistan. However, former department of defence official Elie Krakowski, who worked on the Afghan issue in the 1980s points out that Afghanistan remains important to this day because it is crossroads between what Halford Mackinder called the World's Heartland and the Indian sub continent. It owes its importance to its location at confluence of major routes, a boundary between land power and sea power, it is the meeting point between opposing forces larges that itself. Alexander used it as a path to conquest. So did the Afghan-Tajik. An object of competition between the Saxon (new British) and Tsars (new

Russia) both German empires in the 19th century Afghanistan became a source of controversy between American and Russian in the 20th, with the collapse of the Soviet Union it has become an important potential opening to the sea for landlocked-Afghanistan-central Asia states the presence of large oil and gas deposits in Afghanistan has attracted countries and multinational corporations. Because Afghanistan is a major strategic pivot what happens there affects the rest of the World.

The Golden Pass or Khyber pass 200 years War British,Russian, Babylonian and Europe on the Golden pass. end of Afghan Empire.

Raphael's denial of us interests in Afghanistan also stands in contradiction to fact that, as all reports, "many Afghanistan analysts believe that the American has close political links with the Taliban militia, they refer to vests by Taliban representatives to the America in recent months and several visits by senior American state Department officials to Kandahar including one immediately before the Taliban took over Province of Jajalabad "the Ali report refers to a comment by the Guardian, senior Taliban leaders attended a conference in Washington in mid 1996 and American diplomats regularly traveled to Taliban

headquarters. The Guardian points out that though such visits can be explained, the timing raises doubts, as does the generally approving line, which American officials take towards the Taliban, amnesty goes on to confirm that recent "accounts of the madrassa "religious schools" which the Taliban attended in Pakistan indicate that these European-American links with the Taliban may have been established at the very inception of the Taliban movement. In an interview broadcast by the BBC World service on 4 October 1996, Pakistan's then Prime Minister Benazir Bhutto affirmed that the madrasa had been set up by Britan, the United States of America Saudi Arabia and Pakistan, the Islamic resistance against Russian occupation of Afghanistan. Similarly, former Pakistani interior Minister, Major General Naseerullah Babar, stated that the CIA itself introduced terrorism in the region and is only shedding crocodile's tears to absolve itself of the responsibility. In light of Brzezinski's testimony, the establishment of this American-European like with the Taliban as well as other Afghan factions was initiate even prior to the Russian invasion. Similarly, virgin reports, "the corporate media have, remained silent in regard to American involvement in the promotion to terrorism, on the issue of right wing terrorism, little has been reported. On American's intelligence connection to Islamic guerrillas "and their manipulation of Islam" nothing has been said. Yet, the truth is that amongst those who utilize religious faith to justify war, the majority is closer to Langley, Virginia, that they are to Taliban or Tripoli. In a move to recruit soldiers for the Afghanistan civil war, the CIA and Zia encouraged the region's Islamic people to thing of the conflict in terms of a jihad "holy war" thus was fundamentalism promoted,

William O. Bee man, an anthropologist specializing in the Middle East at brown University who has conducted extensive research into Islamic of central Asia, points out "it is no secret, especially in the region, that the American-Pakistan and Saudi have been supporting the fundamentalist Taliban in their war for control of Afghanistan for some time. The American has never openly acknowledged this connection, but both intelligence sources and charitable institutions in Pakistan have confirmed it, Professor Bee man observes that the American backed Taliban "are a brutal fundamentalist group that has conduced a cultural scorched earth policy" in Afghanistan. Extensive

documentation shows that the Taliban have "committed atrocities against their enemies and their own citizens. So why woulf the American support them?" Bee man concludes that the answer to this question "has nothing to do with religion or ethnicity but only with the economic of oil and gas. To the north of Afghanistan is one of the world's wealthiest oil fields. On the eastern shore of the Caspian Sea in republic formed since the break-up of the Soviet Union, the war of Afghanistan, "Caspian oil needs to be transhipped out of the landlocked region through a warm water port, the resins Afghanistan was the lasted 100 years landlocked from the warm water, for the desired profits to be accumulated, the "simplest and cheapest" pipeline route is through Iran-but Iran is essentially an enemy of the American? Due to being overtly independent of the American-European, as shall be discussed later, notes the American government has such antipathy to Iran that it is willing to do anything to prevent this, "the alternative route is one that passé through Afghanistan" would require securing the agreement of the power that be in Afghanistan the Taliban such an arrangement would also benefit Pakistan elites, "which is why they are willing to defy the, "therefore, as far as the American is concerned, the solution is" for the anti Iranian Taliban to win in Afghanistan and agree to pipeline through their territory, apart from the oil stakes, Afghanistan remains a strategic for the American in another related respect, the establishment of a strong client state in Afghanistan would strengthen American influence in this crucial region of Afghanistan, partly by strengthening Pakistan a prime supported of the Taliban, which is Afghanistan main American base. Of course, this also furthers the cause of establishing the required oil and gas pipelines to the sea, while bypassing Russia and opening up the commonwealth of independent states CIS bordering Russia to the American dominated global market. Strategic interests therefore seem to have motivated what the guardian referred to as the generally approving line that U.S.A officials take towards the Taliban, CNN reported that "American wants good ties with the Taliban but can openly seek them while women are being repressed" hence they can be sought covertly. The intra press service IRS reports that underscoring " the geopolitical stakes, Afghanistan has appeared prominently in American government and corporate planning about routes for Oil, Gas pipelines and roads opening the ex-Soviet republics (ex Afghan

Provinces 1871) on Russia's southern border to world markets. Hence amid the fighting "some American-European businesses are warming up to the Taliban despite the movement's institutionalization of ex Afghan terror, massacres, abductions, and impoverishment, "Leili Helms, a spokeswoman for the Taliban in New York, told IPS that one American company, Union Oil of California "Unocal" helped to arrange the visit of the movement's acting information, industry and mines ministers. The three officials met lower level state Department officials before departing for France, Helms said, several American, French firms are interested in developing gas lines through central and southern Afghanistan. Where the Taliban controlled states" happen to be located, as Helms added to the chance convenience of American and other European companies. An article appearing in the prestigious German daily Frankfurter Rundschau, in early Oct 1996, reported that Unocal "has been given the go-ahead from the new holders of power in Kabul to build a pipeline from Turkmenistan via Afghanistan to Pakistan. It would lead from krasnovodsk on the Caspian Sea to Karachi on the Indian Ocean coast. "The same article noted that UN diplomats in Geneva believe that the War in Afghanistan in the result of a struggle between Turkey, Iran, Pakistan, Russia and the American," to secure access to the rich oil and natural gas of the Caspian Sea. Other that Unocal, companies that are jubilantly interested in exploiting Caspian oil, apparently at any human expense, include AMOCO, BP, Chevron, EXXON, MOBLIE.

It therefore comes as no surprise to see the Wall Street Journal reporting that the main interests of American and other European elites lie in making Afghanistan prime transhipment route for the export of central Asia's vast oil and other natural resources. Like them the Journal continues without fear of contradiction, the Taliban are the players most capable of achieving peace in Afghanistan at this moment in history, the Journal is referring to the same faction that is responsible for the severe repression of women; massacres of civilians, ethnic cleansing and genocide; arbitrary detention, and the growth of widespread impoverishment and underdevelopment. Despite all this the New York Times similarly reported the Clinton administration has taken the view that a Taliban victory, would act as a counterweight to Iran. And would offer the possibility of new trade routes "the old Afghan trade routes"

that could weaken Russian and Iranian influence in the old Afghan region, in a similar vein, the international Herald tribunal reports that in the summer of 1998, the Clinton administration was talking with the Taliban about potential pipeline routes to carry oil and natural gas out of Afghanistan to the Indian Ocean, clarifying the American would be interested in ensuring that the Afghanistan is destabilized enough to prevent the population from being able to mobilize domestic resources, or utilize the Afghanistan's strategic position, for their own benefit. P Stobdan reports Afghanistan figures importantly in the context of American energy security politics. Unocal's project to build oil and gas pipelines from Turkmenistan through Afghanistan for the export of oil and gas to the Indian subcontinent, viewed as the most audacious gambit of the 1990s

American policy shifts against the Taliban
End of the cold war and end of the civil war in Russia

The shift in American policy in Afghanistan from pro-Taliban to anti-Taliban, has not brought with it any change in the tragic condition of the Afghan-people, primarily because the policy shift is once more rooted in America's own attempt to secure its strategic and economic interests. Since the Taliban no longer plays a suitably subservient role, American's policy has grown increasingly hostile to the faction. The shift has also unfortunately, occurred without public discussion, without consultation with American-Congress and without even informing those who are likely to make foreign policy in the next administration. The imposition of sanctions on Afghanistan in the wake of American embassy blasts in east Africa attributed to the Arab Bin Laden, has not only failed to affect the Pakistani-Taliban, but has served primarily to devastate the Afghan-population even. Indeed, the American engineered a punishing Iraq-style embargo of war ravaged Afghanistan at a time when many of its 22 million Afghan-people are staring and homeless, observes the Toronto Sun. the London Guardian reports, "when the UN imposed sanctions a year ago on the Pakistani-Taliban because of their refusal to hand over the Arab-bin Laden, the suffering in Afghanistan increased. The move has not hurt the Pakistani-Taliban. They are well off. It is ordinary Afghan

who has suffered. Those in jobs earn a salary of around $4 a month, scarcely enough to live on. The real losers Afghanistan's women, who have been for bidden by the Pakistani-Taliban from working in Kabul is full of bursa-clad women beggars who congregated every lunchtime outside the city's few functioning restaurants in the hope of getting something to eat, indeed, the imposition of sanctions amidst the ongoing famine in Afghanistan has quite predictably resulted in the exacerbation of Afghanistan's crisis, Afghanistan is the grip of an unreported humanitarian disaster, notes Luke Harding reporting from Province of Kandahar. In the south and west-Afghanistan, there has been virtually on rain for three years. The road from Province of Herat near the Iranian border, to Kandahar, the southern desert city, winds through half abandoned vile lags and stiflingly empty riverbeds, meanwhile the American desire to eliminate the Arab-Bin Laden his likeminded colleagues has led to the formation of a joint American-Russian project to undermine the Pakistani-Taliban to make way for a new more subservient regime. Frederick Starr, Chairman of the central Asia Caucasus institute at Johns Hopkins's Nitze School do advance international studies, reports that the American has quietly begun to align itself with those in the Russian government calling for military action ageist Afghanistan and has toyed with the idea of a new raid to wipe the Arab-Osama bin Laden, until it backed of under local pressure, it went so far as to explore whether a central Asia country would permit the use of its territory for such a purpose.

Meeting between government of American-Russian and Indian government officials took place at end of 2000 to discuss what kind of government should replace the Pakistani-Taliban the American is now talking about the overthrow of a regime that controls nearly the entire Afghanistan, in the hope it can be replaced with a hypothetical government that does not exist even on paper. The fact that American has recently been backing a UN resolution strengthening sanctions against foreign military aid to the Pakistani-Taliban, without including an embargo on the other armed factions in Afghanistan, confirms clearly the shift in policy has on humanitarian basis behind it. The other factions "when they ruled in key areas, showed a brutal disregard for human rights for other minorities that was comparable to the Pakistani-Taliban at its worst, notes central Asia specialist Frederick

Starr, yet the fragment of a government they support on and, with American backing, occupies Afghanistan's seat in the United Nations. HRW criticized the security council measures, urging arms embargo against all combatants, not only the Pakistani-Taliban, indeed, a joint American-Russian draft resolution ignored the ongoing civil war in Afghanistan responsible for the humanitarian crisis, focusing instead on the Pakistani-Taliban's harbouring of the Arab Osama bin Laden would impose new sanctions only on the Pakistani-Taliban until it gives up the Arab bin Laden for extradition and closes camps allegedly used to plan criminal acuities overseas. But the draft resolution does not directly address the ongoing civil war in Afghanistan, which has been accompanied by a sever humanitarian crisis executive director of HRW, Kenneth Roth, has pointed out that the international community's failure to address abuses by the warring parting parties now because they are an important cause of the continuing humanitarian crisis in Afghanistan, signifies that they are inexcusably abandoning the Afghan people to suffer atrocities at home while focusing exclusively on the Afghan government's role in attacks on foreigners.

Conditions in Afghanistan in 2001
4,600 metric tons of opium from 1994-2001
exported to Russia
To keeping Russian out of the civil war

It is clear that the Afghan people have borne the brunt of the actions of international terrorist, after 22 years of war "the cold war" and the American-European drought in history, conditions in Afghanistan are desperate, as a result of the drought, 22 million people are barely surviving and two million Afghans have abandoned their homes in the past year to find nourishment elsewhere, many of them have ended up in encampments where the water source is gone; there is no real shelter, on heat, and no latrines, their animals are dying, depleting their food supply, and the only food source comes from the world food program once a month, some have fled as refugees to Pakistan or contra, but these countries have closed their borders since more that two million Afghan refugees already live in Pakistan "Pakistan is Afghan Land" and contra, the situation is increasingly grim, kenzo

Oshima, the U.N undersecretary for humanitarian affiance affairs and emergence relief, believes that at least 1 million Afghan are at risk of famine and that the people will need at least $ 250 million to survive, Sayed Rahmatullah Hashimi, Taliban envoy, asserts that economic sanctions placed on Afghanistan by the UN have prevented it from receiving food from countries it had contracts with because their airline has been grounded, further exacerbating the situation. The Afghan infrastructure is divested, health care and education are virtually and the infant mortality rate in Afghanistan is the highest in the world Afghanistan today has six working factors, compared to 220 in 1979, fighting and smuggling often only means of employment. The ongoing civic war has produced enormous disruption throughout the area as the Afghan warlords continue to dope on smuggling and drug trafficking for the Russian, to keeping Russian out of the civil war, the UN drug control program reports that Afghanistan produced 4,600 metric tons of opium in 1999 twice as much as the previous years, Afghanistan from 1993 produces three times more opium that the rest of the world put together for the Russian civil war. The Pakistani-Taliban collects a 20 percent tax from opium dealers and transporters to Russia. It has been alleged that production has increased in Pakistan-Taliban controlled areas, but according to a survey by the UN drug control program, the production of opium had decreased in Pakistani-Taliban areas due to higher wheat prices and fear of reprisals by Pakistani-Taliban forces. Taliban has banned drug trafficking, arrested drug addicts, and prosecuted suppliers. Despite denunciations by Pakistani-Taliban leader Mullah Omar, poppy cultivation continues because "to keeping Russia out of civil war" there is no other means of livelihood for the people and although it is contrary to Islam "like opium war in China 1871 with the European". Pakistani-Taliban recognize the difficulty in imposing a ban because Mullah Omar and the religious establishment have banned the growth and sale of opium some Muslim have been more inclined to abide by the policy because they view the ban as divine law. Thus, to violate it would equate to violation Islam and although in a dire situation, Afghan has more of an incentive to follow the law. The smuggling of consumer goods has also expanded enormously, which has crippled the local industry that cannot compeer with duty free products, however, what the international community would

view as smuggling is considered simple trading to Afghans who have utilized the practice as a basic form of livelihood, the Pakistani-Taliban tax on the smuggling trade was its second largest source of income after dugs, the international community has been quick to blame the Pakistani-Taliban for Afghan tan's condition and drug problems that precede their rule and were worsened by the American during the Russian resistance and has not been able to see past individuals such as Arab-Osama bin Laden to recognize the plight of the Afghan people.

Future American policy to Afghanistan
Reconstruct Afghanistan, because not civil war in Russia

Since the international community has ostracized them and because the United Nations refuses to recognize them, the Pakistan Taliban have not been able to get the assistance it needs to reconstruct Afghanistan, the only way other mujahideen groups were able to get around monetary constraints in funding their movement was through foreign aid usually focused on military needs and not the development needs of the people and drudge sales, however, the United Nations and the American have placed a ban on foreign assistance to the Pakistani-Taliban, thus although Pakistan still provides aid, the Taliban receive only limited foreign assistance, in addition, the Pakistani-Taliban have been enforcing its ban on production of opium and drug trafficking and do not benefit from revenue associated with drugs leaving out what was once an alternate source of funding for groups in power. Therefore, the Pakistani-Taliban have few resources to raise the standard of living in Afghanistan, overall, the Pakistani-Taliban's ability to improve conditions in Afghanistan has been limited and it appears likely that it will remain so. It is difficult to judge the actions of the Pakistani-Taliban given the situation in Afghanistan and their lack of basic resources or foundation, any temptations to pass judgment on the policies and actions of the Pakistani-Taliban may be countered by a measure of sympathy and understanding for the situation in which the people of Afghanistan have found themselves. No administrative system exits, no industry, on health sector, very limited education, and yet the American-European demands that the Pakistani-Taliban put an end to the only available source of revenue for the Afghani

people the opium sale and smuggling furthermore, they are supposed to do this while continuing to fight the northern alliance that is being funded by Russia and Iran "not anymore civil war in Russia" among others, at the same time the international community is trying to seal off aid the Pakistani-Taliban from Pakistan, such a policy may indeed increase the likelihood that civil war will continue in Afghanistan. The policy of arming the opposition and sealing off the Pakistani-Taliban makes them potentially more dependent on benefactors such as the Arab Osama bin Laden and less likely to cooperate with the UN by shutting down militant training facilities Questions arise as to who the American expects to run Afghanistan after the Pakistani-Taliban, has the American really thought about whether the northern alliance is a group that it wants to run Afghanistan is that group capable of ruling the Afghanistan and bringing peace since it is made up of the minority ethnic group that has never effectively been in power in Afghan history is allowing Iran and Russia to manipulate internal Afghan politics any better that Pakistan doing the same thing if any lesson can be learned from American involvement during the Russian resistance it is to do research on a group before arming and funding a different party every time one does not cater to American interests. The answer to all these questions is no. the northern alliance controlled by x-Mujahideen groups Rabbani and Massoud also favours the existence of an Islamic society in Afghanistan not that different from what the Pakistani-Taliban have instituted, however, their rule would elevate the interests of minority Tajiks as opposed to Pushtuns. As discussed previously, control of the state has been used in Afghanistan to reinforce the tribe and promote its customs, legitimate rulers are Afghans who are respected members of the dominant tribe, accordingly, traditional politics as practiced and Afghan-culture seems to preclude the possibility of minor Tajiks-tribe like Rabbani and Massoud, ruling Afghanistan much of the reason the civil war has continued is because for the first time, minority groups were empowered by the American with training and weapons. After 1871 "the Russian" this caused a power shift enabling the minority Tajik-tribe to oppose the Pushtun majority for power as evident in the civil war, however, Pushtuns remain the dominant tribe due to the size of their population and their solid control of the Afghanistan from 1747, even if the American and European to fund the northern

alliance, it will be long and destructive fight before Rabbani and Massoud would be able take control of the Pakistan-Taliban's 10 percent of Afghanistan. Even then, it is unlikely that a majority of the population would view Rabbani and Massoud as legitimate rulers of Afghanistan this reality raises serious concerns about a policy to fund Rabbani and Massoud while preventing aid to the Pakistani-Taliban. It is ironic that the American is now cooperating with old Afghan enemy Russia to defeat a group that the American to put in power in the first place. Taliban are the only group that has been able to bring some limited peace to Afghanistan in 28 years of fighting the Taliban has the group that took a definitive stance against drugs and progress in this area had already become apparent, it is troubling that the Taliban exclude the Shi'a minority from parturition in the state and that the rights of women are extremely restricted. This is evident in that ideologies and goals of many of the mujahideen groups were to create an Islamic society after 1924. many countries have refused to recognize the Pakistani-Taliban until they provide equality for women even though they recognize countries like Saudi Arabia and even though countries such as the U.S. A have just recently legally accorded equal rights to women (equal rights between women-men in Afghanistan first times from 1884 by the king until 1991) and the allocation of equality has yet to be achieved in areas such as equal pay for equal works. The achievement of equality for women in the America took an exceedingly long time from 1960 given the fact that the American enjoyed a stable economy in Afghanistan from 1884 was equal rights to women tall 1991. was not engaged in a civil war, and had no history of religiously defined rules regarding women that had to be modernized and overcome, and yet the American demands that the Pakistani-Taliban immediately offer women these rights however limited, even though it is contrary to their belief system and they have to face all of the other above mentioned situations simultaneously.

American-European also criticizes the use of punishments considered to violate human rights as amputation for theft or stoning for adultery, the most recent example of what the west asserts as the Pakistani-Taliban's fanaticism and unreasonableness was their decision to destroy two enormous historic Buddha statues carved from steep cliffs 1800 years ago.

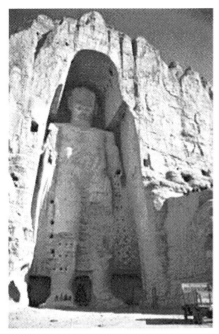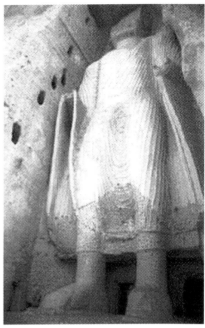

Buddha statues from 200 A.D in Afghanistan in Province of Bemyon

The Russian invasion in Afghanistan cost 5 million live and $900
billion US
And two decades war and civil war in Afghan live
Islamic School in St Petersburg Russia applied originally by Tsar in
1871
"Russia's have to give Compensation for 22 million Afghan"

The end of the cold war and the conflict between the Russia "Soviet
Union and the America in Afghanistan is a better approximation of
the nineteenth century the Great Game in Afghanistan and Afghan
live, that is the contemporary clash of outside interest centering on
Afghanistan , one of Russia's goals in threatening India during the
post Crimea period was to preoccupy the German-Saxon (new
Britain) and thus diminish its role in Europe, the shoe was neatly
transferred to the other foot when nearly a century after Panjdeh,
the Tsar Russia "the German empire of Russia" entered Afghanistan
and a European-power the American in the place of Britain-turned to

local forces to halt the Russia advance and in the processes, weaken Moscow on the larger international scene. As the cold war intensified, the Afghanistan-central Asia became once moor times after 1871 drawn into the conflict. In 1954 large part of Afghanistan signed Pakistan a mutual defence agreement with the American and also joined the Southeast Asia treaty organization, thus aligning itself with the European. Given Afghanistan's then-adversarial relations with now-Pakistan, it was perhaps natural that king in Kabul would begin a partnership with Moscow; particularly given the latter's support on the Pushtunistan issue "the cold war". In 1955 and again in 1965 the two countries signed by the king 10 years non-aggression treaties, the Russian assumed and important role after Panjdeh in Afghanistan's economy, as well as its security. Between 1955 and 1978, the Russian gave Afghanistan $ 2.5 billion in economic and military aid the gas and Uren in 1973 Daud overthrew the king Zaher Shah and established a republic, five years later a coup gave power to a strongly pro-Russian regime, but heavy resistance quickly developed. The Russian invasion of December 1979- 1885 Turkistan at Panjdeh seems to have been a reluctant one, and was probably prompted by two main concerns. The first was the maintenance of a pro-Russian regime the rural revolt in Afghanistan also raised the spectre of Islamic militancy crossing the Afghan bordered into central Asia, although Moscow may have feared that American impelled by its problems Kremlin's decision to invade the Russian had the capability to invade Afghanistan "KGB & CIA The Russian invasion cost 5, million Afghan live and $ 900 billion U.S and two decades war and civil war in Afghanistan, since the 1950s and had not done so, indeed, Moscow paid a high price for its occupation of Afghanistan in terms of its relations with Asian world, Islamabad began lending surreptitious support to Afghan-rebels ageist the regime of Daud in 1974 after the Russian invasion, many of the anti-Russia "Soviet" guerrillas, Mujahidin established by CIA, bases in the north-west frontier province, notably in Pashawar old Afghan-city, for its part, the American's interest in Afghanistan had all but disappeared by the 1960s, and there was a tacit acceptance that Afghanistan was within the Russian sphere of influence, allowing the Russian leadership to assume that invasion of Afghanistan would not provoke a military confrontation with the European-American. Although Pakistan was

early in the field in supporting the rebels, American backing for them only came after the Russian invasion, even the Washington did not begin to supply sophisticated ant-aircraft weapons to the mujahidin until 1986, and it left the main political decision regarding which Afghan should be supported to Islamabad, Pakistan also became the main conduit for European American aid to the mujahidin, with the backing of the CIA and of Pakistan's for European-American aid to the mujahidin, with the backing of the CIA and of Pakistan's inter-services intelligence agony ISI some 35, 000 Muslim radicals from 40 Islamic countries, joined the fight against the Russia and their client Afghan regimes, but the late 1980s combined American Saudi assistance to the only Afghan resistance had climbed to about $ one billion per years, at least 13,000 Russian troops are thought to have died in a nine-year occupation of Afghanistan, and the USSR poured a total of $ 45 billion into the lest war. Afghanistan's neighbours Afghanistan become in on territory neighbours the international attempt to resolve the conflicts in Afghanistan "in Germany" currently revolves around the Six-Plus-Two formula, the "sis" is states neighbouring today Afghanistan; Pakistan "a shared border of 2, 430 km" Iran 936 km Turkmenistan 744-km, Uzbekistan 137 km, Tajikistan 1, 206-km and Easter Turkistan 76-km dos were Afghan-territory 1885, the two are Russia and the British today, whose involvement makes the analogy of the Great Game Russia and British compensation 22 million Afghan, for the 1954, more tenable. If the U.S A is substituted for nineteenth-century British India involvement "albeit outside the Six-Plus-Tow formula" is factored in. Islamabad is the primary external actor in the conflict in Afghanistan "Pakistan compensation of 22 million Afghan" and thus its motives, policies, and actions merit particular scrutiny in any assessment of external intervention in that conflict in Afghanistan, compensation for 22 million Afghan who lift the century or lost live in the American and Russian war. Background from 1947 to 1963, Islamabad relations with Afghanistan were largely determined nay the Pushtunistan "cold war" question, as successor state, Pakistan inherited the Afghan-territory east of the Durand Line, a border demarcated by the British in 1893, but challenged by the Afghan as having been drawn up under duress "is was never intended as a de jute international boundary" consequently, Afghanistan demanded that an independent

Pushtun state "45 million Pushtun established, incarnating a large area, because of this dispute, Afghanistan was the only country to vote against admission to the United Nations in 1947. The issue smouldered for years, even leading to border clashes in 1960, in the latter year; Afghanistan closed the border and severed diplomatic relations. The resignation in 1963 of Daoud khan, then the Afghan prime Minister and a militant exponent of Pushtunistan, along with the intercession of the Durand Line was end in 1992, now Paluchistan and Pushtunistan was Afghanistan the is the civil war in Afghanistan, as noted earlier, Islamabad began giving Afghan rebels surreptitious support soon after Daoud khan's coup, becoming heavily involved-with American and Saudi backing after the Russian invasion, the ISI played an important role in distributing U.S.A weapons and funds in Afghanistan. Thus the ISI was in a position to promote the strictest Islamic and pro-Pakistan elements within the Afghan resistance ISI Lieutenant-General Hamid Gul himself an Islamism a corollary of the campaign.

Motives behind Pakistan Policy towards Afghanistan Duran Line was end in 1993

Given the long border by British shared between Afghanistan and the history of their relations, it is surprising that Pakistan does not feel itself a disinterested neighbours of the war-torn state to its northwest, nor that its involvement far exceeds that any other state Pakistan (from 1947 was British and from 1954 until today American "the is not Pakistan") policy towards Afghanistan is actuated by a large number of strategic, security, political and other factors. For some twenty five years, Pakistan commentators have linked Afghanistan with the notion of "strategic depth" in the event of a conflict with India, many Pakistanis envisage that a compliant regime in Afghanistan would give Pakistan a secure base for its forces, but "strategic depth" seems to have broader meaning that simply military basing, it also appears to refer to sustaining Islamic military, in order to impress upon New Delhi the risk that military would continue even where the Indian army may overrun large parts or all of Pakistan. Thus there would be no finality to Indian victory further, some Pakistanis envisage the creation of a belt of Islamic countries-including the states of central Asia as well

as Afghanistan which would add to strategic rear by increasing its commercial, cultural, political and diplomatic influence. One of the primary concerns of the Pakistan government is internal security, and the conflict in Afghanistan has serious repercussions on the situation within Pakistan there has been a reflux of extremism into Islamabad, with Pakistani-Taliban style groups emerging in the north west frontier province and Baluchistan, in 1995 hundred of Afghan and Taliban were involved in an uprising to demand Sharia law; the army crushed the revolt, Islamic militancy is beginning to seep from these province into Punjab and Sindh, a backwash of violence emanating from Pakistani mujahidin may not be Pakistan's only concern, in lasted September 1999 Pakistani-Taliban first several missiles into Pakistan attack from this quarter would be only a minuscule problem for Pakistan, but it could not ignore the potential for it altogether, given the history of the frontier. Pakistan is trying to perform a balancing act. On the one hand, it wants to control the blowback of violence onto own soil, something that requires, in part, some kind of arrangement with Pakistani-Taliban, on the other hand both former prime minister Nawaz Sharif and present chief executive General Pervez Musharraf have shown themselves anxious to enlist support of Islamic extremists in Pakistan, and this has entailed backing for Jihad, whether in Afghanistan or Kashmir, Pakistan has been an active supporter to the Kashmiri resistance regular troops were involved alongside Islamic militants in the argil incursion into the Indian state in the second quarter of 1999 and thus Pakistan has a common cause with the mujahidin there. Since many of those mujahidin have been trained in Pakistan, and some are Pakistani, any action that Pakistan takes against Taliban could hurt Pakistan's cause in Kashmir, likewise, one of the well springs of international "and particularly American" pressure on Taliban the attempt to persuade Pakistani-Taliban to withdraw sanctuary for the terrorist financier the Arab Osama bin laden the little appeal for those Pakistanis who welcome bin Laden's support for the Kashmir is, Pakistan may also anticipate negative security ramifications from a Taliban defeat, the Pakistan government wants to avoid the break-up of Afghanistan, incorporating a substantial belt territory, by the same token, if the anti-Taliban opposition, the northern alliance, prevails it might bring to the fore a man,

International financial institutions, such World Bank 1893 until 1993 British Durand Line expired on all Afghan territory
Pakistan and Islamic-school applied originally by British in 1947
Russian Iran-China Pakistan has to give compensation for 22 million Afghan

1893-1993 Saxon (from 1917 British) Durand Line expired on all Afghan territory 28 yeas of war, as well as security and social motives for establishing its influence in Afghanistan when the Russian "Soviet Union" collapsed in 1991, many countries saw economic opportunity in the resources and markets of Afghanistan-Central Asia the region's oil and gas reserves are thought to rival those of the north Sea, Pakistan (med by American) is a member of a Muslim economic bloc, the economic Co-operation Organization ECO founded in 1992 and comprising the Afghanistan-central Asia states, plus Pakistan, Iran, Turkey, and Azerbaijan, like other external power, Pakistan has been disappointed by the reality of economic opportunity in Afghanistan-Central Asia. However, one of its biggest dreams oil and gas pipelines linking Pashtunistan (Pakistan) with the energy resources of north Afghanistan-Turkmenistan remains alive, although barely, these pipelines would cross Afghanistan the oil route would be chardzou Turkmenistan Herat Gwadar Pushtunistan, the gas route would be Daulatabad Turkmenistan Heart Kandahar-Multan Palushitan imported $ 2 billing of oil in 1995-96, and although it has gas reserves of its own in Baluchistan, it faces a gas shortfall by 2010. thus, Pakistan is eager to find alternative and cheaper sources of energy, when the possibility of a Afghanistan-Turkenistan-Pushtunistan pipeline was first broached, Balushitan was apparently averse to India's energy needs being met as well as its own "economies of scale would benefit Pakistan consumption" the energy needs of both Baluchistan and India's western states, as well of the New Delhi area, prompted the American company Unocal to explore the potential for a spur line to the Indian capital from the proposed trans-Afghanistan route, for all the rivalry of the two countries, Unocal claimed that there was

support in both Balushitan and India for such a spur-line. Since then, India-Pakistan relations have been soured the kargil conflict of summer 1999 as a result, New Delhi objected when Iran sought to modify a 1993 idol memorandum of understanding on an offshore pipeline between Iran and western India "natural gas from Turkmenistan as well as from sistan and Balusitan fields could flow through this pipeline" the sistan approached Pakistan for transit rights for an Sistan-India land pipeline "which is thought likely to be 15-20 percent cheaper that a shallow water one" Sistan Baluchistan in Iran today is Afghan territory of 1893 British" and on 3 April 2000 Mascara approved the request on the understanding that Pakistan would corn transit fees of $ 600-700 million, the Indians objected to Iran action, on the ground that it would put a major Indian energy lifeline at Pakistan mercy, if a natural gas pipeline were constructed between Iran and India, by land or offshore, one the benefits of trans-Afghanistan route meeting India's need for natural gas would be lost. While cost is a factor in construction of the trans-Afghanistan pipelines, security is a major issue, in order to justify underwriting pipeline construction, international financial institutions, such as the World Bank, and the business community would require the establishment of a stable Afghan government with broad internal support, international recognition, and good relations with its neighbours.

The American dream of tapping into markets in Afghanistan-Central Asia

Does not solely revolve around energy pipelines, in October 1996 then president Faros Leghari visited Central Asia, and one of the issues discussed with host was the establishment of a new transportation corridor from Termz "north of Afghanistan" to Karachi, via Mazar-i-Sharif and Herat "Karachi is old Province of Afghanistan 1893-1993 British" it is doubtful that anything has come of this proposal, but it does give a further indication of Pakistani "British" thinking with regard to trans-Afghanistan communications, as the case of the Afghanistan-Turkenistan-Balushitan pipelines, security would be a key dimension in the realization of an Uzbekistan-Balushitan corridor, as will seen, other transit possibilities are being scouted by Pakistan, suggesting that

route security remains a salient motive for Afghanistan, Pakistan claims that truckers are equally interested in transportation routes across Afghanistan, and that their frustration with being frequently stopped and "taxed" by different factions along a single orate was a catalyst in swinging Pakistan support behind Taliban in late 1994 impoverished as it is Afghanistan has a number of impacts on the Pakistan economy, under international law, Pakistan must allow landlocked "by British" Afghanistan to import and export goods duty-free through old Afghan province of Karachi; the goods should only transit Pakistan, this requirement is incorporated in the 1965 Afghan-trade agreement ATTA whereby certain goods can be imported into Afghanistan free of Pakistan duties, however, a significant proportion of these goods are then smuggled into Pakistan depriving of a source of indirect taxation and undercutting local industry in Afghanistan. The ATTA trade has expanded enormously since Pakistan-Taliban became a force on the Afghan scene, according to the Pakistan government, Pakistan losses in customs revenue and sales taxes from this source in 1998 amounted to 30% of the government's total revenues of $ 6 billion, shortly after the Pakistan coup Musharraf withheld wheat exports to Afghanistan. "States of Pakistan from 1973 until 2001 made of Afghan live Billion Dollars" causing a 20% jump in prices in that country, which is largely dependent on food imports about 450,000 metric tones of wheat per year are shipped from Pakistan to Afghanistan, the ban was reversed on 17 November, while this action may have been an attempt to control Pakistan-Taliban behaviour, it is also likely that it was prompted by a need to protect domestic food stocks, finally whatever the security implications of thousands of Pakistani madrassah students fighting in Taliban ranks might be the reality is that they cannot be absorbed by the Pakistani economy. Likewise, continued fighting in Afghanistan could potentially produce a new influx of refugees, with the economic cost associated with such a development.

Motives behind China's policy towards Afghanistan British-Durand line Afghan-territory 1893-1993 expired East Turkistan (new Xingjian) exchange with Hong Kong, Bangkok Tie won In 2,500 years Afghan people never last war

As many of Afghanistan's neighbours, China sees a potentially series security threat in Taliban, Beijing is concerned by apparent Taliban backing for Uighur separatists in East Turkistan "new Xingjian" Uighur militants have trained and fought with the Afghan sine 1986, and Taliban inherited most of the Uighurs still left in Afghanistan. American-European intelligence officials claimed in early 1999 that almost all of the arms and explosives used in attacks on the security forces in China had come from Afghanistan. The Uighur militants also have close ties with bin Laden and Yuldashev both of who are linked with Taliban, a related worry is the flow of cheap heroin into East Turkistan via Afghanistan's Wahkan corridor, Beijing apparently hopes that by holding out the prospect of improved relations to Taliban "who are desperate for international recognition" the militia will cut off support for the Uighurs and clamp down on drug runners, although it closed its embassy in Kabul an the eve of the Taliban capture of the city in September 1996, China largely ignored the civil war in Afghanistan, however over a period of several months from late 1998 Beijing began to show signs of accommodation with Taliban, following the American cruise missile attack on militant bases in Afghanistan, Beijing got in touch with Taliban to allow Chinese scientists access to the missiles computer guidance system, on 10 December 1998, China and Taliban signed a military accord whereby China would train Afghan pilots, in February 1999, Beijing announced an agreement with Taliban to start direct flights between Kabul Urumqi and to open formal trade talks the militia "apparently Pakistan encouraged China to visit Kabul" since then however the Chinese seem to have shifted their strategy to one of more active containment of Taliban, although they emphasize the need for a peaceful solution to the conflict at the "Shanghai Five" meeting in Tajikistan in July 2000, the Chinese delegation countered Russia's called for military action against Taliban" Eastern Turkistan is 1.6 million Sq km, is Afghan-territory.

Afghanistan President 1992 Dr. Njibullah

Other outside players Russian, on Afghan territory more then 2 million Sq km background after 1992 defeat of President Dr Njibullah, Moscow's proxy in Afghanistan, Russian reduced its involvement in Afghanistan, however, within months Russia was increasingly involved, with its Afghanistan-central Asia allies, in propping up the regime in Bukhrar (new Tajikistan) which was threatened by an opposition largely based in Afghanistan. Indeed, in April 1995 the then government in Kabul protested strongly alleged Russian attacks on rebel within Afghanistan. Pakistani-Taliban's capture of Kabul in September 1996 alarmed Russia, which sought to rally the central Asia states in backing the northern Alliance, however when Pakistani-Taliban captured Mazar-i-sharif and other key stronghold of the northern Alliance in summer 1998, it gave Russia and the central Asia states pause in their support of the alliance, not only were alliance supply lines to central Asia cut, but also Pakistani-Taliban seemed the probable September 1996 greatly alarmed Russia sought to rally the central Asia in backing the northern alliance, however when Taliban captured Province of Mazar-i-sharif and other key strongholds of the northern alliance in summer 1998 it gave Russia and the central Asia pause in their support of the alliance, not only were alliance supply lines to central Asia cut, but also Taliban seemed the probable winner, and for a while both Russia and Uzbekistan looked as if they would accept the situation in return for Taliban not exporting fundamentalism into commonwealth of independent states CIS however, Ahmed shah Masud was able to

reopen the supply line in late 1998 and durability of his resistance encouraged renewed CIS backing.

Motives behind Russian's policy towards Afghanistan, more the 2 million Sq km Afghan-territory, Durand line "the Saxon and Tsar"

Throughout the 1990s the new central Asia state has worried about the possible spread of Islamic militancy in the country, imported from conflict zones on its periphery, in May 1993, then defence Minister Pavel Gretchen claimed that; each day blood is being spilled to turn Tajikistan into an Islamic state, if these plans succeed, we should expect Islamic fundamentalism to spread further to north in Uzbekistan, and so forth, we should not forget that there are around 20 million people in Russia who profess Islam, if the flame of war in Tajikistan in not extinguished, it may have dangerous consequences for Russia, to the more so because aggressive feelings are manifest in Chechnya, three years later, colonel General Vladimir Semenov, commander of ground forces, argued that the greatest potential threat to Russia came from the possible spread of Islamic fundamentalism from the south and southeast. Since Grachve voice his fear of Islamic militancy, there have been two wars in Chechnya, continued fighting in Tajikistan, and eruptions in Kyrgyzstan and Uzbekistan to reinforce such concerns. Russia worries about Islamic militancy have been compounded by thru lattés war in Chechnya, in which large numbers of foreign fighters "notably Wahhabis" have played a major par, it quite likely that the renewal of the Chechen war would not have occurred without the activates of Wahhabi militants in Daghestan, foreign volunteers have played a far more impotent role in the 1999-2000 conflict they did in the fighting in 1994-1996, Russia has been especially exercised by the support given the Chechens and their allies by Pakistani-Taliban. This was epitomized by Taliban's recognition of Chechnya on 16 January 2000, which made Afghanistan the only country to do so. Russia also has a major problem of narcotics smuggling, although a more indirect one that the Iran ort Tajikistan, one of the primary functions of the Russian border forces stationed on the Afghan-Tajik frontier is the prevention of such smuggling "although Russian troops have

themselves apparently been involved in drug trafficking in Tajikistan" on an economic plea, it has been suggested that Russia has an interest in thwarting Tran pipeline projects, thereby increasing the value of its own infrastructure of bringing Afghanistan-central Asia energy to would Market. However, on these kinds of issues, Russia often has more than one "foreign policy" and the highly influential Russian gas company Gasport "which is partly state owned" was a member of the Cent gas consortium.

Motives behind India's policy toward s Afghanistan Afghanistan was borders India until 1947

Pakistan and Islamic-school applied originally by British in 1947

Although India no longer borders Afghanistan, Pakistan and Islamic school of Pakistan applied originally by British in 1947 used during the 1978 on Afghan war for 28 years civil war "cold war" as it did during the nineteenth century "Great Game" like most of those countries immediately adjacent to Afghanistan, it believes that the activities of Pakistani-Taliban threaten its security, yet New Delhi's relative inaction vis-à-vis Afghanistan until recently suggest that it its sense of threat was less immediate that of say, Russia its nineteenth century bogey, the kargil conflict was probably a catalyst of a livelier concern. Within six months of the end the kargil conflict, India suspicion of Pakistani-Taliban was strongly reinforced by the hijacking of an Indian plane at the end of 1999, an action that deeply embarrassed and infuriated the vampire government "which released three Islamic militants to secure the freedom of the passengers and crew motives behind India's policy towards Afghanistan, Afghan-territory; New Delhi is very worried by the role of "foreign militants" i.e.,. Afghanistan trained by CIS in Kashmir local militants in the today Kashmir was South Province of Afghanistan and the people of Kashmir or Afghan, the British Line on 1893-Indian state seem to be tiring of the eleven-year fight, but a large proportion "some Indian sources go as high as three quarters" of the insurgents in Jammu and Kashmir are now thought to be outsiders. The strong switch from local to external militancy appears to have begun in mid 1998, which tends to explain

the relative regency of active Indian concern over the Taliban's role in the export of insurgency, some of the outside fighters in Kashmir appear to be Afghan and proportions of those who are not "such as Pakistani militants" have received training or had combed experience in Pakistan, or Pravin Sawhney, a security analyst in New Delhi who contended that, recently put the Indian view: over 200, 000 Pakistanis have fought in Afghanistan between 1994-2001, these battle-hardened military, most of who are unemployed and threaten Pakistan's own stability, are being routed into Kashmir, sawhney also detects Pakistani-Taliban's hand in the Kashmir insurgency, the view put by Sawhney is Washington. The latest State Department report on global terrorism contends that during 1999, Taliban, permitted the operation of training and indoctrination facilities for non-Afghan and provided logistics support to members of various terrorist organizations and Mujahidin, including those waging jihad, in Chechnya, Lebanon Kosovo, Kashmir, and elsewhere, the Indian government also claims Pakistan-Taliban complicity in the hijacking of an Indian Airlines plane in December 1999, and refused to pay a bill submitted by Taliban for airport and other services provided the seized jet on the ground in Province of Kandahar.

Motives behind American policy towards Afghanistan

During Pakistani-Taliban's first years, American was contentment to follow the lead of Pakistan and Saudi Arabia in backing the militia, which was regarded as anti-Afghan and whose success would permit a pipeline that would circumvent Iran. Thaw Americans also liked Taliban's discipline, aura of incorruptibility, and anticommunism, as well its early announcement that it would eliminated all drugs. At the same time, American officials were hostile to the factions, led by Rabbani, then holding Kabul. More overly commercial soon reinforced these motives. In October 1995 Unocal, an American corporation, along with companies from Saudi Arabia "Delta oil" and elsewhere, signed a memorandum of intent with the government of Turkmenistan that envisaged the construction of a gas pipeline through Afghanistan to Pashtonistan. In addition to by passing, and thereby hurting Iran, such a pipeline was also regarded as likely to bolster Central Asia independence of Russia after 130 years, "1871-2000" and also to

reduce Russia's role in bringing Afghanistan-Central Asia energy to world Market. A trans-Afghanistan pipeline required political stability in Afghanistan, which Taliban seemed best, placed to provide, Rashid asserts that the main factor disposing Washington to favour Taliban in 1996 was the pipelines issue, the American's continuing effort to bring Osama bin Laden to Justice inevitably pits it ageist Taliban, the annual state Department report on international terrorism for 1999 commented that; the primary terrorist threats to the United States of America emanate from two regions, South Asia and the Middle East, in south Asia the major terrorist threat comes from Pakistan, which continues to be the primary safe having for terrorists, while not directly hostile to the American, the Taliban continues to harbour Osama bin Laden and a host of other terrorists loosely linked to bin Laden, the Taliban is unwilling to take actions against terrorists trained in Afghanistan, many of whom have been linked to numerous international terrorist plots, including the foiled plots in Jordan and Washington State in December 1999. the American continues to be exercised by the threat allegedly posed by bin laden, on 13 December Michael Sheehan, the American assistant secretary of State for counter-terrorism, warned the Taliban representative in New York that Taliban would be held responsible for any anti-American attacks linked to Osama bin laden, this warning followed a state Department travel advisory alerting American citizens abroad that the government had "credible information that terrorists are planning attacks specifically targeting American citizens during the period of time leading up to and through the New Year and Ramadan events and celebrations "i.e., to early January 2000" state Department officials said that the threat came from members of Osama bin laden's network, and that two attacks were being planned, thirteen alleged terrorists were arrested in Jordan, and three accomplices were said to be on the run. The group included Jordan ions, an Iraqi, and an Algeria, they were reportedly trained in bin laden's camps in Afghanistan and to be planning an attack in Jordan itself, October 2001 end of Osama bin laden and Pakistani-Taliban government in Afghanistan

Afghanistan today (2009) is completely free and independent in the administration of its domestic and foreign affairs, United States of Americas (President George W Bush is the founder of new Afghanistan) after 72 years October 1929, October 2001, Democratic-Afghanistan Like Germany after 1945.

Hamid Wahed Alikuzai

Autobiography of Hamid Wahed Alikuzai

Born in Kabul in 1949, and educated in a French school until the age of seventeen, Hamid's education was enriched and very influenced by his grandmother, his mother's mother, who was highly educated and passed down ancient wisdoms and cultural heritage. These stories, wisdoms, and discussions touched him deeply and so profoundly that he began even as a young boy to live his life in a way that reflected these teachings. His grandmother's history, culture, wisdom, ideas and knowledge of all religions and the 9 prophets was taught to Hamid. Each story or pearl of wisdom took his grandmother sometimes as long as two to three weeks to tell. In preparation for these teachings the children would have to bathe from head to toe and put on fresh clothes. Every day was like Christmas when his grandmother was there. To Hamid she was looked and spoke like an angel.

Hamid's father, Wahed Alikuzai, was educated in Europe until 1932 in nuclear science for the military and there was very strict discipline and order in the house. Education was the number one priority. Hamid's father was also very powerful in his knowledge and connection with the ancient way of life and our connection to the earth. His father had a one hundred percent firm belief that all people are equal, regardless of faith, education or social status.

In 1919 the King of Afghanistan believed and passed down a law that there would be no distinction between people. There would be no such thing as a first, second or third class citizen. (The word Afghan translated means first class citizen). All people no matter what their background were very proud to be Afghan. This description of the way of life with the nature and equality of people was the fundamental foundation passed down since 3 000 years ago .Since then unity began.

These two individuals in Hamid's life, both father and grandmother, were key in Hamid's development and shaped and inspired his life but also were the fire behind the huge passion Hamid had for history. Upon completion of French High School in 1967, the university was closed due to fighting among the religious groups and the communists. Hamid took a job with the Supreme Court of Afghanistan, and after one year had a scholarship for International Law which was his ticket out of the country. Hamid chose to go Germany to further his education, and entered Germany with his diplomatic passport, fluent in French and Russian, and some English. In one year he spoke German freely. At the age of seventeen, Hamid was alone with no family in Germany except the shadow of his father and the teachings of his grandmother that gave him the foundation that would carry him through the next phase of his life. Under the influence of his father and his father's best friend, who was a five star General in the Afghani army, Hamid would be changing his studies from International Law to Engineering, because of the Islamic movement in Afghanistan. Were he studying law, Hamid would not be welcome back into Afghanistan and therefore it would be more beneficial to study something that would suit the needs of the country. So for the next eight years leading up to 1975 Hamid studied engineering and history in Hamburg Germany.

He took a vacation to go back home to Afghanistan in 1975 with high hopes of staying. At twenty-six Hamid had gained quite a bit of knowledge of his own and was excited to share this with his father. For forty-eight hours straight he proudly talked about all that he had learned as well as some really good engineering ideas he had with

his father. On the third day, Hamid's father explained his concerns because of the current changing of the regime – Afghanistan had become a republic in 1973 during a coup d'etat influenced by Russian powers. During Hamid's visit his father was put under house arrest by the new head of the republic, Daoud Khan. Mister Alikuzai, Hamid's father, was ordered to pay a hundred and fifty million Afghanis to the government. Hamid visited at the courthouse in all of the ministries for letters of recommendation about his father but to no avail. At any given time there could be border closures between Afghanistan and its neighbouring countries. Hamid's father Wahed Alikuzai was thinking that he had made a mistake in believing that Afghanistan was a free country - since 1929 Afghanistan was not an independent country because of the Cold War and Russia's involvement.

At midnight on the third night of his visit, it was decided that Hamid would leave as early as 6a.m. to Iran and then back to Germany. At 5 a.m. Hamid got dressed and knocked on the door of his father's room to say goodbye. This is the last time Hamid would ever see his father again. His father already sitting up in bed stopped Hamid from stepping further into the room. With two fingers raised in the air his father began to say that he only had two years to live whether in jail or in his own bed. Hamid and his father had an agreement that Hamid would write a letter letting his father know that Hamid had passed through the border safely. Passing through the border by car early in the morning, from Iran Hamid drove back to Germany. His diplomatic passport enabled him to continue his studies on many subjects for the next twenty-two years in Germany. Several years later, in 1979, he wanted to renew his passport at the Afghan embassy in Bonn. They refused to renew his visa and kept Hamid's passport, saying he would have to return back home to Afghanistan.

Hence began Hamid Wahed's next course of action to become a German citizen. Hamid's best friend Paul, who studied law, sent a letter to internal and foreign affairs in Germany. The choice was either political asylum or citizenship, and never having being involved with politics Hamid chose German citizenship. Paul made the arrangements for the citizenship interview. When sitting face to face

with the authorities, Hamid was told to put down in his own words and hand writing what was talked about in the meeting. Having put it in letter form, Hamid returned with the letter personally to deliver it. When the man saw the letter he told Hamid he was leaving for six weeks vacation but he would send the letter to internal affairs and the decision would rest upon the German authorities. It was unknown how long this process would take, whether it would be one year or ten years. This gentleman after six weeks called Hamid on the telephone and said congratulations they have accepted you as a German Citizen. Back in Afghanistan the Russians invaded in December 1979. Hamid was never to visit the country of his birth again, not even for his father's or his brother's funeral. His brother was an air force pilot killed in Kandahar by the Muslim Fundamentalists after passing his astronaut exams.

Meanwhile Hamid married in Hamburg, and on the 15th of April 1981 his first son was born and July 6th, 1983 his second son was born. In 1982 the young family came to Las Angeles, California although he would return with his wife and children would return to Germany in 1983 before the birth of his second child. In the years from 1988 to 1994 Hamid had moved to the United States and was working and studying in Los Angeles. From May 1994 Hamid Wahed came to Vancouver B.C Canada, because Hamid wished to see his mother, brother, and sister. His mother and sister immigrated by walking for three months to New Delhi, India from Kabul, Afghanistan, when the Taliban came into power in Afghanistan in 1992. At his mother's urging the family reunited in Vancouver, B.C Canada after a twenty-eight year separation. Hamid hadn't seen his little sister since she was one year old.